Armenia

Masterpieces from an Enduring Culture

Armenia

Masterpieces from an Enduring Culture

Theo Maarten van Lint & Robin Meyer

Bodleian Library
UNIVERSITY OF OXFORD

The Bodleian Library wishes to thank the following for their generous support of this publication:

 CALOUSTE GULBENKIAN
FOUNDATION

The Hagop Kevorkian Fund

We gratefully acknowledge the support for the exhibition from Raffy Manoukian

First published in 2015 by the Bodleian Library
Broad Street, Oxford OX1 3BG

www.bodleianshop.co.uk

ISBN Hardback: 978 1 85124 439 3
ISBN Paperback: 978 1 85124 440 9

Text © the contributors, 2015
Images © Bodleian Library, University of Oxford, 2015 unless specified

Designed by Dot Little at the Bodleian Library in 11/14pt Minion and Sylfaen
Printed and bound in Italy by Graphicom on Gardapat Kiara 135 gsm

British Library Catalogue in Publishing Data
A CIP record of this publication is available from the British Library

Contents

From Bodley's Librarian

In 2015, millions of Armenians throughout the world will commemorate the resilience and vibrancy of their culture, in the light of a genocide that brought unfathomable loss and suffering a century ago. Countless others will mark the anniversary with them and seek to understand the meaning of the events and their aftermath for the future of humanity.

The Bodleian Libraries at the University of Oxford are honoured to be a part of the commemorations, helping to share the history of the Armenian people and their culture with this publication, which marks a major public exhibition, *Armenia: Masterpieces from an Enduring Culture*, held at the Bodleian's new landmark Weston Library. This is the first occasion on which the Bodleian has shared its Armenian books and manuscripts with the public in such an exhibition. In 2015, the University of Oxford also commemorates the fiftieth anniversary of the establishment of an endowed Chair in Armenian Studies: the Calouste Gulbenkian Professorship. It is therefore fitting that the current holder of the Professorship, Theo Maarten van Lint, has co-curated the exhibition and co-edited this accompanying publication.

Scholarly interest in Armenian culture at Oxford dates back at least 400 years, when the first Armenian texts entered the newly founded Bodleian Library through benefactions from Archbishop Laud (1573–1645). The earliest record of the purchase of an Armenian printed book is an entry in the accounts of 1673 for books bought from Thomas Marshall, Rector of Lincoln College: 'To Dr. Marshall for the Armenian Bible and Testament, £20'. Marshall's collection of Armenian books and manuscripts was later bequeathed to the library in 1685. Armenian texts are to be found in other major collections acquired by the Bodleian during the seventeenth century, including the library of John Selden, the London lawyer and historical and linguistic scholar, bequeathed to the library in 1659, and the collection of Oxford University's Laudian Professor of Arabic, Edward Pococke, purchased in 1693. Amongst Pococke's collection was an Armenian item described in the early Bodleian catalogues as 'scriptum Armenum', which for many years escaped the attention of Armenian scholars, since the collection was primarily of Arabic and Hebraic texts. In 1969 it was identified as the only known copy in existence of the first book printed in Iran: an Armenian Psalter produced in Isfahan's suburb of New Julfa in 1638.

The most concentrated period of Armenian manuscript purchasing was in the nineteenth century under the librarianship of Edward Nicholson. During his time as Bodley's Librarian, Nicholson acquired over ninety further manuscripts, including a collection of fifty purchased in 1899 for £75 from Hannan, Watson & Co. These

acquisitions represent some of the earliest Armenian manuscripts in the collection, and include an eleventh-century manuscript containing the Armenian translation of Chrysostom's commentary on the Epistle to the Ephesians.

Many of the Bodleian's nineteenth-century Armenian books come from the collection of the great linguist and Orientalist, Solomon Caesar Malan (1812–1894), Vicar of Broadwindsor, which was donated to Oxford between 1859 and 1894 and formed the basis of a new Bodleian shelfmark 'Arm.', to which all subsequent Armenian printed book accessions were added. The most recent addition to the Bodleian's Armenian early printed book collection, a miniature prayer book purchased in 2014, also once belonged to Malan (cat. 52).

The collection has continued to grow since the early seventeenth century through benefactions, legacies and acquisitions, and today has over 140 manuscripts and over 250 early printed books. Spanning a period of well over 1,000 years, it preserves a rich legacy of poetic, historical and other literary texts that bear witness to the vast cultural achievements of the Armenian people in all walks of life, from literature and art to religion and commerce.

The exhibition has given the Bodleian the opportunity to reflect on the centenary through its Armenian collection, which has been enriched by manuscripts, books and objects from other libraries, museums and individuals. Most poignant of all are the everyday items that have made their way to Britain in the hands of Armenian families who generously lent us these treasured parts of their lives.

I would like to extend my thanks to Professor Theo Maarten van Lint and Mr Robin Meyer of the Bodleian Library, who have curated the exhibition and edited this catalogue, as well as the individual contributors to the volume. The Bodleian Library is indebted to Mr Raffy Manoukian for his financial support for the exhibition, and to the Calouste Gulbenkian Foundation and the Hagop Kevorkian Fund, who contributed towards the making of this publication. I would also like to record our thanks to all the institutions and private individuals listed in the Preface who have supported the exhibition and publication through loans or other acts of institutional, practical or intellectual generosity.

Richard Ovenden

Preface

'To you, young men of Armenia, I speak, with all my heart I beseech you learn ten languages, but your mother tongue, your faith keep strong!' This appeal by Xač'atur Abovean, the author of the first Armenian novel *Wounds of Armenia* (Վէրք Հայաստանի), calls upon his compatriots to be two things: adaptable and at the same time resilient. Written in 1841, Abovean's words resound in present, past and future: the history of Armenia has been dominated by changes of power and political appurtenance, conquest and invasion; only in maintaining their common tongue, faith and cultural heritage have the Armenians been able to resist foreign domination for centuries.

Armenia: Masterpieces from an Enduring Culture, the title of the exhibition that this publication accompanies, is accordingly to be understood in two different ways: one kind of endurance simply refers to the great antiquity of Armenian culture, spanning more than two and a half millennia, from its first mention by the Achaemenid king Darius I (*c.* 550–486 BCE) to the modern Republic of Armenia and the numerous diaspora communities in the Russian Federation, the United States, the United Kingdom and elsewhere; yet endurance also relates to the suffering and hardship which has befallen the Armenians on more than one occasion.

The year 2015 marks the centenary of the genocide perpetrated against the Armenian population of the Ottoman Empire by the Young Turk government during World War I. In this exhibition and its catalogue, we commemorate those who lost their lives in this catastrophe, and those who have suffered its repercussions, by presenting to the public the historical, artistic and other cultural achievements of a people not often in the focus of the public eye, in an effort to educate, fascinate and create a dialogue between nations and peoples. On the occasion of this centenary, and further as a celebration of the fiftieth anniversary of the establishment of the Calouste Gulbenkian Professorship of Armenian Studies at the University of Oxford, we have selected from the Bodleian Library's magnificent collection of Armenian manuscripts those which most vividly demonstrate the richness, variety and uniqueness of Armenian culture.

The multifaceted nature of Armenian history, literature and art is reflected well in the Bodleian Library's collection of Armenian manuscripts and early printed books, beginning with an eleventh-century manuscript of John Chrysostom's *Commentary on the Letter to the Ephesians*, translated over half a millennium earlier, written on parchment pages in the most ancient of Armenian scripts, and ending with the record of a family and its village, penned in modern cursive handwriting just before the genocide in the early twentieth century. Within this

span of more than 900 years, numerous richly illuminated gospel books, prayer scrolls with apotropaic magical formulae, and miscellany books containing liturgies, philosophical treatises and merchants' manuals were produced, and are now some of the highlights of this collection. The Bodleian Library forms one of the most important bases of the academic community interested in Armenian Studies at the University of Oxford. The small but vibrant department, situated within the Faculty of Oriental Studies, houses scholars both young and more experienced at the forefront of their respective disciplines. The history, literature and language of the Armenian people, as well as the development of their society and faith, form the central focus.

Next to written witnesses from the Bodleian Libraries, we are also very fortunate to present artefacts from the British and Dutch diaspora communities, which have passed down the generations and stem from each family's old homeland. One of the most fascinating among these community items is an eighteenth-century edition of the *Book of Lamentation* (Մատեան Ողբերգութեան) by the medieval poet and theologian St Grigor Narekac'i (951–1003), which in Armenia was used widely for its healing powers, and continues to be revered by many families to this day.

We would like to extend our deepest gratitude to all those without whom neither exhibition nor catalogue could have been produced in its present form: Madeline Slaven and the whole exhibitions team; Samuel Fanous, Deborah Susman, Donna Gregory, Dot Little and everyone else involved in the creation of this splendid volume; John Barrett and his colleagues at the Bodleian Libraries' Imaging Services; Marinita Stiglitz and the conservation team; Michael Athanson, who has been instrumental in creating the maps for this volume; and Gillian Evison, who has masterfully co-ordinated, orchestrated and facilitated this project. We would also like to thank Susan Lind-Sinanian of the Armenian Museum of America and Clare Browne of the Victoria and Albert Museum for providing their expertise on Armenian textiles. Further thanks go to the individuals who have kindly agreed to lend us their prized possessions for this exhibition: the Der Tavitian family, Laurent Mignon, Krikor Momdjian, Kevin Norville, Ida Arathoon, Noreen Ashton and Theo Maarten van Lint. Finally, we are very grateful to our colleagues at the Mesrop Maštoc' Institute of Ancient Manuscripts (Matenadaran), the John Rylands Library at the University of Manchester, the British Library and the Victoria and Albert Museum for the loan of some of their Armenian treasures, and Sam Fogg for facilitating a number of private loans.

Theo Maarten van Lint and Robin Meyer

The Armenian Alphabet

Letter	Classical transliteration[1]	Pronunciation[2]	Numerical value[3]
Ա ա	a	sp**a**	1
Բ բ	b	a**b**ack	2
Գ գ	g	**g**oose	3
Դ դ	d	*Scottish English* **d**awn	4
Ե ե	e	b**e**d, word-initially **ye**t	5
Զ զ	z	si**z**e	6
Է է	ē	*Scottish English* d**ay**s	7
Ը ը	ə	b**i**rd	8
Թ թ	t'	**t**in	9
Ժ ժ	ž	vi**si**on	10
Ի ի	i	m**ee**t	20
Լ լ	l	**l**et	30
Խ խ	x	*German* Ba**ch**	40
Ծ ծ	c	nigh**ts**	50
Կ կ	k	tra**ck**	60
Հ հ	h	**h**igh	70
Ձ ձ	j	a**ds**	80
Ղ ղ	ł	*French* **r**ester	90
Ճ ճ	č	b**l**each	100
Մ մ	m	**h**im	200
Յ յ	y	**y**ou	300
Ն ն	n	ni**c**e	400
Շ շ	š	**sh**eep	500
Ո ո	o	*Scottish* g**o**, word-initially *German* **wo**	600
Չ չ	č'	**ch**in	700
Պ պ	p	tri**p**le	800
Ջ ջ	ǰ	**j**ump	900
Ռ ռ	ṙ	*Scottish* cu**r**d	1000
Ս ս	s	**s**and	2000
Վ վ	v	**v**ault	3000
Տ տ	t	s**t**amp	4000
Ր ր	r	**r**ed	5000
Ց ց	c'	*aspirated* **ts**	6000
ՈՒ ՈՒ ու	u	b**oo**t	--
Ւ ւ	w	a**w**are	7000
Փ փ	p'	**p**ool	8000
Ք ք	k'	**k**ite	9000
Օ օ	ō	*Scottish* g**o**	--
Ֆ ֆ	f	**f**ill	--

՞ (abbreviation mark): ա՟ծ

՞ (question mark): ո՞վ

՛ (exclamation, disambiguation mark): մի՛

՝ (explanatory mark): Դանիէլ՝ մեծ մարգարէ. (half stop)

: (full stop)

Glossary

antiphonary: a liturgical book containing religious chants and songs for the daily offices, often accompanied by neumes. Similar in function to the Horologion (ժամագիրք).

bolorgir (բոլորգիր): a style of writing first attested in the Armenian alphabet in the seventh century and used widely since the thirteenth century; meaning 'round/complete writing', it served as a model for Armenian printing.

Cilicia (Կիլիկիա): a region in the south-eastern part of Asia Minor, south of the central Anatolian plateau; in the first century BCE, Cilicia was part of the Armenian Empire, and was an Armenian principality and later kingdom (1198) between c. 1073 and 1375. Armenians continued to live there in large numbers until shortly after the genocide.

colophon (յիշատակարան): a short note, usually at the end of a manuscript or early printed book, containing information concerning place, date, authorship and patronage of the work. Armenian colophons can be very elaborate and often follow traditional formulae.

diaspora: the Armenian communities outside of the modern Republic of Armenia, which were already developed in the Middle Ages, but grew significantly as a result of the genocide. The largest Armenian diaspora communities have settled in the Russian Federation and in the USA.

dpir (դպիր): traditionally a word meaning 'scribe' or 'clerk', this is also a low rank in the Armenian Apostolic Church, comparable to that of a reader or lector in the Catholic or Orthodox Churches.

erkat'agir (երկաթագիր): literally 'iron writing', the earliest attested style of writing the Armenian alphabet, present both in inscriptions and early manuscripts; used from the fifth to the thirteenth centuries, it is still employed for capitals and occasionally for epigraphic purposes.

hmayil (հմայիլ): a scroll, also called phylactery, containing prayers, excerpts from Holy Scripture, and sometimes magical formulae; intended as a talisman which would protect its owner.

Katholikos (կաթողիկոս): the head of the Armenian Apostolic Church; for historical reasons, there are two katholikoi: Garegin II, Supreme Patriarch and Katholikos of All Armenians in the Mother See of Holy Ējmiacin, and Aram I, Katholikos of the Holy See of Cilicia, now in Antelias, Lebanon.

lectionary (ճաշոց): a book containing a collection of Holy Scripture organized according to the liturgical calendar, with specific readings and prayers for every day.

Marzpan (մարզպան): literally 'guardian of the border'; the title of a military governor-general imposed over border regions of the Sasanian Empire, such as Armenia, from 428 CE onwards.

Narek (Նարեկ): colloquial name for the *Book of Lamentation* (Մատեան Ողբերգութեան), composed by the theologian and poet St Grigor Narekac'i; the *Narek* has been used as a holy book and talisman since the Middle Ages.

naxarar (նախարար): title of members of the higher Armenian nobility, who together with their extended families were in charge of large estates within the Kingdom of Armenia; the *naxarar* system bears certain features that distinguish it from feudalism.

neume: related to the Greek word for breath (πνεῦμα); a form of musical notation, written above or within the line of text, that indicates the relative flow of a melody, further determined by the mode.

New Julfa (Նոր Ջուղա): the quarter of Isfahan to which the Armenian community of 'Old' Julfa (now Culfa, Azerbaijan) was deported by Shah Abbas I in 1604; the distance between the two cities is c. 900km.

nōtrgir (նօտրգիր): a style of writing the Armenian alphabet, used widely from the sixteenth century onwards for its quick writing speed; since differences between letters are minimal, it is often hard to read.

psalter (սաղմոսարան): a book containing the Psalms and frequently other devotional material.

Sacra Congregatio de Propaganda Fide: a part of the Roman Catholic Church responsible for missionary work and related matters; founded by Pope Gregory XV in 1622 during the counter-reformation, and charged with fostering and spreading Catholicism.

vardapet (վարդապետ): literally 'teacher', the term is used to refer to a celibate priest who has attained the degree of Doctor of Theology.

xač'k'ar (խաչքար): literally 'cross-stone', an often large stone stele adorned with a cross and other, often very elaborate, ornaments typical of medieval Armenian art.

1 The transliteration in this book is based on the scheme first employed by Heinrich Hübschmann and Antoine Meillet, with minor alterations as standardly used in academic literature, e.g. the *Revue des Études Arméniennes*.

2 Many sounds of Classical Armenian are similar to those of Modern Eastern Armenian; others have been reconstructed on the basis of typologically common sound changes. The pronunciation guide can only provide an approximation to the Armenian sounds, not all of

which exist in English or other commonly known languages.

3 Like Classical Greek and other languages, Armenian assigns numerical values to each letter, which are used to write numbers in general, but most commonly years.

4. A short table preceeds each catalogue entry, providing the following details (in order): size and material; artist (where known); scribe or publishing house (where known); place and date; shelfmark and openings.

DK Dickran Kouymjian
SM Sylvie L. Merian
RM Robin Meyer
NNQ Natalie Naïri Quinn
TMvL Theo Maarten van Lint

Essays

Theo Maarten van Lint

The Armenian People, Their History and Culture

Geography and earliest history

The political borders of Armenia have changed over time and the current Republic of Armenia occupies less than ten per cent of the historical Armenian territory. It is located between the Anatolian and Iranian highlands, and with an elevation of between 900 and 2,100 metres it is the highest of the three, and has the most complex system of rivers. Although located in the temperate zone, the altitude of the plateau defines its climate of short hot summers and harsh winters. Hemmed in between the mountain ranges of the Pontus on the north, the Lesser Caucasus in the east and the Taurus in the south, the plateau's highest peak is Mount Ararat at 5,165 metres. Three large lakes form part of the area: Lake Sevan in the Republic of Armenia, Lake Urmia in Iran, and Lake Van in Turkey. Many high mountain ranges and gorges divide the plateau into smaller entities, which have played a great part in Armenia's history.[1]

Human presence on the Armenian plateau dates back to the early Stone Age. Armenians are first mentioned by the name under which we know them on the Achaemenid Persian ruler Darius I's trilingual inscription at Bisotun of *c*.518 BCE. The land is called Armina in Old Persian, but Uraštu, that is Urartu, in Babylonian. The ancestors of the Armenians may have arrived as early as the twelfth century BCE as part of a wave of Indo-European settlers coming from the West, and may perhaps be associated with the Muški and Nairian tribes. A less universally accepted theory places the Indo-European homeland on the Armenian plateau. Whatever the theory one adheres to, people carrying the name of Armenians have been present for some three millennia on the Armenian plateau.

Linguistically, Armenian is part of an only recently postulated branch of Indo-European languages, and together with Greek, Albanian, Phrygian and some other sparsely transmitted languages forms the Pontic group within the Indo-European language family.[2]

From Urartu to the Arsacid kingdom

The kingdom of Urartu, roughly covering the Armenian highland between the ninth and sixth centuries BCE, is important for Armenian history, language and culture. Armenians may have mixed with the population, as the name of the father of an Armenian mentioned on the Bisotun inscription suggests: 'Halditi' is named after the main Urartian god, Haldi. Remains of Urartian fortresses and settlements are found throughout Armenia, two of the northernmost of which are Teišebaini (Karmir Blur) and Arin-berd (Erebuni) at Yerevan. The foundation of the latter by

King Argišti I in 782 BCE is preserved in an inscription and is considered to mark the establishment of the current capital of the Republic of Armenia.[3]

Following a Median interlude, Armenia became a satrapy of the Achaemenid Persian Empire, out of which emerged an identifiable Armenian royal dynasty, the Ervandids (Orontids, 401–c.190 BCE), for the later period known as the Artašesids (Artaxiads, 188 BCE–6 CE). While the attention of Armenia's neighbours, the Roman Empire on the west and Parthia on the east, was held elsewhere, under Tigran II ('the Great', r.95–55 BCE) Armenia, including vassal states, briefly extended from the Caspian and the Black Seas to the Mediterranean, as far south as Syria and Judea. This period is characterized by the Iranization of Armenian society, including its religion, as a form of Zoroastrianism became dominant.

Upon the conquests of Alexander the Great – which did not include Armenia – aspects of the Hellenistic world began to pervade Armenia as well. Cities were built, and the introduction of coinage under the Artašesids, with kings styling themselves 'Philhellene' in Greek, shows the integration of Armenia in an international trade network. This intensified under Tigran II, whose successor Artawazd II wrote extensively in Greek. Nonetheless, this Hellenistic character was neither pervasive, nor as deeply rooted as the Iranian element. The latter included the pantheon and the court ceremonial with its presence of vassal nobility, and the symbolism on the coinage, with the term (in Greek) 'King of Kings' and the characteristic pearl tiara with the star of divinity. The result was a prosperous, complex and refined civilization.

After the collapse of Tigran II's short-lived empire and thereby of the Artašesid house, Armenia had to balance between the two rival powers of the Parthian and Roman worlds. In Armenia, the Parthian Arsacids succeeded the Artašesids. In 63 CE a compromise between the two empires stipulated that a junior branch of the Parthian Arsacids would rule over Armenia, but that Rome would crown the candidate it chose from among that family. In 66 CE the Roman Emperor Nero crowned Trdat I King of Armenia in Rome. The Arsacids deepened both the Iranian and the Hellenistic aspects of Armenian life.

The geographical structure of the land often defined the social structure, with each family ruling their province. The king was *primus inter pares*, not someone to whom the *naxarar* families, the great nobility, owed vassalage. A subtle network of privileges and obligations defined the political balance of the country.[4] These features form a markedly Iranian element of Armenian society.

Christianization

Christianity came to Armenia early, first from the Syriac speaking world, from Edessa in the south, later from the Greek world, from Caesarea in Cappadocia. With the earlier phase are associated also the stories of the apostle Thaddeus, who in the first century allegedly converted Sanduxt, the daughter of King Sanatruk, whereupon the king had both martyred. Bartholomew continued Thaddeus's mission.

In 224 the Sasanians overthrew Parthian rule in Iran. Now an antagonistic house ruled over Persia. Renewed balancing of influence brought another King Trdat to power – possibly in 298, but the chronology is uncertain – who in 301, according to the official view of the Armenian Apostolic Church (but according to scholarship somewhat later – between 305 and 314), was converted to Christianity by Grigor Lusaworič' (Saint Gregory the Illuminator). Armenia became the first state to adopt

the faith as its official religion. This also created a further cause for division between Sasanian, Zoroastrian Persia and Arsacid, now Christian Armenia.

For Armenian religious and intellectual life, the adoption of Christianity meant a turn westward, to the Greek Christian world of the Eastern Roman Empire, away from the Iranian world. Zoroastrian temples were replaced by Christian places of worship, their priests often adopting the new religion, and the Church became a powerful owner of land. It was led by Grigor Lusaworič's family, the Part'ews (or Parthians). Grigor was succeeded by his son Aristakēs, who also took part in the Council of Nicaea in 325. The Arianism favoured at the Armenian court, following contemporary Byzantine preference, caused a rift with the Armenian Church, pitting katholikos against king. Influential heads of the Church, such as Nersēs the Great (in office 353–373), established hospitals and alms-houses throughout the land. After Nersēs' death, the head of the Armenian Church was no longer consecrated in Caesarea in Cappadocia.

In c.387 Armenia was divided between the Sasanian Empire, which gained suzerainty over four-fifths of the country, now becoming Persarmenia, and the Byzantine Empire, taking control of the remaining part. Very soon, in c.390, the kingdom was abolished in the Byzantine part.[5]

Invention of the Armenian alphabet

Christianity took root slowly in Armenia. The liturgy was celebrated in Greek in the north and in Syriac in the south, with oral translations into Armenian. This proved unsatisfactory. With support from king and katholikos, an ascetic former secretary at the royal chancery and ex-military leader named Maštoc', who had undertaken missionary activities in the country, with divine guidance devised an alphabet of thirty-six signs, capable of adequately rendering the sounds of the language. This alphabet, designed, or 'found' as is the term in Armenian, around 405, is still in use today.

The Septuagint version of the Old Testament and the New Testament was translated from Greek into Armenian, and soon further theological works followed. Initially, Syriac versions had also been used, but a revision of the translation was conducted after 431 when Armenians present at the Council of Ephesus brought back to Armenia Biblical manuscripts with high-quality Greek texts, greatly improving on the efforts of the first translation. A veritable explosion of written Armenian literature followed, including original texts, witnesses of a sophisticated Armenian culture from prominent authors who had partially been trained in the great centres of learning of the Hellenistic world, such as Antioch, Beirut, Athens and Alexandria.[6]

The *marzpanate* and the making of a Christian nation

In 428 the Sasanian King of Kings abolished the Arsacid Armenian kingdom on the request of the Armenian *naxarar* families, who so sought to increase their autonomy against the advice of the leader of the Church, Sahak the Great (d.438), who was temporarily deposed. A *marzpan,* or military governor, was installed to govern Armenia. This was often an Armenian. Political philosophy understood loyalty to the state to include adherence to its religion. Therefore the Armenians were suspect in Sasanian eyes after the Byzantine Empire adopted Christianity as

its state religion. Mazdaism, a form of Zoroastrianism, was forcefully propagated throughout the Sasanian Empire, requiring the Armenians to renounce Christianity. This inaugurated a defining period in Armenian identity formation. Refusal to comply led to oppression and resistance: on 28 May 451 *Sparapet* (commander-in-chief) Vardan Mamikonean led the Armenian army into battle against the Sasanians at Avarayr, resulting in heavy losses. A further thirty years of resistance ended with religious freedom after decisive opposition led by another member of the same family, Vahan Mamikonean in 484. Renewed Sasanian pressure led to an uprising in 572, which forced Vardan II Mamikonean and Katholikos Yovhannēs II to flee to Byzantium, where they were pressured to adopt the Chalcedonian Christological position.

Bishops from Greater Armenia had not taken part in the Council of Chalcedon held in 451, while the Armenian Church rejected the decisions of the Council of Chalcedon in the middle of the sixth century (*c*.551), but several katholikoi subsequently held pro-Chalcedonian views. Byzantine expansion to the east led to the incorporation into the empire of large parts of Persarmenia in 591. The Emperor Maurice established a Chalcedonian Armenian katholikos in Awan, so that for twenty years there were two katholikoi in Armenia. The rejection of Chalcedon led to a better position for the Armenians and their Church in the Sasanian Empire, while there continued to be adherents of the Chalcedonian Christology among the Armenians, as the document *Narratio de rebus Armeniae* (Account of the Matters of Armenia), preserved in a Greek translation only, shows.

The decision against Chalcedon led to a breach with the Georgian Church around 607.[7] The *Book of Letters* (Գիրք թղթոց), documenting Armenia's ecclesiastical and doctrinal affairs, gives a good insight into the gradual deterioration of relations.[8]

The fifth to early eighth centuries were very fertile for Armenian literature, yielding a number of outstanding works of historiography: Agatʻangełos's *History of the Armenians* (Պատմութիւն Հայոց), relates the conversion story based on versions of the hagiographic *Life of St Gregory the Illuminator*; fourth-century events are described in the *Epic Histories* (Բուզանդարան Պատմութիւնք), based on three initially orally transmitted layers – a royal or Arsacid layer, one on the Mamikoneans, and an ecclesiastical one, including hagiographic material. Koriwn described the invention of the alphabet and the saintly life of its inventor in *The Life of Maštocʻ* (Վարք Մաշտոցի; before 451); Eznik's *Refutation of the Sects* (Եղծ աղանդոց) is the prime example of original theological work; the wars for religious freedom are described in Ełišē's *History of Vardan and the Armenian War* (Պատմութիւն Վարդանայ եւ Հայոց պատերազմին), where the parallel with the Maccabees' choice for martyrdom over apostasy is developed, and in Łazar Parpʻecʻi's *History of the Armenians* (Պատմութիւն Հայոց). Hymnography blossomed and liturgical texts developed, preserving Jerusalemite elements absent in many other traditions. The teaching of the *artes liberales,* including philosophical and grammatical thought, led to the adoption of a more literal translation style, so that a marked Graecizing trend is discernable. To these belong translations of Philo of Alexandria, David the Invincible Philosopher, Aristotle and Porphyry, the *Alexander Romance*, and Dionysius Thrax's *Grammar*.[9]

Arab domination (650–884)

When in 650 T'ēodoros, Lord of Řštunik', and the Armenian *naxarars* came to an agreement with Caliph Mu'āwiyah, they had already cut off any chance for relief from Byzantium through their renewed rejection of the Christology of Chalcedon in 649/650. As part of the Arab province of Armīniya, Armenia was united again. The formal establishment of the province took place in *c.*701, when Dvin was declared its capital and an *ostikan* (governor) installed. Umayyad rule during the seventh century was relatively benign – no heavy taxation was imposed and no forced conversions took place. The remarkable surge in architecture that had begun in the last decades of the *marzpanate* continued uninterruptedly into the early eighth century, giving rise to some of the lasting monuments, such as the cathedral at Odzun.

The katholikosate of Yovhannēs Ōjnec'i (John of Odzun, in office 717–728) was defining for the direction of the Armenian Church and for the crystallization of Armenian identity as a Christian nation. Yovhannēs carried out a reorganization of the Armenian liturgy, ensuring the unification of the Hymnal (Շարակնոց) throughout the land, and wrote and acted against the iconoclast Paulicians and the Phantasiasts, who denied the reality of the body of Christ. He also gathered the decisions of the Church councils in a unified code, the *Armenian Book of Canons* (Կանոնագիրք Հայոց). Organizing two Church councils, at Dvin in 719 and in Manazkert in 726, he defined the doctrine of the Armenian Church, avoiding both extreme monophysitism and the duophysite position associated with Nestorius and the Council of Chalcedon.[10]

The later eighth and ninth centuries were more difficult. The Abbasids (ruling from 750), pursued stricter religious and tax policies, which led to harshly crushed rebellions. The battle of Bagrevand in 775 spelled the end of several *naxarar* houses and great loss of life among the common people. Demographic change came about through the settlement of Arabs in the country, and through intermarriage among Armenians and Arabs, with the Muslims sometimes adopting Christianity.

Further serious disruption was caused by internal discord and the crushing of rebellions, in particular by Bugha in the early 850s. Moreover, Byzantium was now expanding eastward, destroying the Emirate of Melitene in 863 and the Paulician state in 870, while the power of the Caliphate waned, leaving Armenia open to local initiatives. The Byzantine Patriarch Photius (in office 858–867 and 877–886) initiated exchanges on Christological matters, which remained fruitless.[11]

The two most prominent historiographical works of the period are the *History* (Պատմութիւն) ascribed to Sebēos, and the *History of Łewond the Eminent Vardapet of the Armenians* (Պատմութիւն Հայոց). It has been proposed that the most famous of all Armenian histories, Movsēs Xorenac'i's *History of the Armenians* (Պատմութիւն Հայոց), a rich and fascinating work combining Armenia's pre-Christian past with its place in Christian salvation history, may, in the form that we have it, date from shortly after 775, while others advocate a fifth-century date.[12]

Independence regained: Bagratids and Arcrunis (884–1065)

Out of the mixed situation prevailing in the later ninth century rose two Armenian kingdoms under the two most powerful *naxarar* houses, the Bagratuni in the north

(862/885) and the Arcruni around Lake Van (908). The princes of Siwnikʿ formed a third powerful family. The influence of the Mamikonean family was curtailed after the devastating losses suffered at Bagrevand, so Ašot I ('the Great', 855–890; r.884–890) was courted and crowned both by Byzantium and the Caliphate. An element of instability was introduced by the breaking up of the possessions of the *naxarar* houses into smaller parts belonging to different branches that would occasionally oppose each other. *Naxarar* rivalry was exploited by external players, resulting in the elevation to royalty of the Arcruni house under Gagik I (d.943) in 909. Gagik's long reign was prosperous and he enjoyed great prestige internationally. Among his legacy is the palatine church of the Holy Cross on the island of Ałtʿamar in Lake Van, built between 915 and 921. Its splendid location, stunning exterior sculpture and fine frescoes make it a lasting witness to the beauty of Armenian architecture.

The Armenian Church sought to play a mitigating role when *naxarar* houses or branches within one house opposed each other, and often had success. The role of Katholikos Yovhannēs Drasxanakertcʿi (897–925), known also as John Catholicos, was considerable in this respect, as was his chronicling of the vicissitudes, including his own diplomatic missions, of the period in his *History of Armenia* (Պատմութիւն Հայոց).

The ascendency of the Bagratuni kingdom over Vaspurakan became firmly established after Gagik I Arcruni's death. The city of Ani became capital of the kingdom in 961, and the Katholikosal See was established there in 992, moving from nearby Argina. Ani's famous cathedral, another high point of Armenian architecture, was finished in 1001. Ani was by then a densely populated city with multiple international economic ties, in which learning and education flourished. Patronage of large monastic institutions such as Sanahin and Hałbat in northern Armenia made an active reception and propagation of Greek learning possible, exemplified in the life and work of the neo-platonist polymath Grigor Pahlawuni Magistros (985–1059). In addition, Greek theological and philosophical scholarship flourished under Abbot Anania Narekacʿi in the monastery of Narek in the Arcruni kingdom, most readily associated with the mystic poet and theologian Grigor Narekacʿi (945–1003). These monks and Grigor's father, Xosrov Anjewacʿi, were suspected of Chalcedonian sympathies and had to justify themselves before the Church (cat. 86, 87).

The Byzantine Empire continued its eastward expansion under Basil II (976–1025). Its acquisition of Taykʿ-Tao upon the death of Bagratid David Kuropalates in 1000 disturbed the international power balance, as did the arrival of raiding Seljuks, the first of three waves of invaders coming from Central Asia (Seljuks, Mongols and Turkomans). King Senekʿerim Arcruni exchanged his kingdom for lands around Sebastia, while at his installation as king of Ani in 1022, Hovhannēs Smbat bequeathed his kingdom to Byzantium upon his death in 1039. The Armenian nobility opposed this arrangement, and in 1042 placed the young King Gagik II on the throne. However, he was soon lured to Byzantium and in 1045 was forced to abdicate. Ani then fell into the hands of the Byzantines, but not for long: the city was seized by the Seljuks in 1064. Bagratid Kars was ceded to Byzantium in 1064, in exchange for lands within the empire. All Armenian kings who were given lands within the Byzantine Empire were dead by 1073. Byzantium lost these newly gained possessions in the defeat against the Seljuks at Manzikert in 1071.[13]

Dispersion

The destruction of Armenian statehood and the exodus of part of its population earlier in the century was followed by a wider dispersion of Armenians in various directions: to the Crimea and further into eastern Europe, where eventually important Armenian colonies would develop in Lvov (Lviv), Galicia and Wolhynia. The most significant movement was into Cilicia where an Armenian presence developed from 1073 into an Armenian state, in 1198 becoming a kingdom that would last until 1375.

Armenians had been living in the Byzantine Empire for centuries as military men and in other capacities, and even reached the highest offices. They also settled in other countries such as Italy, while Fatimid Egypt had an Armenian vizier dynasty from 1073 to 1137.[14]

'Neither the city nor the centralised state seems to have been an indispensable element in the survival of Armenia's identity.'[15] The essential elements were the Armenian language, the social network of the *naxarar* families, and the Church. The social structure of the *naxarar*s suffered through deportation and Bagratid expansion, but continued to exist in reduced form, with the emergence of new families, such as the Pahlawunis, Rupenids and Het'umids, claiming ancient roots.

The vicissitudes of Armenian statehood had repercussions for the Church. The Katholikosal See had to be established somewhere safe. When Ani fell to the Byzantines in 1045, the See moved with Katholikos Petros Getadarj to Sebastia in Cappadocia in 1050, then to T'avblur in 1062 under his successor Xač'ik II, then, under Katholikos Grigor II Vkayasēr (in office 1065–1105), it moved to Camentav, east of Sebastia, in 1066, where it remained until 1145. After a brief spell at Tzovk in Cilicia it moved to Hṙomklay in 1147, in the Dukedom of Edessa, where it was sacked in 1292 and relocated to the capital of the Armenian kingdom of Cilicia, Sis. From there it was moved back to the church of Ējmiacin at Vałaršapat in 1441. From Grigor Vkayasēr's accedence in 1065 until the death of Grigor VI Apirat in 1203, the Pahlawuni family ruled over the Armenian Church, and thereby over the Armenian nation.

Greater Armenia and Cilician Armenia (1080–1375)

The rapid expansion of the kingdom of Georgia gave Armenians the opportunity, through the Zak'arians, to regain control over their affairs. At that time, a great part of Armenia became part of Georgia, and its administration was assigned to a family holding high offices at the Georgian court, the Mkhargrdzeli, later known as Zak'arians or Zak'arids after the name of one of their number: Zak'arē. This period saw the flourishing of architecture, church building and the arts.

The establishment of Armenia in *c.*1236 as part of the Il-Khanate led to a *de facto* vassal status for Greater Armenia, where some of the Armenian families nevertheless managed, by special privilege, to sustain economic, cultural and religious activities on their estates and in the monasteries, as well as in some of the cities, such as Erznka (Erzincan). But punishing taxation and ravaging could take a heavy toll on Armenians.

In Cilicia the Armenians engaged with the crusaders and the ensuing Frankish crusader states, leading to a somewhat different social structure and a more European culture. In 1198 Prince Lewon II was crowned (as King Lewon I) by the

papal legate and regaled with a crown by Byzantium. Armenian Cilicia became a prosperous state through its strategic position for international trade. For the first time since the Artaxiads, Armenian monarchs minted their own coinage (cat. 60–73).

The court's proximity to the Church of Rome, sought in the first place for political reasons, led to discontent among the population and to a rift with the leading monasteries in Greater Armenia. The attempts by Nersēs Šnorhali (1102–1173) and Nersēs Lambronac'i (1154–1198) to come to a union with the Greek Orthodox Church and with the Church of Rome came to nothing, since they were not based on mutual respect for the specifics of the varying traditions, although the Armenians were willing to and did make concessions in orthopraxis, and sincerely sought to overcome doctrinal differences regarding Christology.

From the thirteenth century onwards, Franciscan and Dominican orders were active in Armenia and had some success at converting Armenians from the Armenian Apostolic Church to Catholicism. Two councils aiming at Church union, held in Sis in 1307 and in Adana in 1316, met with opposition in both Cilicia and Greater Armenia, and had no consequences.

This period coincides with the first incursions of Mongols in the Middle East. King Het'um I presented himself in submission at the Great Khan's court in Karakorum in the 1250s. As long as the Mongols were able to keep the Mameluks of Egypt in check, Cilicia felt protected. Both military defeat and the conversion of the Mongols to Islam under Ghazan Khan in 1295 weakened Cilicia's position, and over the fourteenth century it lost ever more territory to the Mameluks, until the country was finally overrun in 1375. The royal family had married into the family of the Lusignan kings of Cyprus, and Armenia's last king, Lewon V, went in exile to Europe; he died in France in 1393 and lies buried in St Denis alongside the kings of France.

In Cilicia the need for legal underpinning of the state led to the translation of existing codes by Nersēs Lambronac'i, while in Greater Armenia Mxit'ar Goš's *Lawcode* (Գիրք Դատաստանի; begun in 1184) was compiled to ensure justice for Armenians living under Muslim rule. Nersēs Šnorhali added significantly to the Armenian Hymnal (Շարական), and to Armenian Christian epics with his *Lament on the Fall of Edessa* (Ողբ Եդեսիոյ) and the long poem *Jesus the Son* (Յիսուս Որդի). Lyrical poetry entered the scene in the thirteenth century with the *tałasac'ner*, 'reciters of poetry', mostly clerics, whose poetics were inspired by Persian models, including Christianized images of the rose and the nightingale. Of these, Kostandin Erznkac'i (*c*.1240–before 1318) is a splendid example.[16]

From the fall of the kingdom of Cilicia to the deportations by Shah Abbas (1375–1604)

The collapse of the Armenian kingdom in Cilicia and the dissolution of the Il-Khanid state in the mid-fourteenth century heralded a difficult period. In 1441, the Katholikosal See was moved from Sis to Ējmiacin, called for already in 1299 by Step'anos Ōrbelean, the Metropolitan of Siwnik' in Greater Armenia in his *Allegorical Prosopopeia on the Holy Cathedral at Vałaršapat* (Բան բառնաական, ողեալ դիմառնաբար ի դիմաց Վաղարշապատու սուրբ Կաթողիկէլէն), in the wake of the aggressively pro-Roman policies of King Het'um II (r.1289–97). This

move was not unopposed, and a Katholikosate of Sis continued to exist, only to be moved to Aleppo in November 1915 to prevent its annihilation in the Armenian genocide. Since 1930, the Katholikosate of the Great House of Sis has been located in Antelias, near Beirut, in Lebanon.

Already in 1113 a katholikosate had been established in Ałt‘amar in Lake Van, in opposition to the election of the young Grigor III Pahlawuni as katholikos. Reconciled to the main See, this continued to exist until the genocide of 1915. It counts among its representatives the sixteenth-century poet Grigoris Ałt‘amarc‘i, also a gifted painter of illuminations and author of *kafas* (comments in poetry), accompanying a version of Pseudo-Callisthenes' *Romance of Alexander the Great* (Պատմութիւն Աղեքսանդրի Մակեդոնացւոյ), translated into Armenian in the fifth century (cat. 42). There are, therefore, currently two establishments at the very top of the Armenian Church: the Mother See, held by the Katholikos of All Armenians at the Church of Holy Ējmiacin at Vałaršapat, and the Katholikos of the Great House of Sis in Lebanon.

The two centuries between the collapse of the Kingdom of Cilicia in 1375 and the deportations of the Armenians from the Ararat valley and the south east of the country, including from Julfa on the Arax in 1604, saw great changes in power. Particularly damaging were three raids by Timur Lane between 1387 and 1403, one of the consequences of which was famine, and by his son Shahrukh (1420, 1428, 1436), as related by numerous manuscript colophons and the *History of Timur Lane* (Պատմութիւն Լանկ Թէմուրայ) by T‘ovma Mec‘opec‘i. Constantinople was conquered in 1453 by the Ottomans, sending shockwaves through the Christian world. Greater Armenia was initially ruled by Turkomans, first the Kara Koyunlu, or Black Sheep (1410–67), then by the Ak Koyunlu, or White Sheep (1468–1502). From 1514 until 1639 incessant wars between the two new superpowers in the region, the Ottoman Empire and Safavid Persia, laid waste to Armenia, leading to famine again by the end of the sixteenth century.

At various times, in 1547 and 1562, the katholikos in Ējmiacin organized secret councils and appealed to the Christian European states for help. In 1585 Zak‘aria, Katholikos of Sis, followed suit. The missions were unsuccessful, and the Armenians were not liberated from their plight. In 1663 Church dignitaries turned to Louis XIV, King of France, for help, and fourteen years later Katholikos Yakob IV Ĵułayec‘i convened another secret council in Ējmiacin and appealed to the Pope and European powers. Israyēl Ōri, from Karabakh, led the mission, which lasted until 1711, obtaining promises of help from Peter the Great, Tsar of Russia. By this time Armenians had begun to pin their hopes on Russia rather than Europe; both orientations remain relevant today.

Many Armenians migrated, and some converted to Islam, although that number seems to have been limited. Sometimes churches were even built, such as Surb T‘eodoros in Amida (Amid, Diyarbakir), on the order of the much-loved poet and painter bishop Mkrtič‘ Nałaš (c.1400–1469). But in the sixteenth century in particular most non-oral cultural activities took place outside of Armenia: a certain Yakob printed five books under the imprint DIZA in Venice between 1511 and 1513, and Abgar Toxatec‘i printed a calendar and psalter there in 1564/65. The first printing of Armenian books in Constantinople took place between 1567 and 1569, while five more titles were printed in Venice before the end of the century. Churches

were usually built in the Armenian colonies, such as Lvov, Moldavia, the Crimea, Russia and Constantinople. Manuscript copying and illumination flourished in the fifteenth century, but reached a low in the sixteenth, to resume towards 1600 around Lake Van and in Julfa on the Arax.[17]

The performance of poetry by *taɫasac'ner* and *gusans* (troubadours) continued unabated. A genre that became highly popular in this period, although present long before, is that of the *hayrēn* (հայրէն, Armenian poem), consisting of minimally a quatrain with prescribed rhythm, which became a vehicle for themes ranging from the devotional to the melancholy, lamenting separation from one's family and land, and the erotic.

Armenian merchant enterprise, power and patronage

In 1604 the Safavid Shah Abbas I (r.1587–1629) deported several hundred thousand Armenians from the Ararat valley and southern Armenia into Persia. Deportees from the prosperous merchant town of Julfa on the Arax were resettled adjacent to the capital Isfahan, where they built New Julfa (Նոր Ջուղա), which became the hub of a world-wide network of trade in silk and diamonds, and many other goods in Europe, North and West Africa and throughout Asia. Shah Abbas I encouraged the building of churches and mansions in New Julfa and even planned to transport the See of the Armenian Church from Ējmiacin to New Julfa. Xoǰa Nazar, the *kalantar*, the highest official of the community (in office 1618–36) was instrumental in changing the Shah's mind and in obtaining support for the restoration of the Mother See, both physically and spiritually.

Merchant families were crucial in the revival of Armenian cultural life, taking upon themselves the costs for the copying and illumination of manuscripts, the printing of books and the erection, decoration and renovation of churches and monasteries. They were also instrumental in the promotion of European artistic styles, on which see the chapter by Sylvie Merian.

Throughout the period the Apostolic Armenians had to contend with two rival creeds: Islam, conversion to which did sometimes occur as favourable circumstances were created for doing so, and Catholicism, which was attractive for the court as it opened up possibilities for co-operation with the European powers against the Ottoman Empire. Some Armenians were Catholics already, as Julfa on the Arax, their destroyed town of origin, had been touched by the mission of the *Fratres Unitores*, the Catholic Armenian order founded in 1330 in Kṙnay in Siwnik'. The great theologians of Greater Armenia of the period, Esayi Nčec'i, Abbot of Glajor (1255–1338), his successor Yovhannēs Orotnec'i (1315–1388) and the towering figure of Grigor Tat'ewac'i (1340–1409), provided sophisticated theological and philosophical education, including refutations of Catholicism and Islam, upon which later generations built, such as Yovhannēs Mrkuz Juɫayec'i (1643–1715), whose dialogues with Shah Suleyman (r.1666–94) in New Julfa gave rise to a bilingual Persian and Armenian apology of the Christian faith.

Chronicling the vicissitudes of the Armenians of the first two-thirds of the seventeenth century is the engaging *Book of History* (Գիրք Պատմութեանց), published in Amsterdam in 1669, by Aṙak'el Dawrižec'i (c.1600–1670), the first Armenian author to see his work printed in his lifetime. One learns about the impressive efforts at restoration and wider patronage that New Julfa merchants and

their spiritual counterparts undertook to vouchsafe the continuation of education and spiritual development of the nation.

In the final years of the seventeenth and early eighteenth century, religious strictness grew and taxes became higher, so that many Julfans settled in other countries, in particular in India. New Julfa's role was over when in 1722 the Afghans sacked the capital, although merchants and their families remained influential in various roles throughout the world.

Armenia and Russia (seventeenth to nineteenth century)

The New Julfa merchants were able to gain access to Russia and travel through it, over water and land, to Europe. They helped facilitate diplomatic ties between the Romanovs and the Safavids and develop Russia's art by sending Sultan Bogdanov, a painter who trained local talent for the palatial workshops. When Peter the Great built St Petersburg he encouraged Armenians from all walks of life to come to the new capital, just as Shah Abbas had facilitated Armenian trade and worship in his own capital a century before. The fact that Russia was a Christian power did fan ideas of liberation from the Ottoman and Persian Empires, which would be partially realized with the wresting of the Caucasus from Ottoman and Persian control. Powerful Armenians, some of them members of the Russian nobility like the Lazarevs, obtained permission to build churches in Astraxan, Moscow and St Petersburg, while the status of the Crimea as Russian vassal in 1778 (it would be annexed in 1783) under Catherine the Great led to the establishment of new cities for Crimean Armenians, such as Nor Naxičewan, adjacent to Rostov on the Don, where a church and printing press were established, and Mariupol' and Grigoriopol'.

In 1815 in Moscow the Lazarev Institute was founded to promote the tuition of Oriental languages. Over the course of the century university chairs were established in Armenian Studies. Since the Treaty of Turkmenchai, concluded with Iran in 1828, Eastern Armenia had become part of the Russian Empire. Moreover, the Russian-Turkish war of 1828–9 had added parts of Ottoman Armenia to Russia. Xač'atur Abovean was the first of a stream of Armenians who received their education in the German language university of Dorpat (now Tartu, in Estonia), contributing to the further spread of Enlightenment ideas among Armenian intellectuals.

With the annexation of the Caucasus, the Church's See came to lie within the Russian Empire. In 1836 the Tsar promulgated the *Položenie*, a statute setting out the relationship between the Russian state and the Armenian Church. One of the stipulations was that the katholikos could only assume function after having been chosen by the tsar himself, out of two candidates identified by the Armenian Church with its lay electors. The initial euphoria over the annexation of Caucasian Armenia gave way to a more critical attitude towards the government in Russia.

Armenians in the Ottoman Empire (seventeenth to nineteenth century)

The conquest of Constantinople in 1453 led to the growing importance of the Armenian Church in the capital. The Sultan considered the religious leader as representative of and responsible for the whole of the community, the *Ermeni millet*. Initially local, the power of the head of the Church in the capital eventually stretched out over the empire, the few dioceses remaining under the Katholikosate of Ałt'amar and under the Patriarchate of Jerusalem excepted. In 1764 the rights and

duties of the Armenian Patriarch of Constantinople were laid out; responsibilities included all religious matters, including heresy; taxation, censorship, the printing press, charity and education; family and inheritance regulations, as well as jurisdiction in these matters.

The Armenian Patriarch of Constantinople was the leader of a community consisting of a majority of usually poor peasants, a growing number of artisans (*esnaf*), as well as better off citizens and a small, very affluent group, the *amira*, responsible among other things for government institutions such as the Mint. Merchants formed an important part of the Armenian population, trading overland and overseas, from cities like Constantinople, Smyrna and Aleppo.

The peasants often lived in circumstances that forced them to emigrate and look for work in Constantinople and elsewhere. The plight of the migrants (*panduxt*) is recounted in a much-loved type of song, the *pandxtakan erg*. These migrants emphasize the stark opposition between *erkir*, the land, and *Bolis*, the city (Polis, Constantinople), throwing light on social and economic differences within the Armenian community. Tensions existed between the other components of the Armenian population of the capital as well. Antagonism between Armenian Orthodox and Catholics, Armenian and otherwise, sometimes ran very high. Catholic missionary activity among Apostolic Armenians was more than a little frowned upon, but instances of poor discipline and slippage in standards among Armenian Apostolic clergy helped open the way towards Catholicism.

A convinced anti-Catholic intellectual of the seventeenth century was Eremia Č'ēlēpi K'eōmiwrčean (Yeremya Çelebi Kümürcyan, 1637–1695), a polymath and polyglot. For a time he was secretary to the Armenian Patriarchate in the capital. He was a good diplomat and led a short-lived printing press. His best known work is *The Jewish Bride* (Ըստամկուլունէ այիր շֆուն ցրցի), written in Turkish in Armenian script (Armeno-Turkish); exhibited is his translation into Turkish of the story of Paris and Vienne (cat. 41).[18] Among other outstanding figures of the time is Patriarch Yovhannēs Kolot' (in office 1715–41), a highly cultured and tolerant man, exponent of a long tradition in the Armenian Church of prelates encouraging translation from works written by adherents of other Christian creeds. He put an end to the irregularities in the Apostolic Church and mitigated the antagonisms between Catholics and Apostolic Armenians. He helped render Constantinople the cultural capital of the Armenian world, which saw it become the principal locus for Armenian bookprinting. Kolot' also founded the Grand Seminary of Scutari, one of the pupils of which was his succesor and the other most notable patriarch of the century, the theologian Yakob Nalian (in office 1741–9 and 1752–64), author, among other works, of an important commentary on the *Narek*.

Missionary activity and political pressure led to the establishment in 1831 of a Catholic Armenian *millet*, and to a Protestant one in 1850. According to the statute of 1764, patriarchal elections had to be conducted by an assembly consisting of ecclesiastics and lay members. Among the latter the affluent *amira*s played an important role, leading to a religious-lay oligarchy ruling over the community. The less socially privileged *esnaf*s and the poor *panduxt*s expressed their disaffection through protest marches, directed in the first place against the *amira*s. In the context of social unrest throughout Europe, in 1839 the Ottoman Empire inaugurated a period of – imperfectly implemented – reforms of Ottoman society,

lasting up to 1876, a period known as the *tanzimat* (reorganization). Among the reforms declared was the equality before law of Muslims and non-Muslims, which was not always adhered to.

In 1863 the Armenian community adopted a National Congregation with legislative powers, consisting of 150 elected members, both laymen and ecclesiastics. A separation of powers was established, and special committees were installed with responsibility for education, social affairs, religion, legislation and economics. The powers of the patriarch were reduced and might be compared to that of a constitutional monarch. This reform provided religious and cultural autonomy to the Armenians. Another significant consequence of the reforms was an increase in education. However, shortly after the ascension to the throne of Abdülhamid II in 1876, reform stalled.

The period from roughly 1800 is known as *veracnut'iwn* (renaissance), which encompassed a range of aspects: a shift to the vernacular language as the primary mode of expression in written and spoken form; the development of a non-clerical modern literature that took as its model contemporary European literatures; a gradual secularization, both philosophically and in the administration of the Armenian *millet*.

Armenians made important contributions to Ottoman culture, state institutions such as the Mint, and architecture. One method among many was through literature in Turkish written in Armenian script (Armeno-Turkish), which had a variety of functions: religious, journalistic, administrative and literary.[19] The first novel in Turkish, *Akabi* (1851), was one such text written by Yovsēp *pasha* Vardanyan, and relates the love story of an Apostolic and a Catholic Armenian. Important contributions were made to the development of Ottoman theatre as well.

Many Armenian poet-performers and storytellers, *ašuł* in Armenian, *âşık* in Turkish, composed and recited as well as sung poetry and told stories, often tragic love-epics called *siravēp*s. Many of them travelled around, performed at village squares, at weddings and in the dwellings of the middle class, even at the palace of the Sultan. Some were retained for longer. They also existed in Persia and in the Caucasus. Most famous among them is Sayat' Nova (1722–1795), court poet to the last Georgian king, Irakli II, whose songs, in Armenian, Georgian and the precursor of Azeri, are still widely performed today. His life and art were made into a remarkable film by Sergei Paradjanov, *The Colour of the Pomegranate* (1968).

The Mekhitarist Brotherhood

In the seventeenth century the need for a better education and deepened spirituality among clergy and lay Armenians alike was recognized by Mxit'ar of Sebastia (1676–1749). Language retention was diminishing and a loss of identity was creeping in. The young cleric founded a new order in 1700, however due to opposition from the Ottoman government and the Armenian Apostolic Church, it could not remain in Constantinople. In 1717 Mxit'ar received permission from the city of Venice to settle on the Island of San Lazzaro in the Venetian lagoon. A split led to a second foundation in Vienna in 1816. In 2000 the branches merged again.

Mxit'ar saw his order as a bridge between the Catholic and the Armenian Apostolic Churches. Its vocation was to help build the entire human being, body, mind and spirit. The order's programme encompassed all culture, including

song and dance, theatre, literature, science, religion and spirituality. Mekhitarist schools spread throughout the Ottoman Empire and many Armenian intellectuals, such as the poet Daniel Varužan (1884–1915) were educated by the Mekhitarists. They initiated printing presses in Venice and Vienna, particularly productive in the eighteenth and nineteenth centuries, and two scholarly journals that continue to be published today, *Bazmavep* (Բազմավէպ, Venice 1843) and *Handes Amsorya* (Հանդէս Ամսօրեայ, Vienna 1887). The Mekhitarists made important contributions to Armenology, and their role in propagating knowledge about Armenia in Europe is hard to overestimate.

Armenia (1870–1915): language, literature, liberation

A central concern from the 1840s onward was language.[20] Since the end of the eighteenth century, educational institutions had been established and their number grew in particular in the second half of the nineteenth century. The establishment of periodicals, the production of books and the publication of translated works shows parallel development.

The Mekhitarists preferred Classical Armenian (*grabar*), the written language, while others advocated the spoken language, as yet fragmented in dialects. However, already before the turn of the first millennium Classical Armenian had ceased to be a spoken language. The vernacular used in the Cilician period had not become a standard language, neither had the supra-dialectal civil (*kʿałakʿakan*) Armenian in which merchants communicated in the seventeenth and eighteenth centuries. In the eighteenth century the civil language gradually developed into two branches, one centred around New Julfa, the other in Constantinople. However, after 1850 the vernacular (*ašxarhabar*) prevailed in both the Ottoman Empire and Russia.

In the Ottoman Empire linguistic change emanated from Constantinople and Smyrna.[21] The Mesropian School, founded in 1775, became a centre of enlightenment, and Matʿēos Mamurean (1830–1901) founded the leading journal *Arewelean Mamul* (Արեւելեան Մամուլ, 1871–1909, 1919–22). Grigor Čilingirean (1833–1923) was a prolific translator, while the Dedeyan brothers established a printing press in the city that published over 200 titles of European literature translated into the Armenian vernacular from 1850 onwards.

In Russia the battle for the Eastern Armenian vernacular, based on the dialect of the Ararat valley, was won by 1860, in the wake of the publication of Abovean's *Wounds of Armenia* (Վէրք Հայաստանի) in 1858 (written in the early 1840s). The generation after Abovean with Mikʿayēl Nalbandian (1829–1866) and Rapʿayēl Patkanean (1830–1892) fanned the flames of national emancipation. The most inciting author was Raffi (1835–1888), who looked to the groundswell of the Armenian people rather than Europe or Russia for help in the struggle for liberation. His novels often address episodes of liberation in the past and were very popular among Ottoman Armenians as well.

The *tanzimat* came to a halt under Sultan Abdülhamid II (r.1876–1909). The Treaty of San Stefano (1878) stipulated that Russia, having won the latest war, annex parts of Western Armenia and station troops in the remainder until reforms would take effect. However, Britain and Germany opposed the terms, resulting in the Treaty of Berlin (1878), which left Armenians deeply disappointed. Only

Kars and Ardahan stayed under Russian control and none of its troops remained. Responsibility for reform was placed with European powers without specification. This prompted Xrimean Hayrik, former Patriarch of Constantinople (in office 1869–73) and future Katholikos of All Armenians (in office 1892–1907), the Armenian representative in Berlin, to compare the Armenian contribution to the treaty to stirring a pot with a paper ladle – the paper on which the Treaty of San Stefano was written – while others had an iron one. It was no idle comparison. In particular Armenian peasants remained *de facto* second rank subjects, exposed to raids, pogroms and massacres. The disinterest in the plight of the Armenians, and under Sultan Abdülhamid active deployment of these factors as instruments of oppression, led to resistance, in particular from 1860 onward. Rebellions in Zeytun (1860, 1895/6), Sasun (1893/4) and Van (1896) were perceived as righteous resistance in the light of Vardan Mamikonean's stance against the Sasanian order to readopt Zoroastrianism, as related by Ełišē in *c.* 500.

After 1878 the 'Armenian Question' became a matter of international diplomacy. Xrimean's comparison was a wake-up call to Armenians, who began to form political parties. The Armenakan Party (Van, 1885) was succeeded by the Constitutional Ṙamkavar Party (Egypt, 1908). It did not accept violence, was popular in middle and higher classes, took sides with the patriarchate, and was reorganized in 1921 into the Democratic Liberal Party (Ռամկավար Ազատական Կուսակցութիւն). More radical was the Hnčʿak Party (Հնչակեան Կուսակցութիւն, Geneva, 1887), which combined socialism and nationalism, aimed at immediate independence for Ottoman Armenia through revolutionary methods and the creation of a socialist state. Yet after the 1890s it splintered into irrelevancy. The staying power lay with the Armenian Revolutionary Federation or *Dašnakcʿutʿiwn* (Հայ Հեղափոխական Դաշնակցութիւն, Tiflis/Tbilisi, 1890), prominent after 1895 and the most important Armenian political party in the diaspora from the 1920s onwards, when it opposed the Soviet regime in Armenia. While socialist, its nationalism came first, aiming at freedom and reforms within the Ottoman Empire rather than independence.

In 1894–6 Abdülhamid II's sanction of violence against Armenians led to massacres that claimed at least 100,000 and possibly over 200,000 lives. While many Armenian intellectuals emigrated, the education system continued to expand, and in literature a remarkable blossoming of poetry by young authors such as Misak Mecarencʿ (1886–1908), Siamantʿo (1878–1915) and Daniēl Varužan (1884–1915) occurred.

In 1908 Young Turks staged a revolution that declared 'Liberty, Equality and Brotherhood', echoing the French Revolution. Armenians embraced it, but it proved a false dawn. In the context of a counter-revolution, around 30,000 Armenians were killed in Cilicia, and investigation committees were sent to establish the causes. The Armenian author Zabel Essayan wrote a memoir based on her experiences there, called *Among the Ruins* (Աւերակներուն մէջ, 1909). Armenian culture continued to thrive up to the beginning of World War I.

Under the Russian government Armenians suffered from a policy of Russification and a growing suspicion of revolutionary activity from 1880 onward. The centre of such activities was Tiflis, home to the largest urban Armenian community in the Caucasus, and the hub of its cultural life as well as of Armenian education and

publishing. The revolutionary tendencies of the Caucasian Armenians shared a socialist ideology with the general trends of Russian revolutionary thought. They were highly motivated to armed resistance and provided weapons to cells in the Ottoman Empire. This element of their activities led to suspicion of widespread Armenian support in the Ottoman Empire for their goals, methods and activities, which was not the case. Most Armenians in fact opposed armed liberation.

In Russia, Russification led to the closure of schools and to circumscription of the powers of the Armenian Church. In 1903, during the katholikosate of Xrimean Hayrik (in office 1892–1907), Russia secularized the possessions of the Armenian Apostolic Church. The katholikos refused to comply and in 1905 the decision was revoked.

Some scholars see this period as the culmination of a long transition from religion-based acceptance of suffering to a liberation movement[22] and discern three types of revolutionary thought among Armenians: Constantinople looked to European liberal and cultural-based nationalism and social ideals; in Tiflis and the Russian Caucasus the nationalism was based on radical romantic social issues; while in the Armenian provinces in the Ottoman Empire a connection with the land itself, a homeland-based nationalism prevailed.[23]

The Armenian genocide

This catalogue accompanies the exhibition entitled *Armenia: Masterpieces from an Enduring Culture*, which commemorates the 100th anniversary of the darkest period in Armenia's long history: that of the 1915 genocide, perpetrated on the order of the Committee for Union and Progress (CUP), the ruling party in the Ottoman Empire. A variety of motives for the crime has been adduced.

One of these is that since the Young Turkish revolution in 1908, a thrust for change had been made, but whereas this initially may have seemed to include non-Muslim minorities, it soon became clear that instead of creating an inclusive, pluralistic society there would be no place for minorities that could not be assimilated, that is Turkified. Initially having welcomed the Young Turk coup in 1908, the *Dašnakcʻutiwn* Party no longer co-operated with them after 1911.

The genocidal policy of extermination of the Armenians formed part of a process during which the Turkification policy of the Young Turks was implemented. Led by the triumvirate of Enver, Cemal and Talaat Pashas of the Committee for Union and Progress, it was carried out under their direction through the Special Organization (*Teşkilat-ı Mahsusa*). It formed the most violent element in the wholesale reconstruction of society, from a multi-ethnic and multi-religious society to a nation state. Pursuing an ethnoreligious homogenization agenda that, in particular after the dramatic losses of its European territories after the Balkan Wars of 1912–13, took on the form of an emergency mission to prevent the Ottoman Empire from collapse, World War I provided the opportunity for – rather than being the cause of – solving the Armenian question. There was no military exigency to deport the Armenian population. The objective was pursued in the most radical way thinkable: through the annihilation of the Armenian population on Ottoman territory, and in some cases where the military situation allowed it, in adjacent territory as well. In the western provinces of the empire, not more than five per cent of the population was to consist of Christians, and in the regions to which they were

deported, Armenians were not to exceed ten per cent of the total population. Recent scholarship has emphasized the longer process which constitutes genocide, of which the physical annihilation of the targeted group, in this case the Armenians, forms part.[24]

The genocide perpetrated on the Armenians was preceded by the planning and implementation of a variety of measures, and followed by a cover up through denial. Prior to the physical annihilation of the Armenian communities, it was decided to place Armenian children in city orphanages, forcibly convert them to Islam, and have them abandon their language and culture. Armenians in the Ottoman army were disarmed in early 1915 and placed in work battalions, later to be killed. On 24 April 1915 hundreds of Armenian intellectuals were arrested and, in the following weeks, murdered, thus eliminating the leadership of the nation. Then the Armenian communities were deported. The men were quickly executed and the women and children sent on marches towards the deserts of Syria and Iraq. En route they were assaulted, raped, deprived of the possessions they had been allowed to take with them, and sometimes killed, while very many died of exhaustion, hunger and disease. A second wave of destruction followed in 1916 and 1917, during which girls and some boys were taken in to Kurdish and Turkish families, where they converted to Islam and assimilated. Families were entitled to the possessions of the person they took in.

There was a clear economic aspect to the genocide as well. The centrally organized and executed character is made clear by archival research, revealing a double track of instructions: those following official government channels of communication, and those outside of it, yet dispatched by the highest authorities from within the CUP. After the policy of annihilation was carried out, denial followed, despite the trials held in 1919 and 1920, which make intent and execution clear. It is helpful to adopt a periodization in twentieth-century history that does not place a rupture in government at the transition of the Ottoman Empire to the Turkish Republic: scholars have pointed to a Young Turk period lasting from 1913 (when a coup assured them power they had first assumed in 1908) to 1950, in which the CUP era is followed in 1919 by a Kemalist one.[25] One might summarize what happened as follows: 'Genocide has two phases: one, destruction of the national pattern of the oppressed group; the other, the imposition of the national pattern of the oppressor.'[26] The Armenian genocide thus forms part of the ethnoreligious homogenization carried out by the CUP leadership and its successor, the Kemalist leadership of the Republic of Turkey.

The genocidal character of the extermination of the Armenians in the Ottoman Empire and of some of those living in Armenian-inhabited areas in Iran and Russia during and shortly after World War I continues to be denied by the successor state of the perpetrators, Turkey. Yet there can be no doubt that the concerted action and the motives did constitute genocide. Between one and one-and-a-half million Armenians were murdered or caused to die, an unknown number were forced to convert to Islam or taken into Muslim families, Turkish as well as Kurdish, and several hundred thousand may have fled. Recent research has mapped the progress of the genocide over time and in space, and the various motives have received in-depth attention.[27] The perception of the problem and the obstacles standing in the way of an honest assessment of the genocidal facts have been tackled by a group of Turkish and Armenian historians in a series of groundbreaking workshops

held for over a decade, the results of which have been published in an important collective study.[28]

The first republic

The last stages of World War I brought about profound changes in Armenia.[29] Western Armenia had been annihilated in a genocide. Eastern Armenia found itself in a geopolitical situation of great uncertainty. The October Revolution of 1917 brought the Soviets to power in Russia, and in March 1918 they concluded the Treaty of Brest-Litovsk with the Central Powers. This was a heavy blow to Armenian hopes, as it redrew the borders to their pre-1878 positions. On 22 April 1918 an independent Transcaucasian Federative Republic was declared, to be dissolved only six weeks later under Ottoman military pressure that led to Georgia seeking German protection and declaring independence on 26 May 1918. The Caucasian Muslims proclaimed independence on 28 May 1918, thus founding Azerbaijan.

The Armenians reluctantly declared independence on 28 May as well. Ottoman troops had overrun the largest part of Armenia and threatened to take Erevan, which would have meant the end of Armenia. However, Armenian military victory in the battle of Sardarapat on 24 May saved the country and its inhabitants. A peace treaty with the Ottoman Empire was signed on 4 June, which left a tiny state to the Armenians. It had few resources and multitudes of refugees who had escaped to Russian Armenia during the genocide. The first Armenian state since the kingdom of Cilicia lasted until 1920. The united Armenia that President Wilson of the United States had drawn on the map remained on paper, since the USA would not take the mandate for the country upon itself; the Western powers withdrew their support for the Armenians. The Treaty of Sèvres was signed by the participants in World War I on 10 August 1920, but it was never ratified. The end came with a renewed Turkish military invasion, the Treaty of Alexandrapol (Gyumri, Leninakan) and the attachment of Armenia to Russia, both agreed on 2 December. The country was carved up between the Soviet and Turkish governments. Armenia became Sovietized, with a two-month *Dašnakcʿutʿiwn* interlude in 1921.

A treaty signed in Moscow in March 1921 annulled those of Brest-Litovsk and Alexandrapol, and was followed by the Treaty of Kars in October that set the frontiers between the three Caucasian republics and Turkey. Zangezur, the southern part of the republic, fell to Armenia; Naxičewan, despite its sizable Armenian population and presence there over several millennia, and Łarabał (Karabakh, Arcʿax in Armenian), where the Armenian population formed an overwhelming majority, were given to Azerbajian, which in 1988 resulted in the decision to secede from Azerbaijan, leading to the 1990–94 war between Armenia and Azerbaijan. In December 1922 Armenia became part of the Soviet Federation of the Transcaucasus and of the USSR. In the Treaty of Lausanne, signed on 24 July 1923, a united Armenia does not even figure in the text.

The second republic: Soviet Armenia

Seven years of war, genocide, revolution, displacement, disease and civil war had left a collapsed economy, and a population which was eighty per cent rural and, at 720,000, thirty per cent lower than before the war, many of whom were refugees and immigrants. Lenin's New Economic Policy allowed private enterprise to ensure

economic growth, while electrification and irrigation were essential for agrarian production.

Governing a Soviet Socialist Republic required a policy on nationalism. The concept of *korenizatsiya*, 'rooting' or 'nativization', gave local nationals responsibility for government, including cultural and language policy. Armenian became the primary language in all areas. A new school system for children as well as adults battled illiteracy, which had virtually disappeared by 1940. New establishments included teachers colleges; a university (1921), later named Erevan State University; the Institute of Science and Art, later the Academy of Sciences (1925); a public library (Miasnikyan Library, now the National Library); the National Museum, a state theatre (later called Gabriel Sundukyan Theatre) and an Academy of Arts (all 1922); the Komitas Conservatory, Erevan film studios (both 1923) – film was an important instrument of propaganda; the State Ballet Theatre (Spendarian Theatre, 1933). In 1925 Hamo Bek-Nazarov made the first silent film, *Namus*, followed in 1935 by the first spoken one, *Pepo*, after Sundukyan's play of 1876. The Church established a centre for culture and history in Ējmiacin.

The Church's manuscript collection was nationalized and housed in the Matenadaran, established in its own building in 1959 as the Maštoc' Institute for Ancient Manuscripts. A productive research institute and the country's most prominent depository of Armenia's cultural heritage, where the book occupies pride of place, expanded in 2011 into a large adjacent new building and now employs some 300 specialists. The national architectural language of Erevan was shaped by T'amanyan, incorporating, along with the tufa stone, designs from the long Armenian tradition of civil and ecclesiastical construction.

In literature and art some established names embraced the new Republic, such as Yovhannes T'umanyan (1869–1923) and Širvanzade (1858–1935), Avetis Isahakyan (1875–1957), the sculptor and painter Ervand K'očar (1899–1979) and painter Martiros Saryan (1880–1972). Upcoming stars were Ełiše Č'arenc' (1897–1937), Vahan T'ot'ovenc' (1894–1938), Aksel Bakunc' (1899–1937) and Gurgen Mahari (1903–1969), whose novel *The Burning Orchards* (Այրվող այգեստաններ), set in Van in 1915, is an indictment of the genocide and is critical as well of Armenian political leaders of the time.

The relationship between state and Church was far from easy. Katholikos Georg V (in office 1911–1930) recognized the Soviet regime only in 1927. Education was taken away from the Church and the government set up a rival Soviet organization, called Free Church. The anti-religious campaign, with its closure of churches and their re-designation, did not go down well with the population.

In 1928 forced collectivization began, equalling a second revolution, and a war on the peasantry. By 1940 almost every farm was either a collective or state owned. Mass migration to the cities created a new, industrial work force, fitting the goals of industrialization needed for the advancement of the Soviet Union's economy. State control turned into oppression and violence with the strict implementation of the First Five Year plan (1928–32). This covered the arts – literature, film, theatre, graphic art with its posters and slogans, and also the press – all of which were considered important instruments in the battle to establish socialism. In 1934 the first All-Union Congress of Writers declared Soviet Realism the official norm for literary production in the USSR, ending a period of great variety.

The Great Terror of 1936–8 decimated Armenian political leadership as well

as writers and artists. Ałasi Xanjian, First Secretary of the Communist Party in Armenia, was killed in 1936, Ełiše Čʻarencʻ in 1937; Aksel Bakuncʻ and Vahan Tʻotʻovencʻ in 1938. The Armenian Church suffered greatly, most conspicuously with the murder of Katholikos Xoren I (in office 1933–8), very likely ordered by the state, after which the Mother See at Ejmiacin remained vacant until 1946.

Since the Church was needed to shore up Armenians' motivation for the war effort, the *sedis vacatio* saw rapprochement between Church and state, including the opening of a seminary and a publishing house and the establishment of a Council of Ecclesiastical Affairs. Armenia took an active part on the side of the Allies in World War II, including entirely Armenian units and no less than sixty generals. Losses were severe. Some of the Dašnaks sided with the Nazis, among them General Dro, but this did not in any way represent party politics.

In literature one sees the same temporary openness during the war. In *The Voice of the Fatherland* (Հայրենիքի ձայն, 1943), Nairi Zarian (1900–1969), who had the blood of colleagues on his hands, harked back to Vardan Mamikonean's martyrdom in the battle of Avarayr in 451 and even endorsed Narekacʻi. Derenik Demirčyan (1877–1956) stands out with *Vardanankʻ* (Վարդանանք, 1944), representing Armenian unity, while downplaying the religious dimension for an emphasis on national unity.

Shortly after the war, Gevorg Čʻorekčʻyan was elected katholikos, and as such endorsed by the USSR. He put his weight behind the USSR's demand that Turkey hand back Kars and Ardahan, which came to nothing.

The call made between 1946 and 1948 for Armenians to 'return to the homeland' (*nergałtʻ*, or immigration) – for most it was not a return, as their home was in Western Armenia – was a programme that both Church and state backed. The immigrants came to a land that was in tatters, and their expressions of disappointment were seen as subversion. A new round of purges (1949–52) saw many sent to the Altai mountains.

Stalin's death in 1953 brought a 'thaw' leading to the posthumous rehabilitation of many of those killed or sent to the Gulag, among them Ełiše Čʻarencʻ. While the political leadership in Armenia remained much the same, consisting of old Stalinists, the period of Khrushchev's leadership (1953–64) opened significant possibilities for artistic expression. Geōrg Ēmin (1919–1998) embraced his nation in *Seven Songs about Armenia* (Յոթ երգ Հայաստանի մասին, 1970). Paruyr Sevak's (1924–1971) masterpiece *Let there be Light* (Եղիցի լույս), was published after his death in a car accident, now long suspected to have been a state-commissioned murder.

In 1955 Vazken I was elected Katholikos of All Armenians. His relationship with the leaders of the atheist state, who not rarely respected the Church's role in the history of the Armenian people, was as circumstances dictated, cautious or bold. The Church could not proselytize, no pastoral work was possible, and the celebration of the liturgy became its central role. The prestige of the Armenian Apostolic Church throughout the diaspora allowed Soviet Armenia to engage with it to pursue its diplomatic ends. In 1964 Soviet Armenia created the Committee for Cultural Relations with the Diaspora.

In order not to jeopardize good relations with Turkey, treatment of the genocide in literature was not officially allowed before 1965. Ełiše Čʻarencʻ had chosen Dante

as model in *Dantesque legend* (Դանթէական առասպել, 1920). Yovhannes Širaz did so as well in *The Dantesque Inferno of the Armenians* (Հայոց դանթէականը, 1990), posthumously published, but enjoying wide popularity through partial readings and radio broadcasts decades earlier. Another model was Komitas (1869–1935), the composer-ethnomusicologist and choirmaster, who, saved in 1915, became deranged and spent the remaining twenty years of his life in a mental institution in Paris. Č'arenc', already ostracized, applied it in *Requiem aeternam* (1936), as did Paruyr Sevak in *The Belltower that Cannot be Silenced* (Անլռելի զանգակատուն, 1958).

In 1965 the authorities were confronted with a demonstration of over 100,000 people demanding public commemoration of the fiftieth anniversary of the genocide. This led to the erection in 1967 of the genocide memorial at Cicernakaberd in Erevan. In 1995 the Armenian Genocide Museum–Institute (AGMI) was added to the commemoration site. It now forms part of the official state protocol, and foreign dignitaries are brought there as part of their visit to Armenia, just as they are taken to the principal *lieu de mémoire* of the country's millennial cultural history, the Matenadaran.

In 1968 a monument commemorating the battle at Sardarapat in 1918 was built, emphasizing the Armenians' resolve to withstand annihilation. A new emphasis on national history and identity was laid, further fuelled by the protests that broke out in 1978 in neighbouring Georgia when the USSR announced plans to delete the constitutional stipulation of Armenian and Georgian as state languages in the respective republics. The idea was withdrawn altogether. The Soviet Union's ideal of the new Soviet human being as an incarnation of its socialist internationalism – in practice a version of Russification – yielded to the results of *korenizatsiya*; cultural and linguistic liberty were vouchsafed as long as loyalty to the party was not in doubt.

Armenia had become a well educated, highly industrialized (eighty per cent urban dwellers) and ethnically the most homogeneous republic of the USSR (89.7 per cent in 1979). Armenian was the *lingua franca* in the republic, used by the 50,000 Kurds and 160,000 Azeris as well. At the same time only sixty-five per cent of Armenians in the USSR lived in Armenia (2,725,000 out of 4,151,000 in 1979).

The Gorbachev era brought unprecedented freedom of speech and opportunity for reform. Several matters claimed particular attention, among these the ecological situation, the pervasive corruption, and the allocation of Karabakh to Azerbaijan; some hundred thousand Armenians lived there, cut off culturally from Armenia. In February 1988 the Soviet of People's Deputies in Stepanakert voted for separation from Azerbaijan and transfer to Armenia. Moscow refused. Pogroms in Sumgait near Baku claimed the lives of some thirty Armenians. In Karabakh and Armenia, popular support for Karabakh committees became overwhelming, leading to the replacement of the Communist leadership in Erevan. On 7 December 1988 a devastating earthquake laid waste to northern Armenia, claiming *c.*35,000 lives, and members of the Karabakh Committee were arrested while organizing help. Gorbachev's popularity plummeted, as did trust in the Soviet Union. Early in 1990 war broke out between Armenia and Azerbaijan over Karabakh, lasting until 1994, killing perhaps 25,000. Most of Karabakh, the areas between Armenia and Karabakh, and those south of the enclave to the border with Iran were in the hands of the Karabakh defence forces. A ceasefire was agreed on 12 May 1994. By this

time an entirely different geopolitical order had emerged: in 1991 the Soviet Union collapsed, and on 23 September 1991 Armenia's independence was proclaimed. Levon Ter Petrosyan, one of the members of the Karabakh Committee and leader of the All Armenian Movement and speaker of the parliament, was elected president.[30]

The third republic: independent Armenia since 1991

The independent republic found itself immediately in difficult economic, social and demographic circumstances. At war with Azerbaijan, the country experienced a blockade from its eastern neighbour. The Soviet Union's economic system had collapsed, with severe consequences for Armenia. The importance of Russia for Armenia's security and energy supplies was paramount, and Armenia joined the CIS, the Commonwealth of Independent Nations. Ter Petrosyan's policy was based on geopolitical reality: Armenia was a small, land-locked country dependent on energy supplies from abroad and located in a politically unstable, often hostile region within Russia's sphere of influence. Civil law codes were drawn up based on European models. A new constitution was adopted in 1995 and a National Assembly with legislative power consisting of 131 members was installed. Relations with the diaspora did not develop smoothly, an instance of which is Ter Petrosyan's banishing of the *Dašnakc'ut'yun* Party in 1994. He was re-elected in 1996. Armenia began to show signs of economic revival, but social and economic inequality grew.

In 1995 Karekin II of Cilicia was elected as Karekin I, Katholikos of All Armenians. Ter Petrosyan had backed his candidacy in order to create rapprochement between the two katholikosates and between Armenia and the diaspora. In 1996 Karekin I and Pope John Paul II signed a text in Rome concerning the Christological views of the two Churches. In 1999 Karekin II, the current Katholikos of All Armenians, succeeded Karekin I.

In 1997 Robert K'oč'aryan, former president of the self-declared Independent Republic of Karabakh, was appointed prime minister of Armenia. Ter Petrosyan's position over Karabakh was considered too lenient and he resigned on 2 February 1998. Kočaryan was elected president in March 1998 and re-elected for a second term in 2003, renewing his battle against poverty and corruption. Armenia's relations with the European Union were guided from 1999 by the EU-Armenia Partnership and Cooperation Agreement. This foresees co-operation in the areas of political dialogue, trade, culture, legislation, investment and economy. In 2000 a revision of the law on elections brought the process in line with European norms. In 2001 Armenia was admitted to the Council of Europe and in 2004 into the European Policy of Neighbouring States, including the Eastern Partnership. In 2005 reform of the constitution curtailed the power of the president; it also stipulated a strict separation of Church and state.[31]

The current president, Serž Sargsyan, was elected in 2008 and re-elected in 2013; allegations of fraud were not supported by international observers. Several issues remain paramount, such as Armenia's geopolitical situation and the consequences for its security, in particular the relationships with Turkey and with Russia, the Karabakh issue, recognition of the genocide, and the relationship with and the role of the diaspora in Armenia. Educational norms and public health also require attention. Of eminent importance has been the development of the country according to political, social, cultural and legislative norms in line with

the standards set by Europe, a market economy, and the problems caused by oligarchies, corruption and human rights issues. Finally, the relationship of the state with the Armenian Apostolic Church remains of great importance, having various ramifications: the issue of the representation of Armenian identity, overcoming the negative Soviet legacy, and the role of the Church in the community and in the lives of individuals. The state's relationship with the Armenian Apostolic Church also determines the place for other Christian denominations as well as other creeds.

Armenia's independence came about in the economically and socially difficult circumstances of a blockade and a war, but economic growth was steady from the later 1990s onwards, with over ten per cent per year just before the 2008–09 global crisis. Currently growth is slowing down (3.5 per cent in 2013, 2.8 per cent in the first half of 2014), as foreign direct investment is diminishing – due among other factors to slower economic growth in Russia, where a large number of Armenians have migrated either temporarily in order to find work, and from there sent part of their earnings to family in Armenia, or where they have emigrated altogether. Some fifteen per cent of GDP consists of remittances sent by Armenians from Russia. Moreover, the country depends on a limited number of commodity exports, and the external economic environment is difficult.[32] Unemployment is high.[33] The gap between rich and poor has dramatically widened since 1991. Demographically, Armenia sees emigration at a higher rate than immigration, which, combined with a low birth rate, is cause for concern. The reasons behind this are the instability of the economic, social and political situation, as well as the desire to find commensurate employment in a democratic and politically stable environment among a well-educated younger generation.

In 2014 President Sargsyan, after – or next to – pursuing European ideals, embraced the Customs Union with Russia, Belarus and Kazakhstan, in effect as of 1 January 2015. In civil society much of the gains are queried by looking at the validity of European norms, affecting the position of women and of sexual minorities, and of NGOs in the country. The ramifications for all the above are not clear yet, not least the status and position of Karabakh, itself a new, albeit unrecognised state carrying an ancient and rich Armenian legacy.

The Armenian Church in the third millennium

The position of the Armenian Apostolic Church gives a stark indication of the impact of the genocide on the Armenian people, as well as of the consequences of the attitudes of the atheist Soviet regime *vis à vis* the Church over a period of seventy years. The Armenian Church lost close to two million of its faithful, was subject to persecution in the Soviet Union, lost 5,000 churches and monasteries all over historic Armenia, including the Caucasus: it was close to obliteration. While ninety per cent of the inhabitants of the Republic of Armenia consider themselves members of the Armenian Apostolic Church, and the Mother See is established in Ējmiacin in the Ararat Valley, the majority of its members – five out of eight million – live outside Armenia's traditional heartland and the Middle East. Yet there is a remarkable renewal in vocations: in twenty years' time the clergy has doubled, their average age has gone down significantly, and their education is much better on average than a century ago. There is a call for devolution of decision-making to local churches, and an ear for the problems the faithful face in modern society. A balance

has to be struck between identity-building and spiritual institution. Private forms of religiosity and secularization no longer match the combination of faith and language that contributed to the identity of many people in the diaspora – while in Armenia a return to the Church can be observed, and adherence to it in the United States and Istanbul remains high.[34]

The global diaspora

Armenian identity has undergone mutations in the diaspora, possibly more perceptibly than in Soviet and Independent Armenia. Traditional constituents of identity were religion and language, to which after 1915 was added the memory of the genocide. With adherence to religion and language use weakening in the Armenian communities of the diaspora, only memory survives, although the re-establishment of an Independent Republic of Armenian might also provide the diaspora with an identity vector.

After the genocide new community structures had to be built, expressing themselves in religious congregations, in relief and support organizations, in allegiances to the various political parties, and in the establishment of newspapers, such as *Haṙaj* in Paris – refounded as *Nor Haṙaj* – literary journals and publishing houses. The diaspora is global and diverse and faces perpetual challenges to the Armenians' identities. In the Middle East the largest communities were found in Lebanon and in Iran, which have been facing waves of emigration in recent decades. In Europe Armenians built new lives in many countries. The community in France succeeded in participating in all aspects of life in the country while remaining keenly aware of its identity. Although it is difficult to provide reliable numbers, the largest communities are found in Russia (a number of over two million is not unrealistic), the United States (over a million) and France. Sizable communities also exist in Poland, Argentina, Canada, Syria and other countries.[35] They face challenges to the traditional tandem of identity determiners, faith and language, with a loss of both in younger generations, while they do not necessary feel less Armenian.[36]

In cinema and literature the experience of Armenians in the diaspora is expressed in a variety of ways, with Atom Egoyan's *Ararat* (2002) gaining global attention. Various attempts to make sense of the incomprehensibility of the catastrophe that was the genocide and of the diaspora reality that ensued have been, and are being, undertaken. Yakob Ōšakan (1883–1948) devoted his critical acumen to a ten-volume *Panorama of Western Armenian Literature* (Համապատկեր արեւմտահայ գրականութեան, 1945–82), while his novels sought to understand the Turkish psyche and its effects on Armenian mentality (e.g. *Remnants,* Մնացորդաց). Philosopher Marc Nichanian (b.1946) publishes a series of interpretative works on modern Armenian literature in French and English, entitled *Writers of Disaster. Armenian Literature in the Twentieth Century* (2002–). Poet and critic Krikor Beledian (b.1945) explores diaspora and memory in a series of seven prose volumes, *Nightfall* (Գիշերադարձ). While most of Beledian's work was published in the diaspora, one of Erevan's foremost publishing houses, Sargis Xačenc' has undertaken to publish his entire oeuvre with support from the Calouste Gulbenkian Foundation, which has actively supported book publishing in the Independent Republic. The last volume of *Nightfall, Wandering* (Շրջում) was first published in Armenia in 2012.

Armenians in the Turkish Republic: the genocide in Turkish and Kurdish consciousness

The genocide destroyed the Armenian heartland and the Armenian communities in Anatolia and in the west of the country. Constantinople also lost hundreds of the most prominent Armenian citizens when they were deported on 24 April 1915 and the following month. Further, until 1930 instances of loss of life among survivors hailing from Xarbert, Diarbekir, Cilicia and Alexandretta occurred. The patriarchate brought groups of survivors in the provinces to Istanbul. During World War II excessive taxation presented a new danger, and in 1955 churches and cemeteries of Armenians and Greeks were desecrated in Istanbul. These events led to emigration.

The numbers of Armenians residing in Turkey are hard to pin down with precision. In 2003 there were *c.*80,000 Armenians living in Turkey, among which were 5,000 Catholics and some 500 evangelicals. The Armenian community is centred in Istanbul, where some 70,000 Armenians live and where the Armenian Patriarchate is located.

However, over the last decade many persons claiming Armenian descent have come forward, with concomitant consequences for the number of Armenians present in Turkey today. There is a series of higher and secondary educational centres, some of these Armenian Apostolic, some Catholic. The community has a variety of community houses, sports, music and other clubs. Among periodicals the best known are Žamanak (Ժամանակ, since 1908, with interruption between 1920 and 1924), *Marmara* (Մարմարա, since 1940), and the bilingual Armenian and Turkish *Agos* (Ակոս, since 1996). Surp Prkiç Hospital publishes a periodical in Armenian and Turkish on aspects of the Armenian community in Istanbul and the hospital's role, which extends well beyond the community.[37] Actively publishing – in Turkish and Armenian – on matters concerning the Armenians today as well as literary works is Aras Publishing House, established in 1993. Among Armenian authors in Turkey several names stand out, such as the poets Zahrad (1924–2007) and Zareh Khrakhuni (b.1926).[38]

Against denial stands the recognition that what happened constituted genocide on the part of a number of states, parliaments and regions in the world, among these the European Parliament (1987), and importantly a growing number of Turks and Kurds in the Republic of Turkey and outside of it.

Over the last fifteen years a remarkable development has seen a growing civil society in Turkey break the taboo on the discussion of the genocide leading to a much greater awareness of what actually happened in 1915. This has become particularly clear after the murder at the hand of a Turkish nationalist of the Turkish-Armenian journalist Hrant Dink on 19 January 2007. In 1996 he founded *Agos*, a bilingual newspaper, and openly discussed the issues of Armenians in Turkey, including genocide. He found great resonance in the country and abroad. An unprecedented wave of identification with the Armenians followed.

This outpouring of recognition of the Armenians' plight is further reflected in the multiplying occurrences of people talking about their Armenian origins, identifying themselves as such, and their desire to claim back their ancestry. Their number is estimated between a half and one million, including well-known communities such as Hemşin on the Black Sea coast in the north-east. The plight of Muslimized Armenians has become a subject of Turkish literature as well (cat. 95).[39]

The Armenian Apostolic Church recognizes the particularly delicate situation of these Muslimized Armenians.

The Kurds, who for several centuries had played an inglorious role in the oppression of Armenians, were among those participating in the genocide. Today, many Kurds from Turkey accept their role and discuss its consequences both in literature and in political fora.

As mentioned earlier, scholarly initiatives have seen Turkish and Armenian scholars debate the issue over more than a decade and publish on it together. While the Turkish government continues to deny the genocide – despite its expression on the eve of 24 April 2014 of commiseration with the plight of Armenians during World War I – there is now in Turkey a growing awareness of the facts and an increasing wish to face the past with honesty, justifying hope that recognition might open the way to reconciliation, co-operation and to truly living together.

SUGGESTIONS FOR FURTHER READING

Akçam, T., *The Young Turks' Crime against Humanity. The Armenian Genocide and Ethnic Cleansing in the Ottoman Empire,* Princeton University Press, Princeton, NJ, 2012.

Aslanian, S. D., *From the Indian Ocean to the Mediterranean. The Global Networks of Armenian Merchants from New Julfa,* University of California Press, Berkeley – New York – London, 2011.

Bardakjian, K., *A Reference Guide to Modern Armenian Literature, 1500–1920. With an Introductory History,* Wayne State University Press, Detroit, 2000.

Beledian, K., *Les Arméniens,* Brepols, Turnhout, 1994.

Dadoyan, S. B., *The Armenians in the Medieval Islamic World. Paradigms of Interaction. Seventh to Fourteenth Centuries,* 3 Volumes, Transaction Publishers, New Brunswick and London, 2011–14.

Dédéyan, G. (ed.), *Histoire du peuple arménien,* Privat, Toulouse, 2007.

Der Nersessian, S., *Armenian Art,* Thames & Hudson, London, 1978.

Garsoïan, N. G., *The Epic Histories Attributed to P'awstos Buzand (Buzandaran Patmut'iwnk'),* Harvard University Press (dist.), Cambridge, MA, 1989.

Garsoïan, N. G., *Interregnum. Introduction to a Study on the Formation of Armenian Identity (ca 600–750),* Peeters, Louvain, 2012.

Hewsen, R. H., *Armenia. A Historical Atlas,* The University of Chicago Press, Chicago and London, 2001.

Hovannisian, R. G. (ed.), *The Armenian People from Ancient to Modern Times. Volume I. The Dynastic Periods: From Antiquity to the Fourteenth Century. Volume II. Foreign Dominion to Statehood: The Fifteenth Century to the Twentieth Century,* Macmillan, London, 1997.

Kévorkian, R. H., *The Armenian Genocide. A Complete History,* I.B. Tauris, London–New York, 2011.

Mathews, Th. F. and R. S. Wieck, *Treasures in Heaven. Armenian Illuminated Manuscripts,* The Pierpont Morgan Library, New York, 1994.

Nichanian, M., *Ages et Usages de la langue arménienne,* Editions Entente, Paris, 1989.

Panossian, R., *The Armenians. From Kings and Priests to Merchants and Commisars,* Hurst, London, 2006.

Robertson, G., QC, *An Inconvenient Genocide. Who Now Remembers the Armenians?,* Biteback Publishing, London, 2014

Stone, M. E., D. Kouymjian, H. Lehmann, *Album of Armenian Paleography,* Aarhus University Press, 2002.

Suny, R. G., *They Can Live in the Desert but Nowhere Else. A History of the Armenian Genocide,* Princeton University Press, Princeton and Oxford, 2015.

Suny, R. G., F. M. Göçek and N. M. Naimark (eds.), *A Question of Genocide. Armenians and Turks at the End of the Ottoman Empire,* Oxford University Press, New York – Oxford, 2011.

Thomson, R. W., *Agathangelos History of the Armenians,* State University of New York Press, Albany, 1976.

Thomson, R. W., *Elishē. History of Vardan and the Armenian War,* Harvard University Press, Cambridge MA, 1982.

Thomson, R. W., *Moses Khorenats'i. History of the Armenians,* Caravan Books, Ann Arbor, 2006 (2nd, rev. ed.; 1st ed. 1978).

NOTES

1 Robert H. Hewsen, 'The Geography of Armenia', in Richard G. Hovannisian, *The Armenian People from Ancient to Modern Times, Volume I*, pp. 1–17; Robert H. Hewsen, *Armenia. A Historical Atlas,* The University of Chicago Press, Chicago and London, 2001.

2 James R. Russell, 'The Formation of the Armenian Nation', in Hovannisian, *The Armenian People, I*, pp. 19–35. For the linguistic appurtenance of Armenian, cf. Charles de Lamberterie, 'Grec, phrygien, arménien: des anciens aux modernes', *Journal des Savants*, 2013, pp. 3–69; and Charles de Lamberterie, 'L'arménien', in Fraçoise Bader (ed.), *Langues indo-européennes*, CNRS éditions, Paris, 1994, pp. 137–63; as well as Jan Henrik Holst, *Armenische Studien*, Harrassowitz, Wiesbaden, 2009.

3 Russell, 'Formation'.

4 Nina G. Garsoïan, 'The Emergence of Armenia' and 'The Aršakuni Dynasty', in Hovannisian, *The Armenian People, I*, pp. 37–62 and 63–94.

5 Garsoïan, 'Aršakuni'.

6 Robert W. Thomson, 'Armenian Literary Culture through the Eleventh Century', in Hovannisian, *The Armenian People, I*, pp. 200–205.

7 Nina G. Garsoïan, 'The *Marzpanate* (428–652)', in Hovannisian, *The Armenian People, I*, pp.95–115.

8 For references to Armenian literature to 1500, see Robert W. Thomson, *A Bibliography of Classical Armenian Literature to 1500 AD*, Brepols, Turnhout, 1995; Robert W. Thomson, 'Supplement to *A Bibliography of Classical Armenian Literature to 1500 AD*: Publications 1993–2005', *Le Muséon* 120 (1–2), pp. 163–213; for references from 1500, Kevork B. Bardakjian, *A Reference Guide to Modern Armenian Literature, 1500–1920*, Wayne State University Press, Detroit, 2000. For surveys of Armenian Literature, see Thomson, 'Armenian Literary Culture'; Peter S. Cowe, 'Medieval Armenian Literary and Cultural Trends (Twelfth–Seventeenth Centuries)', in Hovannisian, *The Armenian People, I*, pp. 293–325; Vahé Oshagan, 'Modern Armenian Literature and Intellectual History from 1700 to 1915', in Hovannisian, *The Armenian People, II*, pp. 139–74; 'A General History of Armenian Literature, 1500–1990', in Bardakjian, *Reference Guide*, pp. 21–252. On the Council of Chalcedon in Armenia, the separation of the Georgian Church and the *Book of Letters*, see Nina G. Garsoïan, *L'Eglise arménienne et le grand schisme d'Orient*, Peeters, Louvain, 1999.

9 Thomson, 'Armenian Literary Culture'.

10 Nina G. Garsoïan, *Interregnum. Introduction to a Study on the Formation of Armenian Identity (ca 600–750)*, Peeters, Louvain, 2012.

11 Nina G. Garsoïan, 'The Arab invasions and the Rise of the Bagratuni', in Hovannisian, *The Armenian People, I*, pp. 117–42.

12 Nina G. Garsoïan, 'L'Histoire attribuée à Movsēs Xorenac'i: que reste-t-il à en dire?', *Revue des Études Arméniennes* 29, 2004, pp. 29–48.

13 Nina G. Garsoïan, 'The Independent Kingdoms of Medieval Armenia' and 'The Byzantine Annexation of the Armenian Kingdoms in the Eleventh Century', in Hovannisian, *The Armenian People, I*, pp. 143–85 and 187–98. Cf. T. W. Greenwood, 'Armenian Neighbours (600–1045)', in Jonathan Shepard, *The Cambridge History of the Byzantine Empire, c.500–1492*, Cambridge University Press, Cambridge, 2008, pp. 333–64.

14 Nina G. Garsoïan, 'The Problem of Armenian Integration into the Byzantine Empire', in Hélène Ahrweiler and Angeliki E. Laiou, *Studies on the Internal Diaspora of the Byzantine Empire*, Dumbarton Oaks Research Library and Collection, Washington DC, 1998, pp. 53–124; Seta B. Dadoïan, *The Fatimid Armenians. Cultural and Political Interaction in the Near East*, Brill, Leiden – New York – Köln, 1997.

15 Garsoïan, *Interregnum*, p. 122.

16 On medieval Armenian poetry, see James R. Russell, *Yovhannēs T'lkuranc'i and The Mediaeval Armenian Lyric Tradition*, Scholars Press, Atlanta, GA, 1987; S. Peter Cowe, 'Models for the Interpretation of Medieval Armenian Poetry', in J. J. S. Weitenberg, *New Approaches to Medieval Armenian Language and Literature*, Rodopi, Amsterdam, 1995, pp. 29–45; S. Peter Cowe, 'The politics of poetics: Islamic Influence on Armenian Verse', in J. van Ginkel, H. Murre van den Berg and Th. M. van Lint, *Redefining Christian Identity: Cultural Interaction in the Middle East since the Rise of Islam*, Peeters, Leuven, 2005, pp. 379–403.

17 Dickran Kouymjian, 'Armenia from the Fall of the Cilician Kingdom to the Forced Emigration under Shah Abbas (1604)', in Hovannisian, *The Armenian People, II*, pp. 1–50.

18 Avedis K. Sanjian and Andreas Tietze (eds) *Eremya Chelebi Kömürjian's Armeno-Turkish Poem "The Jewish Bride"*, Otto Harrassowitz Verlag, Wiesbaden, 1981.

19 The study of Armeno-Turkish texts has begun to develop in the past decades. For introductory works, see Hasmik A. Stepanyan, *Hayataṙ T'urk'erēn Grk'eri ew Hayataṙ T'urk'erēn Parberakan Mamuli Matenagitut'iwn (1727–1968) / Ermeni Harfli Türkçe Kitaplar ve Süreli Yayınlar Bibliografyası (1727–1968) / Bibliographie des livres et de la presse Arméno-Turque (1727–1968)*, Turkuaz, Istanbul, 2005; *Hayataṙ t'urk'erēn grakanut'yunə (Ałbyuragitakan hetazotut'yun)* (Armeno-Turkish Literature, A Source Study), Erevan University Press, Erevan 2001. A brief interpretative study is Laurent Mignon, 'Lost in Transliteration: A Few Remarks on the Armeno-Turkish Novel and Turkish Literary Historiography', in Evangelia Balta and Mehmet Sönmez (eds), *Between Religion and Language*, Eren, Istanbul, 2011, pp. 111–23.

20 On the language issue, see Marc Nichanian, *Ages et usages de la langue arménienne*, Editions Entente, Paris, 1989.

21 Sona Seferian, 'Translator-Enlighteners of Smyrna', in Richard G. Hovannisian (ed.), *Armenian Smyrna/Izmir. The Aegean Communities*, Mazda Publishers, Costa Mesa, 2012, pp. 153–66; Robert H. Hewsen, 'Matteos Mamourian: A Smyrnean Contributor to the Western Armenian Renaissance', in Hovannisian, *Armenian Smyrna*, pp. 167–75.

22 Razmik Panossian, *The Armenians. From King and Priests to Merchants and Commisars*, Hurst, London, 2006, p. 173.

23 Panossian, *The Armenians*, p. 175.

24 Taner Akçam, *The Young Turks' Crime against Humanity. The Armenian Genocide and Ethnic Cleansing in the Ottoman Empire*, Princeton University Press, Princeton, NJ, 2012. The Preface (pp. ix–xxxiii) places both the genocide and scholarship of the Ottoman Empire and the Armenian genocide in context.

25 So Uğur Ümit Üngor, *The Making of Modern Turkey, Nation and State in Eastern Anatolia, 1913–1950*, Oxford University Press, Oxford, 2011, p. vii, following Erik Jan Zürcher, 'The Ottoman Legacy of the Turkish Republic: An Attempt at a New Periodization', *Die Welt des Islams*, vol. 32 (1992), pp. 237–53.

26 Raphael Lemkin, *Axis Rule in Occupied Europe*, Carnegie Endowment for International Peace, New York, 1944, p. 79, quoted in Akçam, *The Young Turks' Crime*, p. xxviii.

27 Raymond Kévorkian, *The Armenian Genocide. A Complete History*, I. B. Tauris, London and New York, 2011 (original version in French, 2006), maps the progress and spread of the genocide. On the motives for the genocide, see Taner Akçam, *A Shameful Act: The Armenian Genocide and the Question of Turkish Responsibility*, Constable, London, 2007, and *The Young Turks' Crime*.

28 Ronald Grigor Suny, Fatma Müge Göçek and Norman M. Naimark (eds), *A Question of Genocide. Armenians and Turks at the End of the Ottoman Empire*, Oxford University Press, New York – Oxford, 2011.

29 Richard G. Hovannisian, 'Armenia on the Road to Independence' and 'The Republic of Armenia', in Hovannisian, *The Armenian People, II*, pp. 275–301 and 303–346.

30 Ronald Grigor Suny, 'Soviet Armenia', in Hovannisian, *The Armenian People, II*, pp. 347–87.

31 The period 1991–2006 is described in 'La IIIe République: l'Arménie face aux défis de l'indépendance (1991–2000)' and 'Les années 2000–2006: l'ère Kotcharian', in Dédéyan, *Histoire*, pp. 659–703 and 705–739.

32 World Bank data, source: http://www.worldbank.org/en/country/armenia, accessed 15 December 2014; see also the World Bank Group publication, Ulrich Bartsch, Donato De Rosa, Gohar Gyulumyan and Tigran Kostanyan, *Armenia: A Cloudy Outlook. Armenia Economic Report No 6. Fall 2014*. It was published before 1 October 2014, and can be found at: http://www.worldbank.org/content/dam/Worldbank/document/eca/armenia/Armenia%20ER.pdf.

33 http://www.indexmundi.com/armenia/unemployment_rate.html, accessed 15 December 2014.

34 Pasteur Jean-Michel Hornus and Mgr Norvan Zakarian, Philippe S. Sukiasyan, 'l'église dans l'Arménie contemporaine (1921–2007)', in Dédéyan, *Histoire*, pp. 741–86.

35 Post 2003 numbers can be found in various websites, including Wikipedia; see for example: http://en.wikipedia.org/wiki/Largest_Armenian_diaspora_communities.

36 The numbers are as published in Յովհաննես Այվազյան, Հայ Սփիւռք Հանրագիտարան [Armenian Diaspora. Encyclopedia], Armenian Encyclopedia Publishing House, Erevan, 2003.

37 For a survey of data on the Armenians in Turkey, see Հայ Սփիւռք, pp. 175–202.

38 See S. Peter Cowe, 'Redefining Armenian Literary Identity in Istanbul', in Richard G. Hovannisian and Simon Payaslian (eds), *Armenian Constantinople*, Mazda Publishers, Costa Mesa, 2010, pp. 431–44.

39 Apart from the exhibited work by Fethiye Cetin, see for example the novel by Elif Shafak, *The Bastard of Istanbul*, Viking Penguin, New York, 2007.

Dickran Kouymjian

Armenian Writing: Palaeography, Epigraphy and Calligraphy

There are in all cultures a variety of writing forms, but only three will be considered below: writing in books, whether manuscript or printed (palaeography); on objects in stone, metal, wood or other media (epigraphy); and ornamental, decorative or beautiful script (calligraphy).

The frontier between them, at least between epigraphy and palaeography, is unstable. This was the case in the first album of Armenian palaeography, prepared as an article, but also issued as a separate publication in 1913 by Garegin Yovsēpʻean, whose purpose it was to present a broad sampling of Armenian writing through photographs accompanied by notices organized like those in manuscript catalogues with occasional commentary.[1] Of the 143 specimens included, the first thirty-one are stone inscriptions, with full transcription and in large type with line numbers and breaks, quite different from the manuscript samples that rarely include transcriptions.

A revitalized *Album of Armenian Paleography* was published nearly a century later in English and Armenian versions, taking advantage of advances in photography and technology to produce a more specific and, at the same time, uniform inspection of some 200 dated specimens, starting mimetically, out of respect for the work of the pioneer, with four precisely dated stone inscriptions.[2]

Writing in manuscript and print: palaeography

Palaeography is literally the study of old handwriting, but by extension or default it also encompasses the history of writing. It is often said that the palaeographer is asked four basic questions: what was written, when was it written, where was it written and by whom? The study of scripts and their evolution, and the change in letter forms, developed out of the need of philologists to decipher texts, but in time the discipline came to be used to date and localize undated manuscripts, and by extension writing in other media, including inscriptions, most often on stone. The common thread between these disciplines is deciphering writing and thereby understanding it, and afterwards dating and localizing the document, whether papyrus, parchment, paper, stone, metal, wood or cloth. Palaeography is associated with the largest pool of material: manuscripts. For each language, from thousands to millions of items, running to billions of pages of text, are available on which to apply the science of palaeography. It is the philologist-palaeographer who differentiated scripts and gave them names, which were in turn adopted by the epigraphers.

I have suggested more than once that the terms by which Armenian scripts are identified seem to fall into two categories.[3] The first is traditional names used by

scribes during the age of the manuscript, which for Armenian continued about three to four centuries after the first printed book of 1512, much longer than in the West where regular manuscript copying seems to come to an end around 1700, or in some cases considerably before. Advances in printing simply made it faster, more reliable and less expensive, whereas in the Armenian world the free labour of monks copying manuscripts in remote monasteries was more economical. We find references in scribal memorials to traditional script names dating back to the medieval period. The second set of terms was invented in modern times by early philologist-palaeographers writing well after the tradition of producing books by hand had given way to printing.

In the first category, I would suggest only three terms qualify: traditional *erkat'agir, bolorgir* and *nōtrgir*. Each has some textual (manuscript) pedigree.

In the second group are terms invented by scholarly observation: transitional scripts (*anc'man gir*), intermediate, semi-angular or fully angular majuscules (*mijin* or *ułagic erkat'agir*), small majuscules (*p'ok'r* or *manr erkat'agir*) and modern cursive (*šłagir*). Even *pun* (original), *bolorajew* (rounded) or Mesropian *erkat'agir* are analytical terms of palaeographers. This second group describes the type of script: size, geometry of the ductus, thinness or slant or relationship to other scripts (i.e. transitional). Confounded by the contradiction between etymological meaning and the appearance of the letters, Yakobus Tašean agreed that the terms *erkat'agir* and *bolorgir* did not conform to the letters one would expect from the name.[4] In reviewing below the major terms and their sense, I believe we find a usage that does, in fact, fit the terms *erkat'agir, bolorgir* and *nōtrgir*.

Palaeographers like neat classifications and distinct periodization, which are easier to work with than a confused tradition. Armenian script styles, like those of neighbouring Oriental and Western languages, are neither neat nor consistent. The use of one type with another is common. Real standardization only occurs universally, and gradually, after the advent of printing, when the idiosyncrasies of scribes are abandoned for total consistency in letter forms. Another moment when there was a similar uniformity was under the patronage of the aristocracy and the high clergy in the Cilician period, which produced a near print-like *bolorgir* or minuscule. Tašean also found that rounded *erkat'agir* had an extraordinary consistency in Gospel manuscripts of the ninth, tenth and eleventh centuries, irrespective of the region in which they were copied.[5] Even after the start of printing, scribes still mixed scripts in manuscripts right up to the nineteenth century. Most recent Armenian manuscript catalogues of Erevan, Antelias and Paris have started including photographic samples of the script of each manuscript, as well as of older guard leaves.

There are four traditional script categories, each designated by a word ending in *gir* (letter), preceded by a qualifying descriptive.

Erkat'agir (Երկաթագիր) or majuscule

Erkat'agir is the script of the oldest Armenian manuscripts, from fragments ascribed to the seventh century to dated and complete codices from the ninth through to the early thirteenth centuries, with occasional archaic use thereafter.[6] Statistical data shows that it was virtually the only script employed for the parchment codex until the mid-twelfth century;[7] the exceptions include Gospel or

Biblical texts. Because of its place as the earliest surviving formal bookhand, early scholars were emphatic that Mesrop created and used *erkatʿagir*. Early studies on Armenian palaeography assumed a chronological evolution of Armenian script from *erkatʿagir* to *bolorgir* to *nōtrgir* to *šłagir*, albeit with overlapping and anomalies, but this theory has gradually lost favour.[8]

The term has engendered controversy for *erkatʿ* (iron) and *gir* gives 'iron letters', the exact meaning of which is not totally clear. The authoritative *New Dictionary of the Armenian Language* (NBHL) offers 'written with an iron stylus' or derivative meanings, 'old manuscript', 'capital letter'.[9] It attributes the earliest use to Mxitʿar Aparancʿi, known as Fra Mxitʿaričʿ, a Catholic Armenian father belonging to the Fratres Unitores writing in the early fifteenth century.[10] There is a much older reference, however, in a short colophon of a tenth-century Gospel manuscript:[11] 'This *erkatʿagir* is not good, do not blame me. In the y[ear] 360 (= 911 CE).'[12] If we accept this early date, its casual use would suggest an even earlier origin.[13]

The term 'Mesropian *erkatʿagir*' describes the script used exclusively in the earliest Armenian Gospel manuscripts, lapidary inscriptions, and fifth- to seventh-century Jerusalem mosaics. The letters are large, very erect, with gracefully rounded lines connecting the vertical elements of the letters or springing from them.

Two theories explain the word *erkatʿagir,* but neither is totally convincing: one suggests an iron stylus was used to write the letters; the other contends that a ferrous oxide was employed in the ink. How then do we explain the name 'iron letters'? If the tenth-century mention of *erkatʿagir* in the Venice Gospels is correct in referring to the type of script used in that codex, then we may assume that the term was associated by the scribe with two Biblical passages in the Armenian translation of the Bible in which the term 'iron' is used in conjunction with writing or engraving. In both, the expression is *'grčʿav erkatʿeav'* ('written with a stylus of iron'):

> Job 19:23–24: Oh that my words were now written! Oh that they were drawn out in the eternal book! [24.] That they were graven with an iron pen engraved in lead or on the stone as eternal witness.[14]

> Jeremiah 17:1: The sin of Judah is written with a pen of iron, and with the point of a diamond: it is graven upon the tablet of their heart, and upon the horns of your altars.[15]

In the passages, an iron stylus or diamond point is used on hard surfaces. The term *erkatʿagir,* therefore, probably refers more to the type of writing made by instruments of iron, that is lapidary inscriptions, which was the same in form as textual majuscule. If the term originated out of the scribal tradition from early Gospel manuscripts, one could speculate that the initial meaning of *erkatʿagir* was simply the equivalent of 'scriptural writing'.

Bolorgir (Բոլորգիր) **or minuscule**

Bolorgir is compact and has very regular shapes employing ascenders and descenders, which dominated scribal hands from the thirteenth to the sixteenth centuries, and continued into the nineteenth. Ultimately it became the model for

lower-case Armenian type fonts just as *erkat'agir* became the prototype for capitals in printed books. *Bolorgir*'s early use for short phrases and colophons, and even for copying entire manuscripts, is clearly attested in the oldest paper manuscript (M2679), a *Miscellany* of 971 or 981,[16] which uses a mixed *erkat'agir–bolorgir* script. It appears even earlier, since at least some of the *bolorgir* letter forms are found in a pre-seventh-century Armenian papyrus.[17] Like medieval Latin and Greek minuscule, *bolorgir* uses majuscule or *erkat'agir* for capitals, resulting in quite different shapes between upper and lower case for many letters.

Because the script is angular with few rounded letters, specialists have been perplexed by the term. But in Armenian *bolor* does not only mean 'round' or 'rounded', it also has an older and stronger sense of 'all' or 'whole', that is 'complete'. Thus, scribes, when using it, may have meant 'whole script', one with both upper and lower case letters, like a standard minuscule and unlike *erkat'agir* majuscule, which had no real capital letters, but simply the same shape written larger.

Most authorities argue that the spread of *bolorgir* was due to time and economics: it saved valuable parchment because many more words could be copied on a page, and it conserved time because letters could be formed with fewer pen strokes than the three, four or even five needed for the ductus of *erkat'agir*.[18]

A major question concerning Armenian palaeography is what letters Mesrop Maštoc' used? Most scholars believe he conceived and used a large, upright, rounded majuscule, similar to that found in early lapidary inscriptions; thus they called it Mesropian *erkat'agir*. Serge Mouraviev's proposed reconstruction of how Maštoc' proceeded systematically from a half-dozen basic forms on to which were added in a consistent manner descenders, ascenders and lateral strokes to the right and left, would in itself preclude any suggestion of evolution.[19] It has been argued that this script went through various changes – slanted, angular, small *erkat'agir* – and eventually evolved into *bolorgir*, and in time into *nōtrgir* and *šłagir*, the post-sixteenth-century cursives. Doubt about such a supposition started quite early; Tašean himself, the pioneer of the scientific Armenian palaeography, hesitated, but Karo Łafadaryan even maintained that *bolorgir* already existed in Maštoc''s time.[20]

It was also once believed that minuscule gradually developed from earlier formal Latin and Greek majuscule found in lapidary inscriptions and the oldest manuscripts. But the late nineteenth-century discovery in Egypt of thousands of Ptolemaic Greek and Roman papyri with minuscule letters forced scholars to abandon this notion. Some scholars trace the roots of Greek cursive of the ninth century back to the informal cursive of pre-Christian papyri. Latin minuscule is evident already in third-century papyri.[21] Is it possible that along with majuscule *erkat'agir*, some form of an informal cursive script, which later developed into *bolorgir*, was available in the fifth century as surmised by Tašean and Mercier?[22]

Uncial was used in the West for more formal writing, such as Gospels, important religious works and luxury manuscripts. The data gathered for the *Album* points to a similar pattern: the earliest *bolorgir* manuscripts (tenth century) appear chronologically anomalous until one notes that they are philosophical or non-liturgical texts rather than Gospels.

Examination of pre-Christian Latin papyri shows the origins of Caroline script, which is similar to Armenian *bolorgir*, in earlier cursive minuscule. But the invention of the Armenian alphabet in the early fifth century precludes any

pre-Christian antecedents. Greek and Syriac, the languages that most influenced Maštocʻ in creating the Armenian alphabet, used both cursive and majuscule in that period. It is difficult to imagine that Mesrop and his pupils, as they translated the Bible, a task that took decades, would have used the laborious original *erkatʻagir* for drafts as they went along.[23] The use of the faster-to-write intermediate *erkatʻagir* seems more than probable, yet it was not a minuscule script nor cursive. Unfortunately, except for the pre-seventh-century papyrus, no such informal writing in Armenian has survived before the thirteenth century. The earliest preserved Armenian chancellery documents are from the Cilician court of the thirteenth and early fourteenth century;[24] by then *bolorgir* was already the standard bookhand.

The theory of evolution to *bolorgir* versus the notion that *erkatʻagir* and more cursive scripts co-existed from the fifth century is still an open question.

Mixed *erkatʻagir*–*bolorgir* script

From the mid-eleventh to the end of the thirteenth century a somewhat bastardized script appeared among manuscripts, mostly from Greater Armenia to the northeast, employing both uncials and minuscule letters – *erkatʻagir* and *bolorgir* – in the same document. It was named 'transitional script' by early palaeographers, however, during the preparation of the *Album of Armenian Paleography*, Michael Stone proposed it as a separate script.[25] I do not fully accept the argumentation, basing my scepticism on what seems to be a statistical trend showing the use of more *erkatʻagir* letters in the earlier mixed-script manuscripts, while towards the end, when *erkatʻagir* is disappearing as a manuscript hand, the majority of the letters seem to be *bolorgir*, suggesting a transition.

Nōtrgir (Նօտրգիր) and *Šłagir* (Շղագիր): the cursive scripts

The secretary working as a scribe (*notarius*) at the Armenian royal court, or the katholikosate, by necessity employed time-saving cursive versions of *bolorgir* and even smaller *nōtrgir* letters. The latter term could have entered Armenian from either late Byzantine Greek or Latin. Łafadaryan felt there was no convincing antecedent to the script and, therefore, he assumed that it must have had its origins in the early centuries, even in the time of Maštocʻ.[26] The script, when it became formalized in the late sixteenth and seventeenth centuries, was composed of small yet thick unattached letters made of dots and short lines, making those letters without ascenders or descenders hard to distinguish from each other. *Šłagir*, which is modern handwriting with attached letters, usually thin in ductus (it derives from 'fine', not 'slanted' as some believe), is easy to identify; its beginnings are probably at the end of the eighteenth century (cat. 45).[27]

By the last quarter of the twelfth century, minuscule *bolorgir* supplanted majuscule, which was to disappear as a regularly used script about a half-century later. According to the data presented in a sampling of 455 dated manuscripts to 1400, tabulating parchment versus paper and majuscule versus minuscule, the phenomenon did not coincide exactly with the disappearance of parchment, which followed nearly a century later.[28] By the end of the thirteenth century one can safely say that the Armenian manuscript was a codex made up of twelve paper folio quires and written in minuscule *bolorgir*. The only change observed from the seventeenth

to the early nineteenth century was the gradual addition of the two cursive scripts, *nōtrgir* and *šłagir*.

Stone, metal, wood, textile and other materials: epigraphy

The reasoning behind the decision to keep some epigraphy in a study of manuscript writing was outlined recently by Tim Greenwood in a most useful overview of Armenian epigraphy.[29] He not only presents in chronological order the important proto-epigraphic works of the late nineteenth century, but a careful listing of the volumes making up the post-World War II *Corpus Inscriptionum Armenicarum* (CIArm).[30] Other volumes have been issued since and are still being prepared outside the CIArm series, often individual rather than institutional initiatives. A recently published corpus brings together 669 inscriptions from a study of all *xač'k'ars* (cross-stones; in this case mostly small commemorative plaques, seldom free-standing, with few that served as funerary monuments), *in situ* for the most part in the urban Armenian centres of Jerusalem (287) and New Julfa, Isfahan (382).[31] Greenwood underlines both the robust activity devoted to epigraphy in the past century as well as the absence of a comprehensive corpus rather than disjointed publications. He also decries the general lack of 'applied epigraphy', that is, the extracting from inscriptions of more than just their transcription and translation. In a final section he insists on digitization of all epigraphic documents and universal and free access to all scholars through the Internet. Greenwood introduces a powerful and free database software (EpiDoc), used as a near standard in Latin and Greek epigraphy, explaining how important it is to bring everything together under a flexible, easily applied and understood system that follows a set of rules already worked out in the middle of the last century. By adopting this universally accepted system, Armenian epigraphy would immediately become a part of international epigraphic studies and at the same time make available to scholars working in Armenian inscriptions all the latest advancements in the field.[32]

Large numbers of the stone inscriptions in the CIArm are on *xač'k'ars*, visually different from ordinary dedicatory inscriptions on churches and other monuments. The most striking difference is the artistic element associated with *xač'k'ars*, which bear not only elaborately rendered crosses, but decorative motifs – floral or geometric – and often figurative carvings. These are works of art, some of them simple, others highly sophisticated. The inscriptions, even if undated, serve to contextualize the art, giving it a date and place (usually where the stone is found, unlike a movable manuscript, which requires a colophon mentioning the place of execution to localize the region of production). Applying epigraphy in such a context allows the establishment of dated design books. In the recently published corpus of mostly commemorative *xač'k'ars* of New Julfa and Jerusalem, the authors have been extremely meticulous in providing illustrated catalogues of all motifs, allowing researchers to date and trace their migration over time. Ultimately, this information can be applied to works of art other than cross-stones.[33]

Xač'k'ars also provide a chronological, it is tempting to say an almost evolutionary, template for artistic motifs and serve as an important tool for palaeographic and grammatical analysis. One might make the same remark for all lapidary inscriptions, but the *xač'k'ar* was ubiquitous in Armenia and wherever Armenians were from the ninth through to the seventeenth century. There may

have been upward of 35,000 surviving monuments until the wilful, open and total destruction of the largest single site of *xač'k'ars* at the ancient cemetery of Julfa on the Arax River by the Azerbaijan army under government orders in December 2005.[34] These monuments, erected as the occasion demanded by skilled and unskilled artisans, throughout Armenia over eight centuries provide a lexical, grammatical and palaeographic source book, the systematic collection and exploration of which has only just begun.

Some of this applied epigraphy, to use Greenwood's terminology, has already been undertaken through the various indices in the CIArm series and conjugate volumes providing complete lists of first and family names, place names, and very minute indices of trades, titles, professions, animals, currency, clothing, etc., mentioned in the collected inscriptions. The data has even been collected in separate monographs, such as one devoted to the sculptors and architects identified in the inscriptions.[35]

Epigraphy is not only devoted to writing on stone. The Armenian penchant for a written memorial, a colophon in the broadest sense, has produced thousands of inscribed objects in metal, wood, cloth, leather and other media in addition to manuscripts. These inscriptions have not yet received the systematic attention that lapidary engraving has. There are exceptions, especially in the domain of numismatics, with the catalogues of scores of collections providing the legends and usually an illustration of each coin. In this exhibition coins carrying epigraphic material dating back from two millennia to some 700 years ago are displayed and briefly described.

For other classes of inscribed objects, the situation is not much advanced. There is a catalogue in the collections of the National Historical Museum in Erevan, covering hundreds of metal objects, including over 200 copper vessels, liturgical silver, wooden doors, altar curtains, rugs, and other textiles with woven or embroidered inscriptions.[36] Few collections have had such comprehensive publications, though when items from them are borrowed for exhibitions in important European or American museums, their inscriptions are published carefully in the accompanying catalogues.[37] Among recent studies devoted to individual collections, several provide entire inscriptions and their translations.[38]

For miscellaneous items, such as the brass bowl of Safavid manufacture (cat. 75), probably from Isfahan, inscribed in Armenian and dateable to the year 1616, epigraphy provides direct evidence of the interaction between the newly arrived Armenians and the local inhabitants. There are a number of such Islamic metal objects with Armenian inscriptions, thus far only treated from a purely epigraphic rather than applied epigraphic perspective.[39] This also holds true for a large number of Armenian liturgical objects and textiles, almost always inscribed. Analyzing the epigraphy on such diverse items provides as much raw data as do *xač'k'ars*. Almost all have inscriptions of dedication, usually to a church or monastery with the name of the donor(s), the place and, more rarely, the name of the craftsmen and the actual place of production. Inscriptions regularly speak of the parish or a person of a particular village, offering a cross or silver binding to the Katholikosate of Cilicia or the Church of the Holy Mother of God in Adana, yet if the place of crafting is not specified we are at a loss to know if the work was made in the hometown of the patrons or somewhere else, wherefore it is often necessary to look at style

and craftsmanship to determine the place; in the case of luxury items, style often suggests Constantinople, in particular from the eighteenth century onwards.

Examination of the writing of these epigraphic documents often pushes the researcher to turn to palaeography for help. But this raises certain problems endemic to Armenian palaeography, for instance the regular mixture of *bolorgir* or lower-case letters in the usual *erkat'agir* inscriptions in all capitals. In publishing such inscriptions, the choice has to be made between trying to recreate on the printed page the exact forms letter by letter, or to make allowances for deviations by recording the entire text in uncial *erkat'agir*. Furthermore, it is not uncommon in metal inscriptions to find individual letters inverse or reversed (see cat. 5, where the Ո in Ովանէս on the cross attached to the binding is inverted). To decide how to transfer this information in print is also a problem; the constant use of '(sic)' to designate each anomaly in a long inscription becomes an impediment to seizing the flow of the text. An obvious question comes to mind in these situations: was the engraver illiterate or improperly educated in the literary language, or was he totally illiterate only in Armenian, perhaps suggesting a non-Armenian jeweller or metalworker? Or was the copy of the text given to the engraver for etching defective? Who in fact was responsible for the composition of the dedicatory text – a clergyman or an educated person in the entourage of the patron-donor? We should keep in mind that unlike Armenian manuscripts, which were almost always copied by religious clerics attached to major churches or monasteries, fine metalworking was not usually carried out within ecclesiastical institutions, but by lay practitioners normally in an urban or semi-urban context.

Ornamental, decorative or beautiful script: calligraphy

Almost nothing has been written about Armenian calligraphy during the age of manuscripts; rather, calligraphy is usually associated with modern fancy writing of the nineteenth and twentieth centuries. The present-day approach to beautiful writing (the literal meaning of the word) for Armenian is probably inspired by Chinese, Japanese, Arabic and Persian calligraphy, all established modes of artistic rendering, often independent of standard texts, rather than by Armenian manuscript writing, even in its fancier forms. Much of this modern calligraphy has also been associated with the production of type fonts. There are a number of artistically inclined individuals actively involved in this renaissance.[40]

In the Armenian manuscript tradition, such deliberately aesthetic writing was usually reserved for works commissioned by royal or high ecclesiastical patrons, often in scriptoria attached to the court or katholikosate. Official decrees or religious encyclicals were by their nature executed by the most skilled scribes, often with coloured ink and gold leaf. Examples of such aristocratic rescripts from the royal chancellery of the Armenian kingdom of Cilicia have survived in foreign archives, such as the profession of faith of 1246 of Katholikos Constantine I, signed by the patriarch in red.[41] There are also a number of large single leaves with talisman prayers arranged in triangular divisions of a rectangle with text, usually in minute but elegant *bolorgir*, running in many different directions in alternating blocks of red and black ink, with small coin-like illuminated medallions depicting Christ, the Virgin and angels against a gold ground from which decorated lines, like spokes of a wheel, radiate and connect the medallions in a tour-de-force of decoration.[42]

In the domain of fine writing in manuscripts, the decoration of incipit pages of each of the four books of the Gospel was usually reserved for an elaborate exercise in calligraphy, employing a strict hierarchy of letter forms, often starting with large *erkat'agir* lines, followed by a line of bird-, animal- or human-form letters, painted in multi-colours – a special scribal effect also known in Latin manuscripts – then rows in red and black ink of graceful *bolorgir*. It was common in luxury manuscripts, especially from Cilicia in the thirteenth century, though the tradition began before, to fashion the first letter of the first word of the Gospel texts with a large, elongated letter in the form of the symbol associated with the Evangelist. This exhibition presents several examples of this pattern in various types of liturgical books (cat. 1, 10, 13, 20 and 26), and also in a manuscript of Dionysius Thrax's Grammar (cat. 33). In the twelfth century such letters would at times extend from the very top of the page to the bottom. In terms of elegant epigraphy-like inscriptions, the striking facing pages of dedication in aristocratic Gospels, again from Cilicia, with ultramarine or lapis lazuli upright *erkat'agir* letters against a gold background, are among the most perfect.[43] Bird and other animal script continued to be used in print as well (cat. 39, 49 and 87).

There are also examples of scribes using special calligraphic scripts, for instance Momik, the famous painter, architect and sculptor of *xač'k'ars* left a remarkable colophon in thick red ornamental *bolorgir* in a manuscript of 1292 from Noravank' in Siunik'.[44] In the current exhibition, decorative script is apparent in the red *bolorgir* surrounding the painting of Alexander's horse Bucephalus in the Alexander Romance (cat. 42), and the diagonal crisscross writing often reserved for the text accompanying the Sacrifice of Abraham, here in the eighteenth-century manuscript scroll (cat. 28).[45] The persistent use of ligatured letters, several at a time, in manuscripts, but also on coins and in lapidary inscriptions especially of the late period, as well as the penchant for monograms, for instance on eighteenth-century ceramics and on façades of the mansions of Armenian notables, can also be regarded as a form of calligraphy (see cat. 5: ս +է in inscription on the cross on front cover of the manuscript; 33: բ + h and ս + ն + ս in the monogramme; cat. 66 and 67: ո + ւ on reverse of Coronation coins of Łewon I; cat. 68: ո + ր on obverse of coin of Het'um I).[46]

Throughout the centuries the importance of the alphabet as protector of Armenian culture and identity has been stressed. Invasions and in particular the genocide have caused devastating losses of cultural heritage, in works of architecture and all they contained; in sculpture, painting and commemorative, legislative and other epigraphic material; in manuscripts and printed books; in secular and sacred utensils, often adorned with writing. When all is said and done, as a result of the creation *ex nihilo* of the thirty-six letters of the Armenian alphabet by Maštoc', an invention intimately tied to Christianity and a source of pride to a people who have had a turbulent history, writing has perhaps been the most important collective expression of the nation, serving as an endless resource for palaeography, epigraphy and calligraphy.

NOTES

1 Garegin Yovsēpʻean, *Grčʻutʻean aruestə hin hayocʻ mēǰ* [The Art of Writing among the Ancient Armenians], published as *Kʻartez hay hnagrutʻean* [Album of Armenian Palaeography], *Šoɫakatʻ*, vol. 1, 1913, pp. 170–214, 90 plates, 143 figs.

2 Michael E. Stone, Dickran Kouymjian and Henning Lehmann, *Album of Armenian Paleography*, Aarhus University Press, Aarhus, 2002; Armenian translation, Gohar Muradyan and Aram Topdjian, Catholicosate of Holy Ējmiacin, Erevan, 2006.

3 Most recently revisited in Dickran Kouymjian, 'The Archaeology of the Armenian Manuscript: Codicology, Paleography and Beyond', in Valentina Calzolari (ed.), *Armenian Philology in the Modern Era. From Manuscript to Digital Text*, Brill, Leiden, 2014, pp. 11–15; and Dickran Kouymjian, 'Armenian Palaeography: The Major Scripts and Their Dating', in *Comparative Oriental Manuscript Studies: An Introduction*, editorial collective, Hamburg, 2014, pp. 278–83.

4 For details, see Dickran Kouymjian, 'History of Armenian Paleography', in Stone, Kouymjian and Lehmann, *Album of Armenian Paleography*, pp. 13–75, esp. p. 25.

5 Yakovbos Tašean, *Aknark mə hay hnagrutʻean vray* [An Overview of Armenian Paleography: A Study of the Art of Armenian Writing], Mekhitarist Congregation, Vienna, 1898.

6 Especially used for titles and incipit lines; the script became the capitals for *bolorgir*, but not for *nōtrgir*.

7 Dickran Kouymjian, 'Notes on Armenian Codicology. Part 1: Statistics Based on Surveys of Armenian Manuscripts', *Comparative Oriental Manuscript Studies Newsletter*, no. 4, July 2012, p. 19, Table 1.

8 For a detailed overview of the – far from linear – development of scholarship on Armenian palaeography, see Kouymjian, 'History of Armenian Paleography'.

9 Gabriēl Awetikʻean, Xačʻatur Siwrmēlean, Mkrtičʻ Avgerean, *Nor baṙgirkʻ haykazean lezui (NBHL)* [New Dictionary of the Armenian Language], 2 vols, Mekhitarist Congregation, Venice–San Lazzaro, 1836–37 (reprint Erevan, 1979–1981), I, p. 686b; Matthias Bedrossian, *New Dictionary Armenian-English*, Venice, 1879 (reprint Beirut, 1985), p. 166, gives 'written with a style (read stylus) or large needle, capital; capital letter'; Emmanuele Ciakciak, *Dizionario Armeno-Italiano*, Mekhitarist Congregation, Venice–San Lazzaro, 1837, p. 470, suggests written with an iron pen [on?] paper, parchment, or, written with capital letters; the oldest text or manuscripts written with capital letters.

10 NBHL, I, p. 588, s.v. *grčʻagir*, where after the editors' explanation, 'Written with a pen (*gričʻ*), especially *boloragir* or *nōtragir*', the full quotation from Mxitʻar Aparancʻi is given more clearly: The Psalter is not uniform throughout; in order to be clear [it is] in *erkatʻagir* and [also] in *grčʻagir* [= *boloragir*], and in other means. Histories [are written] on parchment and on paper, in *erkatʻagir* and *grčʻagir*. It has been suggested that *grčʻagir* in this period is synonymous with *bolorgir*. Bedrossian, *New Dictionary*, gives the meaning, 'written, manuscript' for *grčʻagir*. Stepʻan Malxasyan, *Hayerēn bacʻatrakan baṙaran* [Descriptive Dictionary of Armenian], 4 vols, Erevan, 1944–5 (reprint Beirut, 1955–6), vol. I, p. 587, raises doubt about the meaning: '1. written with an iron pen (?), manuscript written with *erkatʻagir*. 2. the old form of Armenian letters'.

11 Venice, V123, fol. 4. Barsegh Sargisean, *Mayr cʻucʻak hayerēn jeṙagracʻ matenadaranin Mxitʻareancʻ i Venetik* [Master catalogue of the Armenian Manuscripts of the Mekhitarist Library in Venice], vol. 1, Venice, 1914, p. 544, is not sure what the four letters of the second marginal notation on the same page mean, but if *Tʻ* equals the traditional symbol of 'in the year', then the following letters represent the date, namely 911; cf. Artašes Matʻevosyan, *Hayeren jeṙagreri hišatakaranner E–ŽB darer* [Colophons of Armenian Manuscripts, Vth-XIIth Centuries], Erevan, 1988, no. 64, p. 50. Garegin Yovsēpʻean, *Yišatakarankʻ jeṙagrakankʻ (E daricʻ minčʻew ZĒ dar)* [Colophons of Manuscripts (From the Fifth to the Eighteenth Century)], vol. I, *E daricʻ minčʻew 1250 tʻ* [From the Fifth Century to 1250], Cilician Catholicosate, Antelias, 1951, does not include this colophon in his collection.

12 ' Այս երկաթագիրս չէ աղէկ, մի մեղադրէք. Ի թ[ուականին] ՅԺ (= 911)'.

13 There are two other fifteenth-century and three early seventeenth-century colophonic references to the term. The latter citations make it clear that *erkatʻagir* in the minds of the scribes had become an archaic script used for decorations and titles, see Kouymjian, 'History of Armenian Paleography', p. 67.

14 Y. Zohrapean, *Acʻašuncʻ matean Hin ew Nor Ktakaranacʻ* [Divine Scriptures of the Old and New Testaments], Mekhitarist Congregation, Venice–San Lazzaro, 1805, in Armenian (reprinted in Claude Cox (ed.), Caravan Books, Delmar, NY, 1984), p. 482.

15 Zohrapean, Armenian text, *Divine Scriptures*, p. 567.

16 *Album of Armenian Paleography*, nos. 10–11.

17 I have omitted a discussion of the papyrus, which is a Greek text written with Armenian letters preserved in the Bibliothèque nationale de France, despite its importance to Armenian palaeography and scripts. For a thorough discussion and references to earlier literature, see the section devoted to it in Kouymjian, 'History of Armenian Paleography', pp. 59–63.

18 Charles Mercier, 'Notes de paléographie arménienne', *Revue des Études Arméniennes*, vol. 13, 1978–9, p. 53.

19 Serge N. Mouraviev, *Les trois secrets de Mesrop Machtots ou la genèse des alphabets paléochrétiens du Caucase. Vol. I, Erkataguir ou Comment naquit l'alphabet arménien*, Academia Verlag, Sankt Augustin, 2010, pp. 20–45.

20 Kouymjian, 'History of Armenian Paleography', pp. 31, 70–71; Tašean, *An Overview of Armenian Paleography*, pp. 55, 92; Karo Ɫafadaryan, *Haykakan gri skzbnakan tesaknerə, hnagrakan-banasirakan usumnasirutʻyun* [The Original Types of Armenian Letters, Palaeographic-Philological Study], FAN-i hratarakčʻutʻyun, Erevan, 1939, p. 71.

21 Bernhard Bischoff, *Paléographie de l'antiquité romaine et du Moyen Âge*, transl. Jean Vezin, Picard, Paris, 1985, p. 70.

22 Tašean, *An Overview of Armenian Palaeography*, p. 92; Mercier, 'Notes de paléographie arménienne', p. 57; cf. Kouymjian, 'History of Armenian Paleography', pp. 31, 54–5.

23 It is precisely in similar terms that Tašean posed the question back in 1898; Tašean, *An Overview of Armenian Palaeography*, p. 92.

24 Kouymjian, 'History of Armenian Paleography', figs III, 17, 18, 20; Claude Mutafian (ed.), *Arménie: la magie de l'écrit*, La Vieille Charité, Somogy, Paris-Marseille, 2007, pp. 149–152.

25 Michael E. Stone, 'The Mixed Erkatʻagir-Bolorgir Script in Armenian Manuscripts', *Le Muséon*, vol. 111, 1998, pp. 293–317.

26 For a discussion, see Kouymjian, 'History of Armenian Paleography', p. 74.

27 For a longer discussion, see Kouymjian, *ibid.*, pp. 73–5.

28 Dickran Kouymjian, 'Notes on Armenian Codicology. Part 2: Armenian Palaeography: Dating the Major Scripts', *Comparative Oriental Manuscript Studies Newsletter*, no. 6, July 2013, p. 24, Table 1.

29 Tim Greenwood, 'Armenian Epigraphy', in Valentina Calzolari (ed.), *Armenian Philology in the Modern Era. From Manuscript to Digital Text*, Brill, Leiden, 2014, p. 102, note 6. This is volume 23/1 of the *Handbook of Oriental Studies*, the first in a series on Armenology sponsored by the Association Internationale des Études Arméniennes (AIEA).

30 The first six volumes (1966–82) were devoted to areas within the Republic of Armenia, essentially under the direction of Sedrak Barxudaryan, with two subsequent volumes on inscriptions from the Ukraine and Russia, 1996 and 1999; details in Greenwood, 'Armenian Epigraphy', p. 105 and note 23. A ninth volume, dedicated to further areas within the Republic of Armenia, was published in 2012.

31 Haroutioun Khatchadourian and Michel Basmadjian, ԽԱՉՔԱՐ *Xačʻkʻar, l'art des pierres-croix arméniennes d'Ispahan et de Jérusalem*, with a Preface by Dickran Kouymjian, Geuthner, Paris, 2014.

32 Greenwood, 'Armenian Epigraphy', pp. 110–16, followed by an ample six-page bibliography.

33 Khatchatrian and Basmadjian, *Xačʻkʻar, passim*, among motifs and their variants are crosses, geometric and floral designs.

34 *The Destruction of Jugha and the Entire Armenian Cultural Heritage in Nakhijevan*, Documentation submitted to UNESCO, Armenian Parliamentary Group, Bern, 2006; Argam Ayvazyan, *The Symphony of the Destroyed Jugha Khatchkars*, in English, Russian and Armenian, Erevan, 2007, with 727 photographs taken before, during and after the physical destruction of the cemetery. On the history and importance of this cemetery of *xačʻkʻars* see Jurgis Baltrušaitis and Dickran Kouymjian, 'Julfa on the Arax and Its Funerary Monuments', in Dickran Kouymjian (ed.), *Armenian Studies/Études arméniennes: In Memoriam Haïg Berbérian*, Calouste Gulbenkian Foundation, Lisbon, 1986, pp. 9–53.

35 Sedrak Barxudaryan, *Mijnadaryan hay čartarapetner ev kargorc varpetner* [Medieval Armenian Architects and Stone Masters], Armenian Academy, Erevan, 1963.

36 Evkine Mušeɫyan, *Hayeren arjanagrutʻeamb ararkaner* [Objects with Armenian Inscriptions], vol. I of the Catalogues of the State Historical Museum's Collection, Armenian Academy, Erevan, 1964.

37 Two exemplary catalogues from the scores of museum exhibitions during the 2007 *Année de l'Arménie* in France provided notices of various lengths with complete inscriptions in Armenian and in translation of well over 200 hundred objects: Jannic Durand, Ioanna Rapti, Dorota Giovannoni (eds), *Armenia sacra: Mémoire chrétienne des Arméniens (IVe–XVIIIe siècle)*, Le Louvre-Somogy, Paris, 2007; Mutafian, *Arménie: la magie de l'écrit*.

38 Edmund Azadian, Sylvie L. Merian and Lucy Ardash (eds), *A Legacy of Armenian Treasures: Testimony to a People*, The Alex and Marie Manoogian Museum,

Taylor, MI, 2013; Dickran Kouymjian, 'Catalogue of the Liturgical Metalwork', pp. 158–297 and Marielle Reber-Martiniani, 'Textiles', pp. 298–330, in Seta Dadoyan (ed.), *Treasures of the Catholicosate of Cilicia*, Cilician Catholicosate, Antelias, 2015.

39 On such inscribed vessels, see Dickran Kouymjian, 'The Armenian Inscriptions', Annex II, in A. S. Melikian-Chirvani (ed.), *Islamic Metalwork from the Iranian World, 8th–18th Century*, Victoria & Albert Museum, London, 1982, pp. 403–6.

40 Probably the best known is Ruben Malayan, who for some years has been working on a major study on *The Art of Armenian Calligraphy*; details and samples are available on his website: http://15levels.com/art/armeniancalligraphy/ [accessed 21 August 2014].

41 Vatican, Archivio Segreto: A. A. Arm 1-XVIII 1804, Claude Mutafian, *Rome–Armenia*, de Luca, Rome, 1999, p. 167, fig. VI.54; Kouymjian, 'History of Armenian Paleography', p. 72, illus. 20.

42 The most spectacular is dated 1654, London, BL Add 18671, 40.6 x 29.2 cm, *Album of Armenian Paleography*, no. 168, p. 452; Mutafian, *Arménie: la magie de l'écrit*, no. 3.32, pp. 114–15; another example, probably of the late seventeenth century and slightly smaller without illuminations is in Venice, Mekhitarist Library, V3064; Frédéric Feydit, *Amulettes de l'Arménie chrétienne*, Mekhitarist Congregation, Venice–San Lazzaro, 1986, pp. 70–71, fig. 90.

43 New York, Pierpont Morgan Library, ms M740, Marshall Ošin Gospel of 1274, fols 6v–7, Thomas F. Mathews and Roger S. Wieck (eds), *Treasures in Heaven: Armenian Illuminated Manuscripts*, Pierpont Morgan Library, New York, 1994, no. 64, pp. 193–4, pl. 15; Mutafian, *Arménie: la magie de l'écrit*, no. 2.14, p. 58, illus. pp. 56–7.

44 Erevan, M2848, Gospel of 1292, fol. 149v, *Album of Armenian Paleography*, no. 101, pp. 318–19. A variety of calligraphic writing is presented in the *Album* in all of the scripts: nos. 2, 19, 25, 29, 45, 73, 86, 94, 98, 107, 129, 171, 176, 178, 189.

45 Manchester, John Rylands Library, Arm. 3, *History of Alexander the Great*, 1544, fol. 42v, Mutafian, *Arménie: la magie de l'écrit*, no. 3.74, pp. 171–2; private collection, *Hmayil* of 1788, following just after the miniature of Abraham about to Sacrifice Isaac.

46 For lapidary inscriptions, Mutafian, *Arménie: la magie de l'écrit*, nos. 4.7 (1785)–4.8 (1797), pp. 195–7, 4.13 (*xač'k'ar* of 1246 carved in Rome); for ceramics, Kütahya dishes with Abraham's monogram of 1718/19, John Carswell, *Kütahya Tiles and Pottery from the Armenian Cathedral of St. James, Jerusalem*, Clarendon Press, Oxford, 1972, vol. I, pl. 17, a and b, pl. 19, h; for other monogrammed dishes, Mutafian, *Arménie: la magie de l'écrit*, nos. 4.82–4.84, seventeenth century, pp. 255–6; for monograms on houses in Zamość, Poland and Lvov, Dickran Kouymjian, 'Reflections on Objects with Armenian Inscriptions from the Pre-Twentieth Century Diaspora', *Series Byzantina*, vol. IX, 2011, pp. 105–106, figs 7–8; for the same ceramics, pp. 102–103, figs 4a–b, 5a–c.

Sylvie L. Merian

Illuminated Manuscripts:
The Collection in Context

The first Armenian manuscripts must have been produced shortly after the invention of the Armenian alphabet by Mesrop Maštoc' in the early fifth century, but unfortunately from among the *c.*35,000 manuscripts extant, none are from this period.[1] The two earliest dated Armenian manuscripts are the Queen Mlk'ē Gospels of 862 CE (V1144) and the Lazarian Gospel of 887 CE (M6200),[2] although there are many undated fragments written in *erkat'agir* (the earliest script) which have survived due to their use as flyleaves in later manuscripts. A flyleaf is a leaf removed from a discarded manuscript and bound at the beginning and end of a newer manuscript's text block, thereby protecting the most vulnerable parts of that manuscript. Most of these fragmentary leaves do not include dates, but based on palaeographic evidence some are thought to be from as early as the tenth or eleventh century.

The Bodleian Library has assembled dozens of such flyleaves, including a few illuminated ones, most of which were removed from manuscripts in the collection and bound in separate volumes.[3] These leaves date from approximately the tenth to the fourteenth centuries. The Bodleian is also fortunate in having an almost complete manuscript written in a fine *erkat'agir*, estimated to date from the eleventh century, a copy of John Chrysostom's *Commentary on the Epistle to the Ephesians* (cat. 22). Although not illuminated, the manuscript includes a number of braided, foliated marginal decorations coloured with opaque red, yellow, green and blue pigments. The earliest securely dated manuscript in the Bodleian's collection is an Antiphonary produced in 1295 CE in the hermitage of Erez (Arm. Erznka, modern Erzincan, Turkey), written in a graceful *bolorgir* script and replete with musical notations (cat. 12).

Who made manuscripts?

A manuscript is a book that has been meticulously copied by hand, letter by letter and word by word, by a scribe. All the materials used to produce it had to be fabricated by hand: the paper or parchment, ink, pens, pigments, brushes, leather, and so on. An accomplished artist decorated the book and a skilled bookbinder would bind it when complete. These were time-consuming activities, requiring the work of highly trained experts. The production of one manuscript could easily take years, and the process was understandably an expensive endeavour. Only rarely do we find one multi-talented individual skilled not only in calligraphy, but also in miniature painting and binding. In the Armenian tradition, scribes, artists and bookbinders were often clerics, though not always. Even a few female scribes are known.[4] The skills were passed down from master to student, often father to son

(note that Armenian priests can marry), so that veritable dynasties of artists and scribes were created, lasting for generations.[5]

We learn much of this information through the colophon, an inscription written by the scribe, usually at the end of the manuscript, in which he provides his name, the names of his family members, the sponsor or patron who commissioned the manuscript, his teacher, and any other people who helped in its production. The scribe would also include the names of the church hierarchy, the date and place he copied the manuscript, and significant historical or political events that he may have witnessed. In the colophon the scribe asks future readers to remember these individuals in their prayers, all of whom he may profusely praise (especially the sponsor of the manuscript). It was customary that he be extremely modest when speaking about himself, and indeed even describe himself in a disparaging manner, as worthless, untalented, vile or useless, for example. In the colophon he may voice complaints about the conditions under which he was forced to work, cruel or tyrannical rulers of the region in which he lived, or he may describe natural disasters such as earthquakes. Colophons of Armenian manuscripts are often lengthy and replete with such information, as opposed to western European manuscript traditions, where colophons are extremely rare; when they do appear, they are usually quite brief.[6]

When the artistic and scribal traditions were passed down from a teacher to a student who was not related by blood, the student often commemorated his teacher by calling him his 'spiritual' father in his colophon, as opposed to his 'flesh' father, underlining the importance of their close relationship. In cases where the master and student are not related by family ties it is often possible to trace the connections through similar iconography and style. We can sometimes construct 'artistic' family trees by a close reading of colophons and examination of the visual language.[7]

How are manuscripts made?

The first material needed is the support on which the scribe writes his text, either parchment or paper. Parchment (also called vellum) was made from specially prepared animal skin, usually calf, goat or sheep. The animal pelts were soaked in a lime solution for a number of days, the hair scraped, the remaining skin rinsed and stretched on a wooden frame, and then shaved with a semicircular knife and smoothed with pumice. Paper was manufactured from a pulp of macerated rags in which a framed screen was dipped, removed, and then evenly shaken. The resulting sheet was then removed from the screen and dried. The usage of parchment preceded that of paper by centuries, since the latter was not produced in western Europe until the eleventh century in Spain after having been introduced by the Arabs.[8] It would take many centuries before paper became commonly used in books in Europe. But in the Near East, and in the Armenian tradition, paper was used much earlier. The earliest Armenian manuscript on paper is dated 981 CE (M2679). Somewhat surprisingly, parchment continued to be used by Armenians much later than we might expect; the Bodleian Library's collection includes a parchment scroll (*hmayil* or phylactery), probably from Constantinople, dated 1707 (cat. 27).[9]

Paper needs to be 'sized' with either a starch solution or one made from animal products (such as bones and hides) to prevent the ink from bleeding when writing on the sheet. Armenians probably used a starch-based size as this was common in the Near East and has been mentioned in at least one Armenian manuscript's colophon.[10] It was also customary to then polish or burnish the paper with a smooth stone or

shell, a task that fell to either the scribe or an assistant, who sometimes was his wife. The paper or parchment would then be cut to size and folded into bifolios, placed one inside the other to form what is called a gathering (or quire or signature). Multiple gatherings would later be sewn together to form the text block of the volume.

The scribe (or an assistant) would next have to rule the sheets with straight lines so that he would be able to write neatly. This could be done by pricking the edges of an open bifolio with evenly spaced prick marks and then connecting the dots with a straight edge and a hard point or a light lead line. Prickings are clearly visible on the edges of the folios of the *Commentary on Ephesians* (cat. 22). Another way to form ruling lines was by the use of a ruling frame, an instrument common throughout the Middle East.[11] A ruling frame consists of some type of board, either wood or pasteboard, upon which evenly spaced strings were attached. The paper or parchment was placed on the frame and rubbed, producing indented lines for the scribe to follow. These lines are not very visible and therefore not distracting to readers. It is sometimes possible to verify the use of a ruling frame by examining the indented lines under low magnification (such as an 8X loupe), as the twist of the string is often visible in the impressions; this is even perceptible in parchment.[12]

After preparing the ink (usually a carbon black ink) and pens made either of quills or reeds, the scribe would proceed to copy his text on the unbound gatherings of paper or parchment. The copying was always done before binding the book, otherwise an unfortunate mistake would necessitate disbinding the entire volume or discarding the book. It was less costly and less troublesome to discard and rewrite only one bifolio than destroy an entire bound codex.

The artist would receive the written gatherings in order to decorate the leaves. In Armenian Gospel books, the full-page illuminations depicting the life of Christ and the canon tables are generally found in a separate quire or quires at the beginning of the manuscript. This was certainly done independently – the artist did not have to wait for the text to be completed before painting this section. The artwork might be completed by more than one artist – a more skilled or experienced artist might complete the full-page illuminations at the beginning of the manuscript, while another might have specialized in marginal decorations, decorative capital letters or headpieces throughout the text. The artists likely learned to produce their own pigments, their particular components and methods of preparation certainly being passed down from master to student. The pigments most often used by Armenians are discussed in more detail on pages 190–1.

Illumination

Various styles and schools of illumination developed over the centuries in the varied regions where Armenians lived, from the Armenian homeland to Cilicia to areas of the diaspora in later periods. The manuscripts produced in the Cilician kingdom (twelfth to fourteenth centuries), away from Armenia proper, are generally regarded as the pinnacle of Armenian manuscript illumination. Since so many of these manuscripts were commissioned by the wealthy nobility and high-ranking clergy (such as the katholikos, often related to the royal family), a great number of the surviving manuscripts are quite sumptuous and have been noted for their refined, graceful style and generous use of luxurious materials. The nobility would naturally have had the most talented artists and scribes at their disposal. Because Cilicia was in close contact with the Latin west and Byzantium, artists and scribes were also exposed

to new motifs, iconography and styles. Two of the most famous Cilician artists are T'oros Ṙoslin (fl.1256–68) and the prolific Sargis Picak (fourteenth century).[13] While the scribal colophon in the Four Gospels of 1304 CE (cat. 5) mentions the reigning Cilician King Het'um and Katholikos Grigor (VII), this does not establish with certainty that it was copied and illuminated in Cilicia, as copyists outside Cilicia wished to date their work referring to these highest representatives of the Armenians as well.

In other regions, more provincial or folk art styles of illumination developed in stark contrast to the courtly style of Cilicia. Although artists in remote areas perhaps did not have the opportunity to be formally guided by more highly trained counterparts, their work still expresses the traditional motifs, structure and iconography of religious manuscripts (especially Gospel books), while adding their own original twist to certain subjects. The thirteenth- to fourteenth-century manuscripts of Artsakh/Karabagh form one such group, although they have some affinities with manuscripts from Siunik and Vaspurakan.[14] Their naïve, charming style is evident in the fourteenth-century Four Gospels (cat. 6).

The Lake Van region (Vaspurakan) became one of the most prolific areas of Armenian manuscript production, especially from the thirteenth to the sixteenth centuries. Hundreds of artists and scribes are known through many hundreds of manuscripts. Various monasteries and villages formed their own regional schools, training generations of artists and scribes through the centuries. Sargis Mokac'i (also known as Sargis Mazman) is known through about a dozen manuscripts,[15] including a late-sixteenth-century Gospel (cat. 9); he was also one of Mesrop of Xizan's teachers (cat. 1, 2). Bishop Zakaria Gnunec'i, also called Lmec'i, was from Vaspurakan but was so renowned that he was summoned to Constantinople by none other than the Patriarch Astuacatur to copy and illustrate the *Romance of Alexander*, completed in 1544 at Sulu Manastir (cat. 42). He returned to Vaspurakan, becoming Bishop of Lim, and later taught Yakob of Julfa. Yakob, a talented artist from Julfa/J̌ułay (that is, Old Julfa, in Nakhichevan), produced manuscripts in a number of places, culminating in New Julfa (Isfahan) after Shah Abbas' deportations of the Armenians to Iran in 1604. Two of his manuscripts from [Old] Julfa are exhibited: a Gospel book from 1587 (cat. 4) and another one dated 1597 (cat. 3).

Manuscripts from New Julfa are abundant, since this suburb of Isfahan, Iran (capital of the Safavid Empire), to which the Armenians had been forcibly resettled by Shah Abbas, was quite wealthy due to the Armenians' dominant position in the silk trade. Sponsors were therefore able to fund the building of churches and the copying of often luxurious manuscripts.

Mesrop of Xizan, originally from Xizan, just south of Lake Van, worked mostly in New Julfa. Two of his distinctive Gospel books are exhibited here (cat. 1, 2). Although his work continues many traditional forms passed down for centuries, his Gospel book of 1609 includes new iconography in his depiction of the Resurrection on fol. 17v, revealing his exposure to western European art in cosmopolitan New Julfa. He has depicted the three women who have come to anoint Christ's body, with an angel announcing to them that Christ had risen, and the surprised guards below, as is traditional in Armenian manuscript illumination. However, to this he also added Christ floating above the tomb holding the banner of the Resurrection and surrounded by clouds, a theme first used in western European art in the thirteenth century. This is the earliest known depiction in an Armenian manuscript of this type of Resurrection scene, an event usually only implied by the appearance of the three

oil-bearing women or of Christ's descent into limbo (the harrowing of Hell). This portrayal of the Resurrection was unknown in Armenian iconography before contact with western European art, probably through illustrated printed books, and became popular with Armenian artists in succeeding centuries in many different media.[16] A lectionary richly illuminated by Mkrtičʻ *varpet* and his pupil Tēr Petros in 1632 in New Julfa (cat. 15) again skilfully combines traditional Armenian decorative motifs and iconography with this new iconography. This is evident in his full-page Resurrection on fol. 151v, with Christ emerging from the tomb while holding the banner and surrounded by clouds, with three stunned guards at his feet.

Manuscripts were also produced in other regions of the diaspora to which Armenians had settled, ranging from Iran to the Crimea, Italy and Poland. Armenians began migrating to the Crimea between the eleventh and thirteenth centuries, forming a large and vibrant community by the fifteenth century. The 'Bologna Bible' was originally copied and illustrated in Bologna in the thirteenth or fourteenth century (cat. 7); its two full-page Apocalyptic illuminations might have been executed by Italian artists, or by Armenians trained by Italian painters. The manuscript was brought to the Crimea in 1368 where more illuminations were added, and in 1660 the then-damaged manuscript was repaired and partially recopied there. The two unusual Apocalyptic illuminations served as models for other seventeenth-century manuscripts produced in the Crimea.[17]

A commentary on the Psalms was copied in Lvov, Poland (Lviv, Ukraine) in 1610 (cat. 24), which by the seventeenth century had a significant Armenian population. Although modestly ornamented, it remains completely within the traditional decorative vocabulary passed down for generations. Based on stylistic considerations, we can postulate that a parchment prayer scroll (*hmayil* or phylactery) dated 1707 (cat. 27) was probably produced and illuminated in Constantinople, which also had a large population of Armenians. These unusual objects functioned as personal, protective amulets for their owners. They seem to have become quite popular by the eighteenth century, as some paper *hmayil* were even produced on printing presses in Constantinople in the 1720s and embellished with woodcuts (cat. 29).[18]

Traditional Armenian bindings

The manuscript would be bound only after it was completely finished, both the copying of the text and the addition of the illuminations and decoration. After binding it would be covered with leather and further decorated. As is the case with most other cultures, Armenians developed their own characteristic bookbinding techniques.[19] The binders developed a distinctive 'looping' method of attaching the text block to the wooden boards, made possible because they sewed the quires together using a form of 'supported' sewing with cord supports. Supported sewing, although common in most European binding traditions, is unusual in the Near East. Most cultures in the region sew their quires together without any type of support.[20] The wooden boards used for the covers are generally extremely thin (only 2–3 mm) and the grain of the wood is placed horizontally rather than in the more common vertical orientation. The endbands (also called headbands), a type of decorative embroidery or weaving sewn at the head and tail of the book near the spine, were also distinctive. Armenian endbands are referred to as 'raised' endbands because they form a protrusion at the head and tail of the book, which occurs since they are also sewn down into the wooden boards. Although other types of raised endbands are seen in Greek and Syriac manuscripts, the

Armenians developed their own technique and design, resulting in a distinctive chevron weave, usually of red, black and white silk threads (cat. 26).[21]

After the book was sewn together and the endbands worked, the inside of the wooden boards would be lined with a piece of fabric, which could range from a simple, monochromatic tabby weave of cotton or linen to rich silk brocade. On rare occasions, even velvet has been used, such as in the Four Gospels of 1587 (cat. 4). The exterior of the book would then be covered with leather, usually calf. The edges of the text block were coloured with a red substance, leaving an uncoloured horseshoe-shaped area at the head and tail near the endbands, probably to avoid soiling the silk threads of the endbands. The leather was most often decorated by blind-tooling: that is, stamping designs into the leather using metal tools, but without gold leaf. In some cases the decorative metal tools may have been heated before stamping, but not necessarily. Another unusual characteristic of Armenian bindings is the addition of a leather fore-edge flap – a separate piece of leather adhered to the back board which is the same size as the fore edge of the book. It was usually blind-tooled to match the covers and also lined with fabric, frequently the same cloth which covered the inside of the boards.

Many of the manuscripts in the Bodleian Library's collection are still bound in their traditional Armenian bindings, for example the Four Gospels of 1609 (cat. 2), the seventeenth-century *Lives of the Fathers* (cat. 26), and a fifteenth-century Hymn and Song book (cat. 43). These binding techniques were still used even in extremely late manuscripts, such as an eighteenth-century grammatical and philosophical text (cat. 33), testifying to the long endurance of this traditional craft.

There is considerable variation in the blind-tooled decorative patterns on Armenian manuscript covers. One of the most common designs, especially for Gospel books, was a stepped, braided (or guilloche) cross on the front cover, symbolizing a Calvary cross, with a braided rectangle on the back, which may represent the door of Christ's empty tomb, thereby symbolizing the Resurrection.[22] Some covers were decorated with more geometric designs, for example a blind-tooled rectangle with crossed fillet lines in the centre, and small stamps tooled at the intersections of the crossed lines or in the corners. These smaller stamps might be shaped like florets, concentric circles or concentric almond shapes.[23] The binders of seventeenth- to early-eighteenth-century New Julfa developed an interesting decorative scheme whereby they sometimes included stamped inscriptions in the borders, probably made with metal printing type, which included the date of the binding and/or the owner's name.[24] The Bodleian collection includes an unusual example of a manuscript with a traditional Armenian binding from Lvov (Lviv), on which the date has been stamped on the front cover (ՌԿՍ, or 1061 of the Armenian era, equivalent to 1612 CE). Unlike the inscribed bindings of New Julfa, each of the three letters forming the date was composed by repeatedly using a tiny hatched tool to form its shape (cat. 24).

Metal ornamentation on bindings

Wealthy donors might further embellish the covers of bound religious manuscripts by commissioning decorative plaques of precious metals to be affixed to them, sometimes centuries after the manuscript was produced. The plaques were usually silver and occasionally were further decorated with jewels or, in later periods, colourful enamels. They were sometimes inscribed with the donor's name and date and were usually donated to the Church. This is an old custom, whose purpose was not only to glorify God and His Word, but also for the benefactor to be remembered for this pious act.

The earliest extant dated Armenian silver plaques were produced in 1255 and were commissioned by the Katholikos Kostandin (M7690). This tradition endured for centuries, even into modern times. Some silversmiths' workshops have been precisely identified thanks to detailed and dated inscriptions included on the plaques, such as the renowned Armenian workshop in Kayseri (central Anatolia), which was active from the mid-seventeenth to the mid-eighteenth centuries.[25] Many other workshops existed, but due to the absence of inscriptions the craftsmen have usually remained anonymous and we cannot be certain of their geographic location.

Devout people who perhaps could not afford to donate such valuable gifts to the Church could still be memorialized by donating smaller objects, such as inscribed metal crosses, to be placed on a Gospel book or other religious text. These usually included the name of the donor and the date. In addition to crosses, many Armenian religious manuscripts and even printed books are found with what at first glance seem to be rather strange objects randomly attached to the covers. These include small personal items, such as earrings, seal stones from rings, or pieces of a metal belt, as well as coins, carved mother-of-pearl decorations, eye-shaped objects and other unusual amulets which are usually dated or dateable to the seventeenth, eighteenth or nineteenth centuries. These donations were probably votive offerings made to manuscripts or printed books considered to be miraculous or miracle-working as thanks for prayers answered or as gifts given in anticipation of a favourable response. Some of the objects, especially the highly personal ones, probably functioned as a substitute for the person making the request, making physical contact with the sacred book.

The eye-shaped objects are even more curious; note that objects shaped like eyes are thought to protect against the evil eye, a widespread belief in the Near East and Mediterranean basin even today. They illustrate the concept of 'fighting fire with fire', and these items certainly functioned as amulets of protection on the books, not only to protect the donor from the evil eye but also to protect the manuscript itself. Even though a sacred manuscript or printed book might be considered powerful and miracle-working, Christian manuscripts and printed books could still be stolen, vandalized or even viciously attacked.[26] The Bodleian Library's collection includes a typical example of such a decorated binding (cat. 5). The covers of this fourteenth-century Gospel book have been embellished with bosses, six crosses (five of which are inscribed and two of which include semi-precious stones), a seal stone from a ring finely inscribed in Persian, and dozens of metal eye-shaped pieces, all randomly attached to the leather-covered wooden boards. Two of the crosses are dated 1694.

The traditional production of manuscripts in many Near Eastern cultures (including Armenian) lasted a surprisingly long time, up to the early nineteenth century. Although printing in the Armenian language began around 1512 in Europe, it took longer for the technology of printing to reach the Near East, firmly take hold in the region and finally surpass its manuscript traditions, the dominant form of disseminating the written word for centuries. Armenian manuscripts and printed books would coexist for a period of time, each influencing the other in a variety of ways: format, decoration, iconography, even in their binding techniques and decoration. Printed books were initially bound exactly as manuscripts had been for centuries.[27] Although changes occurred over time as hybrid forms developed, the practitioners of Armenian book arts continued looking at their enduring manuscript traditions for inspiration.

NOTES

1 For a bibliography of Armenian manuscripts, manuscript collections and their catalogues, see Bernard Coulie, *Répertoire des bibliothèques et des catalogues de manuscrits arméniens*, Brepols, Turnhout, 1992, with three supplements published in the journal *Le Muséon*, 108 (1995), pp. 115–30; 113 (2000), pp. 149–76; 117 (2004), pp. 473–96; Bernard Coulie, 'Collections and Catalogues of Armenian Manuscripts', in Calzolari, *Philology in the Modern Era*, pp. 23–64. See also Dickran Kouymjian, 'The Archaeology of the Armenian Manuscript: Codicology, Paleography and Beyond', in Calzolari, *Armenian Philology in the Modern Era*, pp. 5–22, and Kouymjian's chapter in this catalogue.

2 Michael E. Stone, Dickran Kouymjian and Henning Lehmann, *Album of Armenian Paleography*, Aarhus University Press, Aarhus, 2002, cats 1–4, pp. 118–24. As there are some problems with the date in its colophon, some scholars believe the Queen Mlk'ē Gospels to have been produced in the early tenth century. Thomas F. Mathews, 'The Classic Phase of Bagratid and Artsruni Illumination: The Tenth and Eleventh Centuries', in Thomas F. Mathews and Roger S. Wieck (eds), *Treasures in Heaven: Armenian Illuminated Manuscripts*, The Pierpont Morgan Library, New York, 1994, pp. 57–8.

3 See MSS. Arm. b. 1 and Arm. b. 2.

4 Avedis K. Sanjian, *Colophons of Armenian Manuscripts, 1301–1480: A Source for Middle Eastern History*, Harvard University Press, Cambridge, MA, 1969, p. 17.

5 For dozens of examples from fourteenth–fifteenth century Vaspurakan, depicted by genealogical trees, see Anna Leyloyan-Yekmalyan, *L'art du livre au Vaspurakan XIVe-XVe siècles: étude des manuscrits de Yovannēs Xizanc'i*, Peeters, Paris, 2009.

6 Anna Sirinian, 'On the Historical and Literary Value of the Colophons in Armenian Manuscripts', in Calzolari, *Armenian Philology in the Modern Era*, pp. 65–100.

7 The published genealogical tree of Yovannēs Xizanc'i is a combination of his blood relations and his 'spiritual' family, which includes those who taught his father Mkrtič' k'ahanay. See Leyloyan-Yekmalyan, *L'art du livre*, pp. 155–9.

8 Papermaking was invented in China in the first or second century BCE, where it was made with various raw plant fibres. The Arabs may have been introduced to paper by the Chinese in the eighth century or by Central Asian papermakers around the same time, when it was made with rags, disseminating it to other areas. Jonathan M. Bloom, *Paper Before Print: The History and Impact of Paper in the Islamic World*, Yale University Press, New Haven and London, 2001, pp. 8–9, 42–5, 87–8.

9 The Morgan Library & Museum's collection includes an even later parchment example: a Gospel book, MS. S.16, produced between 1715 and 1725.

10 The scribe and artist of Morgan Library MS. M.622, a Menologium of 1348 by Sargis Picak, mentions in his colophon that he 'starched' and polished the paper of this manuscript himself. For starch used as sizing in the Islamic tradition, see Bloom, *Paper Before Print*, pp. 68–9.

11 See Mathews and Wieck, *Treasures in Heaven*, pp. 126–27, and fig. 88 for a ruling frame (Arabic *mistara* or *mastara; tołaśar* in Armenian) in the Islamic Dept of the Metropolitan Museum of Art, New York, accession no. 1973.1.

12 For two Armenian examples of parchment manuscripts in which the twist of the string is clearly visible in the indented ruling lines, see: a Hymnal dated 1646 CE produced in Kafa, Crimea (Arm. MS 1, Special Collections, The Burke Library at Union Theological Seminary, Columbia University Libraries, New York); and a mid-seventeenth-century Gospel book now in the collection of the Musée Condé in Chantilly, France (MS no. 1346).

13 Sirarpie Der Nersessian, *Miniature Painting in the Armenian Kingdom of Cilicia from the Twelfth to the Fourteenth Century*, 2 vols., Dumbarton Oaks Research Library and Collection, Washington, DC, 1993.

14 For more information on manuscripts from Artsakh, see: Emma Korkhmazian, Irina Drampian and Gravard Hakopian [H. Hakobian], *Armenian Miniatures of the 13th and 14th Centuries*, Aurora Art Publishers, Leningrad, 1984, esp. plates 64–78; H. Hakobian, *The Medieval Art of Artsakh*, Parberakan, Erevan, 1991; Dickran Kouymjian, 'The Art of Miniature Painting in Karabagh', in Dickran Kouymjian and Claude Mutafian (eds), *Artsakh: Jardin des arts et traditions arméniens*, Somogy, Paris, 2011, pp. 106–137; Hravard Hacopian, *Arc'axi manrankarč'akan arvestə* [The Art of Artsakh Miniatures], Nairi, Erevan, 2014.

15 There is documentation through catalogues and published colophons that he illuminated at least a dozen manuscripts, about half of which are probably lost. These were listed in a catalogue, Ervand Lalayan, *C'uc'ak hayerēn jeṙagrac' Vaspurakani* [Catalogue of Armenian Manuscripts in Vaspurakan], Tiflis, 1915, when they were still located in presumably functioning monasteries and churches in Vaspurakan; the present locations of some are unknown and they may not have survived. A survey of known losses and of the whereabouts of preserved manuscripts is given in Coulie, *Répertoire*, pp. 209–215. See also: Vrej Nersessian, *A Catalogue of Armenian Manuscripts in the British Library acquired since the year 1913 and of collections in other libraries in the United Kingdom*, The British Library, London, 2012, vol. 1, cat. 36; Norayr Covakan (Norayr Połarean), *Hay Nkarołner (ŽA–ŽĒ dar)* [Armenian Painters (11th–17th centuries)], Tparan Srboc' Yakobean, Jerusalem, pp. 157–60.

16 I am preparing an article on this subject. For recent studies on Armenian absorption of Western art, especially from the Low Countries, see: Amy S. Landau, 'European Religious Iconography in Safavid Iran: Decoration and Patronage of *Meydani Bet'ghehem* (Bethlehem of the Maydan)', in Willem Floor and Edmund Herzig (eds), *Iran and the World in the Safavid Age*, I.B.Tauris, London–New York, 2012, pp. 425–46; Amy S. Landau, 'Farangī-Sāzī at Isfahan: the Court Painter Muḥammad Zamān, the Armenians of New Julfa and Shāh Sulaymān (1666–1694)', DPhil thesis, University of Oxford, 2006; Sarah Eftekharian-Laporte, 'Le rayonnement international des gravures flamandes aux XVIe et XVIIe siècles: les peintures murales des églises Sainte-Bethléem et Saint-Sauveur à la Nouvelle-Djoulfa (Ispahan)', PhD thesis, Université libre de Bruxelles, 2006 (http://theses.ulb.ac.be/ETD-db/collection/available/ULBetd-10122006-113503/).

17 Heide and Helmut Buschhausen, 'Die Herkunft der Armenier im ehemaligen Gebiet der Habsburgermonarchie', *Steine Sprechen*, vol. XLII/2–3, no. 127, August 2003, pp. 2–22; Helmut Buschhausen, Heide Buschhausen and Emma Korchmasjan, *Armenische Buchmalerei und Baukunst der Krim, Tafeln*, Editions Nairi, Erevan, 2009; Jannic Durand et al., *Armenia Sacra*, Somogy, Paris, 2007, cat. 123; Sylvie L. Merian, 'Illuminating the Apocalypse in Seventeenth-Century Armenian Manuscripts: The Transition from Printed Book to Manuscript', in Kevork B. Bardakjian and Sergio La Porta (eds), *The Armenian Apocalyptic Tradition: A Comparative Perspective*, Brill, Leiden, 2014, esp. pp. 605–10.

18 For further information on these scrolls, see Frédéric Feydit, *Amulettes de l'Arménie Chrétienne*, St. Lazare, Venice, 1986. For an example of a printed scroll, see Edmond Y. Azadian, Sylvie L. Merian, Lucy Ardash, *A Legacy of Armenian Treasures: Testimony to a People*, The Alex and Marie Manoogian Foundation, Taylor, MI, 2013, pp. 58–59.

19 For further details, see: Sylvie L. Merian, 'The Structure of Armenian Bookbinding and its Relation to Near Eastern Bookmaking Traditions', PhD thesis, Columbia University, 1993; Sylvie L. Merian, Thomas F. Mathews and Mary Virginia Orna, 'The Making of an Armenian Manuscript', in Mathews and Wieck, *Treasures in Heaven*, pp. 124–34; Sylvie L. Merian, 'The Characteristics of Armenian Medieval Bindings', in Gillian Fellows-Jensen and Peter Springborg (eds), *Care and Conservation of Manuscripts*, vol. 10, Museum Tusculanum Press, University of Copenhagen, Copenhagen, 2008, pp. 89–107.

20 Sylvie L. Merian, 'Cilicia as the Locus of European Influence on Medieval Armenian Book Production', *Armenian Review*, vol. 45, no. 4/180, Winter 1992, pp. 61–72.

21 Jenny Hille and Sylvie L. Merian, 'The Armenian Endband: History and Technique', *The New Bookbinder*, vol. 31, 2011, pp. 45–60.

22 Dickran Kouymjian, 'The Decoration of Medieval Armenian Manuscript Bindings', in Guy Lanoë and Geneviève Grand (eds), *La Reliure Médiévale: pour une description normalisée: actes du colloque international (Paris, 22–24 mai 2003) organisé par l'Institut de recherche et d'histoire des textes (CNRS)*, Brepols, Turnhout, 2008, pp. 209–218.

23 A number of manuscripts from Constantinople that I have examined seem to have been decorated with this style of blind-tooling; more research is needed to confirm whether this is common to bindings from this city. A recently published article on eighteenth-century bindings on Armenian printed books from Constantinople has indicated that some were bound using an interesting hybrid form of Armenian and European binding techniques, but the authors focus on binding structure, especially the endbands, rather than decoration; see: Yasmeen R. Khan and Tamara Ohanyan, 'Deceptive Covers: Armenian Bindings of 18th-Century Imprints from Constantinople', *The Book and Paper Group Annual*, The American Institute for Conservation of Historic and Artistic Works, Book and Paper Group, Washington, DC, vol. 32, 2013, pp. 109–117.

24 Dickran Kouymjian, 'The New Julfa Style of Armenian Manuscript Bindings', *Journal of the Society of Armenian Studies*, vol. 8, 1995 (published 1997), pp. 13–36; Dickran Kouymjian, 'Inscribed Armenian Manuscript Bindings: A Preliminary General Survey', in Henning Lehmann and Joseph J. S. Weitenberg (eds), *Armenian Texts, Tasks, and Tools*, Aarhus University Press, Aarhus, 1993, pp. 101–109; Claude Mutafian (ed.), *Arménie: la Magie de l'Écrit*, Somogy, Paris, 2007, pp. 242–7.

25 Sylvie L. Merian, 'The Armenian Silversmiths of Kesaria/Kayseri in the Seventeenth and Eighteenth Centuries', in Richard G. Hovannisian (ed.), *Armenian Kesaria/Kayseri and Cappadocia*, Mazda Publishers, Costa Mesa, CA, 2013, pp. 117–85.

26 Sylvie L. Merian, 'Protection Against the Evil Eye? Votive Offerings on Armenian Manuscript Bindings', in Julia Miller (ed.), *Suave Mechanicals: Essays on the History of Bookbinding*, vol. 1, The Legacy Press, Ann Arbor, MI., 2013, pp. 42–93.

27 Books printed in Europe and exported for sale to the Near East were traditionally shipped unbound, as this made them lighter and therefore cheaper to ship. They would have been bound locally by the buyer.

Alessandro Orengo

500 Years of Printed Armenian Books

At the beginning of the sixteenth century, the Armenian people lacked political autonomy as they were primarily subjects of the Ottoman Empire and Safavid Iran, or residing in various colonies scattered throughout Europe (see pages 21–3). Due to ongoing war in their homeland, the Armenians' access to books was extremely limited, presenting a considerable cultural obstacle since books provided an invaluable medium through which their ethnic identity could be maintained. In fact, the traditional concept of being Armenian meant adhering to the customs of the Armenian Christian Church, as well as speaking and ideally reading Armenian. Of particular importance were religious texts written in the 'Classical' language, which was no longer spoken as a mother tongue, although it remained the language in which religious ceremonies were performed and scholarly works were written. In any case, books were extremely rare at that time; moreover, the process of hand-copying was slow and expensive.

Armenian colonies, particularly in western Europe, were inhabited mostly by merchants who had created a network through which information was relayed, albeit not always rapidly. It is possible that news of technological innovations such as movable-type printing reached the Armenian fatherland through such networks. A few decades after Johannes Gutenberg (1398–1468) invented the technique, an individual about whom little is known began applying it to Armenian books, in order to print them and possibly to transfer to the East the tools required to make the copying process much more efficient than it had been previously (see cat. 51). Very little is known about this person: he could have been living in Venice for a while, or perhaps he had just arrived from the East. Information about who may have assigned him this task is also unavailable.

What we do know – from a very brief colophon at the end of an Armenian missal, the *Pataragatetr* – is that in Venice, in the year 962 of the Armenian Era, this missal was printed by a supposedly Armenian printer named Yakob (James), nicknamed Mełapart ('the Sinner'), an epithet frequently used by hand-copyists. The Armenian year 962 usually corresponds to 1513 CE, but the printer himself informs us in another of his books, the *Parzaytumar* (cat. 51), that in order to convert an Armenian date to the corresponding year of the Christian Era one must add 552, yielding in this case the year 1514. Four more Armenian books, similar to the missal with respect to the font used, are also known to us; they contain no colophon or other identifying marks, except for the fact that all of them, like the missal, share the same printer's mark, namely a circle divided into four parts and surmounted by a cross. In the four sections of the circle, left to right and from above downwards, the letters 'DIZA' in Latin script appear. Different interpretations, none of which are conclusive, have been proposed;[1] however, this scant evidence may be enough to suggest that Yakob produced all five of these books.

Despite a lack of any further information, we may still attempt to determine why a sixteenth-century Armenian printer might decide to learn these new printing techniques and apply them to his work in Venice. Firstly, Venice was a major centre for the printing and trade of books at the time. Secondly, the city was home to a well-established Armenian colony, among whose members a printer might find help for his work, and, more importantly, necessary funding. Finally, from a political perspective, the Venetian Republic did not have good relations with the Church; between 1509 and 1510 it was temporarily excommunicated. Consequently, the control exerted by Rome was relatively weak, an important aspect to be considered by a printer intending to produce ecclesiastical books for a church deemed heretical by the Roman authorities (see cat. 30). It is not known if Yakob intended to print the Bible, but we do know that the Armenians who tried to carry out a similar project at later times were consistently prevented from doing so by Rome. In fact, the Armenian Bible was only printed for the first time in 1666–8 in Amsterdam – a country that supported the Reformation, and where the influence of Rome, albeit not absent, was inevitably weaker than in Catholic countries.

As previously stated, the name of the printer was only mentioned briefly in one of his books; elsewhere, he merely referred to himself by the letters DIZA. The reason for this may have been that he did not have authorization to print Armenian books in Venice. Archival documents indicate that on 15 July 1498, a certain Venetian named Democrito Terracina was granted exclusive printing and trading rights for books written in six Oriental languages, including Armenian. The privilege should have been in effect for a period of twenty-five years both in Venice and throughout the entire territory of the Republic. However, Democrito in fact did not print a single book. After his death – the date of which is unknown – his brother's sons Lelio and Paulo renewed this licence on 31 May 1513, again for a term lasting twenty-five years. It is worth noting that although Democrito's nephews requested this renewal before the period granted to their uncle had expired, we are unaware of any book printed by them, and it is very likely that they also did not print any at all. One might speculate that such a renewal request, submitted before the expiration of the previous privilege, was a reaction to Yakob's activity, the news of which had spread throughout the city. In this way, Democrito's nephews may have tried to re-establish their family's communal position in the face of a threat posed by an outsider.

Alternatively, if Yakob was aware of Democrito's exclusive rights when he began his work, that is, before the years 1513–14, it is reasonable to conclude that he may have used a somewhat cryptic mark to conceal his identity as printer of the texts. Later, when printing his other works, it is possible that he continued to use it, intending to mark the books as having originated from the same workshop.

As previously mentioned, Yakob is believed to have printed at least five books in Venice immediately prior to and subsequent to the years 1513–14. Some scholars have argued that he may have also printed a sixth book, a psalter, but if that is the case, its copies are no longer extant.[2] If we consider the content of the books printed by Yakob, we can formulate some idea of the sort of buyer he was targeting, bearing in mind that he was a merchant, albeit possibly a pious one, and therefore produced merchandise with the intention of selling it.

The relevant books are the following:[3]

Urbat'agirk' (The book of Friday), possibly named thus because of the text's opening word: 'Friday'. This is an anthology of prayers and magical formulae. The first

prayer explicitly requires the presence of a priest and is performed at the door of a church, whereas the subsequent prayers are for recital by the layman in difficult times (for example, in order to neutralize the effects of a venomous snake bite or to ward off the evil eye).[4]

Alt'ark', a collection of short treatises dealing with astrology, astronomy and empirical medicine (cat. 51).

Parzaytumar, a simplified calendar that also contains instructions regarding the prediction of the weather in different seasons, the day of the lunar month that is most propitious for certain activities, and the traits of a new-born child based on the day of the week in which the birth took place (cat. 51).

Pataragatetr, the aforementioned missal.

Tałaran, a collection of poetical works containing, among others, compositions by medieval Armenian poets, and also by Mkrtič' Nałaš, who died just a few decades before the book was printed, as well as by Yovhannēs T'łkuranc'i, who was still alive at the time (if indeed he can be identified with the katholikos of the same name).[5]

To sum up: whereas some of these books are targeted at ecclesiastic readers, others are meant to meet the practical and cultural needs of a merchant (see pages 178–9).

We have discussed at some length the case of the first Armenian printer because many aspects that are detectable in his activity – or at least postulated to be such – are also present in the work of his later colleagues. They learned and exercised their craft mainly in foreign countries, usually in western Europe, and sought the support of their countrymen living in Armenian colonies abroad, especially wealthy merchants, but also ecclesiastics.

In fact, the activity of Armenian printing houses founded and directed by Armenians during the sixteenth and seventeenth centuries took place mostly outside the fatherland. Since the books had to be sold in Armenia, the distance between the city where the printing office was based and Armenia itself was clearly a significant issue: the closer, the better. The best solution was to choose a Mediterranean port from which the books could be shipped to Smyrna (Izmir) and later transported to Anatolia and the Caucasus. If we consider the cities where such printing houses were based, we find that they included Western centres such as Venice, Livorno, Amsterdam and Marseille, but also Lvov (Lviv), where often more than one printing house was operative within the relevant timeframe. In contrast, in the East, Armenian printing houses were only present in Constantinople (Istanbul) and New Julfa (near Isfahan, Iran), and these were often active for only a very short period of time (see cat. 49).

It is not possible to enter into detail here regarding the development of each and every printing office.[6] Nevertheless, it is useful to describe the history of a representative printing house, namely *Surb Ējmiacin ew Surb Sargis zōravar* (St Ējmiacin and St Sergius the general), which was founded in Amsterdam in *c.*1658 and, after being moved to Livorno in 1668–9, Marseille in 1672 and Constantinople in 1695, published its final book in 1718 (cat. 46, 53). From 1665 to 1674 it was headed, sometimes indirectly, by Oskan Łičenc' Erewanc'i (1614–1674), who was able to finally manage the printing of the Bible when the printing house was based in Amsterdam. As stated in the book's title page, printing began on 11 March 1666, and, according to the information provided in the colophon, operations were completed on 13 October 1668. It is a huge quarto volume of 1,470 pages, the text being written in two columns per page.

Surb Ējmiacin was not restricted to the printing of religious books. In Amsterdam,

for instance, Oskan published the *Girk' patmut'eanc'* (History) by Aṙak'el Dawriẓec'i (d.1670) in 1669, a work dealing with contemporary Armenian history, to which the printer himself added an autobiographical sketch and a short philosophical treatise. While still in Amsterdam, Oskan published a short grammar, the *K'erakanut'ean girk'* (1666), which was in fact an abridged version of an Armenian translation, which he himself produced, of a Latin text by the Italian philosopher Tommaso Campanella (1568–1639). Similar books with practical or pedagogical purposes can also be found among the later products of this printing house (cat. 53). When operations were based in Marseille, for example, an Italian grammar, written entirely in Armenian script and including vernacular Armenian forms, was published. The book includes other texts as well, and is entitled *Girk' aybubenic' ew kerp usaneloy zlezun italakan očiw k'erakanut'ean* (Book of the alphabet and ways to learn the Italian language according to grammar, 1675). In the same year a handbook of elementary mathematics (*Arhest hamarołut'ean ambołǰ ew katareal*) in vernacular Armenian was also printed. This is hardly surprising, since merchants were among the intended readership of the publishing house's products.[7]

Thus far, we have examined Armenian printers who learned their craft in Europe and continued to work there, with the object of printing a few books and possibly transferring their newly acquired techniques to the East.

However, European institutions, especially ecclesiastical ones, soon discovered the potential benefits of the press for missionary purposes. To this end, they installed printing houses in order to publish Armenian books written by both Armenians and non-Armenians. The first European scholar to use movable type for Armenian texts was Teseo Ambrogio degli Albonesi (1469–*c.*1540), who, in his *Introductio in Chaldaicam linguam, Syriacam atque Armeniacam, et decem alias linguas* published in Pavia in 1539, inserted a few short texts in the Armenian language written in the Armenian script (cat. 39).

Whereas Teseo Ambrogio's contribution was limited in scope, the Armenian books issued by the Ambrosiana Library in Milan and – to an even greater degree – the printing programme of the *Congregatio de Propaganda Fide* in Rome were more significant (cat. 21, 30, 39). The Ambrosiana Library, founded by Cardinal Federico Borromeo (1564–1631), Archbishop of Milan, and inaugurated on 8 December 1609, had as its aim the instruction of a small number of clerics in various scientific fields so that they could collectively enhance the prestige of the Roman church, spread its dogmas and aid other scholars in their work. An Armenian printing house was established within the Library, publishing only two works, the *Baṙagirk' hayoc'* / *Dictionarium armeno-latinum* (1621) and the *Grammaticae armenae libri quattuor* (1624), both by Francesco Rivola (cat. 40). They were, respectively, the first Armenian dictionary and the first Armenian grammar to be written in a Western language.

Both Rivola's grammar and his dictionary were reprinted in Paris about ten years later. In 1627 Cardinal Richelieu (1585–1642) devised a plan to establish a printing house for Greek, Arabic and Armenian books in Lebanon. It was to be financed by the king of France, and the printed books were to be given to missionaries, particularly French ones, free of charge. When the plan was unsuccessful, the Cardinal proposed to the *Société Typographique*, which included eighteen Parisian booksellers and printers, that they print books in Oriental languages in exchange for the right to print breviaries. As a result of this agreement, Antoine Vitré, the printer of the *Société*, reprinted Rivola's *Dictionarium* in 1633, and his *Grammatica* a year later.

While the Ambrosiana Library's involvement in Armenian printing was short-lived, the work of the *Congregatio de Propaganda Fide* was more permanent. In order to give an idea of the latter's publishing activity, we will focus on books of linguistic interest.[8] Needless to say, books on different matters, mainly religious topics, were also published.

Even before the *Congregatio* was founded, the Vatican Printing House (*Typographia Vaticana*) printed various Armenian books in Rome. Founded in 1622 by Pope Gregory XV (1554–1623), as the supreme authority in charge of spreading the Roman Catholic faith, the *Congregatio* had the dual purpose of achieving a form of unification between the Orthodox and Protestant Churches, and of organizing missions among the non-Christians (contemporarily referred to as 'heathens'). During that same year, an anonymous printer proposed to publish books in Chaldean (Syriac), Arabic, Latin, Greek and Hebrew at his own cost, but acting as the official printer of the *Congregatio*. Later, it was discovered that Stefano Paolini, who was chosen to become the official printer of the *Congregatio* in 1626, was the individual who made this offer. Within a year, he had already made available fourteen different fonts, one of which was an Armenian font.

Initially, the *Congregatio*'s policy was to distribute the books free of charge. However, as a result of high printing costs, it was decided in 1632 that 100 copies should be sold at the production price. About twenty years later a decision was made to commercialize a large part of the stock, selling the books *iusto pretio* (at a reasonable price) to anyone who was interested in making a purchase.

In 1639, the first catalogue devoted to books printed between 1627 and 1633 was published. Fourteen of these were concerned with linguistic subjects, including the *Alphabetum Armenum*, which was printed in 1623 (cat. 39). The second catalogue was published in 1667 and was devoted to the period 1633–67. It also included many linguistic publications, including *K'erakan, ew tramabanakan neracut'iwn / Grammaticae, et logicae institutiones* by Clemente Galano (1610–1666), issued in 1645.

Only a few books were published in the field of linguistics after 1669. Nonetheless, during this period three grammars by Ioannes Agop (Yovhannēs Holov Kostandinupōlsec'i, 1635–1691) were printed: *Zt'ut'iwn haykabanut'ean kam k'erakanut'iwn haykakan / Puritas linguae armenicae*, (1674), a description of the Armenian language in Armenian; *Puritas haygica seu grammatica armenica* (1675), a description of the Armenian language in Latin; and *K'erakanut'iwn lat'inakan hayerēn šaragrec'eal / Grammatica latina armenice explicata* (1675), a Latin grammar in Armenian. In 1695, the *Baṙagirk' latinac'woc' ew hayoc' / Dictionarium latino-armenum* by Deodatus Nierszesovics (Astuacatur Nersēsean, 1647–1709) was issued. At the end of the century, a revision of editorial policy was made. In 1700 the entire stock of books was re-evaluated, and it was decided that a portion of the books would not be reprinted. Yet, as late as 1714, Jacques Villotte's (1656–1743) new work on Armenian lexicography entitled *Dictionarium novum latino-armenum / Baṙgirk' haykakan lezui* was printed.

The *Congregatio*'s aims were closely linked to missionary activity. Its purpose was to provide missionaries with the necessary tools for evangelizing, and, perhaps, new converts with texts that were believed to be important for their progress in the Catholic faith.

As for the *Congregatio*'s linguistic production, it occurred at a time in which there was a strong tendency toward 'grammatization' in contemporary Western culture, which included efforts to describe languages and to make them accessible through grammars and dictionaries. This process of grammatization was deeply

influenced by Latin, which was not only the medium of linguistic description, but whose grammatical structure also provided a framework that was imposed on other languages in order to describe them. From a modern scientific perspective, it is clear that this methodology is unsound and can lead to significant error. One is compelled to find in the target language the same logical and grammatical categories that occur in Latin, regardless of the linguistic differences between it and the Latin language.[9] However, this was the prevalent contemporary method for compiling grammars, and it reflected the common belief regarding the existence of a universal grammar that mirrors the mental processes of every human being. Western scholars often identified this universal grammar with the grammar of the Latin language. This methodology also offered a pedagogical advantage, since students could approach any linguistic feature through known descriptive patterns and schemes.

Any historical survey of Armenian printing, no matter how cursory, clearly should not omit the typographical activities of Mechitar of Sebastia (Mxit'ar Sebastac'i) and the Mechitarist Fathers (see pages 26–7).

Manuk, son of Petros – better known as Mechitar (Mxit'ar, 'the Comforter, the Consoler'), the name he assumed upon ordination as Deacon – was born in Sebastia (Sivas, in Turkey) in 1676. As a young man he came into contact with Catholic missionaries and converted to the Roman faith. In 1701 he founded a new congregation in Constantinople whose purpose was to put an end to Armenia's intellectual decay, which was also evident in the Church ranks. Threatened by local authorities, he decided to flee to the Venetian Republic, first to Modon (Methoni, in Greece) and then to Venice proper, where he arrived in 1715. Two years later, the government granted him the island of St Lazarus (San Lazzaro), which, although having housed a leper hospital in the past, was deserted at the time.

Mechitar's printing activity in Venice began in 1715. In most cases, he published his books using Antonio Bortoli's printing house. Between 1727 and 1729 he was able to purchase the printing tools originally owned by the Vanandec'is, who had managed an Armenian printing office in Amsterdam between 1685 and 1717 (cat. 50, 77). However, he and his brethren continued to use local printers to print their books. Among the most noteworthy of their various publications are the magnificent Bible produced in Bortoli's workshop between June 1733 and November 1735, and Mechitar's *Baṙgirk' haykazean lezui* (Dictionary of the Armenian Language), a huge volume whose title page bears the date 19 May 1749. Unfortunately, since there is no colophon, the book itself does not provide any information regarding the completion of the printing. In any case, Antonio Bortoli also printed this volume. It is a posthumous work, since Mechitar passed away on 27 April of the same year.

When the Mechitarists resumed their printing activity after having elected a new abbot, they engaged the services of another Venetian printer, Stefano Orlando. However, they were dissatisfied with the results and decided to return to Bortoli's printing house.

In 1773, a split occurred within the congregation. Several monks decided to relocate to Trieste (part of the Habsburg empire at that time) and were recognized in 1775 as an independent congregation by Empress Maria Theresa (1717–1780), who also granted them the right to have their own printing office. The Mechitarists of Trieste began to publish, issuing their first book in 1776. When they moved to

Vienna in 1810, they took the printing tools with them, and in 1812 the first books printed in the new location appeared.

Following the split, the Venetian branch continued to have their books printed in local workshops, such as those of Dimitrios Theodossiou, Pietro Valvasiani and Giovanni Piazza. However, soon it became necessary to establish a printing office directly on San Lazzaro. The permit was requested and obtained from the government, and the new workshop began operating on 2 March 1789. In that same year, its first books were published.[10]

In the nineteenth century, San Lazzaro was one of the most active Armenian printing centres worldwide. From its presses many noteworthy books emerged, notably editions of Classical Armenian writers; treatises on history and geography (not only Armenian), often in many volumes; translations of many relevant Greek, Latin and European authors, etc. The Venetian Mechitarists also published grammars and dictionaries, some of which are still used today as reference works. For instance, the most complete thesaurus on Classical Armenian remains the two-volume *Nor baṙgirkʻ haykazean lezui* (New Dictionary of the Armenian Language), compiled by Gabriēl Awetikʻean (1751–1827), Xačʻatur Siwrmēlean (1751–1827) and Mkrtičʻ Awgerean (1762–1854) and printed in St Lazarus in 1836–7, while the most complete Classical Armenian bilingual dictionary is still the *Dizionario armeno-italiano* by Emmanuele Ciakciak (M. J̌axǰaxean, 1770–1835), issued in 1837. Both branches of the order continued their activities throughout the subsequent century.

During the eighteenth century, Armenian printing offices were also established in Armenian centres and in towns where an Armenian population was more consistently present than in the earlier Western colonies. Apart from Constantinople, where, as mentioned, the printing house called *Surb Ēǰmiacin ew Surb Sargis zōravar* was relocated in 1695, and where other workshops soon followed, similar offices were operating in Smyrna (since 1759), in Ēǰmiacin, see of the katholikos (since 1771), in St Petersburg (since 1781), and elsewhere.[11] Printing offices were also opened in Madras, where the Armenian intelligentsia from New Julfa had taken refuge when Safavid Iran had become unsafe for them (see page 24 and cat. 36). In the Indian city, the first Armenian journal, *Azdarar* (The Monitor), founded and edited by Yarutʻiwn Šmawōnean (1750–1824), was published monthly from October 1794 to March 1796, when the eighteenth and final issue appeared.

In the nineteenth and twentieth centuries, Armenian typographical activities continued, both in the fatherland and abroad. After the genocide perpetrated by the Ottoman government in 1915–18, which wiped out a huge section of the Armenian population living in the empire and forced the survivors to escape abroad, printing houses were also established in the cities where the survivors took refuge. Some of them are still operational, as are several printing houses in what is now the Republic of Armenia, and in other countries of the former USSR.

The history of Armenian printing, of which we have attempted to offer a survey here, albeit in a necessarily cursory fashion, began 500 years ago, and, as can be imagined, is far from drawing to a close.

NOTES

1 Some scholars interpreted DIZA, or at least some of these letters, as a reference to Democrito Terracina, about whom we will speak later on. Another comparatively common proposal reads DIZA as **D**ei servus **I**acobus **Z**anni (or **Z**uanne) **A**rmenius, which should contain a reference to the printer, Yakob. Nonetheless, one cannot help but wonder why two words (Dei servus) should correspond to the first letter, and why, in a text written in Latin, the second alleged name – or patronymic – of the Armenian Iacobus/ Yakob should be given in the local dialect (Zanni/ Zuanne). As a side note, we have no information about a possible second name or patronymic of the printer. For other interpretations of D.I.Z.A., see R̄afayel Išxanyan, *Hay grkʻi patmutʻyun. Hator 1. Hay tpagir girkʻə 16–17-rd darerum* [History of the Armenian book. Volume 1. Armenian printed books in the sixteenth and seventeenth centuries], reprint, Antares, Erevan, 2012, pp. 97–128.

2 An incomplete copy of a *Sałmosaran* (psalter), possibly printed by Yakob, was seen in Sebastia (Sivas, Turkey) by Karapet Gabikean, who assigned it to our printer on the basis of the similarity between its fonts and those used in books of certain attribution. Gabikean gave this piece of information in an article published in 1906 (no. 2963 of the journal *Biwzandion*), but we have no further knowledge of the book. On this issue, see Išxanyan, *Hay grkʻi patmutʻyun*, pp. 52–7 and 171–3.

3 A description (in Armenian) of virtually all the Armenian books printed up to 1930 and known to us is provided by the National Library of Armenia on the website of the 'Hakob Meghapart' project: http://nla.am/ arm/meghapart/Arm/frame1.htm. A shorter description in English, limited to books printed up to 1800, is available at http://nla.am/arm/meghapart/English/ frame1.htm. Scanned versions of many Armenian books printed prior to 1800 can be found in the 'Armenian Rare Books' collection: http://greenstone.flib.sci.am/ gsdl/cgi-bin/library.cgi?p=about&c=armenian.

4 This book has been discussed in detail in Alessandro Orengo, 'L'Owrbatʻagirkʻ («Il Libro del Venerdì») e gli inizi della stampa armena', *Egitto e Vicino Oriente*, vol. 34, 2011, pp. 225–36.

5 According to some scholars, this poet should not be identified with the Yovhannēs Tʻlkurancʻi who was ordained katholikos of Sis in 1489 and died in 1525, but with another, homonymous person who lived in the fourteenth century: see J. R. Russell, *Yovhannēs Tʻlkurancʻi and the Mediaeval Armenian Lyric Tradition*, Scholars Press, Atlanta, 1987, pp. 7–8.

6 The interested reader may wish to consult the following works: R. H. Kévorkian, *Catalogue des «Incunables» Arméniens (1511/1695), ou Chronique de l'Imprimerie Arménienne,* Cramer, Genève, 1986; Meliné Pehlivanian, 'Mesrops Erben: die armenischen Buchdrucker der Frühzeit' / Mesrop's Heirs: the Early Armenian Book Printers, in E.-M. Hanebutt-Benz, Dagmar Glass, G. Roper and T. Smets (eds), *Middle Eastern Languages and the Print Revolution. A Cross-cultural Encounter. A Catalogue and Companion to the Exhibition. Gutenberg Museum. Mainz. Internationale Gutenberg-Gesellschaft / Sprachen des Nahen Ostens und die Druckrevolution. Eine interkulturelle Begegnung. Katalog und Begleitband zur Ausstellung. Gutenberg Museum. Mainz Internationale Gutenberg-Gesellschaft*, Skulima, Westhofen, 2002, pp. 53–92 (English and German text), pp. 461–8 (exhibit descriptions), p. 523 (bibliography). Pages 53–92 have been reprinted in G. Roper (ed.), *The History of the Book in the Middle East*, Ashgate, Farnham – Burlington, 2013, pp. 505–44; J. A. Lane, *The Diaspora of Armenian Printing 1512–2012*, Special Collections of the University of Amsterdam, Amsterdam, 2012.

7 On merchants as the recipients of printed books, and in general on their sponsorship of printing enterprises, see Jean-Pierre Mahé's 'Preface/Préface' in Kévorkian, *Catalogue*, pp. viii–xix (text in English and French).

8 See also J. de Clercq, P. Swiggers and L. van Tongerloo, 'The Linguistic Contribution of the Congregation De Propaganda Fide', in Mirko Tavoni et al. (eds), *Italia ed Europa nella linguistica del Rinascimento: confronti e relazioni. Atti del Convegno internazionale Ferrara, Palazzo Paradiso 20–24 marzo 1991. Vol. II: L'Italia e l'Europa non romanza. Le lingue orientali*, Panini, Modena, 1996, pp. 439–58.

9 In order to exemplify one of the ways in which the description of a language could be modeled on Latin, it is worth recalling that, in the aforementioned *Kʻerakanutʻean Girkʻ* by Oskan Erewancʻi (p. 10), while speaking about noun gender, the author says that a noun can be masculine, feminine and neuter – following the distinction present in his source, the Latin grammar by Campanella – and even gives some Armenian examples for it. However, he immediately adds that the neuter does not exist in Armenian (and indeed, the language has no gender distinction). A similar statement followed by a partial negation is repeated at p. 26, in the section devoted to the gender of participles. On grammatization, see S. Auroux, *La révolution technologique de la grammatisation. Introduction à l'histoire des sciences du langage*, Mardaga, Liège, 1994.

10 For more information, see Sahak Čemčemean, 'Surb Łazari tparani cnundə 1789-1989' [The origins of St Lazarus's printing office 1789–1989], *Bazmavēp*, vol. 147, 1989, pp. 7–36; vol. 148, 1990, pp. 259–73.

11 So far we have spoken about books containing texts written in Armenian; however, the Armenian script was also used for writing different languages. As far as printed books are concerned, there is a considerable production of texts written in Turkish in the Armenian script: for a catalogue, see H. A. Stepʻanyan, *Hayataṙ tʻurkʻerēn grkʻeri ew hayataṙ tʻurkʻerēn parberakan mamuli matenagitutʻiwn (1727–1968)* [Bibliography of Armeno-Turkish books and periodical press], Turkuaz Yayınları, İstanbul, 2005.

Catalogue

Sacred Scripture: Gospels and Bibles

The adoption of Christianity as the official religion in *c.*314 CE (301 CE according to the Armenian Church) brought about deep changes in Armenian society. One of these came with a delay of a century: the invention of an alphabet with which to write Armenian, in 405 CE. For Christianity to take root, the word of God not only had to be preached, but read in Armenian. The translation of scripture – first from Syriac and Greek, then from Greek alone – became the first and central task of Mesrop Maštocʻ and his collaborators. Although the first Biblical book translated was the Old Testament text of Proverbs, the Gospels became the most copied manuscript in the Armenian tradition. They present an uninterrupted handwritten tradition from the fifth to the nineteenth century. While from the oldest period very little survives – possibly only fragments used as flyleaves in later manuscripts – the four oldest dated manuscripts are Gospels: the Queen Melkʻē Four Gospels of 862 (V1144/86); the Lazarian Gospels (M6200), dated 887; M6202 of 909; and the Gospel of 966 (BAL W.537). These are all large books, well over 35 x 25 cm, with the last mentioned the smallest at 29.5 x 22 cm. The symbolism of four, based on Ezekiel's vision of the throne chariot carried by four living beings with the faces of a man, lion, ox and eagle, respectively, is

associated with the Gospels and their writers and elaborated upon in hymns and commentaries, but also in the genre of commentaries on the canon tables. Further particularities concern the prefatory cycle of illuminations on the life of Christ, before which have sometimes been inserted essential Old Testament scenes, such as the sacrifice of Abraham. Elaborate concordance systems were applied to facilitate cross-referencing and comparison.

While copies of books of the Bible circulated, they were never placed together into a complete Bible before Nersēs Lambronac'i (1154–1198). His redaction was followed by Gēorg Skewrac'i's in the thirteenth century, which found wide circulation and formed the basis for three early printed editions. These, however, differ among themselves: Oskan Erevanc'i first printed the Bible in 1666–8 (Amsterdam), leaning towards Latinizing influences, while the later editions of Zohrabian in 1805 (Venice) and Arsen Bagratuni, also in Venice (1860), are more faithful to the Armenian tradition. A third redaction hails back to the early seventeenth-century scholar Łazar Baberdc'i, who inserted the verse divisions made for the concordance of the Hebrew Masoretic text in a Bible copied in Lvov (Lviv) in 1619 (M351). His example was followed in many of the Bible manuscripts copied in New Julfa, one of which, M2587, copied directly from it in 1648, is exhibited here (cat. 11).

Cox, C. E., *The Armenian Bible*, Krikor and Clara Zohrab Information Centre, New York, 1996.

Mathews, T. F. and A. K. Sanjian, *Armenian Gospel Iconography. The Tradition of the Glajor Gospel*, Dumbarton Oaks Research Library, Washington, DC, 1991.

Nersessian, V., *The Bible in the Armenian Tradition*, British Library, London, 2001.

Stone, M. E., D. Kouymjian, H. Lehmann, *Album of Armenian Paleography*, Aarhus University Press, Aarhus, 2001.

TMvL

1

John receives the Word of God, and Prochorus writes it down
Four Gospels

22.5 x 16.5 cm, paper
Mesrop *dpir* (clerk) of Xizan
Mesrop *dpir* (clerk) of Xizan and Yovhannēs
Šoš, which is Isfahan [New Julfa] 1618–22
The Nelson-Atkins Museum of Art, Kansas City,
Missouri, 28.2015.a-x fols 221v–222r

Most Armenian Gospel books include a portrait of each evangelist facing the first page of his Gospel text (the incipit page), which is usually superbly decorated. This portrait of John the Apostle also depicts Prochorus, his assistant, writing down what John dictates. Prochorus is shown sitting in an architectural setting, pen poised in his hand, while the standing John is enveloped by brightly coloured undulating lines. The word of God reaches down to John's lips by means of a ray extending from the upper right. John looks up towards the ray, and his body almost seems electrified by those words. Mesrop Xizancʻi used the iconography of John with Prochorus in many of his Gospel manuscripts, as did other Armenian artists. This composition was used in some Armenian manuscripts as early as 1224 (Matendaran MS. 4823), and in Byzantine manuscript illumination beginning in the tenth century. But Mesrop has imbued this image

with an almost abstract sensibility through his use of pulsating bands of strong colours. The headpiece of the incipit page is a striking example of traditional Armenian decoration, including the typical use of the first letter of the text twisted into the symbol of the evangelist, an eagle in this case.

This manuscript includes a lengthy and important colophon from 1618 by Mesrop *dpir* Xizancʻi, who was not only the artist but also one of the two scribes who copied it. Mesrop provides us with the names of his parents, Martiros and Xondkʻar, his brothers, his sisters and his son, as well as his three teachers: Sargis Mazman (cat. 9), Tēr Martiros and his son Tēr Grigoris. These details provide precious information about his family and help us to identify him. He also repeatedly names the patrons of the manuscript: Paron Tʻasali, Yovhanēs the priest and his wife Islim, so that they may be remembered by future readers for their pious deed.

Arakelyan, M., *Mesrop of Xizan: An Armenian Master of the Seventeenth Century*, Sam Fogg, London, 2012.

Covakan, N. (Norayr Połarean), *Hay nkarołner (ŽA–ŽĒ dar)* [Armenian Painters (11th–17th centuries)], Tparan Srbocʻ Yakobeancʻ, Jerusalem, 1989, pp. 198–200.

Gēorgean, A., *Hay manrankaričʻner. Matenagitutʻiwn IX-XIX dd.* [Bibliography of Armenian Miniature Painters from the 9th to the 19th century], Matenadaran, Cairo, 1998, pp. 402–6, no. 238.

Mathews, T. F. and R. S. Wieck (eds), *Treasures in Heaven: Armenian Illuminated Manuscripts*, The Pierpont Morgan Library, New York, 1994, pp. 204–05, cat. 81, figs 156–7, plate 35.

Medieval Manuscripts, Catalogue 14, Sam Fogg, London, 1991, lot 45.

SM

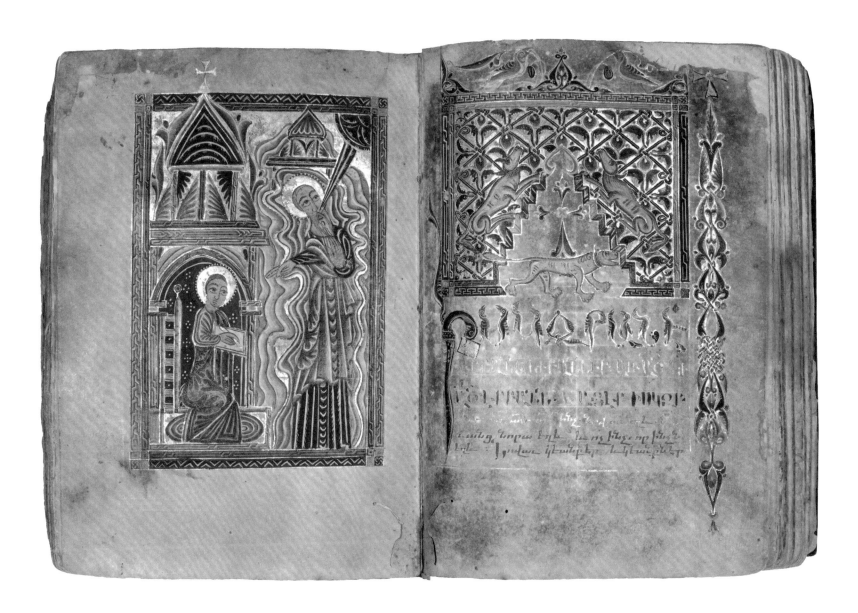

2

Pious donors seeking salvation; Last Judgment
Four Gospels

24.1 x 16.5 cm, paper
Mesrop *dpir* (clerk) of Xizan
Step'anos *k'ahanay*
[New] Julfa/Ĵułay (Isfahan) 1609
MS. Arm. d. 13 fols 21v–22r

Mesrop is named as the artist of this manuscript in two brief inscriptions below illuminations on fols 23v and 33r. This is Mesrop Xizanc'i, originally from the region of Xizan, south of Lake Van. He was trained there by a number of teachers, including Martiros Xizanc'i, his son Grigoris, and Sargis Mokac'i, also called Sargis Mazman (cat. 9), all of whom are memorialized in a fragmentary colophon on fol. 311r. However, most of Mesrop's surviving manuscripts seem to have been produced in New Julfa/Ĵułay (Isfahan), of which this is an example. On the left is his depiction of the Triumphant Cross, with a young Christ visible in the centre, four trumpeting angels and, kneeling below the cross on either side, portraits of the patrons of the manuscript, Xōĵa Tēriĵan and his wife Łayt'arp'aša. Their hope was surely that the pious act of commissioning a manuscript would bring about their own salvation. The Last Judgment, on the right, depicts Christ in the upper register sitting upon the tetramorphic throne, and flanked by the Virgin Mary and St John the Baptist. The weighing of the souls is portrayed in the lower register; a demon on the right tries to tip the scales in his favour. A devout person has purposely smeared and almost completely eliminated the figure of the demon.

Step'anos *k'ahanay*, the scribe of this Gospel book, has written an important colophon which details the suffering that Armenians endured under the battles and deportations of Shah Abbas from 1603–4, including their resettlement across the river Zāyanderūd in the capital city of Isfahan (or Šoš). The Armenians named their new village [New] Julfa/Ĵułay in honour of the town from which many of the deportees came, but Step'anos relates sadly that the residents often called it Č'aĵołay (Unlucky) instead of Ĵułay.

Arakelyan, M., *Mesrop of Xizan: An Armenian Master of the Seventeenth Century*, Sam Fogg, London, 2012.

Baronian, S., and F. C. Conybeare, *Catalogue of the Armenian Manuscripts in the Bodleian Library*, Clarendon Press, Oxford, 1918, cols 107–112, no. 53.

Covakan, N. (Norayr Połarean), *Hay nkarołner (ŽA–ŽĒ dar)* [Armenian Painters (11th–17th centuries)], Tparan Srboc' Yakobeanc', Jerusalem, 1989, pp. 198–200.

Gēorgean, A., *Hay manrankarič'ner. matenagitut'iwn IX–XIX dd.* [Bibliography of Armenian Miniature Painters from the 9th to the 19th century], Matenadaran, Cairo, 1998, pp. 402–06, no. 238.

Hakobyan, V. and A. Hovhannisyan, *Hayeren jeŕagreri ŽĒ dari Hišatakaranner (1601–1620 T'T')* [Colophons of 17th-century Armenian Manuscripts (1601–1620)], Haykakan SSH GA Hratarakč'ut'yun, Erevan, 1974, pp. 337–9, no. 426.

Mutafian, C. (ed.), *Armenie: la magie de l'écrit*, Somogy, Paris, 2007, pp. 366–7.

SM

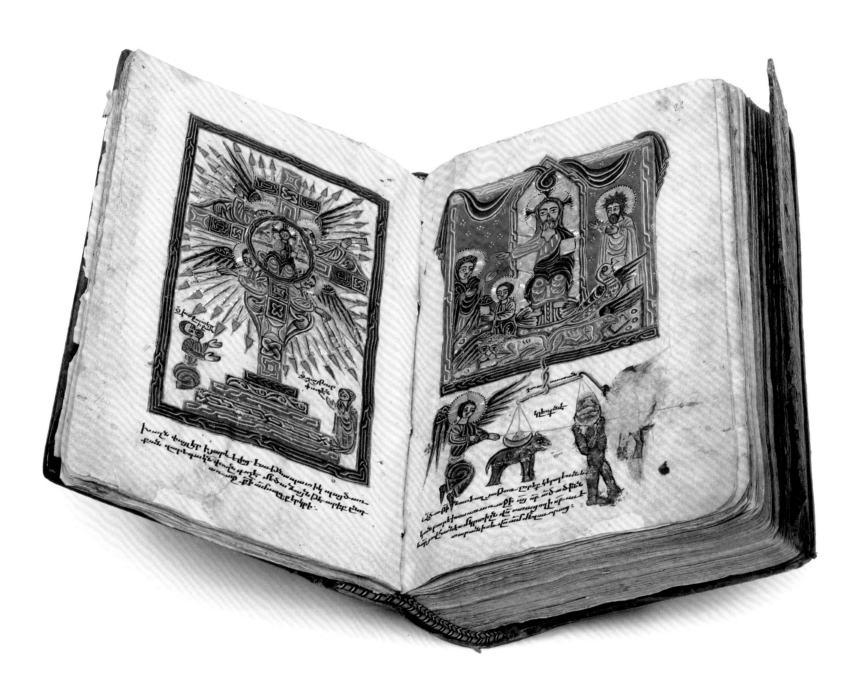

3
Canon tables with owls
Four Gospels

27 x 19 cm, paper
Yakob *k'ahanay* (priest) of Julfa
Anania *vardapet* Šambec'i
[Old] Julfa 1597
MS. Arm. d. 25 fols 14v–15r

This manuscript was copied in (old) Julfa by the scribe Anania *vardapet* Šambec'i in 1597, but the artist Yakob *k'ahanay* of Julfa has added his own colophon underneath the portrait of Mathew (fol. 16v) to inform us of his artistic work and to ask for our prayers. Only nine full-page illuminations from the prefatory cycle remain; some are probably missing and the remaining ones have been rebound out of order. The canon tables are still found in their usual place after the illustrations of the life of Christ. Canon tables are charts forming a type of index to enable the reader to find similar passages in the Four Gospels, and are usually preceded by the letter of Eusebius to Carpianos, in which he explains their use. In the Armenian tradition, they are usually beautifully decorated, as they are meant to also function as a visual meditation. At least thirteen Armenian theologians have written differing interpretations on the symbolism of canon tables, including the renowned twelfth-century katholikos Nersēs Šnorhali (1102–1173; katholikos from 1166), who has written in his treatise that canon tables are 'baths of sight and hearing for those approaching the soaring peaks of God'.

Canon tables usually face each other in pairs, and their decoration may include colourful designs as well as different types of flora and fauna, often birds. Sometimes these creatures are completely fanciful or may be rendered in unnatural colours. In canon tables nine and ten, shown here, we see two wide-eyed, realistic fluffy owls, one on each side of the facing pages, perched near what appears to be a small body of water. Although their precise symbolism is obscure, further contemplation as recommended by Nersēs Šnorhali may one day reveal their meaning.

Covakan, N. (Norayr Połarean), *Hay nkarołner (ŽA–ŽĒ dar)* [Armenian Painters (11th–17th centuries)], Tparan Srboc' Yakobeanc', Jerusalem, 1989, pp. 161–4.

Drampian, I., *Akop Džugaeci* [Yakob Jułayec'i], Publishing Office of the Mother See of Holy Ējmiacin, Ējmiacin, 2009.

Gēorgean, A., *Hay manrankarič'ner. Matenagitut'iwn IX–XIX dd.* [Bibliography of Armenian Miniature Painters from the 9th to the 19th century], Matenadaran, Cairo, 1998, pp. 463–6, no. 274.

Greenwood, T. and E. Vardanyan, *Hakob's Gospels: The Life and Work of an Armenian Artist of the Sixteenth Century*, Sam Fogg, London, 2006.

Łazaryan, V., *Xoranneri Meknut'yunner*, Sargis Xač'enc', Erevan, 1995.

Mathews, T. F., 'The Iconography of the Canon Tables', in Mathews, Thomas F. and Avedis K. Sanjian, *Armenian Gospel Iconography: The Tradition of the Glajor Gospel*, Dumbarton Oaks Research Library and Collection, Washington, DC, 1991, pp. 166–76.

Nersessian, V. N., *A Catalogue of the Armenian Manuscripts in the British Library acquired since the year 1913 and of collections in other libraries in the United Kingdom*, The British Library, London, 2012, vol. 1, pp. 230–40, no. 32.

Russell, J. R. (transl.), 'Two Interpretations of the Ten Canon Tables', Appendix D, in Mathews and Sanjian, *Armenian Gospel Iconography*, pp. 206–11.

SM

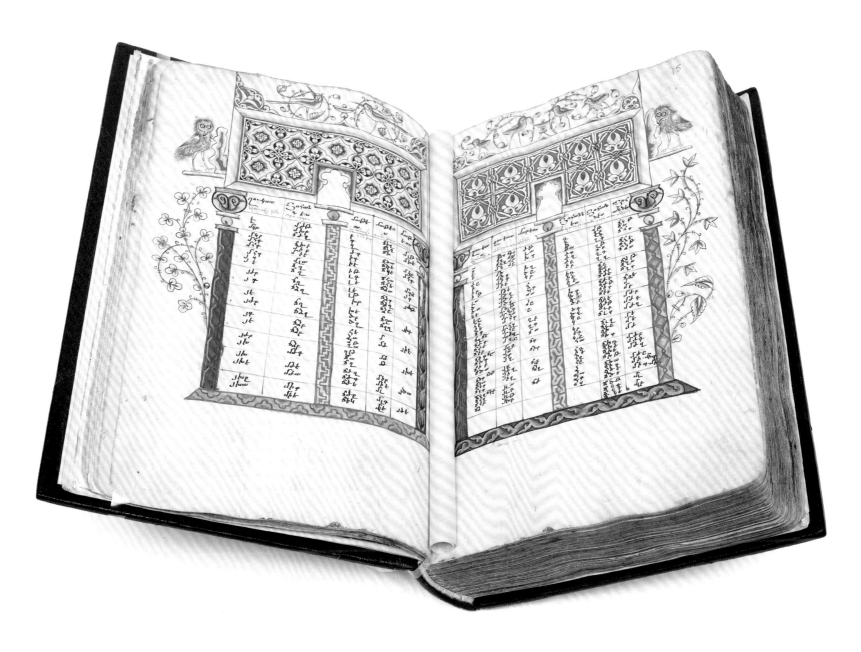

4

And on the seventh day God rested
Four Gospels

27.7 x 19 cm, paper
Yakob of Julfa
Yakob *sarkawag* (deacon) of Julfa
[Old] Julfa 1587
MCR. The University of Manchester Library,
Armenian MS 20 fols 7v–8r

In this Gospel book's lengthy colophon, the scribe Yakob *sarkawag* of Julfa recorded the names of his family members as well as the many people who assisted him in producing this manuscript (fols 334r–336v). He also mentioned his teacher, Bishop Zak'aria Lmec'i, also known as Zak'aria Gnunec'i (cat. 42). Yakob was the son of Xawǰa Vali and Awłanp'aša, and had three brothers: Mirzabēk and Mirzaǰan, who died young, and one surviving brother, Nuriǰan. He was from (old) Julfa and produced this manuscript there in 1587; he also created manuscripts in other towns. A brief and highly decorative inscription formed of large, ornate, entwined letters takes up most of the left column on fol. 268r and states: 'Remember me, Yakob the artist'. The image of the Triumphant Cross (fol. 35v) includes a portrait of Yakob on the left, inscribed: 'Remember the sinful Yakob, O Lord, when you come in glory to judge the sinful'.

This manuscript includes some extraordinary imagery. In addition to the extensive prefatory cycle depicting scenes from the life of Christ, Yakob also included a series of full-page illuminations depicting Genesis, including the six days of Creation as well as the creation of Adam and Eve. Shown here is the seventh day, when God rested (fol. 7v). The beardless God looks to the right while pointing to four heads, one above the other. These are the symbols of the Evangelists: the angel, lion, eagle and ox. The facing page (fol. 8r) is a remarkable, almost abstract depiction of the Gates of Paradise. God's eyes peer over a green arch above what might be a stylized stepped cross or perhaps a stepped altar. A cross appears over God's head; on either side of the cross are blue gates with red drapery hanging above. The source(s) of his inspiration are unknown, but some of Yakob's students perpetuated his remarkable Genesis iconography in late sixteenth-century manuscripts.

Covakan, N. (Norayr Połarean), *Hay nkarołner (ŽA–ŽĒ dar)* [Armenian Painters (11th–17th centuries)], Tparan Srbocʻ Yakobeancʻ, Jerusalem, 1989, pp. 161–4.

Der Nersessian, S., *Armenian Art,* Thames and Hudson, London, 1978, pp. 236–40 and figs 181–2.

Drampian, I., *Akop Džugaeci* [Yakob J̌ułayecʻi], Publishing Office of the Mother See of Holy Ējmiacin, Ējmiacin, 2009.

Gēorgean, A., *Hay manrankaričʻner. matenagitutʻiwn IX–XIX dd.* [Bibliography of Armenian Miniature Painters from the 9th to the 19th century], Cairo, 1998, pp. 463–6, no. 274.

Greenwood, T. and E. Vardanyan, *Hakob's Gospels: The Life and Work of an Armenian Artist of the Sixteenth Century,* Sam Fogg, London, 2006.

SM

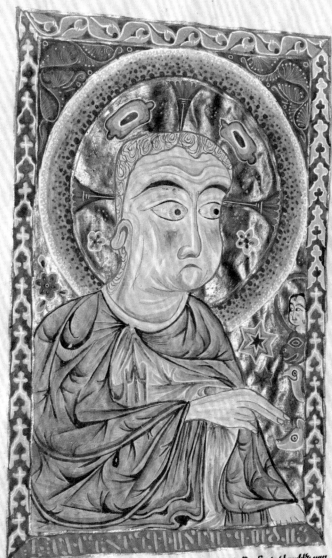

Ի սկզբանէ հարկաւորեաց զաւ զարդեաց զգաղափարեաց ․ պատառել մեզ զինչ կերպասինն զոր
ետես ․ նկարեալ հարկաւոր մեծի ։

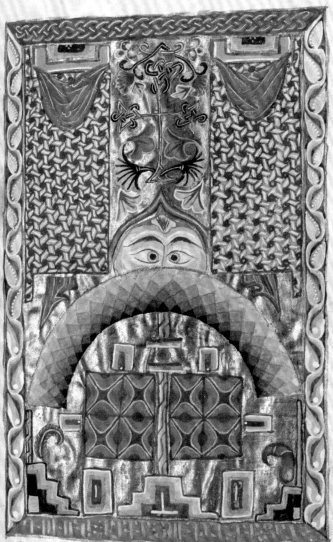

Ա յստեղ զաւ զարբ զբարձ Քեզ զոր բացաւ և բազմահաց հարբ ետ կաբատբելիա ․
վա ․ ֆետա ։

5

Manuscript binding decorated with amulets, crosses, an inscribed seal and a precious stone

Four Gospels

23.8 x 16.5 cm, paper
Karapet the priest, and Tēr Azat and Avak
Karapet the priest 1304
MS. Arm. d. 3 Front cover

This Gospel book is richly decorated with scenes from the life of Christ and the Eusebian canon tables, all placed at the beginning of the book and protected by silk 'curtains'. The Four Gospels are among the most often copied texts in Armenian; many volumes with silver bindings, ornamented with crosses or Biblical scenes and dating back as far as 1249, have been preserved. The decoration of this cover, however, represents an as yet understudied phenomenon. The blind-tooling has become all but indistinguishable under the silver items nailed onto the cover. These include a row of bosses running along the upper, lower and spine side of the cover, forming a border from which more than twenty bosses are missing. Two Maltese crosses dominate the front cover, one with a possibly precious stone in the centre, the other with an upside-down inscription: 'This cross commemorates Lord Yovhanēs [and] his spouse Ana. 1143 [1694 CE]'.

In the centre of the cover is a red seal stone with an inscription in Persian, saying: 'At dawntime Murād Ibrāhīm beseeches the Merciful Lord for the clay of his seal'. Thirty-three eye-shaped silver pieces are randomly nailed to the cover. Merian suggests that these are amulets attached to the cover as votive offerings, meant to protect the owner of the manuscript, and possibly the manuscript itself. It is unclear why the Persian seal, which must have belonged to a Muslim, was attached to the sacred book. Perhaps he too wished to receive its protection, since its central person is Jesus, a prophet in Islam. There are other examples of such cross-faith votive offerings: in the Middle East, Christians and Muslims undertake pilgrimages to shrines of each other's faith.

The manuscript may have been a 'Saint of the Home' (տան սուրբ, *tan surb*), such as are kept in villages in Armenia up to this day. This tradition is still followed by some families of the diaspora as well (cat. 86).

Baronian, S., and F. C. Conybeare, *Catalogue of the Armenian Manuscripts in the Bodleian Library*, Clarendon Press, Oxford, 1918, cols 2–4 (no. 2).

Marutyan, H., 'Home as the World', in Levon Abrahamian and Nancy Sweezy (eds), *Armenian Folk Arts, Culture and Idnetity*, Indiana University Press, Bloomington, IN, 2001, pp. 73–97, figs 2.4.3, 3.5.

Merian, S. L., 'Protection against the Evil Eye? Votive Offerings on Armenian Manuscript Bindings', in J. Miller (ed.), *Suave Mechanicals. Essays on the History of Bookbinding. Volume 1*, The Legacy Press, Ann Arbor, MI, 2013, pp. 43–93.

TMvL

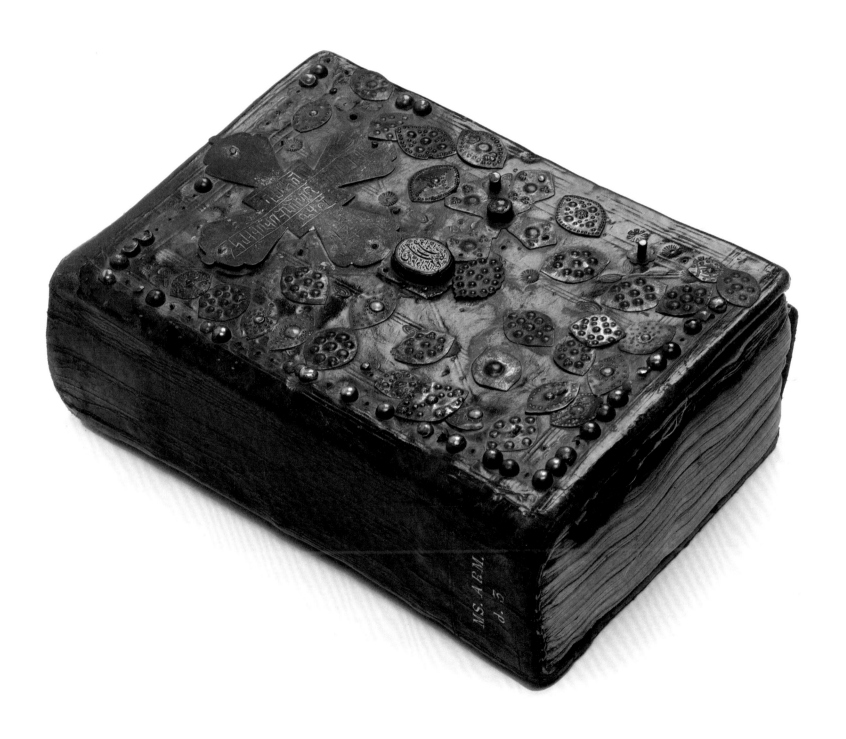

6

Nativity and the Last Supper
Four Gospels

21.5 x 15 cm, paper
Arc'ax-Karabagh (?)
13th–14th century
Matenadaran M316 fol. 11

Pictorial art from Arc'ax/Karabagh is known essentially from manuscript illuminations of the thirteenth and fourteenth centuries. The rendering of episodes from the life of Christ is very different from the standard Armenian iconography. A strong conservative tradition preserved iconography of an archaic nature that often goes back to the times of early Christianity and is dependent on the apocryphal Infancy Gospel.

In the Last Supper from M316, the Apostles are placed rhythmically around a circular table with Christ at the left shown in profile, though the table and those around it are presented in an aerial view: eleven identical, bearded and haloed heads, seemingly detached from their bodies. Judas, however, is removed to the lower right, looking away from the scene. An identical arrangement is found in the corresponding scene of another Arc'ax Gospel (M6319) and a similar setting in a thirteenth-century Syriac manuscript. Another theme of the Virgin as the redeemer of what is called the Sin of Eve has virtually no iconographic trace in early Armenian Gospel illumination. Its first unambiguous manifestation is found in the Nativity of two Arc'ax Gospels, one of them the same M316

(the other M4820). In the centre right of the miniature there is a head under the newly born Jesus. The Virgin Mary through her divine birth has redeemed the fault of the first woman. Perhaps this association could have only been preserved in regions where stories of Christ's early life in texts like the *Infancy Gospel* were popular. In it we read that Joseph shelters Mary in a shepherd's cave to give birth. While searching for a midwife he meets a woman who identifies herself as 'Eve, the foremother of all, and I have come to behold with my own eyes the redemption that is wrought on my behalf'. Within the cave Eve says: '… You restored me from that fall and established (me) in my former glory'.

In Armenian Nativity scenes, where there are often two midwives administering to the baby, it has been suggested that the one holding the child is Eve; only a single example thereof, however, can be identified, in the label 'Eve' in the eleventh-century Mułni Gospel (M7736). The Eve-Mary parallel is extremely rare in Christian iconography; the Armenian artists responsible for these pictures were most certainly inspired by apocryphal texts widespread in Armenian monasteries.

Hakobyan, H., *Miniatures of Artsak-Utik XIII–XIV cc.*, Xorhrdayin Grogh, Erevan, 1989, pp. 144–6, pls. XIII, XIV, XVIII, XXI, XXII, figs 10, 11, 13, 16.

Kévorkian, R. H., *Arménie entre Orient et Occident: trois mille ans de civilisation*, Bibliothèque nationale de France, Paris, 1996, p. 45, fig. 231, no. 45.

Kouymjian, D., 'The Art of Miniature Painting', in D. Kouymjian and C. Mutafian (eds), *Artsakh Karabagh. Jardin des arts et des traditions arméniens / Garden of Armenian Arts and Traditions*, Somogy, Paris, 2011, pp. 106–35.

Kouymjian, D., 'Some Iconographical Questions about the Christ Cycle in Armenian Manuscripts and Early Printed Books', *Analecta Ambrosiana*, Milan, 2015.

Leroy, J., *Manuscrits syriaques à peintures conserves dans les bibliotheques d'Europe et d'Orient; contribution a l'étude de l'iconographie des Eglises de langue syriaque*, Geuthner, Paris, 1964, p. 365, pl. 119, fig. 1.

Mazaeva, T. and H. Tamrazyan (eds), *La Miniature Arménienne: Collection du Maténadaran*, Editions Naïri, Erevan, 2006, pls. 189–91.

Terian, A., *The Armenian Gospel of the Infancy: with three early versions of the Protevangelium of James*, Oxford University Press, Oxford, 2008, p. 44.

Zakarian, L., *Iz istorii Vaspurakanskoi miniatiury*, Akademia Nauk, Erevan, 1980, pp. 93–4, figs 39, 40, 42.

DK

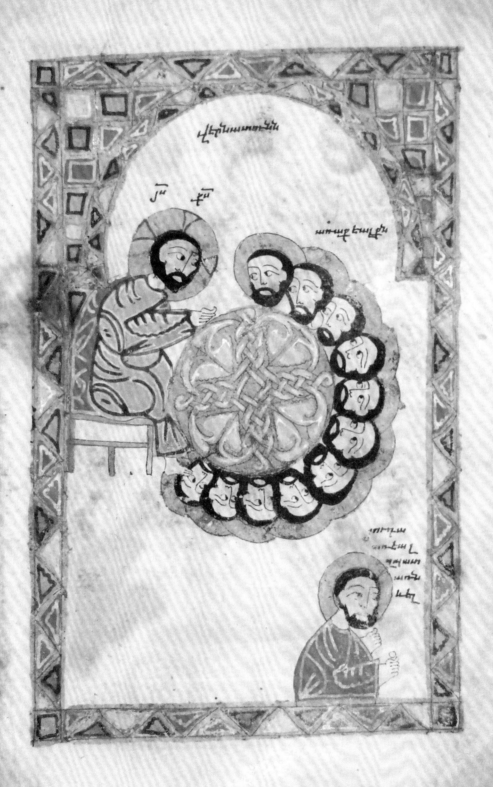

7
An Unusual Apocalypse
Bologna Bible

29 x 21 cm, parchment
a) Aṙak'eal; b) Step'annos *k'ahanay*; c) Nikołos
a) Bologna; b) Kazaria, Crimea; c) Kafa, Crimea
a) before 1368; b) 1368; c) 1660
Matenadaran M2705 fol. 483r

Manuscripts of complete Bibles are less common in the Armenian tradition than other sacred texts, such as the Four Gospels. The complicated history of this Bible results from its three stages of production. The Old Testament and Book of Revelation were copied by the first scribe Aṙak'eal in Bologna before 1368, as we are informed by the colophon of the second scribe, Step'annos *k'ahanay* (priest). Three full-page illuminations, two of which are scenes from the Apocalypse, were completed around this time by an unnamed artist. In 1368, the scribe Step'annos completed the New Testament in Kazaria, Crimea, and more illuminations were added by an unknown artist. By 1660, the renowned scribe and artist Nikołos undertook a major restoration of the manuscript, recopying the Old Testament which had been damaged. He also replaced the Genesis frontispiece, presumably with an exact copy.

In general, Armenian manuscript Bibles before the seventeenth century do not include illustrations of the Apocalypse, except for occasional author portraits or other minor images. By the seventeenth century, Armenian Bibles were often illuminated with literal depictions of the Apocalyptic text, directly inspired by illustrations in western European printed books to which the artists were exposed. The Apocalypse images in the Bologna Bible, probably from the late thirteenth or early fourteenth century, are highly unusual in an Armenian manuscript. The Heavenly Jerusalem, shown here, is a literal depiction of Rev 21–22, with the twelve gates formed of jewels at the bottom, the river of the water of life flowing from the throne of God and the Lamb through the middle of the street of the city, with trees of life on either side. Christ enthroned appears at the top, flanked by the Virgin and a winged John the Baptist (a popular Byzantine figure). Stylistically this has many parallels with fourteenth-century Italian frescos, and it is possible that the artist was an Armenian trained by a northern Italian artist, or perhaps even a local Italian.

Buschhausen, H. and H. Buschhausen, 'Die Herkunft der Armenier im ehemaligen Gebiet der Habsburgermonarchie', *Steine Sprechen*, vol. XLII/2–3, no. 127, August 2003, pp. 2–22.

Durand, J., I. Rapti, D. Giovannoni (eds), *Armenia Sacra*, Somogy, Paris, 2007, pp. 286–7.

Korkhmazian, E. M., 'Deux manuscrits arméniens écrits et illustrés à Bologne', in Boghos Levon Zekiyan (ed.), *Atti del Quinto Simposio Internazionale di Arte Armena*, San Lazzaro, Venice, 1991, pp. 517–26.

Korkhmazian, E., I. Drampian, and G. Hakopian [H. Hakopian], *Armenian Miniatures of the 13th and 14th Centuries*, Aurora Art Publishers, Leningrad, 1984, nos 158–9.

Lymberopoulou, A., 'A Winged Saint John the Baptist Icon in the British Museum', *Apollo*, 158.501, November 2003, pp. 19–24.

Mazaeva, T. and H. Tamrazyan (eds), *La Miniature Arménienne: Collection du Maténadaran*, Editions Naïri, Erevan, 2006, figs 206–08.

Merian, S. L., 'Illuminating the Apocalypse in Seventeenth-Century Armenian Manuscripts: The Transition from Printed Book to Manuscript', in Kevork B. Bardakjian and Sergio La Porta (eds), *The Armenian Apocalyptic Tradition: A Comparative Perspective*, Brill, Leiden, 2014, pp. 603–39.

SM

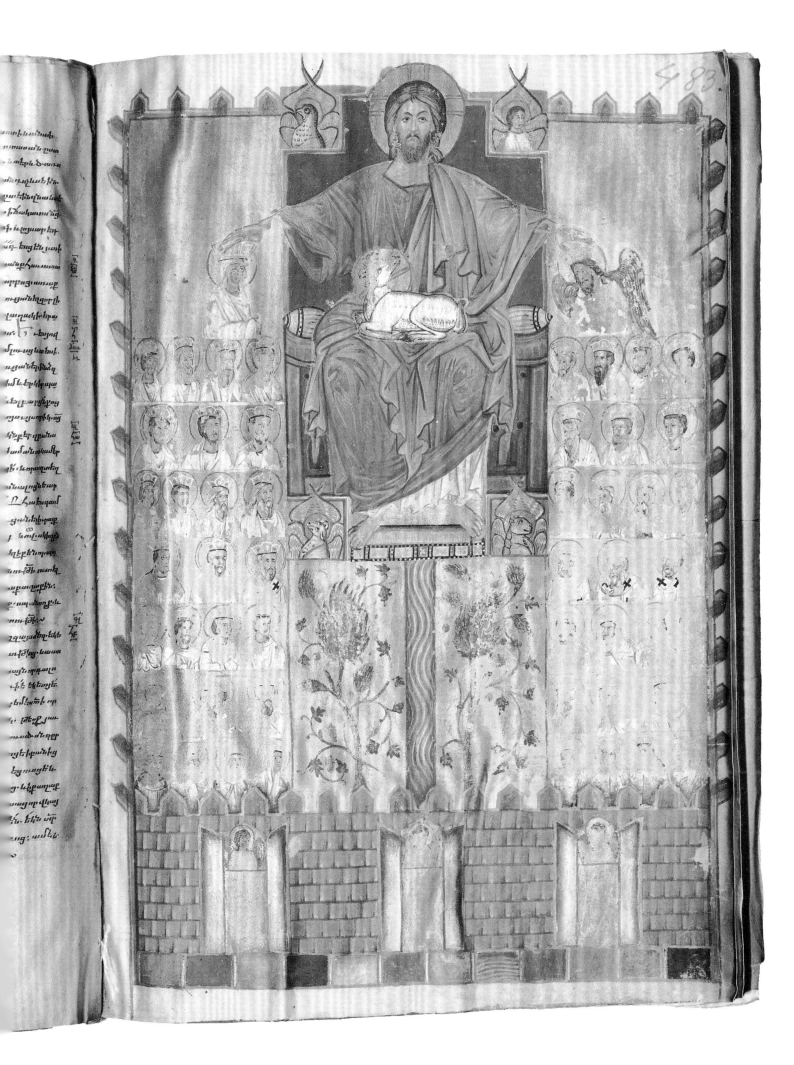

8

One of the three myrophores carrying a flask of spices to anoint Jesus's body

Four Gospels

27 x 19 cm, paper
Bishop Aristakēs
Naxijewan, Sisian
MS. Arm. d. 21 fols 108v–109r

This volume of the Four Gospels, written in black ink in clear *bolorgir*, with capitals in red, was copied and illuminated by Bishop Aristakēs in at least three locations: Naxčevan, then Sisian, and finally 'in the mountains', where he fled through lack of peace in 1617. The manuscript was later bought and restored by a certain Simon, who then offered it to the Church of St Gevorg in Angł, near Lake Van; it is unclear when this happened. In 1755, Hoṙom, his son Gazpar and his sister Gulvard bought the book for two *łuruš* and placed it in the Church of St George the General (Սուրբ Գէորգ Զորավար). On 11 May 1883, Łewond *vardapet* acquired it and in 1915 it was catalogued by Ervand Lalayan as part of the Vaspurakan Collection. It was Sir Oliver Wardrop who donated it to the Bodleian Library in 1920. The canon tables and full-page illuminations are unfortunately absent, except for three of the four evangelists (Luke is missing).

The Gospels were divided in numbered sections. In the left margins, next to the large red initials, these section numbers are given. The first one on the left page is the number 228 (միը = 200 + 20 + 8) over which the abbreviation sign ` is placed to indicate that the letters represent numbers; this sign is called 'honour' (պատիւ), since its use spread from abbreviated *nomina sacra*. It is so used in the first line of the left column of fol. 108v., where 'of god' (այ) renders the fuller form աստուծոյ.

We have a concordance at the foot of the page – մր (mr) for Mark – under which the section at the opening of the page is given: 227 (միէ). Next to it appear the sections with similar content in the three other gospels, for example η (ł) and մլբ (mlb) reflect the Gospel of Luke, section 232. The central capital Թ̊ (T') indicates that this is the last folio of the ninth quire; on the next page we find Ժ̊(Ž), i.e. fol. 1 of quire 10. Uncorrected errors (միլ for մե, զխաչելեալն for զխաչեալն or զխաչեցեալն, ելի for ելին) occur next to orthographical variants (հայրիւ[ր]ապետ and հարիւրապետ), and an unusual grammatical form (եմաւտ).

Nersessian, V. N., *A Catalogue of Armenian Manuscripts in the British Library acquired since the year 1913 and of collections in other libraries in the United Kingdom*, The British Library, London, 2012, vol. 1, pp. 292–4, no. 47.

TMvL

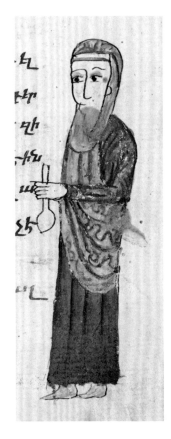

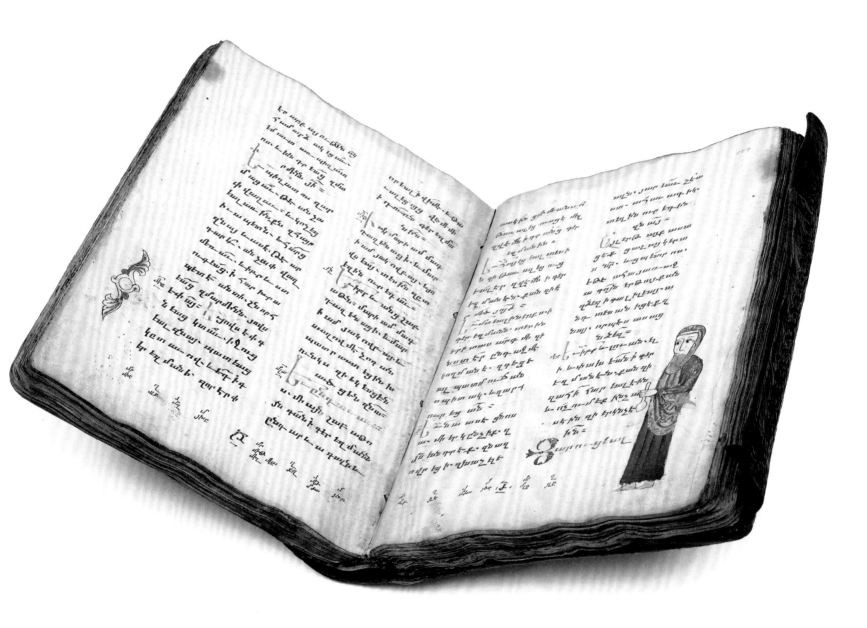

9
Representing the Resurrection
Four Gospels

37 x 19 cm, paper
Sargis Mokʻacʻi (or Sargis Mazman)
Late 16th century
MS. Arm. d. 22 fols 7v–8r

Sargis of Mokʻs (also known as Sargis Mazman), the son of Yovhannēs the priest and Tʻurvantay, was a native of Mokʻs, south of Lake Van, near Xizan. He was a student of the renowned master Martiros Xizancʻi, and in turn taught a number of artists including Mesrop of Xizan (cat. 1, 2). He probably died in 1602.

Although the colophon of this Gospel book is missing, two short inscriptions on fols. 12r and 13r name him as the artist. The programme of illumination for this Gospel book is typical. Fourteen full-page illuminations are placed at the beginning of the book, depicting scenes from the life of Christ. These are followed by the two-page Eusebian letter to Carpianos and then eight full-page canon tables. Each Gospel is preceded by a portrait of its author (except Matthew, whose portrait is missing) and a decorated incipit page. The Harrowing of Hell and Three

Women at the Tomb, depicted here on facing pages, both symbolize the Resurrection. Since there were no witnesses to the Resurrection of Christ and it is not described in any of the Four Gospels, until the seventeenth century Armenian artists did not portray this event by showing him stepping out of the sarcophagus or floating above it, as became common in western European traditions from the thirteenth century. Instead, Armenians showed the Resurrection symbolically by one or both of these scenes. The Harrowing of Hell (left) depicts Christ descending into Hell after his death to liberate the Old Testament saints. On the right are the three women arriving at Christ's tomb to anoint his body; they are the first to learn of his Resurrection. In this manuscript, the illumination of the three women at the tomb is even labelled 'Resurrection of our Lord Jesus Christ' (Յարութիֆ՟ ոʼն մերոյ յի ֆի).

Covakan, N. (Norayr Połarean), *Hay nkarołner (ŽA–ŽĒ dar)* [Armenian Painters (11th–17th centuries)], Tparan Srbocʻ Yakobeancʻ, Jerusalem, pp. 157–60.

Gēorgean, A., *Hay manrankaričʻner. Matenagitutʻiwn IX–XIX dd.* [Bibliography of Armenian Miniature Painters from the 9th to the 19th century], Matenadaran, Cairo, 1998, pp. 663–6, no. 409.

Nersessian, V. N., *A Catalogue of the Armenian Manuscripts in the British Library acquired since the year 1913 and of collections in other libraries in the United Kingdom*, The British Library, London, 2012, vol. 1, 249–53, no. 36.

SM

10

God the Creator, Adam and Eve in Paradise, the Transgression, and the Expulsion from Paradise
Bible

26.1 x 19.5 cm, parchment
Yakob *dpir* Aknc'i (for the priest Gaspar Aknc'i)
Constantinople 1641–3
Matenadaran M188 fols 11v–12r

The style of seventeenth-century Armenian manuscript illumination in Constantinople drew on Cilician Armenian work, which between the twelfth and fourteenth centuries featured masterpieces of manuscript painting, incorporating Byzantine and European elements.

The illumination consists of three strips. The upper one shows God the Creator seated on a throne, surrounded by the four living beings from Ezekiel's vision (Ez. 1, 10), mentioned also in Revelation; three angels flank it on each side. The surroundings are entirely in gold; patches of blue suggest the sapphire firmament.

The lower strips relate Adam and Eve's fall: God's instructions, the snake and the eating of the apple, the confrontation with God, their punishment, expulsion and despair. The second strip shows a naked, then clothed Adam and Eve placed in an unconfined Garden of Eden, with brightly coloured flowers and fruits among the lush green. The third features a walled Garden, guarded by an angel with a sword, next to a flaming seraph: a double depiction demarcating an irreparable loss, except for the four living beings, symbols of the good tidings of redemption through Christ. Birds joyously top the frame, reminding of Sargis Picak's Cilician painting of three centuries earlier (Mathews and Wieck, *Treasures in Heaven,* pl. 25).

The subject and layout of this illumination is found also in BL Or 8833, a Bible copied in New Julfa in 1646. Illuminations in which the days of the Creation are depicted in medallions, with the creation of Adam and Eve followed by their fall, are present in various Bibles, such as Getty MS Ludwig I.14 (fol. 2v), dated 1637–8 and J1933 (fol. 7v), dated 1645; both codices were created in New Julfa, but are based on models from Constantinople (e.g. J438, dated 1620).

Eganyan, Ō., A. Zeyt'unyan and P'. Ant'abyan, *Mayr c'uc'ak hayerēn jeṙagreri' Maštoc'i anuan Matenadarani* [Catalogue of Armenian Manuscripts in the Maštoc' Institute (Matenadaran)], HSSH GA hratarakč'ut'yun, Erevan, 1984, cols 793–804.

Mathews, T. F. and R. S. Wieck (eds), *Treasures in Heaven. Armenian Illuminated Manuscripts,* The Pierpont Morgan Library, New York, 1994, pp. 174–5, pl. 38, no. 39.

Mazaeva, T. and H. Tamrazian (eds), *La Miniature Arménienne,* Matenadaran – Nairi, Erevan, 2006, p. 296, no. 230; p. 303, no. 98.

Nersessian, V., *Treasures from the Ark,* The British Museum, London 2001, pp. 219–20, no. 152.

TMvL

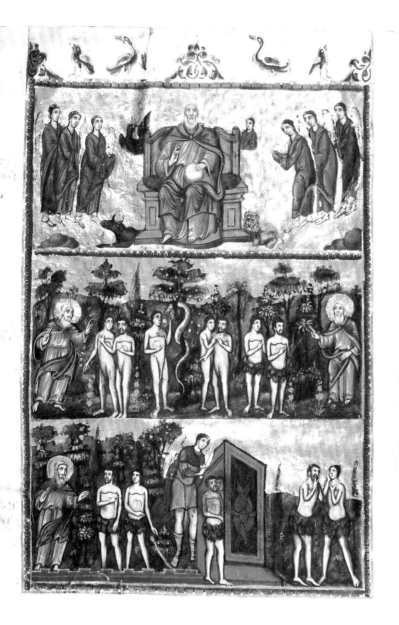

ՍԿԻԶԲՆ ԱՐԱՐԱԾՈՑ

ՀԱՄԵՄԱՏ ԵԲՐԱՅԵՑՒՈՅ ԵՒ ԵՒԹԱՆԱՍՈՒՆԻՑՆ ԵՒ ՀԻՆԳ ՊԱՏ

11

Throne Vision of Ezekiel
Bible

26 x 19.5 cm, parchment
Hayrapet Ĵułayecʻi (for Xōĵa Petros [Vēliĵanean (?)])
Astuacatur
New Julfa 1648
Matenadaran M2587 fols 452v–453r

This Bible was illuminated by Hayrapet Ĵułayecʻi, who in the course of fifty-two years (1639–91) illuminated over thirty manuscripts. Hayrapet enjoyed great prestige, as the seven Bibles he copied in the 1640s alone show, all of which were very expensive commissions.

This particular Bible was copied from an exemplar today held in the Matenadaran as well (M351), the Bible commissioned by Łazar Baberdacʻi, copied in Lvov (Lviv) in 1619. That Bible represents the third Armenian redaction of the Biblical text, after the ones by Nersēs Lambronacʻi (twelfth century) and Georg Skewracʻi (thirteenth century), which was particularly favoured in New Julfa. 'The Throne Vision of Ezekiel' is a fundamentally important organizing image in Christianity for its pervasive influence on the representation of the four evangelists, who together through the New Testament offer a Throne

for Christ-God, and at the same time a renewed Garden of Eden, as both Vardan Anecʻi's mystical poetry and Nersēs Šnorhali's *Commentary on the Canon Tables* witness. This illumination was also copied from manuscript M351. The artist illuminating that Bible had copied it from the Latin Bible printed in Mainz in 1609; it is an almost exact copy from the engraving by Johann Theodor de Bry.

The throne chariot and the cross are both the seat of Christ-God, who is so depicted at his second coming, heralded by trumpeting angels. It achieves all-encompassing importance also as it provides the imagery for the throne of God in Revelation as the Last Judgment is about to be passed. The vision Ezekiel saw at the River Chebar in Babylonian exile proclaimed the omnipresence of God and his global redeeming power; the Christian understanding of it offers a powerful reinterpretation also in Armenian literature and art.

Covakan, N. (Norayr Połarean), *Hay nkarołner* (ŽA–ŽĒ dar) [Armenian Painters (11th–17th centuries)], Tparan Srbocʻ Yakobeancʻ, Jerusalem 1989, pp. 216–20.

Merian, S. L., 'Illuminating the Apocalypse in Seventeenth-Century Armenian Manuscripts: The Transition from Printed Book to Manuscript', in Kevork B. Bardakjian and Sergio La Porta (eds), *The Armenian Apocalyptic Tradition: A Comparative Perspective*, Brill, Leiden–Boston, 2014, pp. 603–39.

Tēr Vardanean, G., Description of M2587: Letter to the Director of the Matenadaran, H. Tʻamrazyan, 7 August 2014.

van Lint, T. M., 'Vardan Anetsi's Poem On the Divine Chariot and the Four Living Creatures, 10th–11th Century', in Richard G. Hovannisian (ed.), *Armenian Kars and Ani*, Mazda Publishers, Costa Mesa, 2011, pp. 81–100.

van Lint, T. M., 'Geometry and Contemplation: The Architecture of Vardan Anecʻi's Vision of the Throne-Chariot. *Theosis* and the Art of Memory in Armenia', in Bardakjian and La Porta, *The Armenian Apocalyptic Tradition*, pp. 217–41.

TMvL

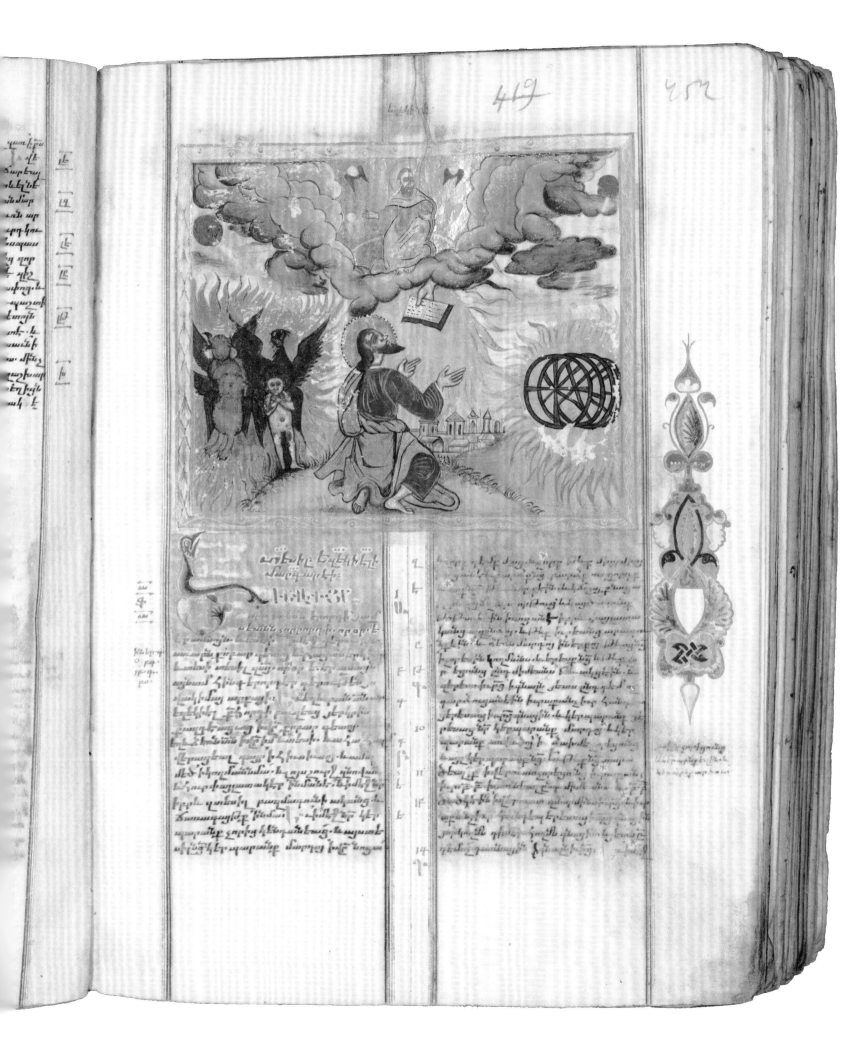

Celebrating the Liturgy: Devotional Books

While Christianity had become state religion in *c.*314 CE, liturgical books in Armenian were developed only after the invention of the Armenian alphabet in *c.* 405 CE. The liturgy was celebrated in Greek or Syriac and translated orally. In several of its elements, the Armenian liturgy preserves the oldest layer of Christian worship. Winkler mentions that in its creeds, initiation rites, the organization of the daily prayers, and in the older recension of the Eucharistic liturgy of Basil of Caesarea, the Armenian offices reflect a Syriac translation technique, thought pattern or liturgical practice. Renoux has shown that the Armenian Lectionary (Ճաշոց) derives from fourth-century practice in Jerusalem. Three early components are thus discernable: a Syriac layer, based on the earliest evangelization, from Edessa; a Cappadocian layer, centred around Caesarea, reflecting Greek Christianity; and a Jerusalemite layer. A fourth layer is formed by changes and additions introduced on the basis of the Latin liturgy from the twelfth century onward.

The Four Gospels (Աւետարան, lit. *Book of Good Tidings*) are indispensible for the celebration of the liturgy. They are the most frequently copied manuscripts in

Armenian, with over 2,000 preserved exemplars. The readings and prayers read throughout the year are collected in the Lectionary (Ճաշոց), usually a book of considerable format. The *Maštocʿ* (Մաշտոց), and *Mayr Maštocʿ* (Մայր Մաշտոց, an amplified version of the previous) contain the sacraments, funeral rites, hymns and prayers, as well as blessings. The Homiliary (Տօնական, Ճառընտիր) contains sermons from the Church Fathers read during the Night Office. Another usually large volume is the Menologion or Synaxarion (Յայսմաւուրք), containing readings for the Saint for every day of the year.

The Breviary (Ժամագիրք) contains the psalms and prayers of the eight daily offices (կարգ); the Psalter (Սաղմոսարան) contains the Psalms and other devotional material. The Hymnal (Շարակնոց) is of particular importance for the development of Armenian poetry and music, as are the *Tałaran* (Տաղարան) and *Ganjaran* (Գանձարան). There are further: the Missal (Խորհրդատետր), the text of the Divine Liturgy (Պատարագամատոյց). The *Tonacʿoycʿ* (Տօնացոյց) indicates the readings performed during Mass, often accompanied by a liturgical calendar (Պարզատումար).

Galadza, P., 'Books, Liturgical. 2.1. Armenian', in P. F. Bradshaw (ed.), *The New SCM Dictionary of Liturgy and Worship*, SCM Press, London, 2002, pp. 67–8.

Mahé, J.-P., 'Connaitre la Sagesse: le programme des anciens traducteurs arméniens', in R. H. Kévorkian (ed.), *Arménie entre Orient et Occident. Trois mille ans de civilisation*, Bibliothèque nationale de France, Paris, 1996, pp. 40–61.

Nersoyan, T., *Pataragamtoycʿ hay aṙakʿelakan ułłapʿaṙ ekełecʿwoy* [Divine Liturgy of the Armenian Apostolic Orthodox Church with Variables, Complete Rubrics and Commentary], Saint Sarkis Church, London, 1984

Outtier, B., 'Les recueils arméniens manuscrits', in C. Mutafian (ed.), *Arménie: la magie de l'écrit*, Somogy, Paris, 2007, pp. 94–103.

Renoux, Athanase (Charles), *Le codex arménienne Jérusalem 121*, 2 vols, Brepols, Turnhout, 1969, 1971

Renoux, C., 'Traduction liturgiques et rite arménien', in M. Albert, R. Beylot, R.-G. Coquin, B. Outtier, C. Renoux, A. Guillaumont (eds), *Christianismes Orientaux. Introduction à l'étude des langues et littératures*, Les Éditions du Cerf, Paris, 1993, pp. 130–36.

Terian, A., *Macarius of Jerusalem. Letter to the Armenians, AD 335*, St Vladimir's Seminary Press, St Nersess Amenian Seminary, Crestwood, NY, 2008.

Winkler, G., 'Armenian Worship', in P. F. Bradshaw (ed.), *The New SCM Dictionary of Liturgy and Worship*, SCM Press, London, 2002, pp. 25–8.

TMvL

12

The last page of an Antiphonary, followed by the colophon
Antiphonary

13.3 x 8.9 cm, paper
Banarges
Erznka (Erzincan) 1295
MS. Arm. f. 22 fols 178v–179r

The opening of the scribe Banarges' colophon on fol. 179r reads: 'By the grace of the Lord I began and through his mercy I finished this little book in the era of the Armenians 744 (ՉԽԴ = 1295 CE) in the hermitage called Erez, under the protection of the Holy Mother of God and of the Sufferings of this Place of St Grigor the Illuminator of the Armenians'. The monastery was large and prosperous, located in the area of Erznka (Erzincan), and was known under various names, one of which was the Monastery of the Iron Thistle (տատասկ), an instrument of torture applied to St Grigor.

The manuscript contains antiphons (մեսեդի), developed from the Psalms and sung at the various offices performed in Church, and at different feast days in the ecclesiastical year. Fol. 178v and the first five lines of fol. 179r give the opening lines of hymns; the mode in which they are sung is noted in the margin. Some words are abbreviated, the remainder being known to the singers.

This hymnal can be easily held in one's hand and is much used. Often text and neumes (խազ) succeed one another seamlessly. Neumes are placed above vowels as well: of the two alleluias (ալէլուիա) in ll. 5–6 of the right page, the first has neumes above the letters, while those for the second are on the same level as the script.

Baronian, S., and F. C. Conybeare, *Catalogue of the Armenian Manuscripts in the Bodleian Library*, Clarendon Press, Oxford, 1918, cols 121–23, no. 60.

Galadza, P., 'Books, Liturgical; 2. Eastern Churches; 2.1 *Armenian*', in Paul F. Bradshaw (ed.), *The New SCM Dictionary of Liturgy and Worship*, SCM Press, London, 2002, pp. 67–8.

Ōrmanean, M. A., *Cisagitutʻiwn Hayastaneaycʻ Surb Ekełecʻuoy* [Liturgiology of the Holy Armenian Church], Tparan Srbocʻ Yakobeancʻ, Jerusalem, 1977, pp. 69–70.

Oskean, H. Hamazasp, *Barjr Haykʻi vankʻerě* [The Monasteries of Barjr Haykʻ], Mekhitaristenverlag, Vienna, 1951, pp. 101–03.

Thierry, J.-M., *Répertoire des monastères arméniens*, Brepols, Turnhout, 1993, p. 29, no. 144.

TMvL

13

The beginning of the Order of the Alleluias in the Night Office
Antiphonary

14 x 10.2 cm, brownish paper
14th century
MS. Arm. f. 23 fols 16v–17r

The colophon of this Antiphonary is lacking, wherefore the script, identified by Baronian and Conybeare as fourteenth-century *bolorgir* (roundscript, բոլորգիր) and corroborated by dated examples in the *Album of Armenian Paleography,* is the only dateable feature. The manuscript has no other decorations except for the marginals and rubrics in red ink, the latter of which are characteristic also of cat. 14. The structure of this Antiphonary is similar to that of the older example exhibited (cat. 12). The left page gives the final part of the chant called Kings (թագաւորք) for Stephen Protomartyr, which is the last of the chants of penitence in the Night Office on Fridays. The term derives from the appellative 'King of Heaven', with which the first of the three parts of these penitential chants opens. The second part is called 'psalm' (սաղմոս), indicated here in the left margin with the abbreviation sł (սղ).

The third part is called 'change' (փոխ) and contains a doxology of the trinity.

Under the decorative band the right page shows the opening of the Order of the Alleluias of the Night Office (կարգ զիշերութեան Ալելուաց), with the sign aj (աձ) in the margin indicating that these need to be sung according to the first of the eight different modes (առաջին ձայն). Then follow the abbreviated opening lines of the Alleluia section for the Night Office of each of the dominical feasts, also indicated by abbreviations in the margin: յր for Resurrection (յարութիւն), then ծն for the Nativity (the birth of Christ, ծննունդ Քրիստոսի), followed by հբ, that is Ascension (համբարձումս), խչ for the Cross (խաչ), and եկ, the Church (եկեղեցի). The last Alleluia, indicated as ղյ, that is the Raising of Lazarus (ղազարու յարութիւն), is only sung on a particular day.

Baronian, S., and F. C. Conybeare, *Catalogue of the Armenian Manuscripts in the Bodleian Library*, Clarendon Press, Oxford, 1918, cols 136–7, no. 62.

Ōrmanean, M. A., *Cisagitutʻiwn Hayastaneaycʻ Surb Ekełecʻuoy* [Liturgiology of the Holy Armenian Church], Tparan Srbocʻ Yakobeancʻ, Jerusalem, 1977, pp. 31–4.

Stone, M. E., D. Kouymjian and H. Lehmann, *Album of Armenian Paleography*, Aarhus University Press, Aarhus, 2002.

TMvL

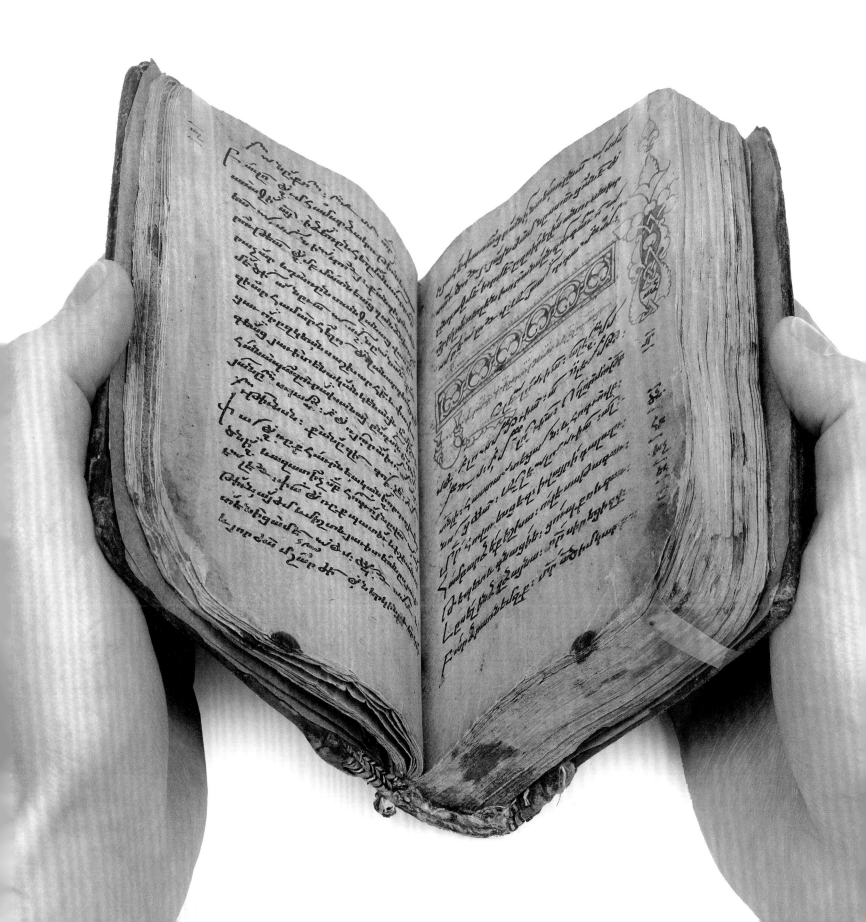

14

Bless the Lord with a new blessing, bless the Lord all earth
Psalter (Սաղմոսարան)

14.6 x 10.8 cm, paper
17th or 18th century
MS Arm. f. 4 fols 102v–103r

No names of scribe or patron, nor place of provenance of this Psalter (Սաղմոս[արան]) have been preserved. Baronian states that the neat *nōtrgir* writing suggests a date of copying in the seventeenth or eighteenth century. Comparison with several dated examples in the *Album of Armenian Paleography* roughly corroborates this: one is another Psalter, dated 1590; another contains Nersēs Šnorhali's *Commentary on Matthew*, dated 1644. The manuscript is held in a modern Near Eastern binding.

While the origins of the manuscript are unclear, a note at the end of the volume states that Tēr Karapet was consecrated priest in May 1850 at Nicodemia by the Archbishop Stepʻanos. It was sent as a donation to the Bodleian Library from Smyrna by the Rev. G. J. Chester (BA) on 28 November 1889.

This Psalter is divided into eight canons or books (կանոն), all divided into seven sections (պարողայ). Section beginnings are marked with ornamental initials and marginal decorations. Each canon has an illuminated headpiece of light red and dark blue. The pages shown contain Psalm 94 (95): 9-11 and Psalm 95 (96): 1-12. The opening of Psalm 95 (96) reads: 'Bless the Lord with a new blessing, bless the Lord all earth' (Աւրհնեցէք զտէր աւրհնութեամբ նոր. աւրհնեցէք զտէր ամենայն երկիր). The NRSV has 'song' for the Armenian 'blessing'.

The size favours carrying the book on one's person, and may have been used for private devotion as well as for church service. The Psalter would be recited and prayed through in its entirety every week.

Baronian, S. and F. C. Conybeare, *Catalogue of the Armenian Manuscripts in the Bodleian Library*, Clarendon Press, Oxford, 1918, cols 137–141, no. 47.

Stone, M. E., D. Kouymjian, H. Lehmann, *Album of Armenian Paleography*, Aarhus University Press, Aarhus, 2000, pp. 432–3 and 440–41, nos 158 and 162.

TMvL

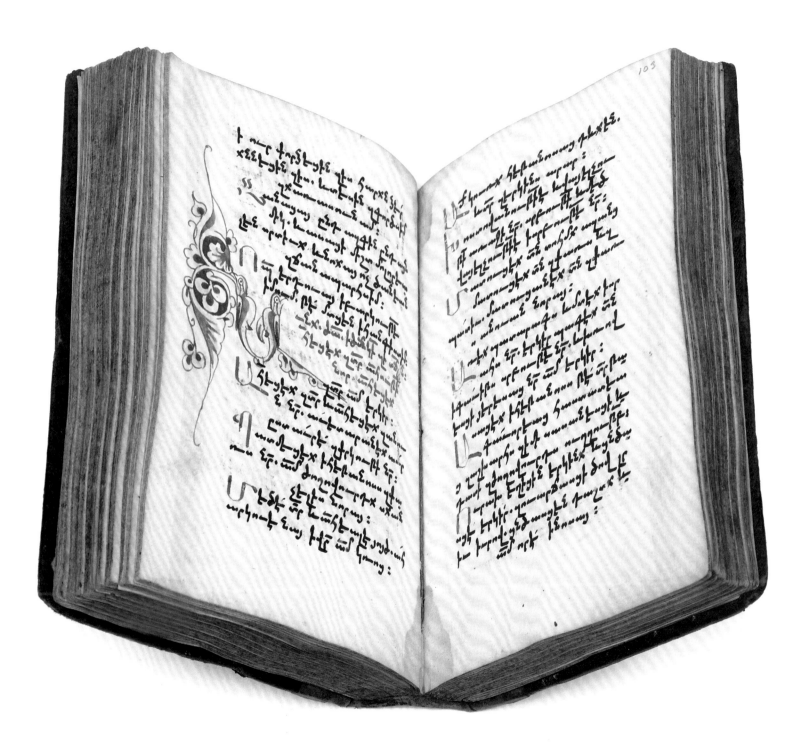

15

Adoration of the Magi and Revelation to the shepherds
Lectionary (Ճաշոց)

34 x 21.7 cm, paper
Mkrtič' *varpet* and his pupil Tēr Petros (for Paron and Xōĵa Barałam and Parakʻiaz)
'non-Stepannos'
New Julfa 1632
MS. Arm. c. 1 fols 1v–2r

This Lectionary (Ճաշոց) was copied in New Julfa by a scribe who calls himself 'non-Stepannos', so as not to associate his sinful self with the protomartyr. The Lectionary contains the readings and prayers read throughout the year, and is usually a book of considerable format, as is this copy. This volume is organized according to the fifteenth-century arrangement, which added more saints' days. It closely resembles the printed editions of Venice (1688) and Constantinople (1732). There are three full-page illuminations, each richly coloured upon a background of gold, opposite the pages where a main section of the liturgical year begins. These are demarcated by high-quality headpieces and marginal decorations, while the heading of each day has a large initial and the rubrics are in red ink.

The script on the right page is a feast of colour and imparts the joy their meaning conveys: the good news of Christ's birth proclaimed to the shepherds. The initial shows two saintly persons carrying swords, followed by large ornithomorph capitals in many colours. Then warm gold and clear blue abound until the text settles down in neutral but firmly and elegantly shaped *bolorgir*. The decoration on the right side of fol. 2r, a tree of life topped by a cross, contains figures of birds, other animals and people, over a gold background with suggestions of foliage. It was added after the text was finished: some letters have disappeared under it as in l. 6 [ւա], l. 8 [ւծ]ետաւլ and l. 9 [ից] էր. The text on the opening page relates the story according to the Gospel of Luke (2.8–13). The illumination shows instead the story of the Magi, related in Mt 2.1–12, at the moment they enter the house and adore the Christ child in Mary's arms (Mt 2.11). Its division of space is reminiscent of Persian manuscript painting. The architectural structures with the vista of nature and the windows suggest a use of perspective that enlivens the flat surface of the gold background. The youngest of the magi stepping out of the frame of the image also lends dynamism to the scene.

Baronian, S. and F. C. Conybeare, *Catalogue of the Armenian Manuscripts in the Bodleian* Library, Clarendon Press, Oxford, 1918, cols 137–41, no 63.

Renoux, C., 'Traduction liturgiques et rite arménien', in Micheline Albert, Robert Beylot, René-G. Coquin, Bernard Outtier, Charles Renoux, Antoine Guillaumont (eds), *Christianismes Orientaux. Introduction à l'étude des langues et littératures,* Les Éditions du Cerf, Paris, 1993, pp. 130–36.

TMvL

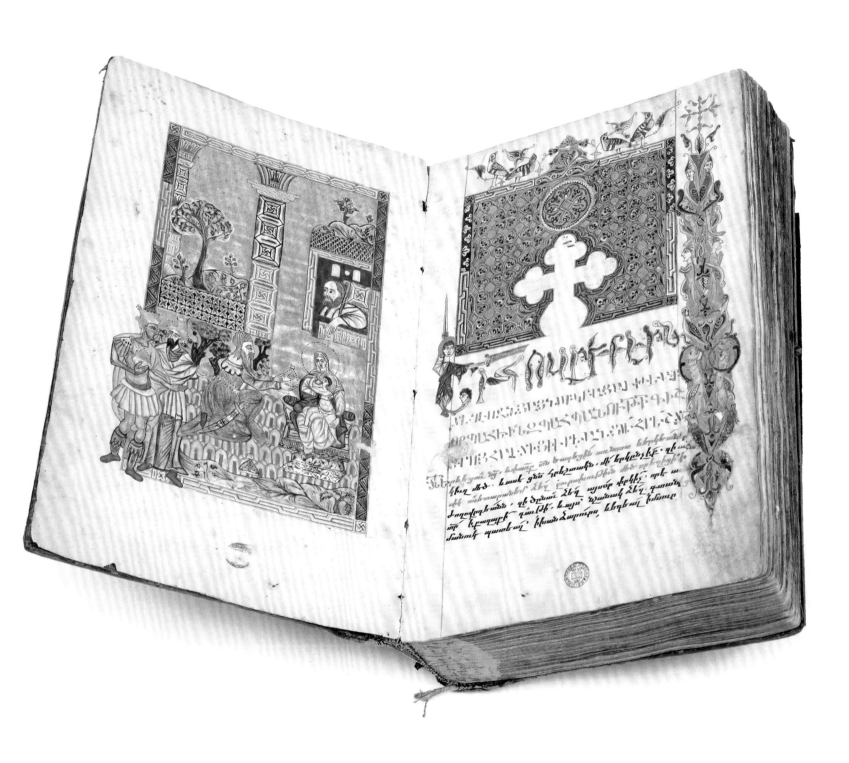

The opening of the Armenian liturgical year
Synaxarion (Յայսմաւուրք)

36.8 x 26.7 cm, paper
Daniel and Thomas (for the priest Sion)
*c.*1500
MS. Arm. c. 3 fol. 1r

This sixteenth-century Synaxarion (Յայսմաւուրք), also called a menologion or martyrologion, opens with a multi-coloured headpiece preceding the vitas of St John the Baptist and At'enogenes, which mark the opening of the Armenian liturgical year, on 1 Navasard, coinciding with 11 August; as is usual, the opening line of the first life is written in ornithomorph letters, some lines in rectangular script or *erkat'agir* (Երկաթագիր), the remainder in *bolorgir* (roundscript, բոլորգիր).

The manuscript can be dated between 1421, since a miracle reported in that year is recorded, and before 1618, the year in which it was repaired and bound by Mesrop *dpir*. Based on the style of writing, Baronian and Conybeare consider a date soon after 1500 most likely. Daniel and Thomas

copied it for the priest Sion, whose family is mentioned extensively. Others have contributed memorial notes as well, in particular the family of the later owners Xodšay T'uman and his brother Mahdas Andrias, who bought the book and placed it at the door of Holy Sion. The Bodleian Library bought it from Hannan, Watson & Co. in 1899.

The Synaxarion records the lives of saints, both Armenian and others, to be read on each day of the year, and contains a series of homilies as well. The lives are either translated or original compositions. The book has gone through various redactions since its inception. A colophon (fols 543v–544r) states that this volume follows the redaction of Grigor Xlatec'i Cerenc', who was also a well-known manuscript illuminator (d.1425).

Baronian, S., and F. C. Conybeare, *Catalogue of the Armenian Manuscripts in the Bodleian Library*, Clarendon Press, Oxford, 1918, no. 64.

Galadza, P., 'Books, Liturgical. 2.1. Armenian', in P. F. Bradshaw (ed.), *The New SCM Dictionary of Liturgy and Worship*, pp. 67–8.

Outtier, B., 'Les recueils arméniens manuscrits', in Claude Mutafian (ed.), *Arménie: la magie de l'écrit*, Somogy, Paris, 2007, pp. 94–103.

Połarean, N. A., *Cisagitut'iwn* [Liturgiology], T'aguhi Tamsēn Foundation, New York, 1990, pp. 47–61.

TMvL

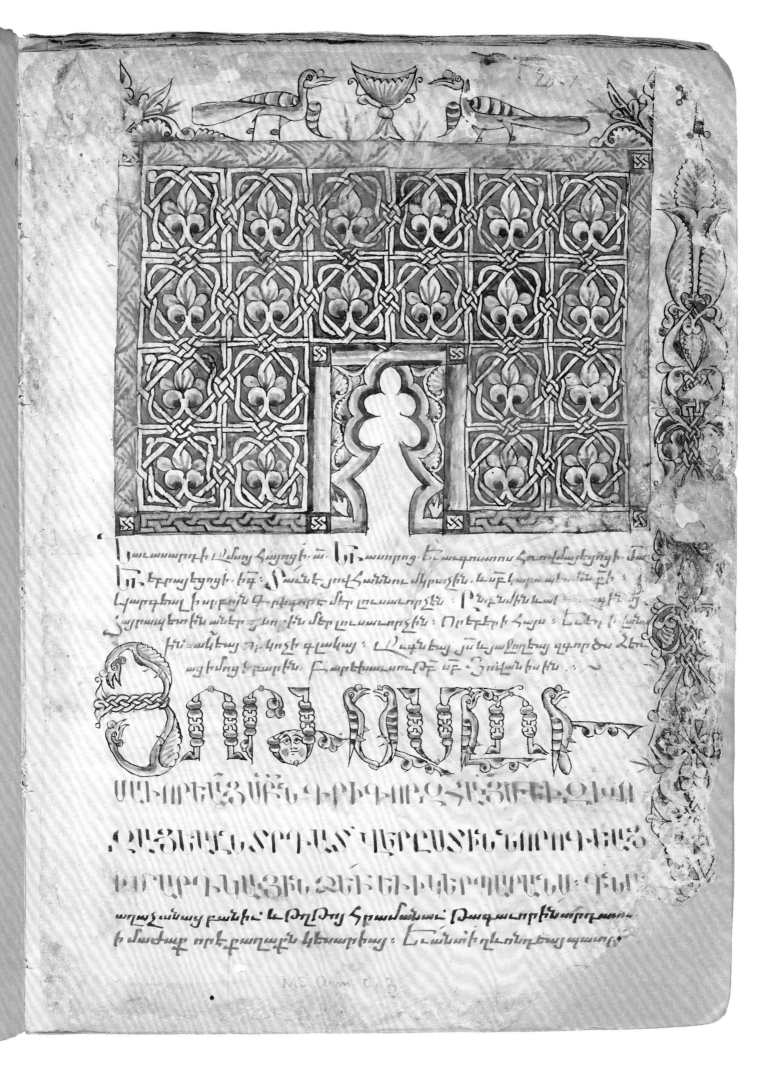

Նախատոնակ Վերայ Հայոց է ․․ Ներառոց ․․ ագուտատու հատ ․․
եւ երկրպագեցի ․ Սահմ յայ Հաննէս վիպատէն․ ամեն ․․
կարեցեալ ․ ի սիրբին ․ Գ ․․ եր ․ լուսատուէն ․ Ռուկեմե․ ․․
յայ ․․ անմիջ ․ մեր լուսատուէն ․ Որեքերե ․ Հայա ․ եւ․ եւ ․
․․ ․ օրհ․ ․ զ ․ գ․ Վ․ յ․ ․ գործ ծա ․ Հա ․
ագ ․ բարին ․ ի․ թե ․ ․ մե ․ Հովհաննէսին ․․

ՅՈՐՋՈՐՋՈՒ

ԱՆՈՒՐԵՆՅԱՆԵ ԳԻՏԳԱՐ ՀԱՅՐԵԹԵՈՒ ՄԻ

ՈՒՅՅԵՆ ՏԻՐԱՆ ՎԵՐԼՈՒՏԵ ԵՐՈՂ ԵԱԾ

ԵՐԱԲՐ ԵՆԱՅԵ ՀՆԵ ԵՒ ԵԵՐԳԱՆ ՏԵ

ագ ․․ բանէ ․ եւ Ող ․ Հրանածու ․ Բագատրեն ․ ․
ի ․․ օր ․ քաղաքին ․ ․ եւ ․․ զ ․․ մր ․ աղ ․

17

Decorated beginning of Psalm 18 [17]: 'I shall love you lord …'
Breviary (Ժամագիրք)

6.4 x 4.1 cm, vellum (fols 1–208), paper (fols 209–31)
(for Zak'aria)
1637
MS. Arm. g. 2 fols 30v–31r

The Armenian Breviary (Ժամագիրք) contains the psalms sung and the prayers offered during the eight offices of the day. These are the Night Office (Գիշերային) and Morning Office (Առաւօտեան), now united into one. The Sunrise Office (Արեւագալի) is only performed during Holy Week, while the Offices of the Third Hour (Երրորդ Ժամու), Sixth Hour (Վեցերորդ Ժամու) and Ninth Hour (Իններորդ Ժամու) are now merged into the Midday Office (Ճաշու Ժամ). This is followed by the Evening Office (Երեկոյեան). The Offices of Peace (Խաղաղական) and Rest (Հանգստեան) are merged into one as the Vigil (Հսկում).

The Breviary is usually not a large book; this one is smaller than the 9 x 7 cm average suggested by Outtier, while the other two exhibited and described here are somewhat larger (cat. 18, 19). This book was a private copy brought along to church in the owner's bag or pocket. The book is opened at Psalm 18, which is sung during the Night Office. The volume consists of two parts from different eras: the older part, comprising fols 1–208, is written on thin vellum, with the text written in seventeenth-century *bolorgir*. The remaining twenty-three paper folios stem from the eighteenth century; here, both *bolorgir* and *nōtrgir* are used by different hands.

The manuscript was copied near the church of St Sargis and Martiros, his son, the location of which is unknown, for Zak'aria the clerk (դպիր). Already in 1645 it had come into the possession of Iskandar, son of Davut and Gohar, and subsequently of Catur, son of Murut' and Bet'el.

Baronian, S., and F. C. Conybeare, *Catalogue of the Armenian Manuscripts in the Bodleian Library*, Clarendon Press, Oxford, 1918, cols 17–18, no. 18.

Outtier, B., 'Les recueils arméniens manuscrits', in C. Mutafian (ed.), *Arménie: la magie de l'écrit*, Paris, Somogy, 2007, pp. 94–103.

Połarean, N. A., *Cisagitut'iwn* [Liturgiology], T'aguhi Tamsěn Foundation, New York, 1990.

TMvL

18

Bishop with deacons and Hymn of Vesting for the Divine Liturgy
Žamagirkʻ (Breviary)

12.7 x 12.1 cm, paper
Sargis, son of Martiros the priest and Pʻarixan (for Baron Martiros)
New Julfa 1657
MS. Arm. g. 5 fols 245v–246r

In the prayer of commemoration of living prelates, a certain Tēr David is mentioned; this refers in all probability to David I of New Julfa (1651–1683). A quatrain in Persian, written in Armenian characters by the scribe Sargis, son of Martiros the priest and Pʻarixan, strengthens the assumption that this manuscript stems from New Julfa, Isfahan, the capital of the Safavid Empire. The book was copied for Baron Martiros. In 1824, the book was owned by 'Stepʻanos, servant of Christ', as a stamp on the first and last pages of the book testifies. The Bodleian bought it in 1899 from Hannan, Watson & Co.

The illumination shows two deacons (սարկաւագ) assisting an unidentified bishop with mitre (խոյր) about to celebrate the Mass, although neither church building nor altar are visible: the scene is set in the open against an architectural background. The deacon on the bishop's right side holds a liturgical fan (բշ ng) or flabellum, consisting of a disc with the image of a seraph on it and little ball-shaped bells on the rim, which here are invisible. The deacon on the bishop's left holds the censer (բուրվառ). The manuscript contains only one other full-page illumination, also of a bishop. The palette of this miniature is more varied and contains warmer tones than the headpieces (խորան), marginal decorations and initials.

The hymn (շարական) 'Mystery impenetrable' (խորհուրդ խորին) is sung while the celebrant vests at the opening of the Divine Liturgy. It was composed by Xačʻatur Tarōnacʻi, who was Abbot of the idyllically located monastery of Haḷarcin in north-eastern Armenia in the late twelfth and early thirteenth century.

Baronian, S., and F. C. Conybeare, *Catalogue of the Armenian Manuscripts in the Bodleian Library*, Clarendon Press, Oxford, 1918, cols 119–120, no. 57.

Nersoyan, T., *Pataragamatoycʻ hay aṙakʻelakan uḷḷapʻaṙ ekeḷecʻwoy* [Divine Liturgy of the Armenian Apostolic Orthodox Church, with Variables, Complete Rubrics and Commentary], Saint Sarkis Church, London, 1984, pp. 11–24, 195–201, 248–51.

Žamagirkʻ Hayastaneaycʻ S. Ekeḷecʻwoy [Book of Hours (Breviary) of the Holy Church of the Armenians], St Vartan Press, New York, 1986, p. 679.

TMvL

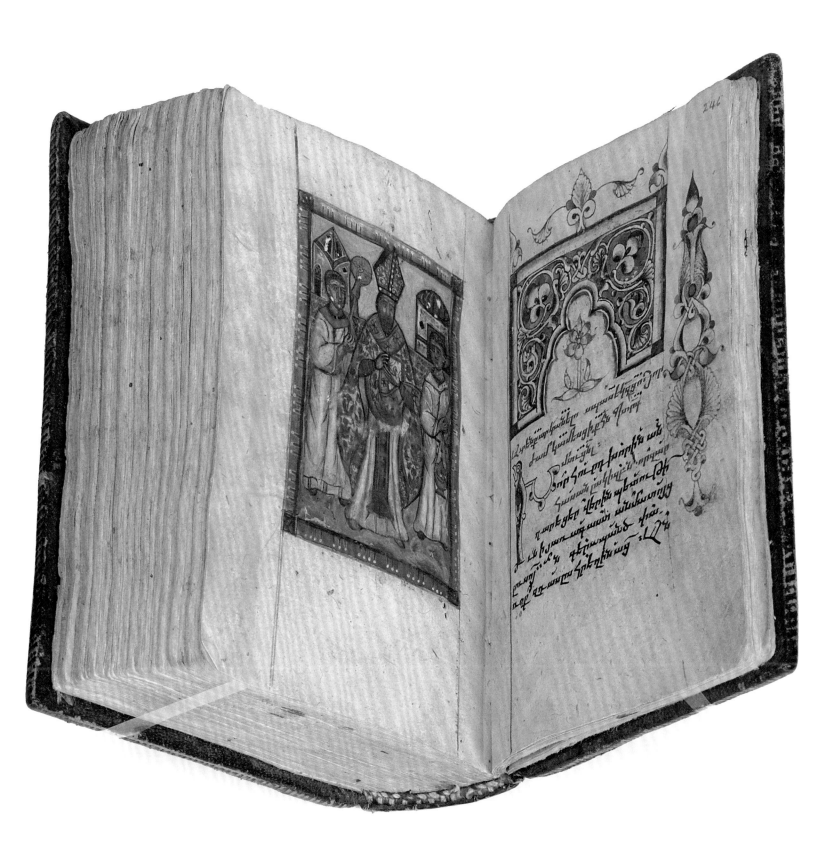

A sacred song (մեղեդի) with neumes in line with the text
Manual for musical instruction (Մանրուսումն)

9 x 12.5 cm, fine white vellum
Mik'ayēl
Ejmiacin 1654
MS. Arm. g. 12 fols 270v–271r

This manuscript contains four different works, all concerning church services: a Breviary (Ժամագիրք), a Calendar of Dominical Feasts (Տօնացոյց), a Manual for Musical Instruction (Մանրուսումն) and a fourth text giving advice on a place of worship. The first three are found together more often, as in M752, a manuscript copied in 1314.

The volume was copied in 1654 in the See of the Mother Church, Ējmiacin, in the city of Vałaršapat, Armenia, by the scribe Mik'ayēl for his own use, on 325 folios of fine white vellum. The pages shown here belong to the above-mentioned Manual, which provides instruction in ecclesiastical chant. On the right-hand page begins the part devoted to the chant of a lyrical and highly rhythmic song (մեղեդի), following either a lyric song (տաղ) or a longer recited piece devoted to the occasion of an ecclesiastical feast (գանձ). This song extols Mary as 'immaculate virgin and pure motherhood'. The initial K (Կ) consists of two birds singing, while the text of the opening line is drawn in brownish yellow, except for the neumes (խազ), the musical notation that is kept in black. In the following lines no such distinction is made.

The exact interpretation of the neumes was lost over the centuries and a new system was developed in the nineteenth century, while the old neumes continue to be printed and are only approximately understood. The notation of the neumes in this volume is of particular note, as they are not printed above the text, as usual, but in line with it.

Kerovpyan, A., 'La notation neumatique arménienne', in Claude Mutafian (ed.), *Arménie: la magie del l'écrit*, Somogy, Paris, 2007, pp. 127–9 (with note 3.54 on M752).

Nersessian, V. N., *A Catalogue of Armenian Manuscripts in the British Library acquired since the year 1913 and of collections in other libraries in the United Kingdom*, The British Library, London, 2012, vol. 1, pp. 392–5, no. 75.

Outtier, B., 'Les recueils arméniens manuscrits', in Mutafian, *Arménie: la magie de l'écrit*, pp. 94–103.

TMvL

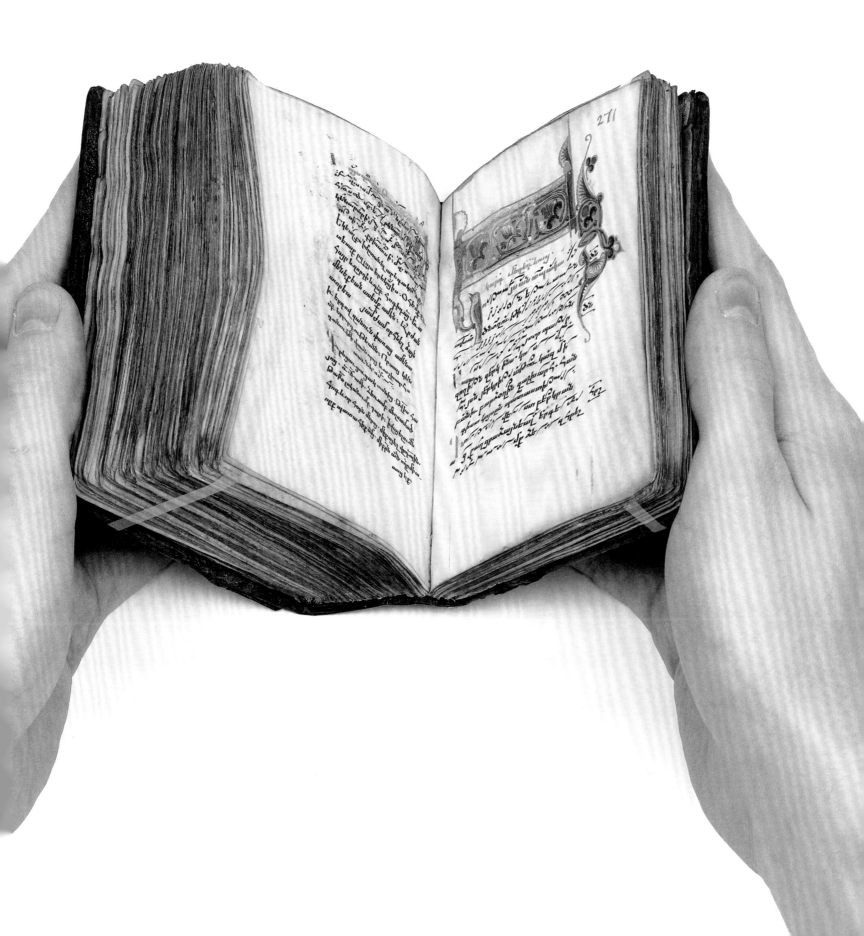

Christ in Glory
Synaxarion (Յայսմաւուրք)

36 x 25 cm, paper
Gaspar the priest, and his student Astuacatur (for Łukas)
The Church of the Holy Godmother, T'oreškan, Isfahan 1631
MS. Arm. b. 3 fols 7v–8r

This is the first of a two-part Synaxarion (the other being MS. Arm. b. 4). An inscription in English states that the manuscript travelled to Mysore, in eastern Bengal (Bangladesh) between 1819 and 1820. It had passed into the hands of the priest Yarut'iwn by 1827, who possibly took it there. The Bodleian Library acquired it from Hannan, Watson & Co. in Glasgow in 1900.

The illumination shows Christ in Glory at his Second Coming. He is seated in the centre of the cross holding a book in his left hand, anticipating the Last Judgment, and making a blessing gesture with his right hand. Four angels announce his coming, their wings radiating from the centre of the cross and protruding beyond the green disc surrounding it. The cross is placed on steps as a sign of victory. The inscription around the disc reads: 'Cross of Christ help me Sark'is, weakened officiating priest' (խաչ քի օգնեալ ինձ տկարացել սարքիս ժմայրաբիս).

Under the steps of the cross there is an inscription reading: 'Remember in your immaculate prayers Yakob, son of Haron, and Yarutiwn, son of Sołomon; I am in great vexation because of our evil deeds and day after day our iniquity increases. Woe me sinner! How shall it be and what shall I answer at our last judgment? I have no other means but only the immaculate Mother of God who always intercedes with her Son for sinner(s). […] In the year 1176 [1727 CE]'.

The right-hand page gives the opening of the vita of St John the Baptist and At'enogenes, which opens the Armenian Liturgical year on 1 Navasard, coinciding with 11 August.

Nersessian, V. N., *A Catalogue of the Armenian Manuscripts in the British Library acquired since the year 1913 and of collections in other libraries in the United Kingdom*, The British Library, London, 2012, vol. 1, pp. 674–8, no. 122.

TMvL

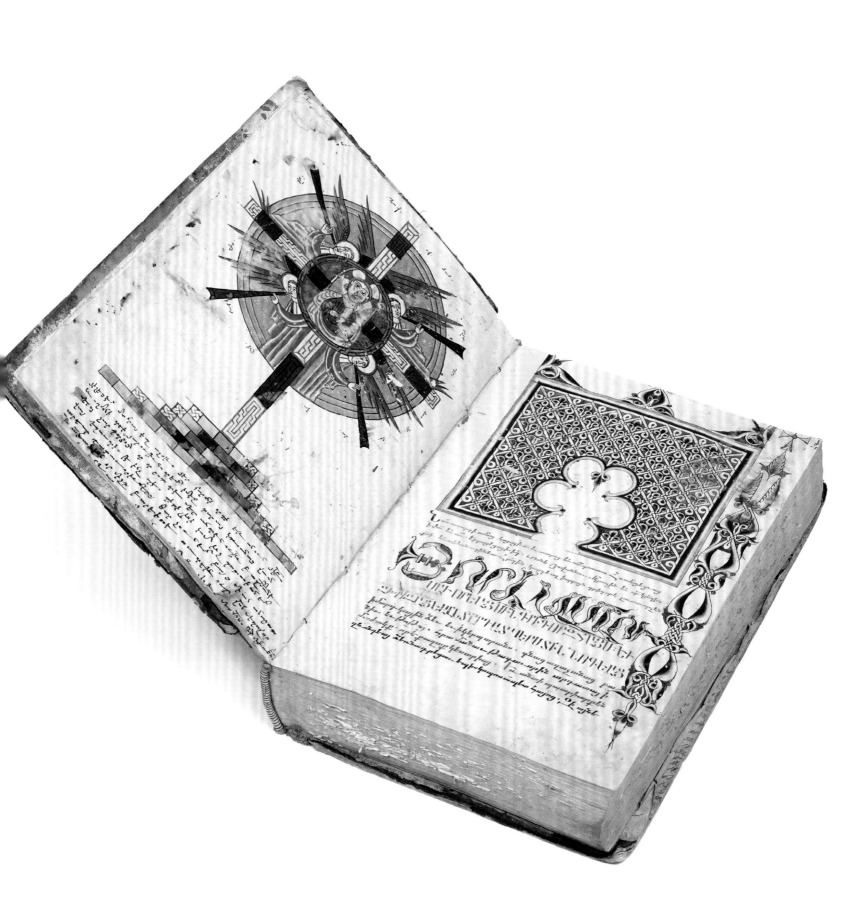

Woodcut of the Crucifixion

Lyturgia Armena (Խորհրդատետր պատարագիին Հայոց)
Edition corrected by Barseł Kostandnupōlsecʻi (Armenian Liturgy)

*c.*30 x 22 cm, paper
Sacra Congregatio de Propaganda Fide
Rome 1677
Mason T 120 pp. 10–11

The Roman Catholic Church had been active in Armenia since the thirteenth century, initially in Cilicia. For the Armenian court there, military and political considerations of Church union prevailed over religious ones, although King Hetʻum II (r. 1289–1307) would become known as Franciscan frère Jean. Katholikos Nersēs Šnorhali and Archbishop Nersēs Lambronacʻi held unrealized hopes of Christian unity on an equal footing with the Churches of Rome and Byzantium. A Catholic Armenian order known as the *Fratres Unito*res (Միաբանողք) was established in Greater Armenia in the 1330s.

The invention of printing strengthened Catholic missionary efforts among eastern Christians. The *Sacra Congregatio de Propaganda Fide*, established in 1622, subjected three Armenian ecclesiastical works to correction: the Divine Liturgy, the Breviary and the Hymnal. The corrector was Barseł Konstandnupōlsecʻi. The corrections here refer to the 1667 Amsterdam edition of the Armenian Apostolic Liturgy by Oskan Erevancʻi. In his commentary, published only in 1868, the Mekhitarist father Gabriēl Awetikʻean (1750–1827) has little patience with the lack of 'delicacy and circumspection with which Rome usually undertook such an enterprise', citing 'private authority' and 'the most biased inexactness' as reasons for its errors in translation and correction. In 1854 his own bilingual edition of the Armenian Liturgy was published in Armenian, with translation into Italian.

Avedichian, P. G., *Sulle Correzioni Fatte ai Libri Ecclesiastici Armeni nell'anno 1677*, Tipografia armena di San Lazzaro, Venice, 1868.

Avedichian, P. G. Dott., *Pataragamatoycʻ Hayocʻ. Liturgia Armena. Liturgia della messa armena trasportata in Italiano*, Tipografia armena di San Lazzaro, Venice, 1854.

Dédeyan, G. and I. Augé, 'Le rayonnement de l'État arménien de Cilicie', 'Le dilemma de l'Église: ouverture ou défense de la tradition nationale', in Gérard Dédéyan (ed.), *Histoire du people arménien*, Privat, Toulouse, pp. 336–56.

Kévorkian, R. H., *Catalogue des «Incunables» arméniens (1511–1695) ou chronique de l'imprimerie arménienne*, Patrick Cramer, Geneva, 1986, pp. 152–65, no. 180.

Orengo, A., 'Gli scambi culturali armeno-italiani (XV–XVIII sec.)', in Claude Mutafian (ed.), *Roma–Armenia*, Edizioni De Luca, Rome, 1996, pp. 256–60.

TMvL

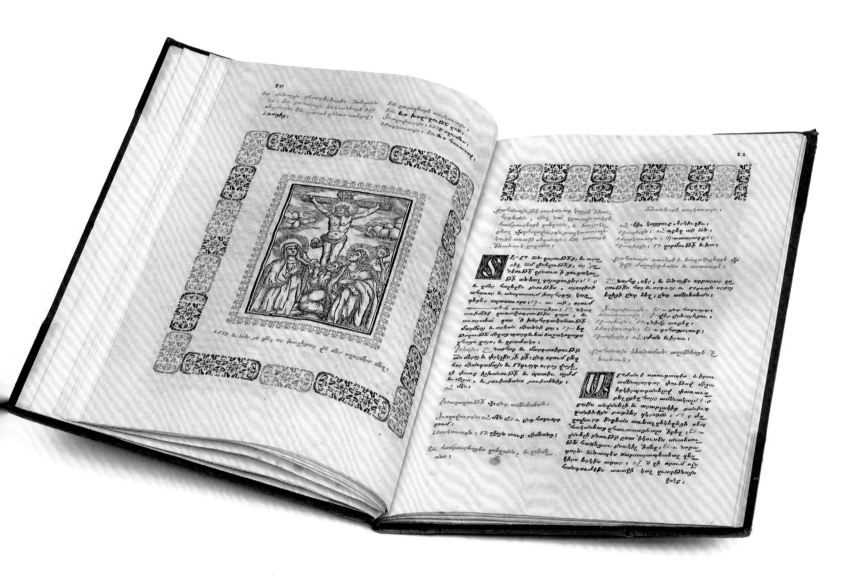

Telling Christianity:
Commentaries and Prayer Scrolls

Armenian Christianity has a rich tradition of commentary, preaching and instruction. It developed forms of personal devotion and Christianized the desire for protection from physical as well as metaphysical danger. Amulets and talismans abound: the Church could not prevent types of devotion that involved apotropaic elements. In the fifth century the translation of homilies and Biblical commentaries from Greek and Syriac Fathers began, and original works were also composed, such as Eznik's *Against the Sects*, and the *Teaching of Saint Gregory*, the latter incorporated into Agatʻangełos's *History of Armenia*. The earliest commentaries on Biblical books (Genesis, Joshua, Judges) are ascribed to Ełišē (*c.* 500). His *History of Vardan and the Armenian War* shaped Armenian views on a national faith that was worth the sacrifice of martyrdom. A brief work on the Psalms is ascribed to Davitʻ Anyałtʻ, the sixth-century neo-Platonist philosopher. Sermons, homilies and exemplary lives, whether 'crowned' by martyrdom or not, provided further material for emulation. Polemic writings were important, condemning grave errors such as the powerful movements of the Paulicians and Tʻondrakians. The Zoroastrian Children of the Sun (Արեւորդիք) persisted after Christianity became defining for Armenia's identity; Nersēs Šnorhali wrote Christian hymns on the Zoroastrian tunes he heard his guards sing. *The Book of Letters* (Գիրք թղթոց) documents relations with the

Georgian and Byzantine Churches. Relations with the Church of Rome became prominent in Cilician Armenia, however neither the *vardapet*s in Greater Armenia, nor much of the Armenian population of Cilicia bowed to Catholic pressure for change in doctrine and liturgical praxis. The *Fratres Unitores* inspired polemical literature in which the tools provided by Thomas of Aquinas were turned against him. The Catholic Brotherhood of the Mekhitarists, founded by the saintly Mxit'ar of Sebastia, made a tremendous contribution to Armenian spirituality and education, as well as to Armenian studies.

Armenia's relations with Islam varied over time. The eleventh-century epic poem 'Magnalia Dei' by Grigor Magistros presents the Bible in verse, and a letter by him explains Christianity in the light of contemporary Muslim polemics. Grigor Tat'ewac'i (*c*.1345–1409) dedicated part of his *Book of Questions* to the refutation of Islam, while the seventeenth-century Shah Suleyman held disputations in the Armenian churches of New Julfa, reflected in Yovhannēs Mrk'uz Julayec'i's (1643–1715) treatise presenting the argument for Christianity in both Persian and Armenian. *Hmayils* or phylacteries protect the believers against headaches, attacks by demons and anxiety over childbirth, and contain prayers by Nersēs Šnorhali and Grigor Narekac'i. They afford insight into everyday religion, folklore and the psychology of Armenians from the fifteenth century onward.

TMvL

The Bodleian's oldest Armenian manuscript
John Chrysostom's Commentary on the Epistle to the Ephesians

29.2 x 22.3 cm, parchment, thin and corrugated
Step'anos
11th century
MS. Arm. d. 11 fols 115v–116r

Due to the lack of the main colophon, the dating of this volume of John Chrysostom's *Commentary on the Epistle to the Ephesians* relies largely on its script, a fine, elegant and regular *erkat'agir* or uncial script; words are not separated, and a line regularly filled out contains some sixteen letters, the last one often a vowel. Having been left without binding for a considerable time, the first and last quires are lacking. The first page preserved is hardly legible and folios one to six have been perforated with a hot iron. Traces of dampness are visible as well, both in discolorations on the page and the corrugation of the parchment. The binding is recent.

Comparison with two other manuscripts containing Chrysostom's text points to an origin in the Arcruni Kingdom of Vaspurakan. In 1852 Tēr Nersēs Sargisean copied it in Tbilisi; it was there in Tēr Giwt Ałaneanc''s possession in 1891. A year later the Bodleian Library bought it from F.C. Conybeare, who had brought it from Tbilisi.

Illuminations are limited to marginal decorations, such as the one here, held in strongly contrasting colours. It indicates the beginning of Homily 14 (ԺԴ), on Ephesians 4.25–27. Translated in the fifth century, works by John Chrysostom belong to the first Greek texts made available in Armenian script and language. They were copied widely throughout the centuries. About a millennium old, this manuscript is the earliest Armenian volume preserved in the Bodleian library.

Baronian, S., and F. C. Conybeare, *Catalogue of the Armenian Manuscripts in the Bodleian Library*, Clarendon Press, Oxford, 1918, cols 154–7, no. 68.

TMvL

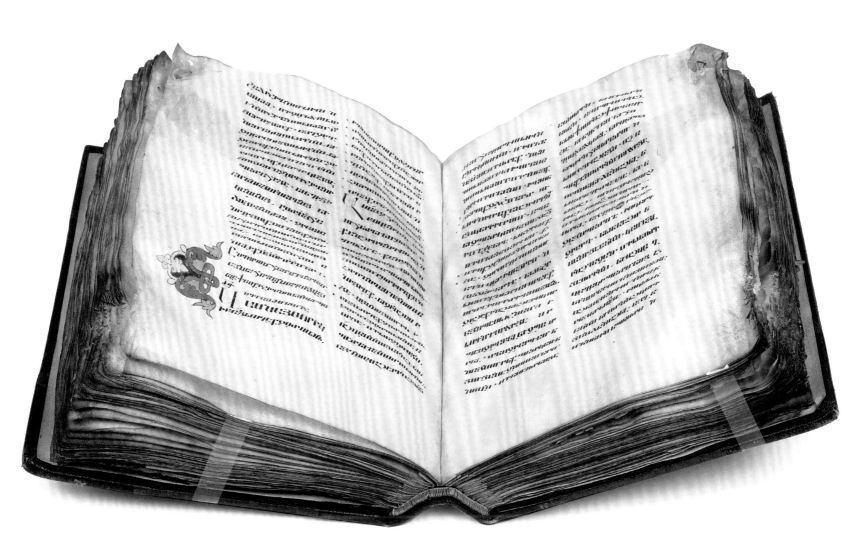

23

Theological tenets of Cyril of Alexandria

Scholia and Correspondence of Cyril of Alexandria, translated by Step'anos Siwnec'i, and Explanation of the Nicene Creed

21 x 15.3 cm, paper
Sargis the priest
New Julfa 1689
MS. Arm. e. 36 fols 35v–36r

Lacking the full-page illuminations found in Gospels and Bibles, this manuscript of theological works has rubrics and bird initials (shown is the capital E [Ե]), and marginal decorations, indicating the beginning of the *Salutations*.

The priest Sargis, son of Yovhannēs and Tatkum, states that he copied the manuscript in 1138 of the Armenian era (1689 CE) in the royal city of Šōš, now called Aspahan, in the town of J̌ułay, under the protection of the Holy Church of Bet'łehēm (fol. 197). This is a magnificently decorated church in New Julfa, Isfahan, built under the patronage of the immensely wealthy merchant Petros Veliǰanean. For 50 *tumans* the volume was sold to Grigor, son of Xōǰa Yovhannēs and Xatun Mariana. In 1691 he transferred the volume to Astuacatur *vardapet*. A further note, dated 1834, mentions Yordan Nersessian, probably a later owner. The Bodleian bought the manuscript from Hannan, Watson & Co. in 1890.

Cyril of Alexandria's definition of the nature of Christ as 'one nature of the Word incarnate', coined in his refutation of the position of the Nestorians, was followed by the Armenian Church, which in the mid-sixth century rejected the Council of Chalcedon, held in 451 CE. This copy of the text may well have been a tool in the debates with the Jesuits, Carmelites and with the Armenian families in New Julfa that had converted to Catholicism. The Apostolic Armenians in the Persian capital had to engage with Islam and with Catholicism, each of which had their attractions for the merchant community (cf. cat. 24).

Baronian, S., and F. C. Conybeare, *Catalogue of the Armenian Manuscripts in the Bodleian Library*, Clarendon Press, Oxford, 1918, cols 162–4, no. 70.

Landau, A. and T. M. van Lint, 'Armenian Merchant Patronage of New Julfa's Sacred Spaces', in Mohammad Gharipour (ed.), *Sacred Precincts. The Religious Architecture of Non-Muslims Across the Islamic World*, Brill, Leiden – Boston, 2014, pp. 308–33.

Louth, A., 'Cyril of Alexandria', in Frances Young, Lewis Ayres and Andrew Louth (eds), *The Cambridge History of Early Christian Literature*, Cambridge University Press, Cambridge, pp. 353–7.

TMvL

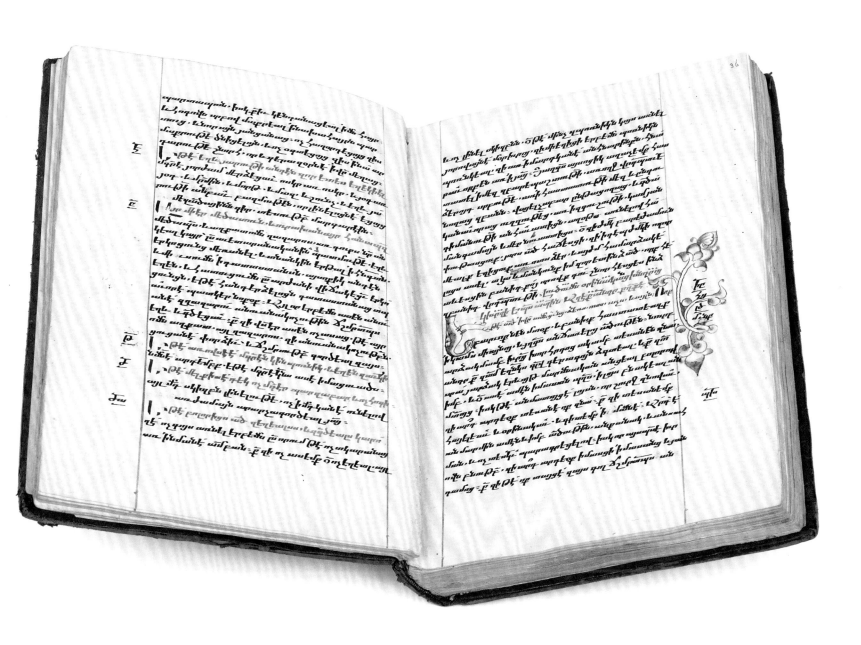

24

Vardan Arevelc'i, Commentary on Psalms

29.5 x 20.6 cm, paper
Simeon the priest (for Tēr David, the chief chorister)
Lvov (Lviv) 1610
MS. Arm. c. 2 fols 22v–22r

This well-preserved manuscript was copied from British Library MS. Add. 7942, which was written in Kamenec in 1606. Its binding, maroon-tooled leather with flap, three thongs and brass studs, is likely original as the date stamp of 1612 on the front cover suggests. Coloured headpieces, marginal decorations and ornithomorph initials mark the beginning of each canon. A note on fol. 173v, dating to 1169 of the Armenian era (1720 CE) mentions a Tēr Martiros 'at the gate of the church of Łarc'gēl' in Persia. As the cataloguers of the Bodleian collection note, this manuscript must be one of the thousand that ended up in Persia after having been dispersed far and wide

when Archbishop Nikol T'orosovič' converted the Polish Armenians to Catholicism, as the seventeenth-century historian Aṙak'el Dawrižec'i relates. The manuscript was bought from Hannan, Watson & Co. in 1899. Vardan wrote his commentary in 1251. It is in the form of a *catena*, giving the views of various authorities on a particular verse; these include Athanasius of Alexandria, Basil of Caesarea, Epiphanius of Salamis, Ephrem Syrus and Nersēs Lambronac'i. The passage in red elucidates a point of translation, stating that Aquila and Theodotion interpreted 'end, consummation' (կատարած) as 'victory'.

Baronian, S., and F. C. Conybeare, *Catalogue of the Armenian Manuscripts in the Bodleian Library*, Clarendon Press, Oxford, 1918, no. 85.

Bournoutian, G. A., *Aṙak'el of Tabriz. Book of History (Aṙak'el Dawrizhets'i, Girk' patmut'eants')*, Mazda Publishers, Costa Mesa, 2010, ch. 28, pp. 283–301.

Petrosyan, E., and A. Ter-Step'anyan, *S. Grk'i hayeren meknut'yunneri matenagitut'yun* [Bibliography of the Armenian Commentaries on Sacred Scripture], Armenian Biblical Society, Erevan, 2002, p. 24.

Thomson, R. W., 'Armenian Biblical Commentaries: The State of Research', *JSAS*, vol. 18, no. 1, 2009, pp. 9–40.

TMvL

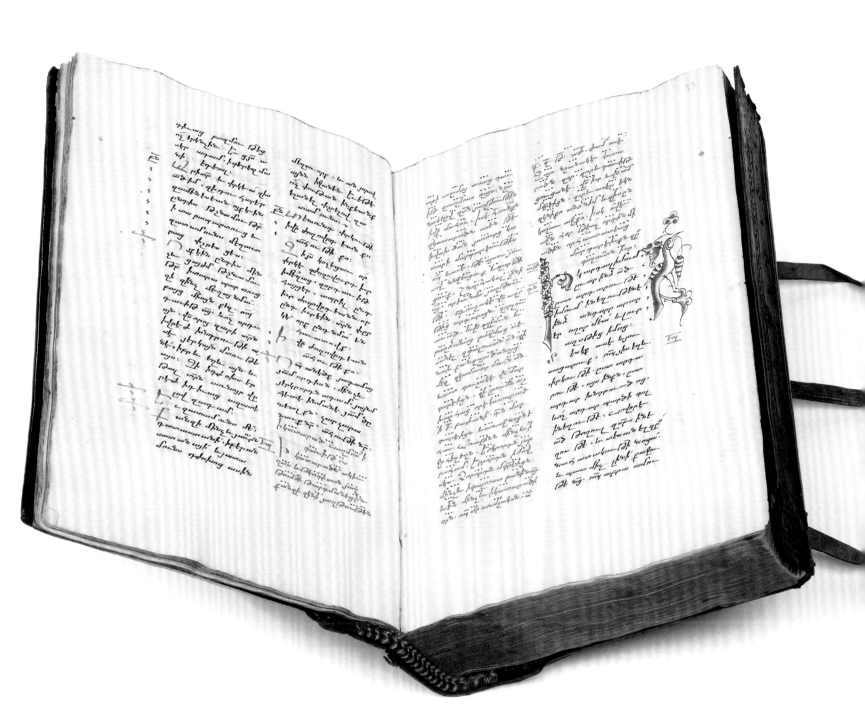

Catholic Christianity in Armenian
Giovanni Bona, Guide to Heaven (Ներածութիւն Յերկինս)

11.5 x 6.5 cm, paper
Rome 1700
MS. Arm. g. 11 pp. xxiv, 1

Cardinal Giovanni Bona's *Guide to Heaven* (Ներածութիւն Յերկինս, orig. Latin *Manuductio ad Coelum*) was translated into Armenian in 1671 in Rome by Vardan Yunanean, who was made Primate of the Catholic Armenian Diocese of Lvov (Lviv) in 1683. This manuscript copy is based on the edition printed in Rome in 1674 under a similar title (Զերբածութիւն Յերկինս). The gold-tooled calf leather binding resembles bindings of printed books of the period. The copyist of this manuscript is unknown, as is the intended owner. A pencilled note added to the *ex libris* label inside the front cover indicates that it was done in 1700; the grounds upon which this was established are unclear.

Giovanni Bona was made cardinal by Pope Clement IX (in office 1667–9). The *Guide to Heaven*, published in 1672, contains 'the marrow of the Holy Fathers and the perceptions and thoughts of the ancient philosophers'. It is noteworthy that the Armenian translation was made before the book was published, showing the close ties between the Vatican and representatives of the newly converted congregation in Poland. The translator was a convert of Clemens Galanus and had received his theological education at the *Sacra Congregatio de Propaganda Fide*. The administrative transition from Apostolic Armenian

diocese under the See of Ējmiacin to a Catholic diocese took place in 1689. In the process the Armenian liturgical books were, from a Catholic point of view, corrected to conform to Roman theology and orthopraxis (cf. cat. 21). A further printed edition, with the same title as the 1674 edition, was published in Amsterdam in 1705.

Nersessian, V. N., *A Catalogue of Armenian Manuscripts in the British Library acquired since the year 1913 and of collections in other libraries in the United Kingdom*, The British Library, London, 2012, vol. 2, no. 160.

Oskanyan, N. K. Korkotyan, A. Sakalyan, *Hay girk' 1512–1800 t'vakannerin* [The Armenian Book in the years 1512–1800], Ministry of Culture of the Armenian SSR, Erevan, 1988, nos 86, 224.

TMvL

26

Lady Šušan's commission
Lives of the Fathers (Վարք հարանց)

26 x 20.3 cm, paper
17th century
MS. Arm. d. 17 fols 244v–245r

This volume is bound in blind-tooled leather, with flap and studs; the cover shows an interlaced eternity pattern held within four leaves, while the flap is decorated with leaves and different eternity symbols. Similar patterns occur in the marginal decorations in the book. The latter are held in red, green, orange and grey, as are the headpieces at the beginning of chapters.

A verse colophon (fol. 251) describes the copyist as a forty-six-year-old man from Norašink, but no name, place or date are given. The patron and her family are mentioned: Lady Šušan, her father Bašxin and mother Xurmēn, a brother Manuk and his son Tōlmšin. Three sisters are also mentioned: Mrvatʻ and Mariam on the same page, and the recently deceased Varden on fol. 399v.

The manuscript contains the *Lives of the Fathers of the Egyptian Desert* according to the twelfth-century redaction (a fifth century redaction survives as well), in which each chapter closes with verses ascribed to the renowned poet, composer, theologian, diplomat and Katholikos Nersēs Šnorhali. This is visible on the left page, where the lines of the right column from the last orange initial onward (almost) all end in 'in' (ին), sometimes written slightly apart from the preceding letters of the same word. It is a coda to the story, written in the first person, to encourage personal application. The right page contains the opening of chapter 15, discussing the matter of obedience to the father and *vardapets*.

Baronian, S., and F. C. Conybeare, *Catalogue of the Armenian Manuscripts in the Bodleian Library*, Clarendon Press, Oxford, 1918, no. 88.

TMvL

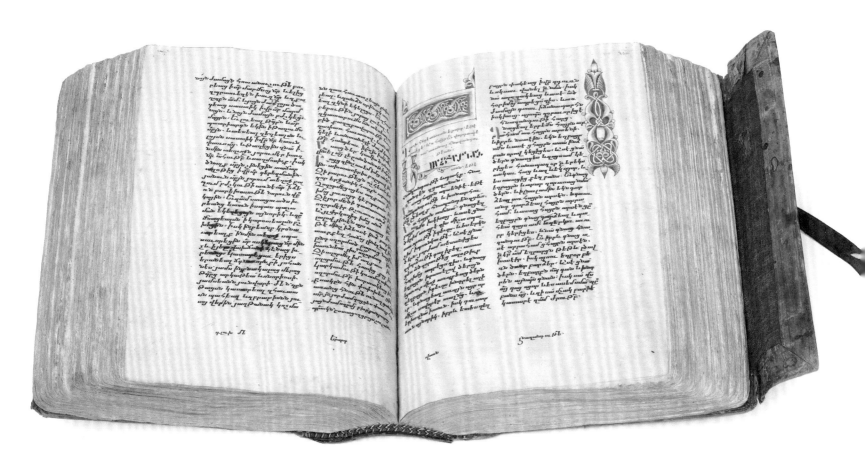

27

Christ on the Cross with Mary and John
Hmayil

577 x 7.62 cm, parchment
Mat'os
1706–7
MS. Arm. g. 4

This talisman was produced at the high point of fashion of such scrolls, the first half of the eighteenth century, and is of average size, assuming it is preserved as made. There are perhaps up to 2,000 such portable rolls preserved, with the most, more than 460, in the collection of the Matenadaran in Erevan. In an informal and random personal database of some fifty-one scrolls, the longest measures 2530 cm, though longer ones are known with width varying from 3.7 to 14 cm; only four were written on parchment, the other 90 per cent on either Western or Near Eastern paper. Since Armenian scribes were obsessed with the need to leave a colophon, it is not surprising that 66 per cent are precisely dated, the oldest to 1428 and the most recent to 1816; 75 per cent of the sampling was produced between 1654 and 1796, with the peak around 1750. From the whole group, only eleven preserve a place of copying, five of which are clearly from Constantinople and four attributable to it. We find the names of fifteen scribes, only two or three of whom are clearly church clerics. Only a small number of the original commissioners are known; more often we have the name of the last or later owners, who, following the prescription of placing one's name after each of the prayers, have effaced, usually crudely, the name or names of previous owners.

This phylactery contains ten sections of prayers, among them the most famous ones included in almost all such scrolls: the confessional prayer of Katholikos Nersēs Šnorhali; on Christ's Crucifixion; the Sacrifice of Abraham; a prayer of St Grigor of Narek (951–1003); prayers to the archangels and to the warrior saint Sargis. Each prayer begins with its title or incipit; Fréderick Feydit has conveniently provided the full Armenian text and translation of 154 of these found in some thirty *hmayils* in the Mekhitarist Fathers Collection in San Lazzaro, Venice.

The first miniature depicts St Nersēs in full regalia with a *konk'er*, a liturgical purse, hanging from his waist, used for keeping homilies or offerings, and reserved in the Armenian Church solely for the katholikos. The representation of the Crucifixion combines a simplified iconography popular in Western engravings with the Virgin and St John, but with the titulus above the cross: YNT'H (ՅՆԹՇ), equivalent of the Latin INRI (*Iēsus Nazarēnus, Rēx Iūdaeōrum*) after Jn 19.19–22, 'Jesus of Nazareth, King of the Jews'. Blood spurts in two streams from Christ's right side, one red, the other colourless, separating the blood and the water, thus emphasizing the Armenian tradition of not mixing the wine and the water of the communion.

Baronian, S. and F.C. Conybeare, *Catalogue of the Armenian Manuscripts in the Bodleian Library*, Clarendon Press, Oxford, 1918, cols 73–4, no. 33.

Feydit, F., *Amulettes de l'Arménie chrétienne*, Mekhitarist Congregation, Venise-St. Lazare, 1986

Vardanyan, E., 'Les amulettes', in Claude Mutafian (ed.), *Arménie: la magie de l'écrit*, Somogy, Paris, 2007, pp. 123–5.

DK

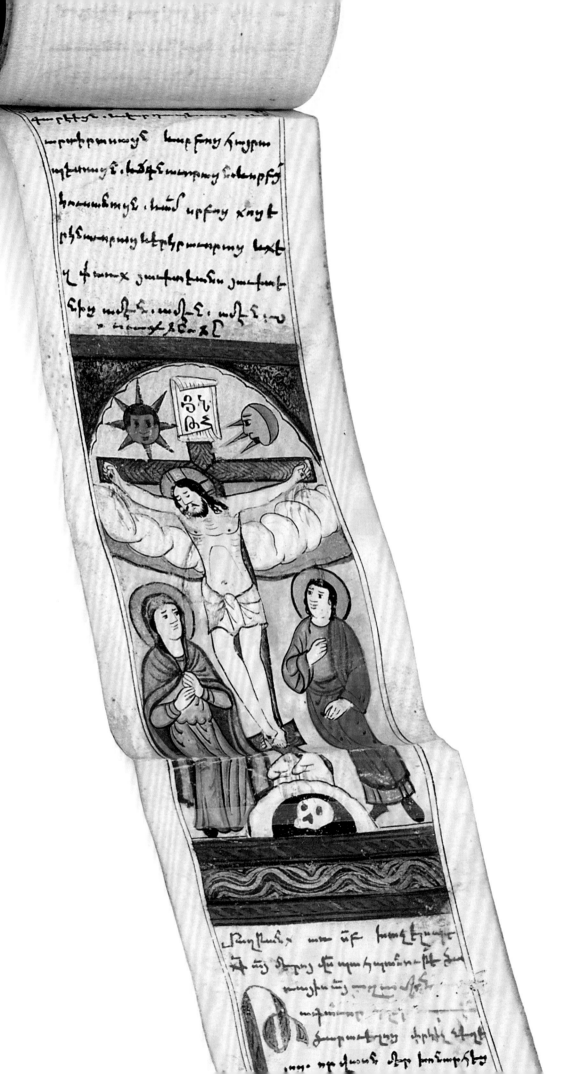

28

Sacrifice of Abraham with part of crisscross text below
Hmayil

10.2 x 1112.5 cm, paper
Karapet, son of Melk'on
1788
Private collection

Phylactery scrolls (պահպանակ or հմայիլ), from the verb 'to divine, conjure' (հմայեմ) function as talismanic amulets. They are often very long rolled manuscripts on parchment or more often paper, with dated examples from the fifteenth to the nineteenth century; they were also printed, at times anonymously. The main colophon is at the very end of the manuscript: 'This *hamayil* was written by the hand of Karapet son of Melk'on, remember us with a (prayer) "Father, I have sinned" and may you be remembered in Christ Amen. In the Armenian year 1237 [1788]. Amen'. There is a later colophon of 1810 in another hand somewhat higher up in the space around the head of St George. As is typical with such scrolls, this one is composed of a series of prayers, quotations from the Gospels, and miscellany, some passages in cryptic code or secret writing. It is written in a poor *bolorgir* with careless capitalization of proper nouns or the start of sentences. As is customary, the name of the owner is mentioned regularly, usually at the end of every prayer or piece of writing; this name has been effaced by a later owner with only ' … the son of Manuk' surviving, but the relation to those mentioned in the colophon is not clear, nor that to Mariam, the wife of Karapet, presumably the copyist of the scroll, also mentioned in the phrase preceding 'Manuk'.

There are thirty-nine coloured vignettes, usually clearly framed, sometimes with an arch above; in two or three places pictures are stuck together, two, three or four at a time. The palette is pleasing: red, rust red, pale green, light violet, yellow, dirty blue-purple. The entire length of the scroll is framed by an attractive narrow border-frame on each side in pale green. The art is at times clearly influenced by Western iconography, almost certainly inspired by engravings in early printed books or late Armenian manuscript art, which had already absorbed an Occidental style, e.g. the Annunciation with Gabriel carrying a lily instead of a wand, approaching the Virgin standing before a lectern. The art and layout of the scroll needs to be compared to already published *hmayils* and, if possible, the place and milieu of production identified.

Feydit, F., *Amulettes de l'Arménie chrétienne*, Mekhitarist Congregation, Venise-St. Lazare, 1986.

DK

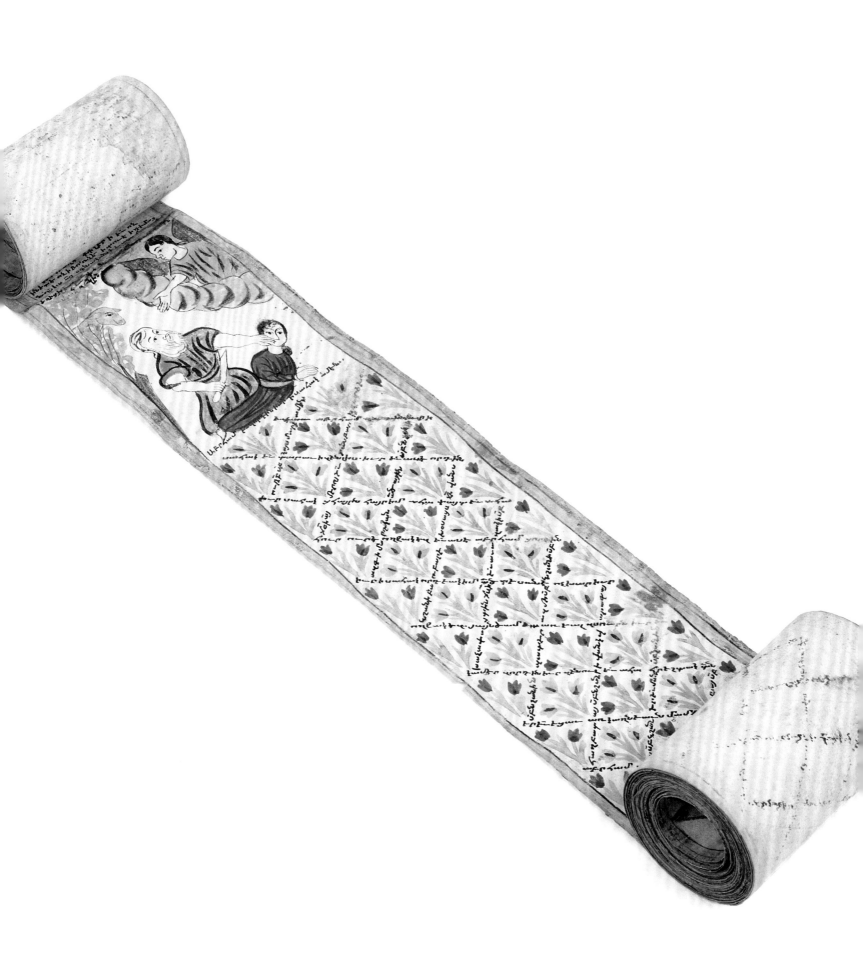

29

Christ with the instruments of his martyrdom
in chalice of blood
Hmayil

9.8 x 633.7 cm, paper
1724
Private collection (TMvL)

This prayer scroll (հմայիլ) served the protection of its owners, Yohannēs, Ełisapet, and their sons, as indicated by the final colophon. The scroll is kept in an embroidered pouch of uncertain date, but more recent than the scroll itself.

The opening shows Christ with the instruments of his martyrdom in a chalice of blood, a prayer to the guardian angel (Isaiah 6.3), with a prayer against aching of the head and of the eyes.

The scroll consists of fifteen strips of printed paper that are glued together. They vary in length between 41 and 45 cm, totalling 654.1 cm, which is 20.4 cm more than the surface length of the scroll, due to the unprinted areas of the strips glued on top of each other.

The scroll is incomplete: it opens in the middle of the first stanza of Saint Nersēs Šnorhali's famous prayer 'I confess in faith' (Հաւատով խոստովանիմ): '[I confess in faith and worship You, Father and Son and

Holy Spirit, uncreated and immortal Nature, Creator] of angels and humankind and of all creatures'. The text comprises twenty-nine prayers and thirty-three intercessions for the owners. The names of previous owners are routinely erased; the beginning of a name starting with H (Հ) can be recognized, as well as the names Karean (Կարեան) and Ovakimean (Ովակիմեան), which may or may not be the family name of the owners. Many times the name Galo is found written in pencil in the margin, since the space left open in the printed text for the person for whom intercession is requested is filled, most of the time with an erased name.

There are twenty-one illustrations of different provenance, some of which are signed DR (ԴՐ), and in some cases initials are drawn up in combined form of birds, fish and other animals. The language of the scroll is Classical Armenian with many orthographical uncertainties and inconsistencies.

Feydit, F., *Amulettes de l'Arménie chrétienne*, Mekhitarist Congregation, Venise-St. Lazare, 1986.

Vardanyan, E., 'Les amulettes', in C. Mutafian (ed.), *Arménie: la magie de l'écrit*, Somogy, Paris, 2007, pp. 123–5.

TMvL

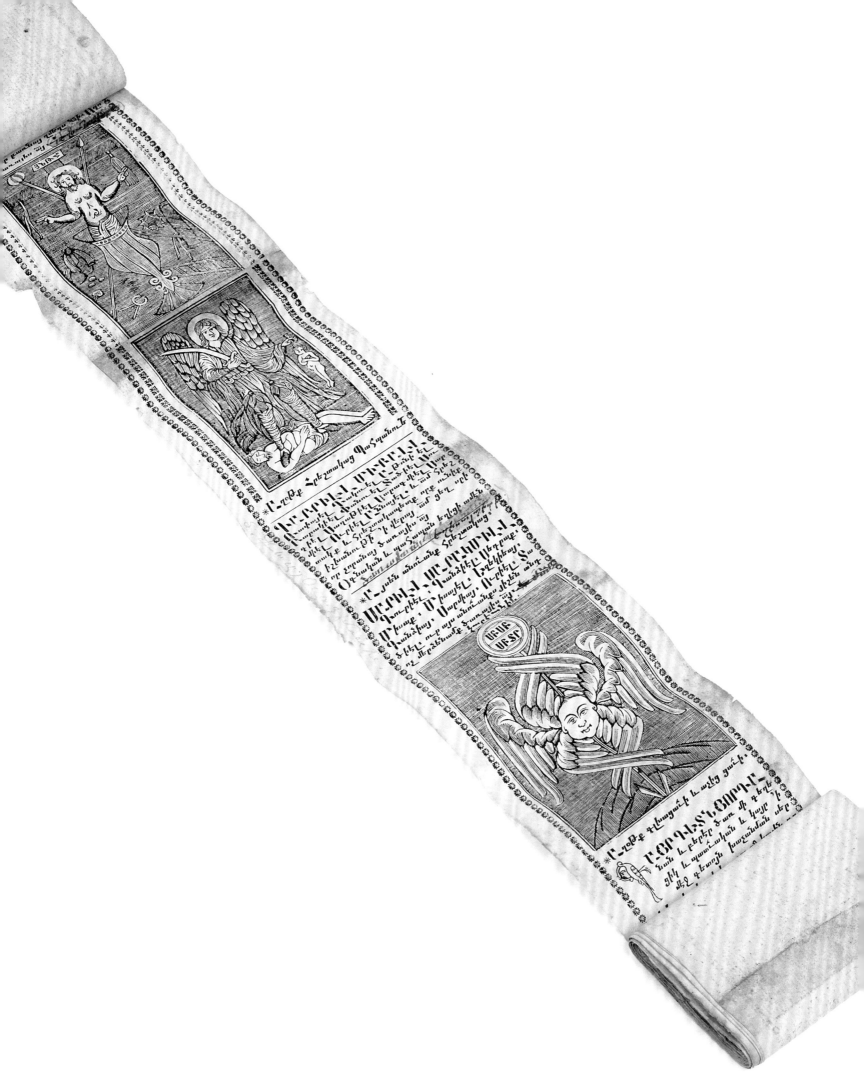

Ա շորք Հեշտատկաց Բաշգանունի

Ա․ԲՐԲԵԼ ԱԲՐԲԵԼ
հարբբել Հեշատատկան եերահեա եՆ
Նեն ե Հեշատատկարտեա ՂՁ եՏԳ
Նաեն ե Հեշատատկարտեայ ամ գեֆ ՝եր
եհետայ Տառելեա ետեֆ եֆա
եՀայ եՆանաճան Հեշատատկաց
Պ ել ա ղ ա ն ա ն աշ ե ա ե Օբման աա ՝ եՆ Հեշատատկաց

Ա․ԲՐԲԵԼ Ա․ԲՐԲԵԼ
Ղոֆեֆ․ Մ եահեֆե Ա եեզե
Ֆեխաղ․ Մ ռաֆեա, Ռ ֆեՆ ատ
Ֆեեֆ ատ ատ ատ ամեՆատ ֆառտեՆ
Ֆֆ ֆեֆաֆեՆե ՏառելեՆ Տ

ԵՕՐԲեՆՏ ԹԱՐԴ֊Ն
Նան ե եՆեֆեՆ ֆա ատ տեֆ
ՆՀ գ եատ ֆ․ գ եետ ֆեֆ ֆերֆ բաֆաՆ ատ ե
ՆՀ գ եֆա․ ֆեֆետեֆ բաշՆատ ֆ

30

Advice on the seriousness of sins

Giovanni Bona, Directions to Heaven (Ձեռբածութիւն Յերկինս),
translated by Vardan Yunanean

18 x 11 cm, paper
Sacra Congregatio de Propaganda Fide
Rome 1674 (transl. 1671)
Wadham College, Oxford, Wadh. Arm. D. 240 pp. 24–5

Rome, the seat of the Roman Catholic Church, was one of the first places in which books in Armenian were printed. It must be considered historical irony that a great number of these volumes should be directly intended to convert the Armenians to Catholicism; produced under the authority of the *Sacra Congregatio de Propaganda Fide*, an ecclesiastical institution set up in 1622 by Pope Gregory XV as a means to foster the counter-reformation, these books included dictionaries and grammatical primers, but also distinctly instructive material such as the *Directions to Heaven* (Ձեռբածութիւն յերկինս).

Originally composed in Latin, this Armenian translation of Cardinal Giovanni Bona's work maintains the main feature of the original: its simplicity. Attempting to explain the basic tenets of the Catholic doctrine, each chapter provides practical suggestions. Chapter two,

for example, calls those who wish to live a righteous life to seek a religious mentor, while chapter three elucidates that 'sin is the root of all evil, and straight from this seed grows what tortures us'; the best way of living a sin-free life is constant meditation on death and eternity.

Leaving aside the religious component, Rome, next to Amsterdam and Venice, is one of the Armenian printing centres of historical importance; the type fashioned here at the beginning of production in 1579, cut by punchcutter Robert Granjon, who had previously developed many other non-Latin typesets, was used mainly for the small publications of the *Congregatio*, but survived more than two centuries, only to be confiscated in the early nineteenth century by Napoleon, and then to be used by the French Imprimerie Impériale in Paris.

Lane, J. A., *The diaspora of Armenian printing, 1512–2012*, Special Collections of the University of Amsterdam, Amsterdam, 2012.

Maurer, P., 'Kardinal Giovanni Bona. Cistercienser, geistlicher Schriftsteller und Pionier der Liturgiewissenschaft', *Analecta Cisterciensia*, vol. 59, 2009, pp. 3–166.

RM

Գլ. Դ.

Տաղագս մեթիցուԹեն 'ւեն
ղաց։ Մեկանաւէֆեն շղձուեեա
հետեցեաֆ առ նոսին, և յայ ու
Զեն կձատեֆէ Զեց գոժա
ֆա զգանչուՆ ան և զրա է
հեսեականուՆ
յասա
նասնե

ի վեֆստ ղաֆանան
 առ ուֆ մաֆն,
շեֆ չաֆեՆ, որե պատաու աս
նանե ուղղաֆե մֆերեումե, ոֆ
ֆեֆ չափֆաֆ զեեց, այտո ԹասնԷ

բերա տեեեֆե ղեղակին եղեաֆ
մանան ։ Շֆ՛ Զաֆմֆաֆ ,
մֆֆ դեֆ Զեֆակատամֆֆֆ . ֆայֆ
ֆֆֆ աֆգոֆֆֆ աֆդոֆֆ Թե ուֆ
ֆան ֆֆ եֆ եֆեֆուֆ ֆֆֆֆֆֆֆֆ
եֆ։Ոֆաֆֆ ԷԹԷ պֆֆֆֆֆ գԷ'ֆ ֆՆ
ֆֆֆ, ֆֆֆ ֆֆֆֆաֆֆֆ, ֆԷ 'ֆֆֆֆ
ֆֆֆֆֆԹԷֆ ֆֆֆֆֆֆֆֆֆֆֆֆ
ֆֆֆ ֆֆֆֆֆֆֆ ֆֆֆ 'ֆֆֆֆֆֆֆ,
ֆֆֆֆֆֆֆ ֆֆֆֆֆֆֆֆֆ ֆֆֆ
ֆֆֆֆ ֆֆֆֆֆֆֆ, ֆֆ' ֆֆֆֆֆֆ ֆֆ
ֆֆֆֆֆֆ ։ Ոֆ ֆֆ ֆֆֆֆֆֆ ֆֆֆ, ֆֆ
ֆֆֆֆֆֆ ֆֆֆֆ ։ ֆֆֆֆ ֆֆֆֆֆֆֆ ։ Հֆֆֆ ԹԷ
ֆֆ, ֆֆ ֆֆֆֆֆֆֆ ։ ֆֆֆֆֆ ԹԷ
ֆֆֆֆֆ ֆֆֆֆֆֆԹԷֆ ֆֆֆֆֆֆ, ֆ
ֆֆ ֆֆֆֆֆֆֆ Է'ֆֆ ֆֆֆֆֆ ֆֆֆֆֆ
ֆֆֆֆֆֆ ֆֆֆֆֆֆ ֆֆֆֆ, ֆֆֆֆ
ֆֆֆֆֆֆ ֆֆֆֆֆֆֆֆֆ ֆֆֆ Է'ֆֆֆֆֆֆֆ

Grammar, Science, Astrology and Philosophy

The pursuit of knowledge, be it in the form of the humanities, applied or natural sciences, has played an important role in the history of Armenian writing, to such an extent indeed that a whole school of translation evolved around it, providing Armenian students with helpful material for the study of challenging works in a foreign language. Inspired by the grammatical treatise of Dionysius Thrax, and the philosophical works of Plato, Aristotle, Porphyry and many others, Armenia herself has given rise to important thinkers.

The most well-known of them is likely Anania Širakacʻi, born at the beginning of the seventh century CE; after his studies of mathematics, which he called 'the mother of all knowledge', and other sciences in Trebizond, he returned to Armenia, there to open a higher school himself, the first of its kind in Armenia. Like many scholars of Late Antiquity, Anania was interested in a number of subjects, and next to treatises on mathematics and astronomy also wrote a book on Armenian geography, that would long be wrongly attributed to Movsēs Xorenacʻi. Among his more mathematically minded writings is the *Perpetual Calendar*, which in uniting

his previous work on the motions of the moon and discourses on Christmas and Easter provides a framework for the calculation of important dates in the liturgical calendar.

A century later, the philosopher, theologian and grammarian Stepʻanos Siwnecʻi produced significant works at the other end of the spectrum of knowledge in providing commentaries on the works of the Neo-Platonic philosophers David Anyałtʻ and Porphyry; like Anania, so Stepʻanos, too, was a writer with wide interests, and in addition to his philosophical writings composed the first commentary on the symbolology used in Armenian renditions of the Eusebian canon tables, as well as a number of spiritual chants (շարական).

The great number of translations from and commentaries on Greek texts found in Armenian is without doubt testament to the close relation of the Greek and Armenian cultural sphere; similarly, the diverse topics dealt with by individuals, often incorporating scientific, philosophical and theological inquiries, are a clear indicator of the oneness of these subjects in the authors' perception.

Hewsen, R. H., 'Science in Seventh-Century Armenia: Ananias of Sirak', *Isis,* vol. 59, no. 1, 1968, pp. 32–45.

Mahé, J.-P., 'Connaître la sagesse: le programme des anciens traducteurs arméniens', in R. H. Kévorkian (ed.), *Arménie, entre Orient et Occident: Trois mille ans de civilization*, Bibliothèque nationale de France, Paris, 1996, pp. 40–61.

Mahé, J.-P., 'Quadrivium et cursus d'études au 7e siècle en Arménie et dans l'Empire Byzantin d'après le "K'nnikon" d'Anania Shirakacʻi', *Travaux et Mémoires*, vol. 10, 1987, 159–206.

Nichanian, M., *Ages et usages de la langue Arménienne*, Editions Entente, Paris, 1996.

RM

31
Feast days in the month of December
Perpetual Gregorean Calendar (Տօմար Գրիգորեանն յաւիտենական)

21.2 cm, paper
Typographia Dominici Basae
Rome 1584
Ary. 3. 364 pp. 169–9

This Eternal Gregorian Calendar, detailing the dates of certain feasts and explaining the calculation of such moveable feasts as Easter and Ascension, is one of the earlier volumes published by a Cardinal committee established by Pope Gregory XIII which would be formally instituted as the *Sacra Congregatio de Propaganda Fide* in 1622 under Gregory XV.

The difference in the date of Easter, for example, between the Roman Catholic Church, which has followed the Gregorian Calendar since its implementation in 1582, and the Armenian Apostolic Church, which until adopting the Gregorian Calendar in 1923 used the Julian Calendar for the computation of feast days, varied every year: in 1634, the year in which this calendar was published, Easter fell on 16 April in the Roman Catholic calendar, but was celebrated by the Armenians and other Oriental Orthodox Churches on 6 April.

The page exhibited here shows details for the feasts held in December according to the Catholic calendar, for the most part noting martyrs' name days, starting with St Vivian on 2 December (Վիվանա կուս[ին] մ[ար] տ[իրո]սին յիշատակ). As expected, Christmas (Ծնունդ տ[եառ]ն մերոյ յ[իսու]ի ք[րիստոս]ի) is listed on 25 December, yet Armenian tradition differs from both the Catholic calendar and that of the other Oriental Orthodox Churches in celebrating Christmas together with the feast of Epiphany / Theophany, the feast of Christ's baptism in the River Jordan. The date for the Nativity used in the Catholic Church is not set in the Bible itself, and is first attested in the fourth-century Philocalian Calendar from 336 CE. It is unclear whether the date is related to the Ancient Roman feast of Saturnalia or Sol Invictus, or whether it relates to the concept that Christ was born on the same day of the year as he was later crucified, thus calculating the date of Nativity nine months from Annunciation.

Cross, F. L., and E. A. Livingstone (eds), *The Oxford Dictionary of the Christian Church*, 3rd revised edition, Oxford University Press, Oxford, 2005.

Vardanyan, Ṙ. H., *Hayocʻ Tonacʻuycʻə: 4–18-rd darer* [The Armenian Church Calendar: 4th–18th Centuries], HH GAA "Gitutʻyun Hratarakčʻutʻyun, Erevan, 1999.

RM

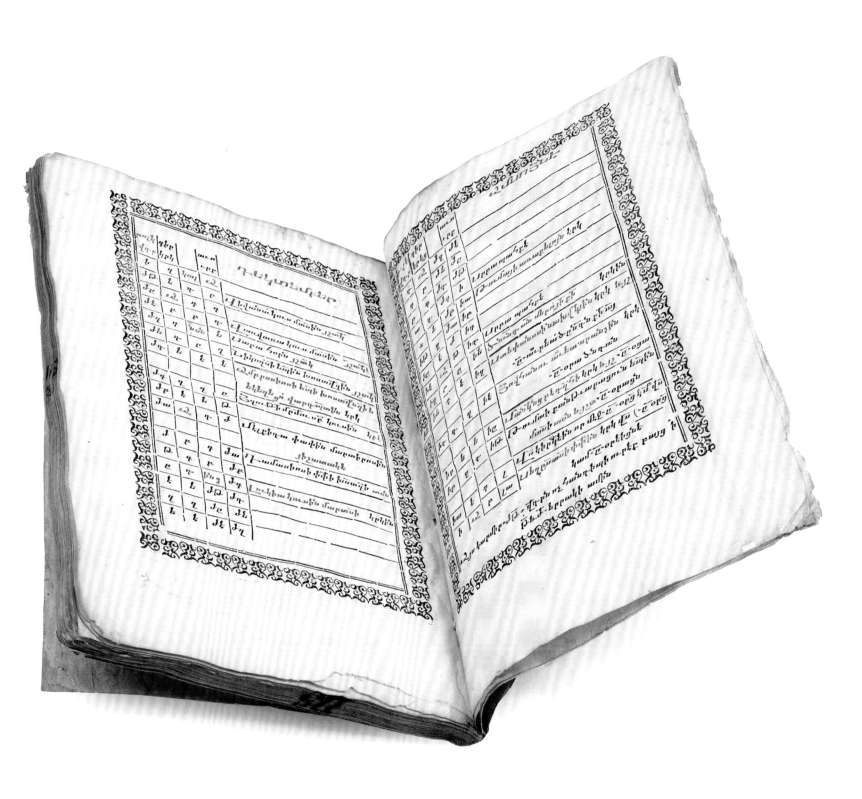

32

Table for the calculation of the beginning of a month
Perpetual Calendar (Պարզատումար)

10.1 x 7.6 cm, paper
Constantinople (Istanbul)
(?) 17th century
MS. Arm. g. fols 18v–19r

A perpetual calendar (Պարզատումար) allows for a number of calculations concerning certain dates of the year, most importantly Easter, which can fall in its limit from 22 March to 25 April and governs all the moveable feasts of the year.

In this seventeenth-century volume are presented thirty-five separate calendars, each organized according to a dominical or year letter (տարեգիր), with the help of which the date of Easter can be determined. A complex set of instructions accompanies these calendar tables, taking into account both leap years and their interaction with the lunar cycle.

The table on the left allows, amongst other things, for the calculation of the day of the week in the Gregorian calendar with which a month begins; older volumes contain similar tables for the Classical Armenian calendar, in which each month had thirty days to which was added an intercalary month of five or six days every year.

The column labelled կրկնակն է (its doublet is) contains a number parameter for each month which, added to the set septenary number of each year, yields the number of the month's first day. The septenary number for 2014 is 3; to calculate the weekday of 1 August, this number is added to the կրկնակ for August (oqnuunu), which is բ, 2, and augmented by 1 for the new day; thus 3+2+1=6. With Sunday being the first day in this calculation, one arrives at Friday.

Apart from tables and calendric commentaries, the volume contains a number of hymns for the Night Office, and a short chapter concerning the holy places in Palestine and Jerusalem.

Broutian, G., 'Persian and Arabic Calendars as Presented by Anania Shirakatsi', *Tarikh-e Elm*, vol. 8, 2009, pp. 1–17.

Dulaurier, É., *Recherches sur la chronologie arménienne: technique et historique*, Imprimerie Impériale, Paris, 1859.

RM

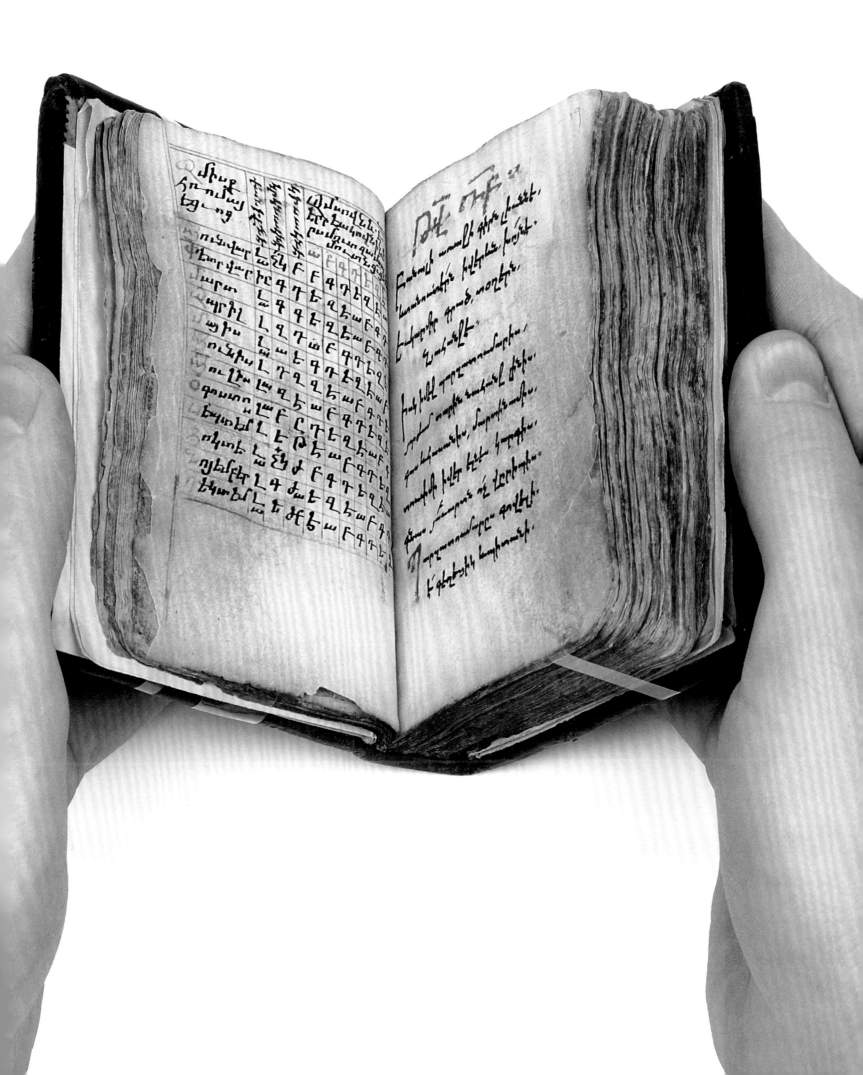

33

The Tree of Porphyry and the beginning of Dionysius Thrax's Grammar
Grammatical and Philosophical Tractates

17.8 x 12.1 cm, paper
Bałtʻasar (copyist)
18th century
MS. Arm. e. 34 fols 3v–4r

In this manuscript are collected a number of works on grammar and philosophy, neatly copied in the classical round script (բոլորգիր) and decorated throughout with marginal arabesques and colourful headpieces at the beginning of the different tractates.

On the left-hand side is found the so-called Tree of Porphyry, a diagrammatic illustration of the scale of being, suggested most famously in the Western tradition by the Neo-Platonist philosopher Porphyry. Based on his *Isagoge*, an introduction to Aristotle's *Categories*, Porphyry suggests that each category can be dichotomously subdivided by differentiation. This process is continued logically until no further subdivision is possible. At the top of the tree is found substance (Գոյացութիւն), which is divided into corporeal (մարմին) or incorporeal (անմարմին); the incorporeal is exemplified as an angel (հր[ե]շտ[ա]կ), and not further subdivided, while the corporeal is organized further into animate (շնչաւոր) and inanimate (անշունչ). The actual text

of Porphyry's *Isagoge* (Ներածութիւն) follows later in this volume.

The right-hand page contains the beginning of the Armenian translation of the Classical Greek grammar attributed to Dionysius Thrax, entitled here only *Concerning Grammar* (Յաղագս քերականութե[ան]). Assumed to be one of the earliest texts translated in a Grecizing fashion, the translation attempts to render comprehensible phonological differentiations and grammatical rules applicable in Classical Greek through the medium of Classical Armenian; where such differentiations or categories do not exist, the translator artificially introduces them, so for example in the differentiation of gender which Armenian does not know. The grammar is followed by a glossary explaining the terminology.

Apart from the texts mentioned above, the volume also contains pieces on orthography, such as the *Art of Penmanship* (Արուեստ գրչութեան) by Aristakēs the Writer, pieces by Movsēs Xorenacʻi, as well as translations of Aristotle.

Adontsʻ, N., *Denys de Thrace et les commentateurs arméniens*, transl. from Russian, Fundação Calouste Gulbenkian, Lisbon, 1970.

Clackson, J. P., 'The "Technē" in Armenian', in Vivien Law and Ineke Sluiter (eds), *Dionysius Thrax and the Technē grammatikē*, Nodus, Münster, 1995.

RM

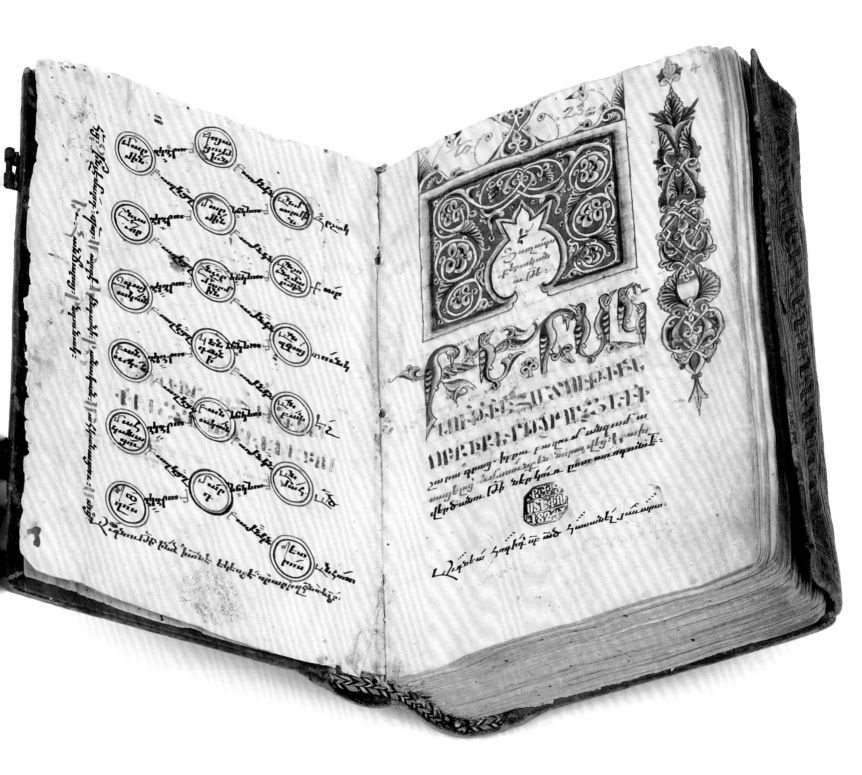

34

Aides for the calculation of the full moon and the Golden Number
Chronological Tractates

13.3 x 9.5 cm, vellum
17th century
MS. Arm. f. 3 fols 165v–166r (p. 354–5)

This whole volume is dedicated to the provenance of the Armenian calendar, its usage, and the calculation of important dates in the year as well as abstract numbers which aid in the calculation of the Easter date.

On the left-hand side, next to the table, is found a short instructive text concerning the computation of the so-called Golden Number, an abstract number assigned to each calendar year based on the nineteen-year cycle, in which the beginning of solar and lunar year fall together. To calculate this number, the year is divided by nineteen, the remainder of which operation, augmented by 1, yields the Golden Number. Thus for the year 2015, this number is 2, since (2015 mod 19) + 1 = 2.

With the aid of the circular guide on the right-hand side, and tables on subsequent pages, the Golden Number and the so-called epacts – an indicator of difference between solar and lunar year – the tremendously difficult calculation of the date of Easter is possible. The instructions within and below the circular guide further allow for the determination of the full moon for each month, and vice versa the determination of certain calendric indicators based on the full moon in any month.

The tractate concerning the origins of the Armenian calendar mentions amongst other things the beginning of the Armenian Era in 552 CE, established as a pre-emptory token of separation from the Chalcedonian Western Churches, which was later formalized at the Second Council of Dvin in 554 CE. The difference in date between the reckoning according to Anno Domini and the Armenian Era is thus 551 years.

Mosshammer, A. A., *The Easter Computus and the Origins of the Christian Era*, Oxford University Press, Oxford, 2008.

RM

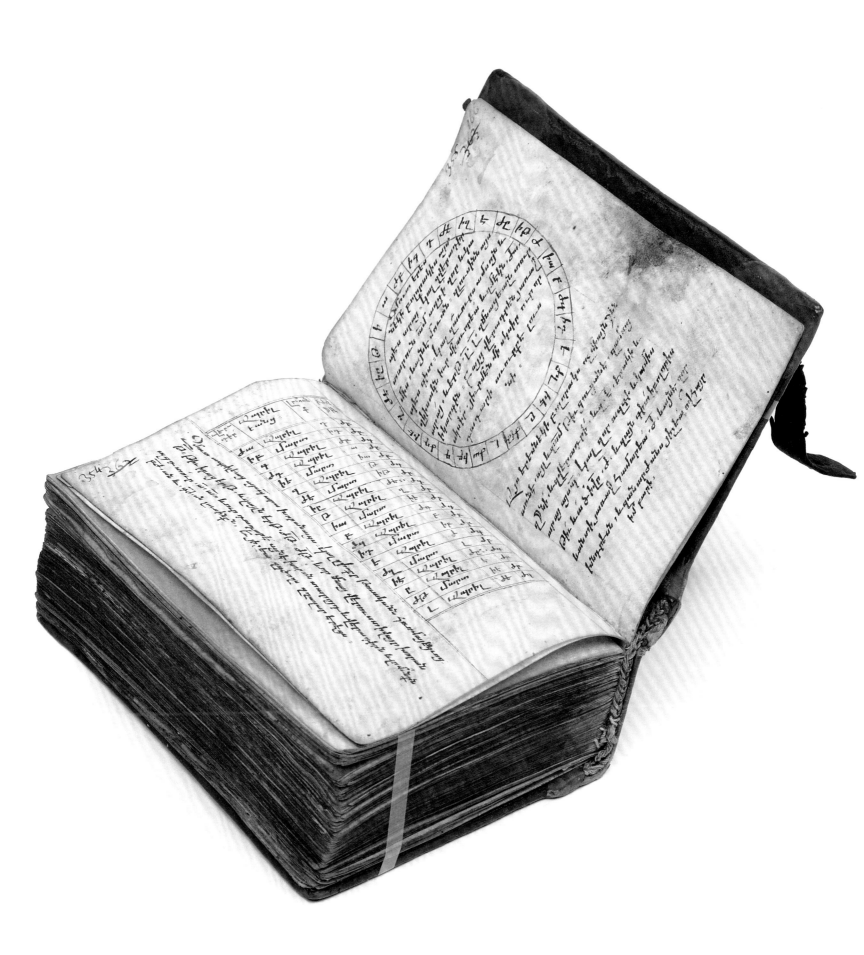

The first Armenian manuscripts in the Bodleian Library
Thomas Hyde's Catalogue of Armenian Manuscripts in the Bodleian Library

29 x 17 cm, paper
Oxford 1667
MS. Arm. d. 23 fols 1v–2r

Thomas Hyde (1636–1703), who took on the position of Bodley's Librarian in 1665, was a polyglot Orientalist, probably best known for his *History of the Religion of the Ancient Persians*, in which he expounded the dualistic nature of Zoroastrianism, seeking to set right ancient misconceptions. Although elected to the Laudian Professorship of Arabic after the first incumbent Edward Pococke, as well as the Regius Professorship of Hebrew, Hyde held the opinion that 'Lectures … will do but little good, hearers being scarce'; he had little luck in finishing research projects, many of which remained in essay form and were only published posthumously. Although complaining of the lack of money for the purchase of books, Hyde managed to increase the Library holdings threefold, and furnished it with a catalogue. It was under his stewardship, too, that the first Armenian manuscripts made their way into the Bodleian collection, as evidenced by Hyde's handwritten catalogue. His notes, composed in French, give a brief resumé of the contents of each manuscript, unfortunately not assigning them any more abstract identifier.

While a few manuscripts are identifiable on the basis of these descriptions, Hyde has in some cases overestimated the age of individual items: an Armenian grammar, which in his time was meant to be more than 500 years old (twelfth century), is in fact far more recent. Similarly, his entries show that Hyde was not well versed in Armenian history, describing the tractates of the important Neo-Platonic philosopher Davitʿ Anyałt as 'certain philosophical works by some David who lived in the fifth century'.

It is impossible, however, to identify all 95 manuscripts listed by Hyde, and indeed to trace their fate, since the vast majority of the current 140 Armenian manuscripts in the Bodleian were acquired in the late nineteenth century.

Feingold, M., 'Oriental Studies', in Trever Henry Aston and Nicholas Tyacke (eds), *The History of the University of Oxford, vol. 4: Seventeenth-century*, Clarendon Press, Oxford, 1977.

Macray, W. D., *Annals of the Bodleian Library*, second ed., Clarendon Press, Oxford, 1890.

RM

petit Dictionnaire Arménien. 5° un petit Dictionnaire Arménien ... Historien de la Bible. 60 une histoire abrégée ... Arménien.

Ms contenant une Grammaire, et des Cantiques ... extraits, et le Vocabulaire ...

Ms contenant ... commentaires de Gigor Zadaraci ...

Histoire de la Conversion des Arméniens, par Nazarus ...

... sur l'Apocalypse par Nazarus Lampronaci ...

Ms contenant un Traité de ... l'Eglise Arménienne ...

Ms contenant 1° les Controverses de Jean Odnizki 2° les Commentaires de Gregoire Zadaraci, et ceux de Noadzy ...

Recueil contre les Ariens par Vartadier Magisis ...

Gissean, sur la Théologie, la Philosophie, et ...

Traité d'Astronomie par Jacob Vokerbec en Tartarie ...

Théologie Arménienne ...

Calendrier ... avec des notes Philosophiques ...

Commentaires sur les Proverbes de Salomon par Gregoire ...

Commentaires sur les ouvrages de S. Denys ...

Commentaires sur l'Evangile de St Mathieu ...

Traité sur l'Antichrist.

Avis et Conciles donnés aux Religieux par le Magne Evagnius ... Ms a plus de 400 ans.

Grammaire Arménienne; ce Ms a plus de 500 ans.

Fables composées en Arménien par Vartan.

Les Pseaumes. Ancien Ms.

Ms contenant quelques morceaux d'Aristote, traduits, ... Philosophiques d'un nommé David, qui vivait dans le 5e Siècle. ...

Traité de Musique, avec les notes, et un recueil des Chansons.

Poèmes sur la fin du Monde et le dernier Jugement.

Recueil Arménien fort ancien. Ce Ms est d'autant plus considérable que les anciens des Hérétiques Arméniens s'y trouvent ...

Ms intitulé Giarrantir ... long de deux pieds ... dix pouces, ...

Ms qui contient l'histoire des différentes hérésies faites par les Arméniens ...

... le langage ... Patriarches ...

Ces ouvrages ... Ecclésiastiques d'Arménie ...

Ms fort ancien sur l'Histoire de l'Eglise Arménienne.

... Cantiques qu'on chante ordinairement dans l'Eglise Arménienne ...

Prières à l'usage des Cantiques qu'on chante ... les fêtes ...

... la Conférence de Zulpha ...

Théologie Arménienne de 300 ans ... des Evêques Prêtres et Diacres Arméniens pour l'ordination ... à S. Athanase 3°

Le Rituel Arménien ... St Grégoire l'Illuminateur ...

Ms contenant ... les Pseaumes de David avec les Prières ...

Mes très anciens contenant les Pseaumes ...

Livre de Controverse par Mikhitar Canonay ... d'Alexandrie ... contre les Catholiques ... Patriarche d'Ephraim Henry ...

Les Enfants de Jérusalem ...

Patriarche des Arméniens ... St Grégoire l'Illuminateur ...

Ms contenant 1° les Enfants de Jésus ... le Roy Cosroy a la prise de Jérusalem.

... la croix, ... Théodose le Grand 4° différents sermons. 2° ... Histoire de Théodose ...

3° l'Histoire d'un Chrétien ... du monde, avec plusieurs morceaux de Géographie.

Traité des sept Merveilles du monde ...

Histoire des ceux qui ... les Patriarches Arméniens ...

Histoire Ottomane.

Traité de la Naissance et de la Passion de Jésus ...

Asmathousk, ou les Actes des Saints dont l'Eglise Arménienne ...

Bréviaire des Arméniens ...

Les manuscrits Arméniens ...

36

Woodcut of Porphyry and the beginning of his *Isagoge*

Porphyry's Isagoge (Ներածութիւն Պորփիւրի)

18 x 11 cm, paper
Yarut'iwn Tēr Šmawōnean Širazec'i
Madras 1793
Wadham College, Oxford, Wadh. Arm. C. 8 pp. 16–17

Armenians settled in India as early as the mid-sixteenth century under the Mogul Emperor Akbar. After the fall of the Mogul Empire, it took time for the Indian community to flourish, helped by trade from the newly established and wealthy settlement in Persian New Julfa. The largest local community in Madras took to printing in 1772 and as its first book published a grammatical primer with the aim to spread knowledge of Classical Armenian language and literature.

The present volume, a translation into Armenian of a philosophical tractate by the third-century Neo-Platonic philosopher Porphyry, was printed by the community's second printing press, established by Yarut'iwn Šmawōnean before 1789. Many works of philosophical, religious or scholarly importance originally composed in Greek were translated into Armenian from the late fifth century onward, and reflect the Armenians' desire to accrue knowledge and sagacity. The peculiar format of these translations, which consist of verbatim renderings of the original Greek with frequent neologisms and little regard for Armenian syntax, may be the result of their function as study aids rather than formal translations. Their excessive literality, however, created a rich technical vocabulary for the Armenian language, large parts of which are still used in modern Armenian.

Under the woodcut portrayal of Porphyry, clad in distinctly medieval robes, can be found a short rhyming stanza: 'Noble Porphyry | a great moralist and philosopher | writes this to Chrysaorius | who is a Roman, a great *hypatos* [high public official]'. On the other page begins the *Isagoge*, an introduction into Aristotle's *Categories*; this work, in its Latin translation by Boethius, was used throughout the Middle Ages as a basic introduction to logic.

Nersessian, V., *Catalogue of Early Armenian Books, 1512–1850*, British Library, London, 1980.

Seth, M. J., *History of the Armenians in India. From the Earliest Times to the Present Day*, Luzac & Co., London, 1897.

RM

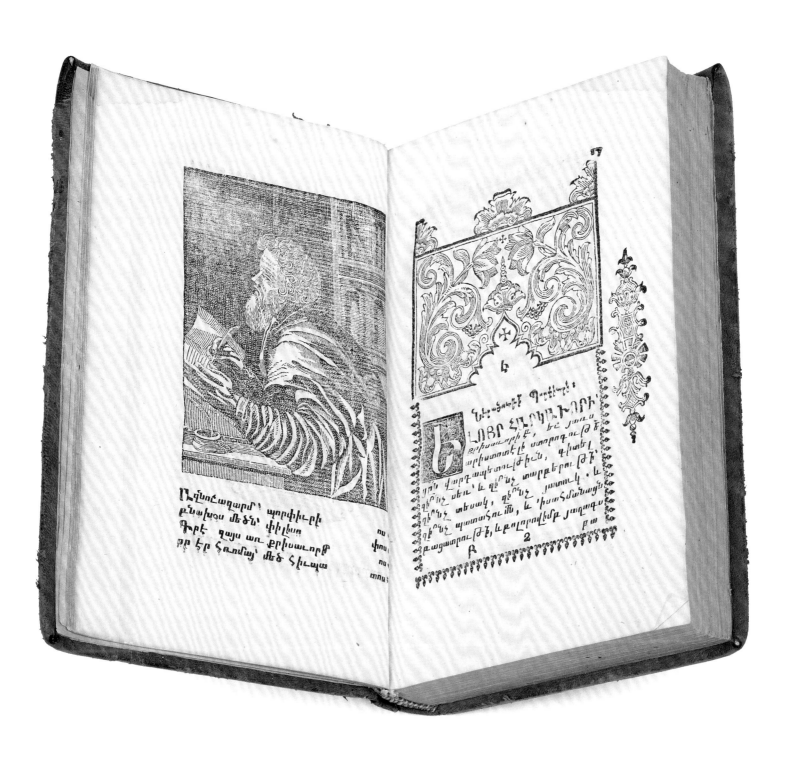

Ա

Բ 2 Բա

The Armenian Alphabet: Devised for One, Used for Many Languages

Armenian, as an Indo-European language, had been spoken for centuries by the time St Mesrop Maštocʻ created an alphabet for the language in the early years of the fifth century CE. Other scripts, such as Pahlavi, Greek and Syriac, had been used for religious and administrative purposes before and were known to the intellectual elite; the great literary tradition of the Armenians, however, begins only with the inception of their own, unique alphabet (Այբուբեն). As detailed in the biography of St Mesrop written by his disciple Koriwn (Վարք Մաշտոցի), a different alphabet developed by a Syrian bishop called Daniēl had been intended for use with Armenian first, but proved inadequate; with the help of some of his students, and divine inspiration, however, the new alphabet came into being in Edessa. Owing to a variety of historic factors, the precise date of the creation cannot be determined with certainty. Koriwn's account details that Mesrop's journey to Edessa took place in the 'fifth year of the Armenian King Vramšapuh', which is the year 394 CE; traditional accounts, however, suggest the early years of the fifth century as more likely.

The inspiration for the letter shapes themselves are mixed in origin. Of the thirty-six original letters, some are clearly of Greek origin, such as the letters

p'iwr փ from Greek φ, or rē ռ from Greek ρ; other letters, however, are more closely related to shapes of the Syriac alphabet, such as da դ from Syriac ܕ

The Bible would be the first work to be translated into Armenian, and thus written in the new letters; tradition has it that the first sentence written by St Mesrop stemmed from Proverbs 1.2: 'To know wisdom and instruction; to perceive the words of understanding' (Ճանաչել զիմաստութիւն եւ զխրատ, իմանալ զբանս հանճարոյ). The Armenian script would be used not only to write Armenian; in the Ottoman Empire, a great number of official documents and literature would be written in Armenian letters, but composed in Turkish, as well as in other languages of the Empire and elsewhere. From the nineteenth century onward, it would further be used to write the Kurdish languages.

Over the centuries, the Armenian alphabet and script have changed. In the Middle Ages, two letters were added to aid in the spelling of loan words and names. The script has undergone vast changes, from an uncial form (երկաթագիր), via the most common round script (բոլորգիր), to a minuscule cursive (նոտրգիր), all of which are still used for different purposes. Next to regular shapes for writing, a highly stylized form of the alphabet used bird and other animal shapes (թռչնագիր) and was employed for ornamental purposes.

Sanjian, A., 'The Armenian Alphabet', in Peter T. Daniels and William Bright (eds), *The Word's Writing Systems*, Oxford University Press, New York, 1996, pp. 356–7.

Stone, M. E., D. Kouymjian and H. Lehmann, *Album of Armenian Paleography*, Aarhus University Press, Aarhus, 2002.

Winkler, G., *Koriwns Biographie des Mesrop Maštocʻ: Übersetzung und Kommentar,* Pontifico Istituto Orientale, Rome, 1994.

RM

37

A sinner washes Christ's feet (Luke 7.37–44)
Polyglot fragment of the Gospel of Luke

(Restored) vellum
14th century (?)
MS. Copt. c. 2 recto

Although the Bible has been translated into a vast number of languages, and bilingual versions thereof have existed for centuries, the present fragment of a Gospel manuscript, containing passages from Luke, is exceptional owing to its polyglot nature: split into five columns, the text is written in (from left to right) Aethiopic, Syriac, Memphitic Coptic, Karshuni (Arabic in Syriac script) and Armenian. The factor uniting all of them is that the Aethiopic, Coptic, Armenian and some of the Churches using Syriac as their liturgical language all belong to Oriental Orthodoxy, the strand of Christianity that rejected the dogmatic formulations of the Council of Chalcedon in 451 CE regarding the divine and human nature of Christ.

Due to the fragmentary nature of the manuscript, very little about its heritage can be known for certain; the use of vellum (calf skin parchment), however, as well as the manuscript hands suggest an origin in the fourteenth century. It was presented to the Bodleian Library in 1884 by A. J. Butler, a fellow of Brasenose College, who had acquired it in Egypt. For this reason, it has been assumed that Coptic was the primary language of the manuscript. Coptic, as the language of the Christians in Egypt, was one of the earliest into which the Bible was translated, and thus often offers interesting insights into textual traditions. The passage shown here, Luke 7.37–39, the washing of Jesus's feet by a woman sinner in the house of the Pharisee, suggests that the complete polyglot gospel codex must have been a rather large volume.

Baronian, S., and F. C. Conybeare, *Catalogue of the Armenian Manuscripts in the Bodleian Library*, Clarendon Press, Oxford, 1918, cols 5–6, no. 4.

RM

38

The Lord's Prayer in Armenian, with transcription and Latin translation

Teseo Ambrogio, Introductio in Chaldaicam lingua[m], Syriaca[m], atq[ue] Armenica[m], & dece[m] alias linguas, characterum differentiu[m] alphabeta …

4°, paper
Pavia 1539
4° A 55 Art. Seld. pp. 184-5

Teseo Ambrogio's *Introductio in Chaldaicam linguam…* offers the first Western account of both Armenian and Syriac, and makes mention of many other Oriental languages. A humanist, Teseo was interested amongst other matters in the kabbalah and mysticism and devotes parts of this work to exploring the relations between the alphabets and the divine, noting, for example, that the Armenian letter a (ա), with its three stems, recalls the Holy Trinity, and that the digraph aw (աւ) and the letter ō (օ), which are phonetically interchangeable, resemble Jesus who was both the Alpha and the Omega. This latter correspondence, occurring also in Latin, is attributed by Teseo to Noah, who, having landed his Ark in Armenia, migrated to Italy.

Mythological etiologies and comparisons are also at the heart of the introduction to the book. As the Greeks had under the guidance of the Sun discovered grammar, arithmetic and music, and as Pythagoras had introduced the concept of harmony, so would he, Teseo, discover the harmonies between the alphabets of different languages. It is his interest in harmony, and the fact that the volume is dedicated to his uncle Afranius, that warrants his in-depth discussion and depiction of the latter's musical invention: a phagotum, a sort of bagpipe shown in two detailed woodcuts.

In spite of references to the classics and mysticism, Teseo is a faithful Catholic and makes use of, amongst others, the Hail Mary and the Lord's Prayer when comparing and transliterating Armenian and Syriac. The passage on the right page, taken from Mt 6.9–13, shows first the Armenian version, an idiosyncratic transcription into Latin letters, and a word-by-word translation underneath; the Armenian contains a number of mistakes which suggest that Teseo had only seen, but not heard, this prayer.

Strohmeyer, V. B., *The importance of Teseo Ambrogio degli Albonesi's selected Armenian materials for the development of the Renaissance's perennial philosophy and an Armenological philosophical tradition*, Publishing House of the National Academy of Sciences 'Gitutyun', Yerevan, 1998.

Wilkinson, R. J., *Orientalism, Aramaic, and Kabbalah in the Catholic Reformation: The First Printing of the Syriac New Testament*, Brill, Leiden, 2007.

RM

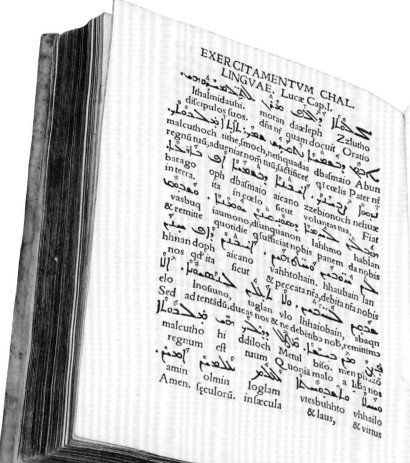

discipulos suos. moran daæleph dñs nr quam docuit Oratio
Ithalmidauhi Zzlutho

malcuthoch tithe, smoch, nethquadas dbasmaio Abun
regnū tuū, adueniat nom tuū, sãctificet qi cœlis Pater nr

barago oph dbasmaio aicano zzebionoch nehuæ
in terra. ita in cœlo sicut voluntas tua, Fiat

vasbuq iaumono, dsunquanon qsufficiat nobis lahhmo hablan
& remitte quotidie panem da nobis

hhnan doph aicano vahtohain
nos qd ita sicut & peccata nra, debita nra nobis

elo Inosiuno, taglan vlo Ihhaiobain,
Sed ad tentādū, ducas nos & ne debētibo nob, remittim

malcutho hi ddiloch bisо. men phazō
regnum est tuum Metul Quoniā malo a libа nos

amin olmin loglam vtesbuhhto vhhailo
Amen. sæculorū. insæcula & laus, &virtus

Hair mer or iercins des surb eglzzi anun
Pater noster q icœlis es sãctū sit nomen

cho, ecesszz archaiuthai cho eglizzin camch cho
tuū. Veniat regnum tuū, Fiant placita tua

orpęs iercins eu iercri, Zhazt mer hanapa-
sicut icœlo & iterra, Panē nrm supsubstātias

zord tur mez aisaur eu thogl mez zpaar-
lem da nobis hodie & remitte nobis debi-

tis mer orpęs eu mech thoglumch merozt part-
tis nostra, sicut & nos remittimus nostris debi-

panazt eu mi tanir zmez i phorxuthai ail
toribus, & ne ducas nos in tentatione, Sed

libera i zaræ, zi cho æ archaiuthai
libera nos a malo. Q m̄ tuū est regnum

eu zaruthai eupharhch iauiteans. Amen.
& virtus & gloria, insæcula. Amen.

 Aa

Armenian bird letters in print

Alphabetum Armenum, cum Oratione Dominicali, Salutatione Angelica. Initio Evangelii S. Iohannis et Cantico Poenitentiae

8°, paper
Typis Sacra Congregationis de Propaganda Fide
Rome 1784
8° B 185(1) BS. pp. 18–19

After earlier, less successful attempts at establishing Armenian printing in Rome, publications in and concerning Armenian began to flourish in 1579 under Pope Gregory XIII, the inventor of the Gregorian Calendar. A new type developed by the Frenchman Robert Granjon, akin to Yakob Mełapart's manuscript-style type but somewhat more elegant, was employed by the *Sacra Congregatio de Propaganda Fide* until the middle of the eighteenth century, largely in counter-reformatory publications aimed at converting Christians from the East to Catholicism (see cat. 30).

The publication of alphabets of various Christian and non-Christian Oriental languages, often accompanied by translations into those languages of passages from the New Testament and Catholic prayers and meant as field guides for missionaries, made up a significant part of the activity of the *Congregatio*. This edition of the Armenian alphabet, edited by Venerio Achille and first published in 1673, was reprinted with a new foreword in 1784. Showcasing the variety of Armenian script, it contains three different types:

round characters, representing both uppercase iron writing (երկաթագիր) and lowercase round writing (բոլորգիր,); a cursive script, containing elements of both *bolorgir* (բոլորգիր) and notarial writing (նոտրգիր), in which majuscules and minuscules closely resemble each other; and bird writing (ձագագիր or թռչնագիր), mimicking in woodcuts the typical ornamentation of manuscript headings with bird, fish (ձկնագիր) or human (մարդագիր) shaped letters.

Next to the letters themselves, Venerio Achille, who also published an Aethiopic alphabet and compiled a Georgian-Italian dictionary, provides a phonetic transliteration of the Armenian into Latin letters that most closely reflects the pronunciation of contemporary Italian speakers: thus Armenian č᾿ (չ) is rendered as cc, the sound in 'cappuccino'. This transliteration also betrays the dialect of the speakers with whom the editor was in contact: the rendition of k (կ) as g suggests one of the Western dialects as spoken in the Ottoman Empire, and in today's Levantine and many other diaspora communities.

Eggenstein-Harutunian, M., *Einführung in die Armenische Schrift*, Buske, Hamburg, 2000.

Lane, J. A., *The Diaspora of Armenian Printing, 1512–2012*, Special Collections of the University of Amsterdam, Amsterdam, 2012.

Stone, M. E., D. Kouymjian and H. Lehmann, *Album of Armenian Paleography*, Aarhus University Press, Aarhus, 2002.

RM

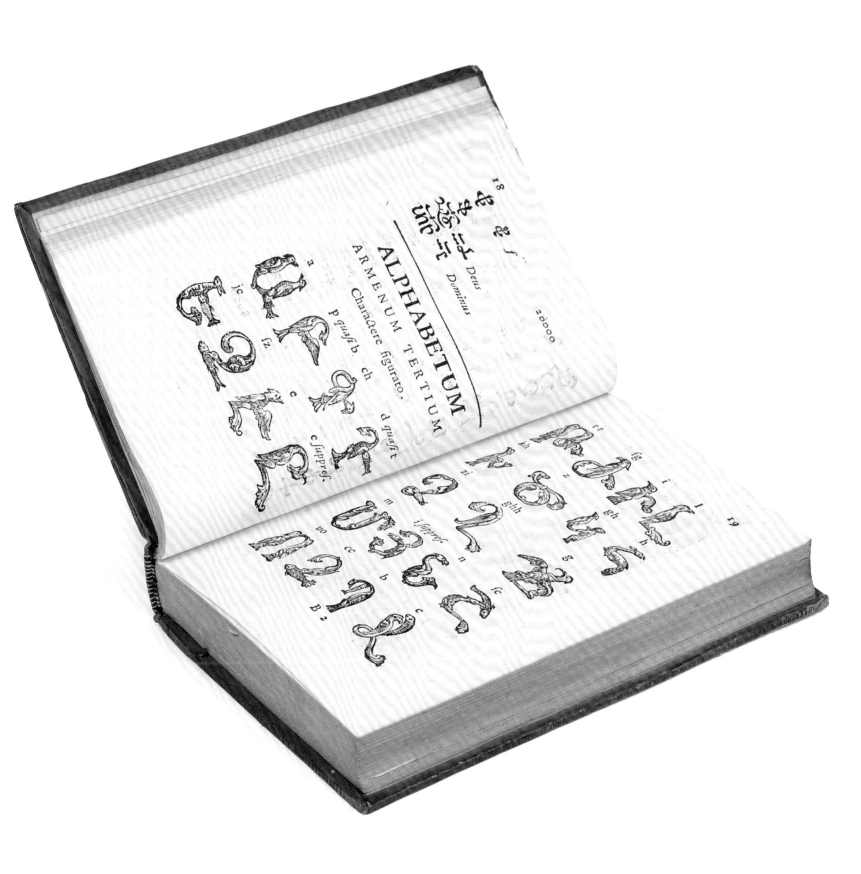

ALPHABETUM
ARMENUM TERTIUM
Charactere figurato.

40

A prominent misprint in the oldest printed Armenian dictionary
Armenian–Latin Dictionary (Բառագիրք Հայոց)

24 cm, paper
Typographia Collegii Ambrosiani
Milan 1633
C 5. 11 Linc. pp. 330–31

Published a little more than 100 years after the inception of Armenian printing, the Բառագիրք Հայոց was the first Armenian dictionary to be typeset. Commissioned by Cardinal de Richelieu, first minister of the French king Louis XIII, the volume translating Armenian into Latin was edited by Franzisco Rivola, a Milanese scholar, who in years to come would further author a grammatical primer of Armenian.

In the Latin preface to the Dictionary, Rivola notes the great zeal of his patrons to understand the languages and Christian faith of the Orient. Their ulterior motives, however, were less scholarly: comparing Richelieu to a military commander, Rivola states: 'Dux noster Cardinalis alia mente eo venturus est; ut nempe totam illam Orientis plagam luce fidei illustret, ut errorum fibras omneis elidat, oues dispersas congreget, Iesu Christi Regnum ibi rursus restituat, stabiliatque' ('Our lord, Cardinal Richelieu, will travel there with other [non war-related] plans; he will, of course, illuminate the whole afflicted Orient so as to wipe out all fibres of their sins; he will gather the lost sheep, and re-establish and re-affirm there the Kingdom of Christ Jesus'). This sentiment is put into practice in other printed books of the seventeenth century, published by the *Sacra Congregatio de Propaganda Fide*, which attempted to spread Catholicism amongst the Armenians.

The Dictionary is beautifully executed, still preserving some traits of Armenian manuscript art, such as the ornamented drop cap. Intended mainly for the study of Christian texts, the volume contains a great number of Biblical names in addition to standard vocabulary. A curious typographical error occurs on p. 331, where the typesetter mistakenly printed the glyph Մ upside down; although Մ does indeed resemble Ո like a mirror image, it is interesting that individual woodcuts had been manufactured for both letters, as betrayed by the different leaf pattern ornamentation for each glyph.

Ĵahukyan, G., 'Hay baṙaranagrut'yun', in Franz Josef Hausmann (ed.), *Wörterbücher: ein internationales Handbuch zur Lexikographie*, vol. 3, Walter de Gruyter, Berlin, 1991.

Lane, J. A., *The Diaspora of Armenian Printing, 1512–2012*, Special Collections of the University of Amsterdam, Amsterdam, 2012.

RM

LITTERA n.

Na ex litteris Armenijs.
Rahab.
Sors à punctorum ob-
 seruatione pendens.
Eiusmodi sorti operam nauans.
Rusticus.
Portus maritimus Syriæ.
Rusticorum caterua.
Copiosus, abundans.
Facultates, substantia, opes.
Facultatibus dit are.
Locupletem euadere.
Romulus.
Locus superior domus.
Vide

Plæraque eorum, quæ in n. incipiunt, ea reperies in littera

LITTEA u.

Aba.
Caniftrú maius, & am-
 Patientia. [plum.
Anitra.
Sachaël, princeps Dæmonioru.
Strictus gladius, ensis euagina-
Sadducæus. [tus.
Sidon.
Sidonius.
Vestis simplex absque subsuto.
Instrumentum musicum, quod
 manu pulsatur.
Academia musicis canentium
 instrumentis.
Musici instrumenti manu pul-
 fandi peritus.
Musica instrumenta concorda-
Vide [re.
Viuus lapis lætus, & planus,
 ITAL. laftra.
Cistula, canistellus.
Strena, quæ datur pro felici iti-
 nere.
Cycnus.
Nomen vrbis Armen. maioris.
 T t ij

41

Woodcut and the beginning of *The Story of Paris and Vienne*
Yeremya Çelebi Kömürcyan, The Story of Paris and Vienne (Հիքեայէի Ֆարիս վէ Վէնա)

11.5 x 14 cm, paper
Asitane Zardarean Piraterler Fabrikası
Constantinople (Istanbul) 1871
Private Collection (LM) pp. 10–11

This 1871 edition of Yeremya Çelebi Kömürcyan's (1637–1695) *The Story of Paris and Vienne*, based on an old French romance, may be set in Armenian letters, but is actually composed in Ottoman Turkish; although most frequently written in the Perso-Arabic script, the variegated ethnic composition of Ottoman society, especially in Constantinople (Istanbul), meant that other scripts, such as Greek, Hebrew and Armenian would also be employed.

The story focuses on two star-crossed lovers, Paris and Vienne, who due to the reluctance of Vienne's father cannot get married, even after Paris has proved his prowess in battle and other contests. The couple decides to elope, but, being pursued by her father's men, separate and promise to be faithful to one another until they are reunited. Paris, who subsequently exiles himself to the Near East for many years, perchance manages to free Vienne's father, then held prisoner in Egypt, and is finally promised her hand in marriage.

First composed in French in 1432, Yeremya creatively adapted the Armenian version, done at Marseilles in 1587 by Yovhannes Terznc'i, into Turkish, making sure to omit most overt references to Christianity and the Turks.

Yeremya, whose designation *çelebi* refers to his social standing as a gentleman, was one of the most notable figures of Armenian society in the seventeenth century; the son of a priest, he was well versed in Ottoman politics and served as adviser to the Armenian patriarch when only in his early twenties. Written in both Armenian and Turkish, his literary work, consisting of translations, prose and verse compositions, as well as historical treatises, is considered an important contribution to the development of Armenian literature owing to its inquisitive style and largely non-religious content.

Yeremya, a fervent Armenian Apostolic, in 1677 also founded the second Armenian printing press in Constantinople in order to counter the growing presence and influence of Roman Catholic Capuchins and Jesuits, as well as the publications of the *Congregatio de Propaganda Fide*.

Dankoff, R., "'The Story of Faris and Vena": Eremya Çelebi's Turkish Version of an Old French Romance', *Journal of Turkish Studies*, vol. 26, no. 1, 2002, pp. 107–61.

Oshagan, V., 'Modern Armenian literature and intellectual history from 1700 to 1915', in Richard G. Hovannisian (ed.), *The Armenian People from Ancient to Modern Times, Volume II*, Macmillan, Basingstoke, 1997, pp. 139–74.

RM

վԷնա Ֆարիս.

ՀԻՔԷԱՅԷԻ
ՖԱՐԻՍ ՎԷ ՎԷՆԱ.

Ա.

Թուրբէև էրբուա։ — վէենան ՆԷԳա, Էբան,
վէ չԷօնԷԷն — զան զԷյնէնՆա՜զ ՊԷ։

ՖՐԱՆՍԱ, պատուշանԷն մէմԷբէԷԹէնաԷ,
Իսմէ զաբԸ ԴԸբալ ՅԷուլէա ԷԺտԷբ.բէւ.
Էանայ էվԼէւն վԷ ապԸբբԸնաԷ,
Իշզու ՆաԴԼ օզաՆաբ վազգաՆԷն ԷսՂԷ։

ՀայբԷֆԹԷ ԷստանԷն պԷն ԹարիէմէբաԷ,
ՊԷն Էֆբ կԸՆզ ԹէմԷմֆ, սանֆ էՐԺմէբաԷ,
ՊԸ ապԷմ չԷՅԸբԸմֆան վաբ օԼ ալզաբաԷ,
ՖԸ.բ մնՅատապաԷ ԷԷ վԷնա խամԷնաԷ։

ԵաՂէն օն մԸէ Էէ ԼէՕն շաՅ ԷսվԷԷ,
ՕԼ ՖԷ Էգէնայէ մԷբ Ֆօմա շաՅ ԷսվԷԷ,
ՊԸ սաւԼՅա վաբ խԷ մէգԸբա չԷՅԷբաԷ,
ՖԸ ապԷաստապա ԼամԷ օԼ պԸատումՅԷՆԷ։

ՊԸ ուԼա, մԷռա խԷ ՖԸբԷՆԳ ԶաբԷՖԷ,
ՄԻբԷ ՖԷԼաբ, ԷԺաապէ՝ ԹԷՖԸսԷբ սանԷբվաէ,
ԱՅվաէ, ալէՎ ավԼաբ ԿԸՐՇԷֆ Թաբ.ԷֆԷ,
վԷՖԸ, օՖաՅ պէՖէ խՄէԼԷ Տա.ԼԷֆԷ։

Histories, Poets and Storytellers

As in many literary traditions that have begun before the dawn of modernity, the boundary between story and history in Armenian literature is often unfathomable. Historical fact is presented in often masterfully woven narrative cloth, ornamented with fictional elements or other hyperboles to which the modern reader is unaccustomed; it must be borne in mind, however, that what is taken for fiction and exaggeration by the reader in our time was likely plausible reality to the author. Movsēs Xorenac'i's account of the Armenian people's heritage combines myth and fact just so: the defeat of the giant Bel by their legendary hero and founder Hayk (Հայկ), a descendant of Japheth, son of Noah, has its place, as do more factual reports on recent, i.e. fifth-century Armenian history. Writing in this fashion, Movsēs is in good company: this type of historiography is reminiscent of Herodotus, whose *Histories* of the Greco-Persian wars and the accompanying excursions are equally varied.

While Movsēs's work is usually assigned to the more factual side of the above divide, other works based more or less loosely on historic personalities belong quite clearly to the realm of myth and legend. Most prominent amongst them is

the Alexander Romance, describing the legendary exploits of the Macedonian king Alexander the Great. His life and achievements were of interest to the Armenians since their nobility had, during the Battle of Gaugamela, fought on both sides, some for Alexander, some for Achaemenid Persia. On a different level, the Alexander Romance has impressed on the academic community the importance of Armenian witnesses, with the help of which passages lost in the Greek original can be restored.

The wealth of Armenian literature does, of course, not end in Late Antiquity; Armenians were active throughout the ages, and some of their most famous stories and tales, such as the epic *The Daredevils of Sasun* (Սասնա Ծռեր), had survived since the Arab Conquest in the oral tradition and were put to paper only in the nineteenth century.

The survival of the historiographic tradition is manifest also in documents such as the twentieth-century chronicle of the town Muncusu (modern Güneşli) and the history of the Izmirlean family, dating back to the mid-sixteenth century. Only with the aid of such invaluable historical sources, however recent or ancient, is it possible to understand Armenian history, custom and culture, and in turn often the reasons underlying the admixture of fable and fact.

Hacikyan, A. J., G. Basmajian, E. S. Franchuk and N. Ouzounian, *The Heritage of Armenian Literature*, Wayne State University Press, Detroit, 2000.

Kouymjian, D., 'Did Byzantine Iconography Influence the Large Cycle of the Life of Alexander the Great in Armenian Manuscripts?', in M. Janocha (ed.), *Bizancjum a renesansy: Dialog kultur, dziedzictwo antyku: tradycja i współczesność* [Byzantium and Renaissances: dialogue of cultures, heritage of antiquity: tradition and modernity], Instytut Badań Interdyscyplinarnych 'Artes Liberales' UW, Warsaw, 2012.

Pseudo-Callisthenes (ed. Albert M. Wolohojian), *The Romance of Alexander the Great*, Columbia University Press, New York, 1969.

Thomson, R. W., *Moses Khorenats'i. History of the Armenians*, Caravan Books, Ann Arbor, 2006 (2nd, rev. ed.; 1st ed. 1978).

RM

42

Alexander the Great's horse, Bucephalus
The Romance of Alexander the Great

22.2 x 14.8 cm, parchment
Zakʻaria Gnunecʻi for Astuacatur Patriarch
Zakʻaria Gnunecʻi
Constantinople (Sulumanastir) 1544
MCR. The University of Manchester Library, Armenian MS 3 fol. 42v.

This manuscript was copied and illuminated by Bishop Zakʻaria Gnunecʻi in Constantinople at Sulumanastir shortly after he had copied and partially illustrated an earlier manuscript of *The Romance of Alexander the Great* in Rome (Matenadaran M5472) between 1538 and 1544. The vast cycle of miniatures is close in iconography to the oldest illustrated Armenian version of c.1300 (Venice Mekhitarists V424; cf. Der Nersessian, 1977, p. 233), which suggests a familiarity with the oldest illustrated Armenian *Alexander*.

The Romance of Alexander was the first secular text to be illustrated with a cycle of miniatures, and although the first extant illuminated copy was produced in 1300, the work itself had been translated into Armenian in the late fifth century from a Greek original of Pseudo-Callisthenes' version, since lost. More than eighty Alexander manuscripts survive, of which fourteen are illustrated with an average cycle of some 125 scenes. There are common elements in the iconography, but strong differences even in the work of the same artists.

Perhaps the most striking painting in this manuscript is a large full-page miniature of Bucephalus, the famous horse of Alexander (fol. 42v), which also occurs in two of the other manuscripts: Venice Mekhitarists, Kurdian no. 280 from 1526 (fol. 74) and J473 (fol. 10v), both painted by Grigoris. The earliest representation is a drawing in an Armenian modelbook (V1434) for miniaturists, executed prior to 1512. The horse was called Bucephalus because on its thigh it had a scar or brand that looked like the head of a bull. King Philip of Macedon had been given the horse with a prediction that whoever could control and ride it would be a world conqueror. But the horse had a mean disposition and killed and ate all would-be tamers. Yet, fourteen-year-old Alexander calmed him down, and the two became inseparable. Bucephalus is widely depicted in all Armenian versions of the *Romance*, but in these images uniquely the horse's body is composed of a maze of human and animal bodies, its toes of small birds. Such composite animal figures are known in Islamic and Indian art of the seventeenth century and after, but unknown in either the earlier Islamic tradition or in Byzantine illumination. The earliest clearly identified composite animals are found in a late thirteenth-century Cilician Gospel canon table headpiece (M9422, fol. 4).

Der Nersessian, S., *Armenian Art*, Thames and Hudson, London, 1978, p. 233.

Dournovo, L., *Armenian Miniatures*, Harry N. Abrams, New York, 1961, p. 123.

Kampouri-Vamvoukou, M., 'Le Roman d'Alexandre et ses representations dans les manuscripts byzantins', in *Apʻieroma sti mnimi toy Sotiri Kissa* (in Greek with French resume), University Studio Press, Athens, 2000, pp. 126–7, 133, fig. 24.

Kouymjian, D., 'Illustrations du Roman d'Alexandre', in Claude Mutafian (ed.), *Arménie: la magie de l'écrit*, Somogy, Paris, 2007, pp. 164–72, fig. 3.74.

Kouymjian, D., 'Illustrations of the Armenian Alexander Romance and Motifs from Christian Iconography', in Uwe Bläsing, Jasmine Dum-Tragut, Theo Maarten van Lint (eds) with assistance from Robin Meyer, *Armenian, Hittite, and Indo-European Studies. A Commemoration Volume for Jos J.S. Weitenberg*, Peeters, Leuven, 2015, pp. 149–82.

Kouymjian, D., 'L'Iconographie de l'Histoire d'Alexandre le Grand dans les manuscrits arméniens', in Laurence Harf-Lancner, Claire Kappler and François Suard (eds), *Alexandre le Grand dans les littératures occidentales et proche-orientales, Actes du Colloque de Paris, 27–29 novembre 1997*, Université Paris X, Nanterre, 1999, pp. 99, 101, fig. 4.

Kurdian, H., 'Cʻucʻak hayerēn jeragracʻ Manšēsdri Čan Řaylencʻ matenadaranin' [Catalogue of Armenian Manuscripts in the John Rylands Library, Manchester], *Sion*, vol. 49, 1975, p. 199.

Ross, D. J. A., *Alexander Historiatus, a Guide to Medieval Illustrated Alexander Literature*, Warburgh Institute, London, 1963; 2nd ed., Athenäum, Frankfurt am Main, 1988, p. 7.

Ross, D. J. A., 'A funny name for a horse, Bucephalus in Antiquity and the Middle Ages', *Bien dire et bien apprendre*, vol. 7, 1989, pp. 55–6.

Simonyan, H., *Patmutʻiwn Ałekʻsandri Makedonacʻwoy* [History of Alexander of Macedon], HSSH GA hratarakčʻutʻyun, 1989, pp. 94–5.

Traina, G., C. Franco, D. Kouymjian and C. Veronese Arslan, *La Storia di Alessandro il Macedone, Codice miniato armeno del secolo XIV (Venezia, ms. San Lazzaro 424)*, 2 vols, Helios, Padua, 2003, II, pp. 42–3, suppl. pls IV a–b, VII, XIII.

Yovsēpʻian, G., *Xałbakeankʻ kam Přōšeankʻ hayocʻ patmutʻean mēǰ* [Xałbakians or Přōšians in Armenian History], Catholicosate of Cilicia, Antelias, 1969, re-edition of Vagharshapat, 1928, pp. 128–32, figs 104–07.

DK

ոս, զայդ querզյ է սպասայրս կերդեսէ զղպրքելայրա է զաբապաո
ետ, ապես՞ ա զանացելն զոմանտա սրատաս ոյ հերելե, երը որ Քստ
ատատասապրնի՞ նիունանա ապապաոէ ատես: ատաստլէ
իրելնԽզյ ատա անհ ամբասնիա օրբին դիրիելք, դոյւանԴ Հ
ատապապաս ատխան զոզապատոց եր գրրելապատին, ա՞ե
երատ է գապձատ նիչնանա ապնանառիելթ ար զրագատպատե
երոսէ գ զապէ են ատանհ, ե բատասփն որ զապա տիրեէ:

ֆյա, գ կերապապ ատատֆ ծ ենրա լատ ատ դրիա սա
ել սա սիատ սրաատայելեան ֆ ատրրնեազ ա
ու սատե եդապ ատապաղագապխ, եայելատ ատախապյ նրելա
ել զա գատ ատ ատեխոդ տերԺ ա պայդ զնատա սապա

43

Hymn for the third day after Assumption
Hymn and Song book (Գանձարան և Տաղարան)

17.8 x 15.2 cm, paper
Mēlk'isēt' (copyist)
Awan (?) 1453
MS. Arm. e. 18 fols 225v–226r

The Armenian word for treasure (գանձ) is also used to refer to a number of liturgical hymns. Together with a selection of canticles, called տաղ in Armenian, this volume contains a collection of 200 songs arranged in the order of the yearly feasts. Unfortunately, not all hymns are preserved in their entirety, since some leaves are missing; as is apparent, the volume is very tightly bound and had to be restored quite substantially as the result of heavy use.

On the right-hand side is found the beginning of a hymn commemorating the third day after the feast of Assumption of the Virgin Mary into Heaven; celebrated by both the Orthodox and Catholic Churches, the feast remembers the bodily taking up of Mary at the end of her natural life, without having to suffer death as such. The hymn commences with 'The celestial being, most luminous and wonderful, soared up

high in awe-inspiring appearance' (Մեծապայծառ հրաշակերտ վեհին սաւառնացե[ա]լ տեսլեամբն ահագին) and details the descent of the Archangel Gabriel, who had already appeared to Mary at the Annunciation and now takes her up into the heavens. The hymns contain neumes, a form of musical notation, which in this manuscript are used sparingly, noted above the line as strokes of varying length and form.

The decoration of the volume is restricted to occasional marginal arabesques or illustrations and ornate chapter headings; the reason for the relative simplicity of these ornaments is found in the colophon, in which the scribe and illuminator Mēlk'isēt' asks for forgiveness from his readers, since this is his first illuminated work. While the origins of the manuscript are unclear, a later colophon suggests that by 1798 it had made its way to New Julfa in Isfahan.

Hakobyan, G. A., *Šarakanneri žanrə hay mijnadaryan grakanut'yan mej (X–XV dd.)* [The Genre of Hymns in Medieval Armenian Literature (5th-15th Centuries)], Haykakan SSH GA Hratarakč'ut'yun, Yerevan, 1980.

RM

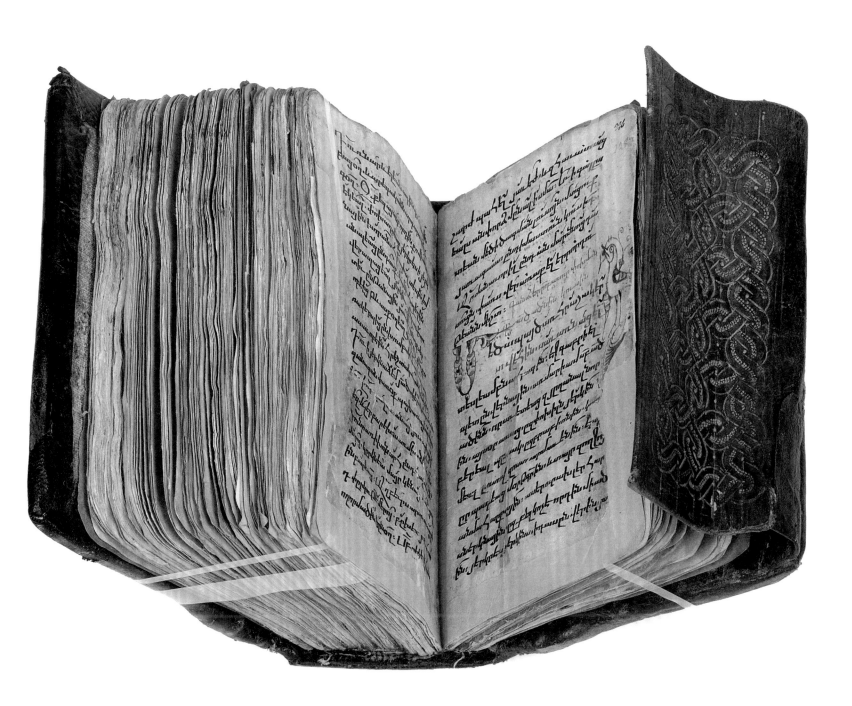

44

Abraham receives Nader Shah's decrees on behalf of the Armenian Church and nation
Abraham Kretac'i, Chronicle of his and the Persian Nader Shah's Vicissitudes

21 x 17 cm, paper
18th century
MS. Arm. d. 24 fols 35v–36r

Abraham Kretac'i's *Chronicle of his and the Persian Nader Shah's Vicissitudes* (Պատմագրութիւն անցիցն իւրոց եւ Նատր-Շահին Պարսից) runs from April 1734 to November 1736, and was written in 1736–7. The manuscript is undated, but probably from the eighteenth century.

Abraham of Crete was anointed Katholikos of All Armenians on the first Sunday of Advent, 24 November 1734. A lengthy election procedure involving Armenian clerics and communities from Isfahan and Constantinople was unacceptable to Hajji Ḥusein Paša, governor of Erevan for the Persian realm. Under the millet system, the 'caliph', as the katholikos was known in the Persian and Ottoman Empires, was the representative of the Armenian people, and since Armenian economical contributions were valuable, stability was desirable.

The Chronicle is one of three Armenian works describing the period and is unparalleled in any language for its information on the coronation ceremony of Nader Shah on 8 March 1736. From their first meeting in 1734, Abraham had a good relationship with Nader. Existing decrees were confirmed and new ones promulgated, such as the disinheritance of Armenian converts to Islam, reversing the opposite, oppressive practice obtaining under the later Safavids, in particular under Shah Sultan Ḥusein. A skilled diplomat and careful steward, Abraham's Chronicle, 'open[ing] a window of almost modern reportage into a short but important episode of Nader's life' (Axworthy, p. 149), is valuable for its eighteenth-century terminology, representing an orderly document for a troubled time.

Axworthy, M., *The Sword of Persia. Nader Shah. From Tribal Warrior to Conquering Tyrant*, I.B.Tauris, London and New York, 2006.

Bournoutian, G. A., *The Chronicle of Abraham of Crete (Patmut'iwn of Kat'oghikos Abraham Kretac'i)*, Mazda Publishers, Costa Mesa, 1999.

Bournoutian, G. A., *Abraham of Erevan. History of the Wars (1721–1738) (Abraham Erewants'i, Patmutiwn paterazmats'n)*, Mazda Publishers, Costa Mesa, CA 1999.

Łorłanyan, N. K., *Abraham Kretac'i. Patmut'yun* [Abraham Kretac'i. History], HSSH hratarakčut'yun, Erevan, 1973.

Nersessian, V. N., *A Catalogue of Armenian Manuscripts in the British Library acquired since the year 1913 and of collections in other libraries in the United Kingdom*, The British Library, London, 2012, vol. 2, pp. 943-7, no. 179.

TMvL

45
The histories of a family and village
Bedros Izmirlean, The History of My Village

27 x 21.5 cm, ruled paper
Bedros Izmirlean
Muncusu (Güneşli) 1910–15 (?)
MS. Arm. d. 26 pp. 120–21

The E.J. Brill catalogue published on the occasion of the first conference of the Association Internationale des Études Arméniennes in 1983 describes this exhibit as an 'Armenian town and family chronicle of the greatest historical importance, written *c.* 1910 by Bedros Izmirlean, priest in the Turkish village of Muncusu (now Güneşli, 15 km east of Kayseri)'.

The manuscript is written on ruled paper in nineteenth-century cursive script. The large cahier contains Bedros Izmirlean's *The History of My Village* (Գյուղիս պատմութիւնը) and *From the History of Our Family* (Մեր տոհմային պատմութենէ). The volume is rich in detailed information on the village's history, including local and Islamic customs, tomb inscriptions and dialects. The history of the Izmirlean family was started by

'the grandfather of my grandfather's grandfather', Xōǰa Astur (for Astuacatur, or Theodoros), between 1550 and 1600.

A note penned in 1917 implies that author and manuscript became separated before 1917, possibly as a consequence of the genocide. It states that the book was found after the exile of the donor and given to the priest Hagopos Bidefeyan (Yakobos Pitēfeean). A note dated 17 November 1935, written in Turkish by Rahip Sımbat, associated with the Armenian Church in Kayseri, confirms that the book was written by Bedros Izmirlean. The church is probably the Surb Grigor Lusaworič̣ Church in Kayseri. It is unclear when the manuscript left the church, and when E. J. Brill acquired it in Leiden. The Bodleian Library purchased it on 12 June 1984 with funds from the American Friends of the Bodleian.

Bodleian Library Record, volume XI (1984), pp. 251–2.

Catalogue No. 534 Caucasica. Published on the occasion of the First Conference of the Association Internationale des Études Arméniennes (AIEA), Leiden, The Netherlands, August 29–31, 1983, E.J. Brill Ltd Leiden, Antiquarian Booksellers, Leiden, 1983.

TMvL

A panegyric poem and the beginning of Anania Širakac'i's *Geography*
Geography and Fables (Գիրք Աշխարհաց և Առասպելաբանութեանց)

13 cm, paper
St Ējmiacin and St Sargis
Amsterdam 1668
Mar. 421 pp. 2–3

While in the early days of Armenian printing the volumes produced were largely concerned with spiritual or religious matters, later efforts show a greater variety of subjects. The present type of volume, containing a geographical treatise and fables, was probably intended for the use of merchants and other travellers, providing both historical information about their destinations as well as some literary entertainment.

Traditionally, authorship of the *Geography* (Աշխարհացոյց) is attributed to Movsēs Xorenac'i, the eighth-century historian and author of the *History of the Armenians*. For this reason, as not uncommon in such volumes, the editor has composed a short poem (shown here) extolling the virtues of Movsēs, calling him a man of truth and skilled with words. More recent research indicates, however, that this tractate was more probably composed by Anania Širakac'i, an Armenian mathematician and

astronomer of the seventh century, who – according to his autobiography – introduced mathematics to Armenia singlehandedly. A relatively loose compilation of realistic and mythological facts about the Caucasus, Armenia and parts of Iran, the *Geography* details both the distribution and characteristics of Roman provinces and Sasanian satrapies, as well as relating lore, e.g. that Noah built his Arc in Phrygia.

After the *Geography*, the editor Oskan Erevanc'i, best known for his printing of the first Armenian Bible, added a collection of fables, the so-called *Book of the Fox* (Աղվեսագիրք), composed in the thirteenth century by Vardan Aygekc'i. Many of the stories contained therein, such as 'The Old Lion' and 'The Wolf and the Lamb', bear great similarities to those found in Classical Greek and Sanskrit, frequently warning against the power of tyrants.

Greenwood, T., 'A Reassessment of the Life and Mathematical Problems of Anania Širakac'i', *Revue des Études Arméniennes*, vol. 33, 2011, pp. 131–86.

Hewsen, R. H., *The Geography of Ananias of Širak (Ašxarhac'oyc'). The Long and Short Recensions*, Dr Ludwig Reichert Verlag, Wiesbaden, 1992.

Hewsen, R. H., *Ašxarhac'oyc': The Seventh Century Geography*, Caravan Books, Delmar, NY, 1994.

RM

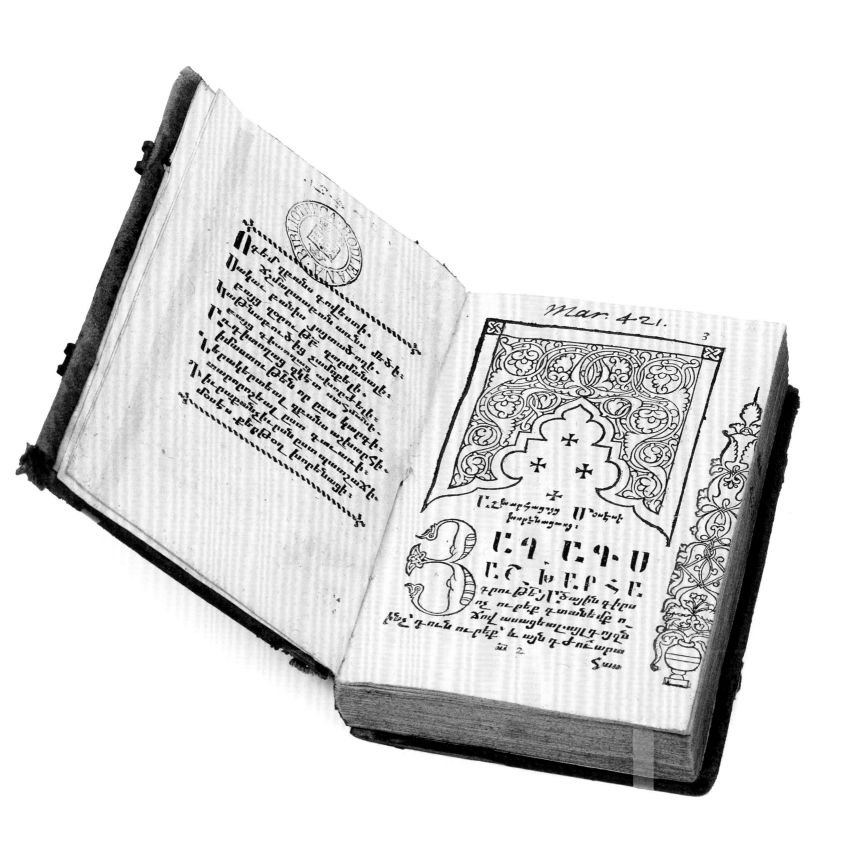

47

The 'Song of Vahagn' in Movsēs Xorenacʻi's *History of the Armenians*

Mosis Chorenensis Historiæ Armeniacæ (Մովսիսի Խորենացւոյ Պատմութիւն եւ Աշխարհագրութիւն)

4°, paper
Ex officina Caroli Ackers typographi; Apud Joannem Whistonum
London 1736
(IND) 98 E 4 pp. 74–5

Movsēs Xorenacʻi's *History of the Armenians* (Պատմութիւն Հայոց) is one of the most important works detailing the actual and mythological pre-history of Armenia from the times of the Biblical patriarch Adam to his own days.

Considered the father of Armenian historiography (պատմահայր), Movsēs's work has long posed a difficult problem for scholarship: purporting to have been written in the fifth century on behest of Sahak Bagratuni, internal references, such as the Iranian advance into Bithynia during the Byzantine-Sasanian War of 602–28 CE, and absence of citations from Movsēs's work until the tenth century, suggest that it was, perhaps, written only in the eighth century CE.

Irrespective of his time of activity, Movsēs's work is an inestimably precious source of the Armenian oral tradition; one of the most famous remnants of pre-Christian Armenian poetry, the 'Song of Vahagn' shown here relates the birth of the Armenian hero and later god of war Vahagn, who with Aramazd and Anahita formed the core of the Armenian Zoroastrian pantheon. The song details the circumstances of his birth and describes him as having fiery hair and a fiery beard; it bears close resemblance to similar stories of the Iranian God Vərəθraγna, and the Indian Indra, indicating the widespread and internal diversity of mythology in Eurasia.

This particular edition of Movsēs's *History*, prepared by the Whiston Brothers, stands out in a number of respects: it is the first of its kind in Europe, offering a translation of the Armenian into Latin, thus making it more widely accessible to scholars interested in Armenian studies.

Russell, J. R., 'Carmina Vahagni', *Acta Antiqua Academiae Scientiarum Hungaricae*, vol. 32, 1989, pp. 317–30.

Watkins, C., *How to Kill a Dragon: Aspects of Indo-European Poetics*, Oxford University Press, Oxford, 1995.

West, M. L., *Indo-European Poetry and Myth*, Oxford University Press, Oxford, 2007.

RM

…aliósque quatuor quosdam Aramazdis nomine appellari placet. Atque itidem cum multi sint, qui Tigranus nomen acceperint, hic tamen est unus Armeniorum Astyagem, qui draconum matrem in servitutem duxit, & familiam ejus Anusiamque adjutus, Cyrique alacritate ac studio imperium arripuit, Medorum sibi & Persarum Babiun, Tiranus, Vahagenius; de quo ita regionis nostrae fabulae narrant.

" Parturiebat coelum, parturiebat terra, parturiebat etiam purpureum mare. Partûs quoque dolores occupabant rubram arundinem, per arundinis fistulam fumus prodibat, per arundinis fistulam flamma prodibat, & ex flammâ prosiliebat rubicundus juvenis, cui crines ignis comprehendit, cujus barbam comprehendit, atque oculi & palpebrae erant soles."

Atque haec quidem ad cymbala canentes quosdam ipsi audivimus, qui deinde certamen ejus cum draconibus ac victoriam in carminibus memorabant, heroicásque ejus res gestas, Herculis factis simillimas celebrabant.

Eum quoque in Deorum numerum relatum ferunt, statuásque ejus, instar staturae ejus fabricatae, in Iberorum regione sacra fieri. Ab hoc ortos esse tradunt Vahunios, & à filio ejus natu minimo Aravanus, ei Nerses. Huic filius fuit Aravanus, à cujus stirpe gens Zarehavania profecta est. Caeterum is filium habuit, natu maximum Armodum, is deinde Bagamum, is Vahanum. Vahem, is Alexandro Macedoni repugnans, interit. Deinceps usque ad Valarsacis in Armenia imperium, nihil omnino certi tibi narrare habeo. Etenim tumultu erant omnia confusa, iisque adversus alium dimicabat, ut regionis imperium teneret; atque eâ re, facilem Arsaces magus in Armeniam aditum nactus, fratrem suum Valarsacem Armeniae regem constituit.

CAP. XXXI.

Quòd bellum Iliacum sub Teutamo fuerit, in quo Zarmaerus nostras, simul cum parvâ Aethiopum manu illô profectus, morte occubuit.

Eae res duae, quas à nobis flagitâsti, gravissimum nobis laborem attulerunt, studium brevitatis, atque orationis festinatio, cum splendidâ, ut ita dicam, dilucidâ, ac Platonicâ; quae narratione conjuncta; quae, à falso procul remota, iis conferta sit, quae errori obsisterent; cum praesertim à primo homine ad tua tempora histo-

a Deest in Edit.

c Cl. Schroederus in Diss. P. 9. nescimus quo argumento inductus, haec verba in eam sententiam accepit, quasi duo diversi reges, Babiun ac Vahagenius, uno praemisso, hic fuerint numerati. Quod nisi fit quod interciderit, tria haec nomina unum tantùm eundemque Tigranis filium videntur designare.

En prisci apud Armenios historiarum generis specimen egregium; qui utique rerum gestarum veritatem carminibus obscuris solebant tegere atque involvere, ut adeò, quod Tacitus de Germania refert, § 2. hoc unum ferè apud illas memoriae & annalium genus fuisse videatur. Plura lector hujus rei vestigia invenit, I. c. 5, 17; 23. 29. II. c. 46, 47. & alibi dispersè. Gesborum cantiones memorare mos consuetúsque vetus erat.

Nostra non indigena est. Armenium Maccabaeorum Interpretem pro *Hercule* in versione suâ posuisse *Vahagenium.* 2 Mac. IV. 19.

Scriptores de rebus gestis Alexandri hunc regem nihil memorant; nec miram, quum id ipsum taceant, quomodo Armenia sub imperium Macedonicum fuerit subjuncta, quam tamen Mithreni ab Alexandro commendatam fuisse tradunt Diod. Sic. XVII. p. 539. Q. Curt. V. 1.

Portrait of Christopher Columbus, beginning of *The History of America*

William Robertson, The History of America (Վիպասանութիւն Ամերիկոյ), *translated by Minas Gaspareanc'*

19.5 cm, paper
Mxit'areanc' Press
Trieste 1784–6
Mar. 513 pp. 1–2

William Robertson, a Scottish historian and from 1763 until 1793 Historiographer Royal to George III, began writing his *History of America* in 1777. A testament to their curiosity and productivity, the Armenian translation, based itself on an Italian version of the books, was printed in Trieste only seven years later.

Although the USA is home to the largest Armenian diaspora community next to the Russian Federation, immigration on a large scale did not begin until the end of the nineteenth century as a result of hardship and persecution; in the eighteenth century, fewer than 100 Armenians settled in northern America, none of whom had come as a community.

The translator's note prefacing the main text gives an indication as to why the book was translated with so much zeal and speed. Apart from being a 'more faithful and interesting' telling of the history of America than those that had come before it, Robertson's work demonstrated, in more abstract terms, 'how this country, like a child, advanced from imperfection to perfection; … how much man is indebted to civic education and … how the arts, sciences and order improve the nature [of man], and … how for the comfort of man order and hierarchy are important'. While in Late Antiquity the Armenians had often compared themselves to the Maccabees of the Old Testament, this late-eighteenth-century perspective is indicative less of a struggle for independence, but rather of the supreme integration of the Armenians into society, both in Europe and in the Ottoman Empire, where they frequently held high administrative offices.

The woodcut of Christopher Columbus (Քրիստոփանոս Քոլոմպոս, K'ristop'anos K'ōlōmpos), subtitled 'first discoverer [of America]' (Առաջին Գտիչ), shows typical drafting instruments needed by seafarers, such as compass and dividers. The artist's decision to change Columbus' first name is curious, since K'ristop'anos, like the Greek Christophanos, refers to the apparition of Christ, rather than to the 'Christ-bearer'.

Mirak, R., 'The Armenians in America', in Richard G. Hovannisian (ed.), *The Armenian People from Ancient to Modern Times, Volume II*, Macmillan, Basingstoke, 1997.

RM

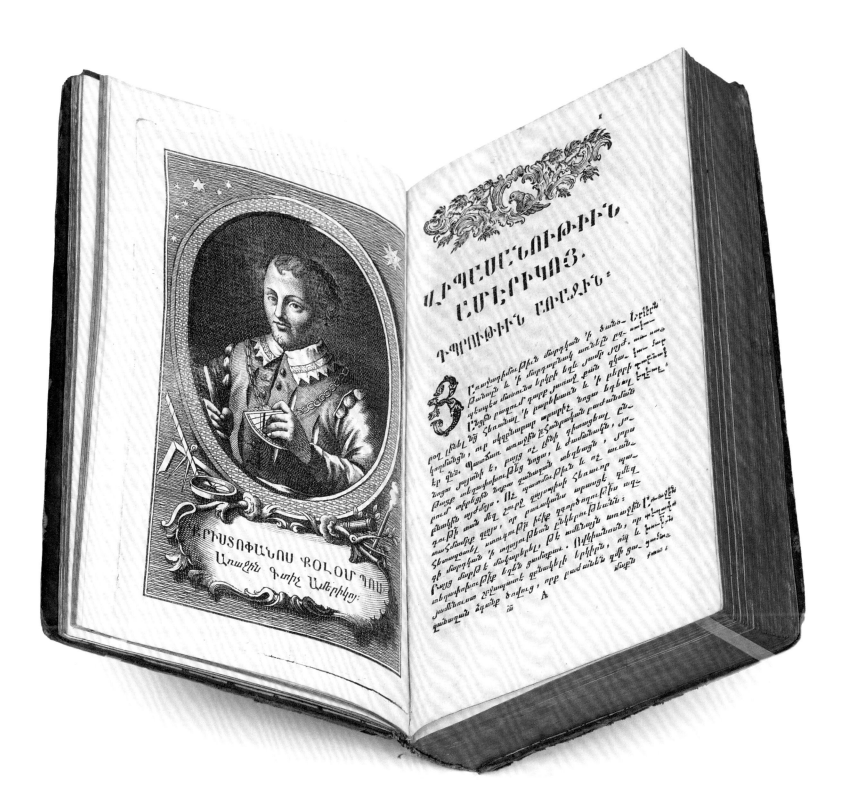

ՔՐԻՍՏՈՖԱՆՆՈՍ ՔՈԼՈՄՊՈՍ
Առաջին Գտիչ Ամերիկոյ։

ԱՊԱՍՆՈՒԹԻՒՆ
ԱՄԵՐԻԿՈՅ
ԴՊՐՈՒԹԻՒՆ ԱՌԱՋԻՆ։

Նաւագնացութեան մարդկան ՚ի ֆահ, Նոյն
թանայն և ՚ի մարդգրանչ աւելի
 պեսպէս մասունս երկեր եղե
Ընդին բացուծ ջայր յանուր քան
կորդացին, որ ամաչեն ՚ֆ հայրենեաց ...
էք ձեն. Պատահ առաջին ՚շ վեր գիտացեալ ...
նոյս ... գրայան է, բայց ոչ վերֆ գիտացեալ, յո
թայց աներեցին նոցա պատահրութիւն և ոչ
ցուր աերեցին պլմննա ։ Ոչ ... պատահ
դուֆ տան
Նեսնիջք զայս , որ բանակման արասցէ ...
Ստացեալ
ֆի մարժն է
Յայս մարֆ է
...

A

Commissioning Culture: Armenian Merchants in Religion, Enlightenment and Practical Life

Since Antiquity, Armenians have been known to travel far and wide; before the turn of the eras, they had travelled as far as India in the armies of Cyrus the Younger, described by the Greek historian Xenophon and Alexander the Great. While the geographical position of Armenia over the centuries has proved to be precarious, as evidenced by ever-changing borders, alliances and wars, it has also provided for great economic stability and diversity owing to its prominent and strategically vital position on the Silk Road, confirmed by the many caravanserais still preserved in Armenia.

In Europe, the communities and trading posts established in Constantinople (Istanbul), Venice, Amsterdam, Lvov (Lviv) and many other cities would prove not only their mercantile importance, but provide the place and necessary economic background for the establishment of printing presses, and thereby the promulgation of important information and general learning required for business as well as personal enlightenment.

Both content and size of the volumes printed were variable and often depended on a range of factors. The first Armenian printed books, the DIZA series published in 1512–13 under the auspices of Yakob Mełapart, dealt largely with religious and liturgical matters of the Armenian Apostolic Church, and some astrological concepts.

Later volumes, however, would concern themselves with a great variety of topics, including basic grammar and orthography, geography and philosophy; it is not uncommon for all these to be combined in a single, slim volume that the reader could carry about with ease. Especially in the case of trade manuals, containing equivalence charts and exchange rates, the form factor was of significance. Next to such earnest tractates meant for self-improvement and information, however, there are also volumes of a spiritual nature, as well as fables, novels and other tales meant for divertissement.

Apart from volumes meant for personal use, other printed material pertaining to the merchants' world includes the splendid *Map of the World* (Համատարած Աշխարհացոյց) from 1696. A reflection of the state of the art and science of map-making, this map, prepared by masters of their craft, was an enormous financial endeavour on the part of T'ovmas Vanandec'i, since Armenian labels made the usage of existant material impossible; the map may serve as a point in case as to why the establishment and flourishing of Armenian printing houses is almost inextricably tied to a vibrant trade community, which delivers both demand for new books and the financial input to support it.

Aslanian, S. D., *From the Indian Ocean to the Mediterranean: The Global Trade Networks of Armenian Merchants from New Julfa,* University of California Press, Berkeley, 2011.

Lane, J. A., *The Diaspora of Armenian Printing, 1512–2012,* Special Collections of the University of Amsterdam, Amsterdam, 2012.

Papazian, K. S., and P. M. Manuelian, *Merchants from Ararat: A Brief Survey of Armenian Trade through the Ages,* Ararat Press, New York, 1979.

RM

49

A prayer by Nersēs Šnorhali in the first book printed in Iran
Psalms by David (Սաղմոս ի Դաւիթ)

9.8 cm, paper
Xačʻatur Kesaracʻi
New Julfa, Isfahan 1638
Vet. Or. f. Arm. 1 un-numbered opening 10 pages from back

This volume of prayers and psalms, entitled *Psalms by David* (Սաղմոս ի Դաւիթ), after its incipit, is the only extant copy of the first book printed in Iran. Purchased by the Bodleian Library in 1693 from noted Hebraist Edward Pococke, the historical significance of this exemplar was only realized in 1969.

After a large number of Armenians had been deported by Shah Abbas I from Julfa to the outskirts of his capital Isfahan in 1604, a community very active in commerce developed, which in honour of their abandoned home called their new town New Julfa. Arts and crafts developed swiftly. Apart from improving trade with India, where other Armenian communities had arisen, in 1636 New Julfa would become home to the second Armenian printing press outside of Europe, after Surb Nikołos in Constantinople (1567–69).

Having been denied permission to set up a press in Rome, the typesetter and printer Bishop Xačʻatur Kesaracʻi began casting his own type, and produced woodcut engravings for decorative drop caps. In addition to the present volume, four other books were printed in New Julfa: *Lives of the Fathers* (1639–41), a missal (1641), a Breviary (Ժամագիրք), and a calendar (Գիրք տումարաց).

The book begins with Psalm 1: 'Blessed is the man who walks not in the counsel of the wicked…' (Երանեալ է այր որ ոչ գնաց ի խորհուրդս ամբարշտաց), but also contains passages from other books, such as Moses's praise of the Lord in Exodus 15, or Manasseh's prayer in 2 Chronicles. The passage shown here, set in a distinctly smaller and denser type, is the beginning of 'In faith I confess' (Հաւատով խոստովանիմ), Nersēs Šnorhali's best-known and much reprinted prayer; upon it follows the colophon detailing the travails of setting up a printing press in Isfahan.

Kévorkian, R. H., *Catalogue des «Incunables» arméniens (1511–1695) ou chronique de l'imprimerie arménienne*, Patrick Cramer, Geneva, 1986.

Nersessian, V. N., *Catalogue of Early Armenian Books 1512–1850*, British Library, London, 1980.

RM

50

Comparison of currency values

Thesaurus of measures, weights, figures and currencies of the whole world
(Գանձ չափոյ, կշռոյ, թըլոյ և դրամից բոլոր աշխարհի)

8°, paper
T'ovmas Vanandec'i
Amsterdam 1699
8° U. 135(2) Th. pp. 14–15

Commissioned and printed by the same Archbishop T'ovmas Vanandec'i in whose printing press was issued the *Map of the World* (Համատարած Աշխարհացոյց), this handy little book contains a number of short treatises. Next to a key to the world map, a grammatical primer and a piece on natural philosophy, a further section delineates the various measures, weights and currency values the Armenian merchant might come across on his journeys.

Based on earlier works of similar content, Łukas Vanandec'i, the nephew of T'ovmas, updated this piece with a number of details about new European trading routes. The opening shows, on the left, a guideline as to how much copper (պղինձ), iron (երկաթ), lead (արճիճ), etc. could be obtained in France for the price of one pound of silver (արծաթ). Similar equivalences are listed for the value in gold and silver coins in a number of places; on the right side, more specifically, are noted the equivalences for one hundred Antwerp pounds in, e.g., Amsterdam, Kraków and Ancona. Apart from Amsterdam, one city features prominently in large parts of this tractate: Moscow. The merchant community of New Julfa had, in successive steps from 1660, arranged for good trade relations and routes with the Russian tsar Alexei Mikhailovich, enabling them to avoid traversing the Ottoman Empire with which relations were uneasy.

This volume and a few others were presented to the Bodleian Library by Archbishop Vanandec'i in 1707, when he visited England, obtaining an audience with Queen Anne and receiving the honorary degree of Doctor of Theology from Oxford at age ninety.

Hacikyan, A. J., G. Basmajian, E. S. Franchuk and N. Ouzounian, *The Heritage of Armenian Literature, Volume 1*, Wayne State University Press, Detroit, 2000.

Kévonian, K., 'Marchands arméniens au XVIIe siècle. A propos d'un livre arménien publié à Amsterdam en 1699', *Cahiers du Monde russe et soviétique*, vol. 16, no. 2, 1975, pp. 199–244.

RM

51

The Zodiac signs and character descriptions of Aries and Taurus
Astrology (Աղթարք եւ աստղաբաշխութիւն է գիրքս այս եւ վիճակ)

16 cm, paper
Yakob Mełapart, DIZA
Venice 1512–13
Ary. 3. 365(1) pp. 39–40

After the *Friday Book* (Ուրբաթագիրք) and the *Missal* (Պատարագատետր), the *Horoscope* (Աղթարք) is the third of the first five books to be printed in Armenian, compiled and typeset in Venice by Yakob, about whom next to nothing is known, save that he styles himself *mełapart* (sinful), a common self-deprecatory designation. Venice, as the third most populous European city of its time, was home to the largest Armenian community in the West, as well as a centre of the newly founded printing culture. All of Yakob's books contain a printer's mark consisting of a cross atop a quartered circle in whose quadrants are set the letters DIZA, the meaning of which is uncertain. The present volume is special in that it contains not only the Աղթարք, but also the later *Calendar* (Պարզայտումար) in the same volume.

Conceived as practical tools for merchants and travellers, they contain information about medicine and astrology as well as prayers, notably those written by Nersēs Šnorhali. The typeface, being the first of its kind, is remarkable for its upright setting, ever the more so since it resembles no well-known manuscript style. In like manner, the text, written in contemporary Armenian, is set without indicating word breaks like most manuscripts, and contains some errors – երկաւոր (Gemini) is missing an ր – and phonetic spellings. While generally kept simple, the book is not without ornament: scrolls with the tractate's title, ornate drop caps, the use of black and red ink as well as the inclusion of occasional woodcuts render the volume more than just a practical manual.

The astrological part of the Աղթարք contains, amongst other elements, a table of the Zodiac signs and their planetary rulership: Mars (հրատ); Sun (արեգակն); Venus (լուսաբեր); Mercury (փայլածու); Moon (լուսին); Saturn (երեւակ); and Jupiter (լուսնթող for լուսնթագ), all of whose names are given in their pre-Latinized forms. The descriptions on the right side characterize the Zodiac: an Aries (խոյլ) 'shines upon you the frightful light of glory', while a Taurus (ցուլ) 'does not fear even in times of sadness'.

Lane, J. A., *The Diaspora of Armenian Printing, 1512–2012*, Special Collections of the University of Amsterdam, Amsterdam, 2012.

Pehlivanian, M., 'Mesrop's Heirs: The Early Armenian Book Printers', in Eva Hanebutt-Benz, Dagmar Glass, Geoffrey Roper et al. (eds), *Middle Eastern Languages and the Print Revolution*, WVA-Verlag Skulima, Westhofen, 2002, pp. 53–92.

RM

խաչն	ցուլ	եկեա որ	եեզգ էատն	աղբ ծա
եղջան	կշեռ	կարիճ	աղէ ձ սաս	այծ ձեռ
շրտա	հուկ	Հրատ	աղեղ ասն	լուս ատր
վայլա հուն	լուսեն երեան			
			լուսան Թող	

Մարտ ․ այսսաւզագի
նեարտաց ․ կշառաւէ եայն
եկառաց ․ նկառաւ ․ ջաղ
զասամս ․ ագ ․ ծառան
այեւիկերայ զոորիկզգարեզան
նիկերայաբարացող ․ նոյսակս
եերուեանեսէրեկարարեայ ․ և
տոկասատեցգեհեշշրուամ
քն ․ այպյրազգեստւեեեգար
ջուրէն ․ երազեեերարեկզն ։
վմարց ․ լուսաւորիետորՏուր ցուլ
ջարտոր ․ ատժանՀատրուԱն ս․
Ակասեէր ․ զիեզարստոաւՏոՏ ․ եգո
քէն ․ կարեեանՏովեցաս ․ եզո
եկարտէեես ․ շտտոպկայ թեզան
զեերորազոանւ Թէն ։

52

Chinese annotation in an Armenian prayer book
Prayer Censer (Բուրվառ Աղօթից)

5.5 x 9 cm, paper
St Łazar
Venice 1831
Vet. Or. g. Arm. 1 pp. 6–7

In this minuscule prayer book, printed in Venice in 1831, are united a multitude of cultures and languages. The leather-bound volume, whose cover is decorated with an embossed golden cross and a floral bordure, is divided into a number of sections for each portion of the day and various occasions. The opening shows two prayers pertaining to the morning, the 'Supplication to the Holy Mother of God' (Յանձնարարութի[ւն] առ ս[ուր]բ ա[ստուա]ծամայրն) and the 'Angelic Exultation' (Փառատրութիւն հրեշտակականն).

The text shown here is covered in Mandarin characters, reading 錯這求祈, roughly translated as 'This is the wrong prayer'. Such comments are found throughout the book, written by its owner, the well-known Orientalist

and divine Solomon Caesar Malan, a former Oxford student and later lecturer in Classics at Bishop's College, Calcutta (Kolkata). Well-versed in Latin and Greek, as well as Sanskrit, Arabic and Hebrew, Malan spent less than four years in India due to ill health, but in that time also acquired a foundation in Chinese and Tibetan, leading to an interest in Chinese religion. Later, during his vicariate in Broadwindsor, Dorset, Malan further acquired Georgian, Armenian and Coptic.

Although Malan had in his lifetime bequeathed the majority of his personal library to the Indian Institute at Oxford, this volume has only been acquired by the Bodleian in spring 2014, making it the most recent addition to its collection of Armenian manuscripts and early prints.

RM

53

Two woodcuts: Jesus the Teacher and The Lord Blesses St Mesrop
'Offering' is the name of this book (Անուն գրոյս այս կոչեցաւ ձիր)

8°, paper
St Ējmiacin and St Sargis
Amsterdam 1662
8° D 375 BS. pp. 2–3

This small grammatical primer, presented and dedicated to Oskan Erevanc'i, who founded the printing press of St Ējmiacin and St Sargis and would later produce the first complete Armenian Bible in print, already in its preamble showcases the importance and interconnectedness of education and religion in Armenian culture.

The two woodcuts, subtitled 'Christ will teach you, fresh and beautiful youth' and 'God blessed St Mesrop, who established the script of the People of Hayk', respectively, emphasize the importance of language and writing for the Armenian people, who due to their geographic situation had often been part of different empires; only by maintaining their own language and interpretation of the Christian faith were they able to establish and keep alive a sense of national and cultural coherence. It may be thus that the preamble ends in the assurance that the book was printed 'not for profit, but as a present and for the glory of Christ [to] be given to whoever needs it'.

Little is known about the rate of literacy among the Armenian population, but it seems likely that only the upper classes were able to read. It is interesting to note, however, that both woodcuts and preamble make reference to the education of both 'young boys and girls, men and women'. This relates well to the historical role of women as educators, elucidated in the descriptions of Ełišē, and a force in the spreading of Christianity in Armenia, as laid out in Agat'angełos's story of the holy martyr Hŕip'simē.

Grammatical primers, along with prayer books, conversion tables, calendars and other practical manuals, were frequently commissioned by merchants and formed part of their libraries; due to space constraints, the size and conciseness of these volumes were important.

RM

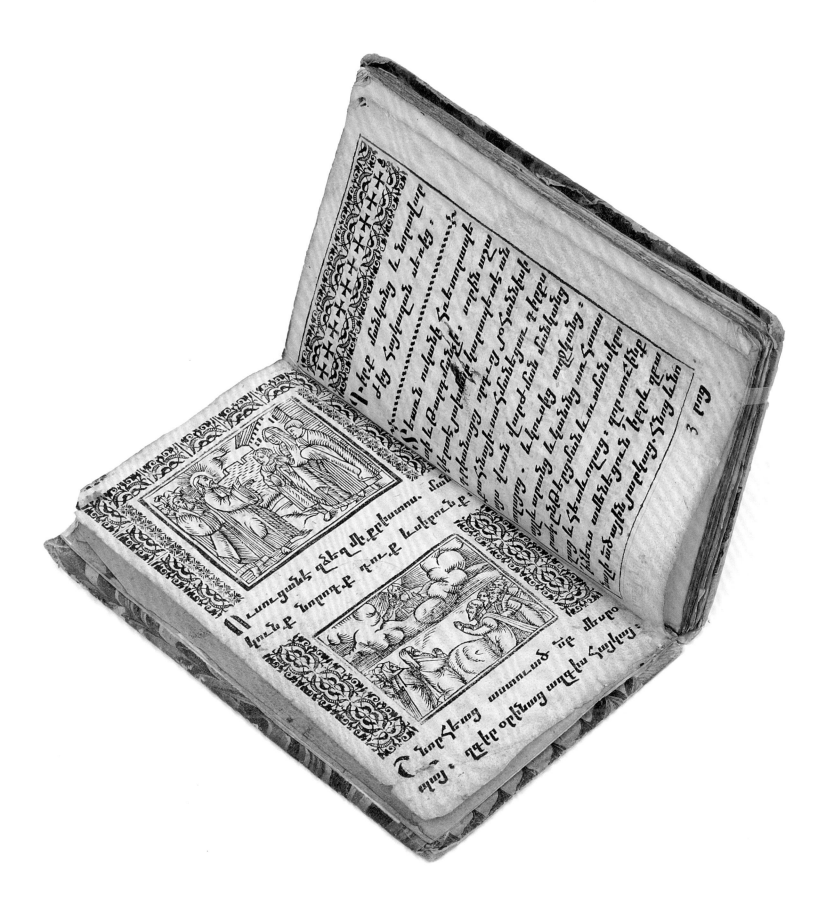

Pigments

SECTION 8

Artists likely produced their own pigments and tools such as brushes. Although no Armenian manuscript describing how pigments were manufactured yet has been located, modern pigment analyses allow us a glimpse into the secrets of their composition. Viewers often remark on the brightness of the pigments used in Armenian manuscripts. This is due to the fact that most are derived from minerals, as opposed to organic pigments made from plants or insects, which are more susceptible to fading.

The most common pigments used by Armenian artists are displayed in the 'Scriptorium' section of the exhibition. Gold was used for highlights, halos and backgrounds, albeit only in more expensive, luxury manuscripts because of the high cost. White lead, a toxic substance, was common not only in Armenian manuscripts but was also widely used in Europe and the East. Vermilion was the substance most often used for red; it occurs in nature as the mineral cinnabar

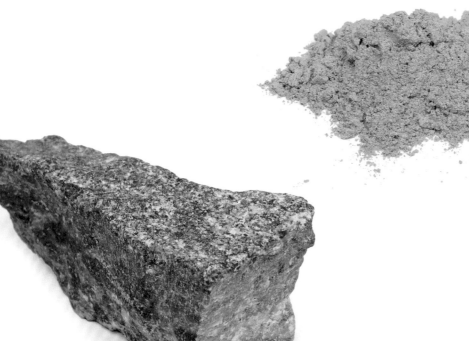

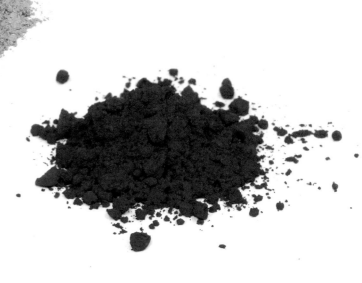

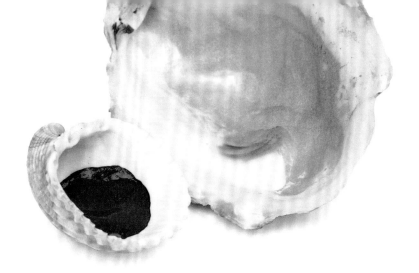

but can also be manufactured by combining mercury and sulphur. Red lake pigments also provided red colours, and can be formulated from various organic substances such as the root of the madder plant or the secretions of the lac insect. The most widespread substance used by Armenian artists to produce yellow pigment is orpiment, another toxic mineral (arsenic sulphide). Ultramarine (blue) was produced from lapis lazuli, a mineral found in Afghanistan; highly expensive in Europe, ultramarine was used in only the most luxurious manuscripts there, but it was more readily available in Armenia and was especially common in Cilician manuscripts. In some regions, Armenians used another blue pigment produced from the mineral azurite. Indigo, an organic blue pigment derived from the indigo plant, was also utilized. A natural green was not found in the Armenian palette, but instead was formed by mixing yellow pigment (orpiment) with blue (either indigo or ultramarine).

Mathews, T. F. and R. S. Wieck (eds), *Treasures in Heaven: Armenian Illuminated Manuscripts*, The Pierpont Morgan Library, New York, 1994.

SM

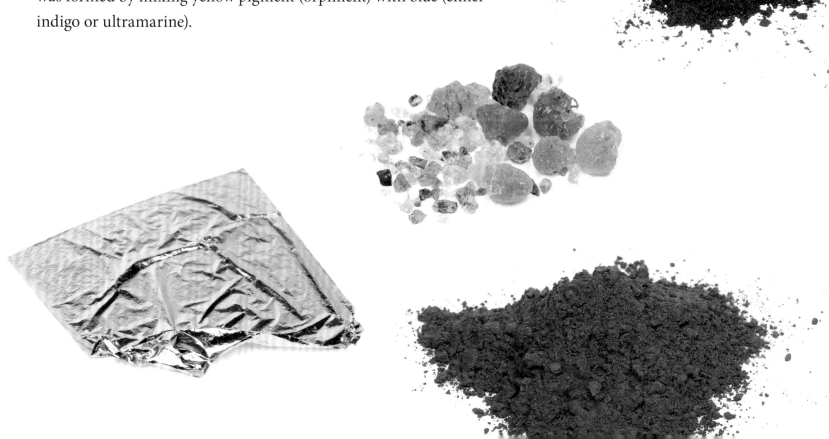

A History in Coins

Just like manuscripts and books, coins can be an expressive witness of their time, speaking in their own cryptic language of the political affiliation, wealth and overarching importance of the barons and kings under whose authority they were minted.

A great variety of Armenian coinage has survived the ages; the earliest samples date back to the third century BCE, to the Armenian kingdom of Sophene. It was under Tigranes II the Great (r. 95–55 BCE), during whose rule the kingdom of Armenia reached its largest extent, that the largest amount of extant ancient coinage was minted; having conquered former Seleucid territory, Tigranes II took over their mints in Damascus and Antioch, and established his own in Artaxata and Tigranocerta, the old and new capital respectively.

Minted more than a millennium later, the coinage of Armenian Cilicia would look rather different: the Greek coin legends of Artaxiad and Arsacid times were replaced by Armenian legends; iconography and denominations similarly shifted from Hellenistic imagery – the goddess Tyche, for example – to Christian symbols and the lion, emblem of the Armenian kingdom of Cilicia.

Founded as a principality in *c.* 1080 CE by Ṙuben I, it was not until Lewon II's (1150–1219) entering (a largely ineffective) full communion with the Roman Catholic Church that Cilicia became a kingdom, and King Lewon I its first monarch from 1198. The difference in status was evident in coinage, too: where the principality had only issued copper coins, the rule of Lewon I saw the minting of gold and silver coinage. Another relationship between history and coinage is quality: coins minted in the heyday of the kingdom were struck with greater precision than their counterparts from the time of the Mamluk threat.

The selection presented here, twenty coins from a private collector and benefactor of the exhibition, also form the pivot of a private story: the collector purchased a great number of coins in 1994 from the estate of the late Asbed Donabedian, a Lebanese-Armenian antiquarian and scholar, who many years before had been his teacher. In class he would, from time to time, mention that more than half of his salary each month was earmarked for the acquisition of antiquarian coins – a fact the youths found incredible. When alerted to the sale of the collection by the auction house Spink, his teacher's 'tale' proved true, and the collector chose to acquire a large portion of coins in honour of his memory.

Bedoukian, P. Z., 'The Bilingual Coins of Hetoum I, (1226–1270), King of Cilician Armenia', *Armenian Numismatic Society Museum Notes*, vol. 7, 1957, pp. 219–30.

Bedoukian, P. Z., 'Coins of the Baronial Period of Cilician Armenia (1080–1198)', *Armenian Numismatic Society Museum Notes*, vol. 12, 1966, pp. 139–45.

Bedoukian, P. Z., 'A Classification of the Coins of the Artaxiad Dynasty of Armenia', *Armenian Numismatic Society Museum Notes*, vol. 14, 1968, pp. 41–68.

Nercessian, Y. T., *Armenian Coins and their Value*, Armenian Numismatic Society, Los Angeles, 1995.

RM

Coins of Tigranes II

These six silver coins, struck in the reign of King Tigranes II the Great (140–55 BCE), are very similar in their overall make up. The obverse shows a bust of Tigranes draped right, wearing an Armenian tiara, while a diadem knotted at the back encircles the head and falls downward. Divided drapes cover the ear and neck. The tiara is adorned with an eight-pointed star flanked by two eagles back to back and with heads turned to each other. In most cases the tiara is low and the five peaks are made of one or two beads. In high tiaras the peaks are made of beaded triangles. The bust is encircled by a fillet border. The reverse, in turn, is struck with a depiction of the Tyche of Antioch, draped right and wearing a turreted crown, seated on a rock, holding a palm branch in hand. At her feet, the upper portion of a youthful male nude figure of the river god Orontes swims right. The depiction is surrounded by a laurel wreath. The legend reads ΒΑΣΙΛΕΩΣ ΤΙΓΡΑΝΟΥ (King Tigranes).

All issues show different, or no, monograms or other field marks; similarly, the die cast of both obverse and reverse differ in the execution of the tiara or the seating position of Tyche. One constant feature is the occurrence of the river god Orontes, signifying the extent of the territory ruled by Tigranes II, whose empire stretched to include the entirety of the river in modern Syria and Lebanon.

Most of the coins struck under his rule, which are shown here, are tetradrachms from Antioch; only the drachm, probably issued late in his reign and struck in an Armenian mint, shows the title ΒΑΣΙΛΕΩΣ ΒΑΣΙΛΕΩΝ ΤΙΓΡΑΝΟΥ 'King of Kings Tigranes', which he had adopted in analogy to the former Achaemenid rulers of his newly gained lands.

Bedoukian, R. Z., *Coinage of the Artaxiads of Armenia*, Royal Numismatic Society, Special Publication No. 10, London, 1978.

RM

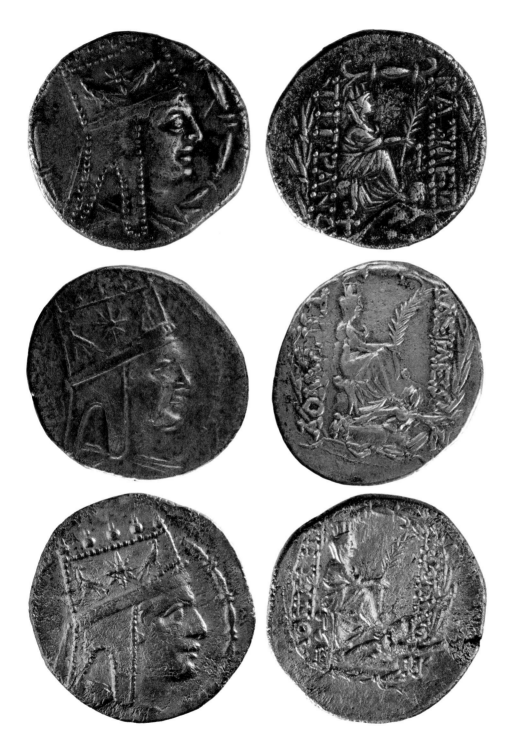

54
Coin 121

Ruler Tigranes II
Value Tetradrachm
Reference Bedoukian 20, Foss F1
Condition Distinctive portrait, better than very fine

55
Coin 139

Ruler Tigranes II
Value Tetradrachm
Reference Bedoukian 19/34, Foss H
Condition Reverse double-struck, about very fine

56
Coin 136

Ruler Tigranes II
Value Tetradrachm
Reference Bedoukian 17/37
Condition Reverse surface lightly corroded,
 otherwise very fine

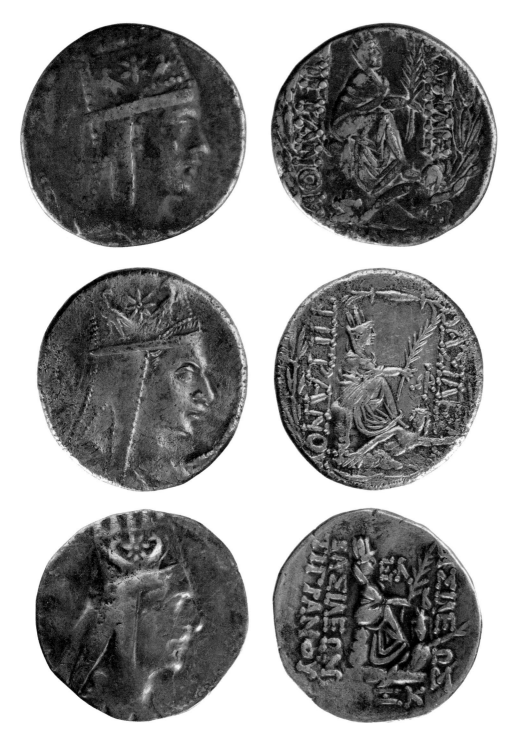

57
Coin 141

Ruler	Tigranes II
Value	Tetradrachm
Reference	Bedoukian 21, Foss I1
Condition	Good fine

58
Coin 123

Ruler	Tigranes II
Value	Tetradrachm
Reference	Bedoukian 20, Foss F1
Condition	Corrosion on obverse, good fine, the reverse well-centred and very fine

59
Coin 152

Ruler	Tigranes II
Value	Drachm
Reference	Bedoukian 52
Condition	Good fine/very fine, rare

Baronial Coins of Armenian Cilicia

The coins of the principality of Armenian Cilicia exhibited on the following pages stem from the reigns of Tʻoros I (r. 1100–29) and Lewon II (r. 1187–99), who would later be crowned King Lewon I of the Kingdom of Cilician Armenia. Struck in copper like all baronial coins of the time, these issues show their considerable age in the form of general wear and corrosion; while coin hoards are often found in vessels or wrapped in cloth, the caking especially on the coins of Tʻoros I suggests that they may have been in extended contact with earth or other organic material.

Based on the evidence of similar coins, it is nonetheless possible to decipher the present issues. In the case of Tʻoros I, the obverse shows a cross in the centre, with a clockwise legend reading ԹՈՐՈՍԻ Է Ո Բ (Tʻoros

of the Ṙubenians); the dynasty was named after the first lord of Armenian Cilicia, Ṙuben I. The reverse shows another cross and the letters Խ.Բ.–Ղ.Թ, commonly interpreted as rendering the motto Խաչն Քրիստոսի յաղթող (the Cross of Christ Victor).

The coins of Lewon I are no less difficult to decipher, but allow for a somewhat clearer identification. The obverse shows an armoured knight galloping left, a flying banner in his hand; the horse's head and parts of the knight are still discernible on issue 235. The legend reads ԼԵՒՈՆ ԾԱՌԱ ԱՅ (Lewon, servant of God); the letters ԱՌԱ are legible on the lower left side. On the reverse, a Greek cross is surrounded by the legend ՈՐԴԻ ՍՏԵՓԱՆԷԻ (son of Stepʻanē).

RM

60
Coin 230

Ruler T'ołos I
Value Copper
Reference Bedoukian 2a
Condition Fair to fine, very rare

61
Coin 231

Ruler T'ołos I
Value Copper
Reference Bedoukian 2a
Condition Fair, very rare

62
Coin 233

Ruler Lewon II, later King Lewon I
Value Copper, large module (24–5 mm)
Reference Similar to Bedoukian 4
Condition Fair, rare

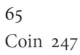

63
Coin 235

Ruler	Lewon II, later King Lewon I
Value	Copper, large module (24–5 mm)
Reference	Similar to Bedoukian 4
Condition	Fair, rare

64
Coin 239

Ruler	King Lewon I
Value	Double-tram
Reference	Bedoukian 24 var.
Condition	Very fine, scarce

65
Coin 247

Ruler	King Lewon I
Value	Double-tram
Reference	Bedoukian 13
Condition	Somewhat double-struck on obverse, otherwise extremely fine, rare

Royal Coinage of the Kingdom of Cilicia

Both quality and material of Cilician coinage changed with the coronation of Prince Lewon II as King Lewon I of Cilicia (r. 1198–1219), which is reflected in the silver trams issued on the occasion of his ascent to the throne. The obverse of issue 253 features his new title in the legend, ԼԵՒՈՆ ԹԱԳԱՒՈՐ ՀԱՅՈՑ (Lewon, King of the Armenians), and shows him crowned by a figure graced by a halo. The reverse shows a single lion draped right with a patriarchal cross on his back, accompanied by the legend, ԿԱՐՈՂՈՒԹԲՆ ԱՍՏՈՒԾՈՑ (by the power of God). A similar coin, issue 258, also from his coronation, features two lions on the reverse, separated by a patriarchal cross, and surrounded by the same legend in variant spelling; the obverse of this coin, however, shows Lewon I seated on the throne, dressed in the attributes of his new status: on his head the crown, sceptre and orb in his hands.

Later coins will generally continue the same motifs. The double-trams similar to issues 239 and 247 have an obverse as above, with the exception that the legend now refers to Lewon I as King of all Armenians; its reverse shows a crowned lion draped left, with the same cross on its back and the same legend. Yet even between these two types, differences in execution are obvious: both legend and depictions on 247 are struck much more clearly, and show finer craftsmanship, as 239 refers to the old beaded style more closely.

The coins of King Het'um I (r. 1226–70) are rather different in nature. Their obverse shows the king on horseback draped right, surrounded by a cross, a crescent moon and a star; whether the latter allude to his recognition of the suzerainty of the Seljuq Sultanate of Rum, or are used in a less expressive manner is unclear. The formula naming Het'um as King of the Armenians is retained. The reverse, however, features a Persian inscription which denotes that the coin was struck in alliance with Sultan Kay Khusraw II in 1242; the formula on 281a and b runs as follows: 'Struck at Sīs in the year [six hundred] and forty four [1246 CE] | The Most Magnificent Sultan | The Succour of the World and of the Faith | Kay Khusraw son of Kay Qubād'.

On a different coin, issue 293, Het'um I is displayed with Queen Zabel, who after long struggles in the succession of the kingdom became his consort in 1226, although reluctantly; the legend encompassing the couple uses a common formula, 'by the power of God'. The reverse of the coin features a crowned lion draped right, bearing a cross, surrounded by the legend proclaiming Het'um I as king of the Armenians. A very similar design, albeit without the cross, is found in a later coin issued by King Lewon II (r. 1270–89).

The tram coins of King Smbat (r. 1296–8), however, recall a motif used by King Lewon I: the obverse shows the king on the throne with his regalia, surrounded by the legend, ՍՄԲԱՏ ԹԱԳԱՒՈՐ ՀԱՅՈՑ (Smbat, king of the Armenians); the obverse shows a similar constellation of two lions back to back, but faces turned to each other, separated by a double cross, and surrounded by the legend 'by the power of God'.

Bedoukian, P. Z., *Coinage of Cilician Armenia* (rev. ed.), Paul Z. Bedoukian, Danbury, CT, 1979.

RM

66
Coin 253

Ruler	King Lewon I
Value	Coronation tram
Reference	Bedoukian 77, this coin cited
Condition	Clipped but fine, very rare

67
Coin 258

Ruler	King Lewon I
Value	Coronation tram
Reference	Bedouin 572
Condition	Very fine to extremely fine, scarce

68
Coin 281a

Ruler	Het'um I, with Kay Khusraw
Value	Bilingual tram
Reference	Bedoukian 814, 827
Condition	Good very fine

69
Coin 281b

Ruler	Het'um I, with Kay Khusraw
Value	Bilingual tram
Reference	Bedoukian 814, 827
Condition	Good very fine

70

Coin 293

Ruler Het'um I with Zabel
Value Half-tram
Reference Bedoukian 1279, this coin cited
Condition Good clear strike, fine, very rare

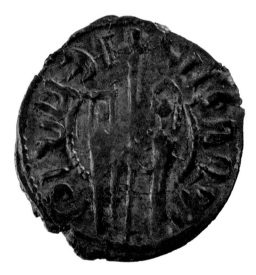 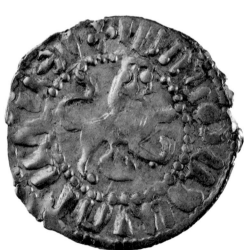

71

Coin 325

Ruler King Lewon II
Value Tram
Reference Bedoukian 1427
Condition Very fine, rare

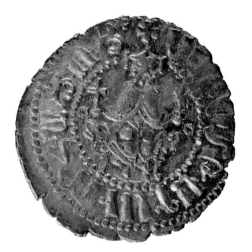
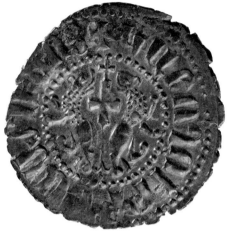

72
Coin 365

Ruler	Smbat
Value	Tram
Reference	Bedoukian 1653
Condition	Good very fine, rare, as struck

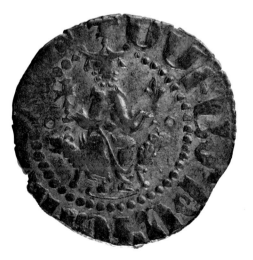
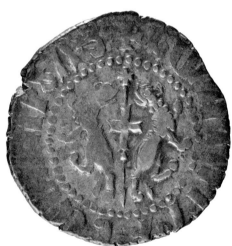

73
Coin 367

Ruler	Smbat
Value	Tram
Reference	Bedoukian 1653a
Condition	Fine to very fine, rare

Modern Armenia Before, During and After the Genocide

The seventeenth century was a period of upheaval and resurgence, seeing the gradual emergence of the current geopolitical situation, with powerful states to the north, west and south of Armenia: Russia, Turkey and Iran.

From 1605 onward, the establishment of the Armenian community in New Julfa in Isfahan, capital of the Safavid Empire, as the hub of a multi-nodal merchant network spanning much of the known world, brought great prosperity to Armenian merchant families and their communities, some of whom had already made their mark in the silk trade from Julfa on the Arax. New Julfa's merchants set themselves up in cities in Europe and Asia, with many establishments in India and further to the east. In some they created printing houses, such as in Amsterdam, where the Map of the World (cat. 77) was produced.

In New Julfa, copyists and painters reached new heights in the production of stunning illuminated manuscripts, inspired by the art from Armenian scriptoria in Constantinople, where the examples of the masterpieces created in the thirteenth and fourteenth centuries in the Armenian kingdom of Cilicia and the Crimea were followed. The Julfan masters fused these with aspects of painting from the Vaspurakan area around Lake Van, and with European models both of painting and engraving. In 1636, Xač'atur Kesarac'i, bishop of New Julfa, established the first printing press in the Safavid Empire and began printing a Psalter, which was produced in 1638 (cat. 49).

The successful commercial activity, manuscript production and printing accompanied a regeneration in learning and education, and an extensive building and restoration programme of Armenian churches, financed by the merchants' wealth and, sometimes, the Church. In

seventeenth-century New Julfa, circumstances initially were favourable for the building of churches. Of the ecclesiastical items in this section, the icon and the brass bowl (կոնք, cat. 74, 75) stem from Persia, and the style of painting of the Yovnat'anean family, as seen in the eighteenth-century decorations of the Mother See at Ējmiacin, is also Persian. Nałaš Yovnat'an, the painter of the icon exhibited, was the first of three generations of renowned painters in Armenia.

The altar curtain (cat. 76) was made in Kesaria (Կեսարիա), Caesarea or Kaiseri, a significant city in the Ottoman Empire, which was famous also for its sumptuous silver manuscript bindings. The curtain gives evidence of the level Armenians reached in other crafts as well.

Armenian books were briefly printed in Constantinople between 1567 and 1569 by Abgar dpir T'oxatec'i, but censorial intervention precluded continuation. Once censorship on printing books had been lifted, the Ottoman capital became, together with Venice, one of the most important centres of Armenian book printing in the eighteenth century, concentrating on works of the Armenian Church. Exhibited from among these is Grigor Narekac'i's *Book of Lamentation* (Մատեան ողբերգութեան), of which there were no less than nine eighteenth-century editions in Constantinople, against two in Venice, and none elsewhere. The exhibited copy (cat. 86) has been much consulted and is a good example of the range of religious feeling the book inspired, including mystical contemplation, prayer in a variety of circumstances, and acquiring protection against all kinds of evil. The latter use may be compared to that of the *hmayils* (cat. 27, 28, 29) and the amulets on the cover of one of the exhibited Gospels (cat. 5).

Armenians living in the Caucasus were at different times subject to Persian, Ottoman or Russian rule, the latter established over the territory of the current Republic of Armenia since 1828. The aspiration of living under Christian suzerainty was realized, but the high hopes for greater freedom were soon dashed. This is a subtext of Abovean's *The Wounds of Armenia*, written in the early 1840s and published in 1858 (cat. 88).

A fundamental difference in the geopolitical situation of the Armenian people today compared with that of previous centuries lies

in the genocidal destruction of 1915 and the following years of historic Armenia's location within the confines of the Ottoman Empire, depleting the greater part of the Armenian Highland of the Armenians who had lived there for at least two and a half millennia. The same happened in many other parts of the realm. While Armenians had experienced deportation and massacre before, the genocide of 1915 and its denial by the Turkish authorities – but not by all inhabitants of Turkey – is an unfathomable event that the survivors and subsequent generations seek to understand and overcome to this day.

The survivors of the genocide have given rise to the twentieth-century diaspora of tens of thousands of displaced Armenians throughout the world. Pieces of a lost world were salvaged, others acquired underway; sometimes the exact year of purchase is lost over the generations, but the meaning of a family samovar or needlework carries overtones of tradition and continuity, as do other heirlooms and photos, as well as the panoramic collection of postcards, and the lithography of a cross-stone (խաչքար), which fuses memory, culture and ancestral land.

The soil of one's native land is found tucked away in little bags of cloth in the eighteenth-century *Narek* kept in Yorkshire, never to be separated from it. The poet Taniel Varužan, far away from his hometown, fathomed its meaning in 'Red Earth' (Կարմիր հողը), a poem he wrote after the 1894–6 massacres; he would himself be killed in 1915. The opening lines of the poem read:

> On my desk, in
> this bowl lies a handful of soil, brought there
> from the fields of the fatherland.
> It is a gift. Who gave it to me
> thought he gave his heart, without even supposing
> that with it, he also gave his ancestors.
> That's what I look at. Sometimes, for hours
> my pupils directed at it,
> I remain silent and sad, as if my fiery
> glance took root in that soil.

The thirst for freedom expressed in Abovean's work and the perceived effect of the *Narek* enjoining personal contrition rather than collective rising in defence of one's inviolable rights led to a debate about the preferable attitude in view of mortal danger, a dilemma also presented in Franz Werfel's novel *Forty Days of Musa Dagh*. In his *Retreat without Song* (Նահանջը առանց երգի), written in Paris a decade after the genocide, Šahan Šahnur, born in 1903 in Constantinople, considers its consequences, one of which is a loss of identity, assimilation, a severed self: the main character, Bedros, becomes Pierre. It also contains a debunking, by one of the characters, of Narekacʿi's sacred position in Armenian culture as a harmful one. This is not a widely shared position, except perhaps temporarily by the early Ełiše Čʿarencʿ (1897–1937), an eventually disillusioned Communist who fell victim to Stalin's terror. Armenian literature of subsequent generations addresses the phenomena of dispersion and loss, life in the diaspora and the significance of genocide in sometimes hauntingly beautiful language and imagery. There is a blurring of chronology expressed by the internal monologue of protagonists, whose observations mingle with memories that convey the image of persons searching, seemingly aimlessly, in an attempt to fathom, make sense of life – forge a homecoming perhaps? Less straightforward than the meanderings of Homer's epic hero, and wondering like Joyce's protagonists, this literature fundamentally questions the human condition.

Recent years have seen significant changes in the views on the genocide within academia and within society in Turkey. The gradual formation of a vocal civil society in Turkey encourages understanding. Developments such as the solidarity with the Armenian minority following the murder of the journalist Hrant Dink in 2007, and the 'coming out' of people such as Fethiye Çetin, whose older family members were stripped of their Armenian identity during the genocide and lived their lives as Turks or Kurds, show that there are possibilities for a deeply problematic past to be overcome in recognition and reconciliation.

TMvL

74
An icon from the Treasury of Ējmiacin

26 x 21 x 2.5 cm
Tempera on gesso-covered wooden boards, silver and gold repoussé frame
Nałaš Yovnatʻan
Ējmiacin 1696
Sam Fogg 16018

The Armenian tradition of icon painting developed relatively late, largely under the influence of Russian and Greek schools, wherefore this exemplar from the treasury of Ējmiacin, crafted by the same Nałaš Yovnatʻan (1661–1722) who also painted large parts of the dome of Ējmiacin Cathedral and was later court artist to King Vakhtʻang VI of Georgia, is a true rarity. Despite foreign influence, with its floral ornaments and dress patterns, the style and patterning of the image is typically Armenian, and strongly reminiscent of a relief in the Armenian Church of Spitakavor from 1338 CE.

Nałaš, who was also a noted poet and bard (աշուղ), executed this icon of the Virgin and the Child in tempera on gesso-covered wooden board, and further ornamented it with a partly gilded silver repoussé frame. Two inscriptions grace the frame: the upper line, in silver, reveals the date of creation (AE 1145 = 1696 CE), whereas the lower line, in gold, states that it was a gift of Moses Vardapet to Tēr Łazar, consecrated Katholikos of All Armenians in 1738. A note on the back of the icon informs of its later history: under Katholikos Epʻrem, it was presented in 1815 to Xačʻatur Yohannisean, of whom nothing is known, for the protection of his family.

Of Nałaš's poetic work, his 'Praise of the City Yerevan', which is thought to describe the results of a disastrous earthquake that laid waste to Yerevan in 1679, is probably best known.

Baker, J., S. Harlacher, S. K. Batalden and Zs. Gulácsi, *Sacred Word and Image: Five World Religions*, Art Museum, Phoenix, AZ, 2012.

RM

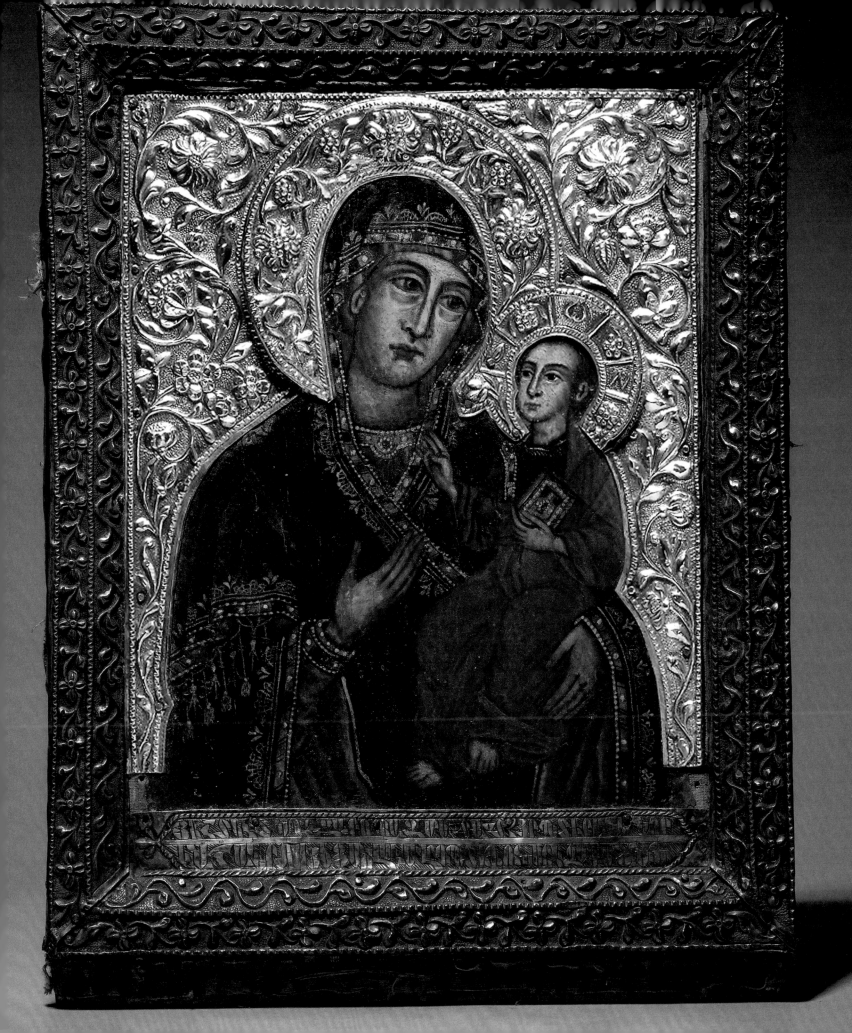

75
Safavid brass bowl

h: 12 cm; rim Ø: 24 cm, brass
New Julfa, Isfahan 1616
Sam Fogg 16701

The design and shape of this brass bowl suggest a provenance from early-seventeenth-century Iran; the scenes depicted on the bowl show groups of individuals, often sitting, clad in garments of Persian fashion. This is confirmed by the Armenian inscription figuring on its upper rim, which reads: Նուր Բեկ որդի Թասալի թ[վականի] ՌԿԵ ('Nur Bek, son of T'asal, in the year AE 1065 [1616 CE]'). Whilst the name Bek, derived from a former Persian title referring to a chieftain or prince, alludes to the social standing of the owner, nothing else is known of him.

Given its date and Armenian inscription, the bowl was most likely fashioned in New Julfa, the district of Isfahan established by Armenians in 1604 as a result of the forceful resettlement of the Armenian merchant community of Julfa under Shah Abbas I. The community thrived and developed an extensive trade network, especially in silk, but also gave rise to a school of magnificent artisans, producing some of the finest illuminations found in Armenian manuscripts.

Together with a ewer, the bowl would have been used by a priest during the ritual washing of hands, a part of the Divine Liturgy, in accordance with Psalm 25: 'I will wash my hands in innocency and I will compass Thine altar, O Lord, that I may hear the voice of Thy praise and tell of all Thy wondrous works'. This ritual, practised in one form or another in most Christian denominations and many other religions, can be dated back to the fourth century CE.

Baghdiantz McCabe, I., *The Shah's Silk for Europe's Silver: The Eurasian Silk trade of the Julfan Armenians in Safavid Iran and India (1590–1750)*, Scholar's Press, Atlanta, GA, 1999.

Der Nersessian, S., and A. Mekhitarian, *Armenian Miniatures from Isfahan*, Les Editeurs d'Art Associés, Armenian Catholicosate of Cilicia, Brussels, 1986.

RM

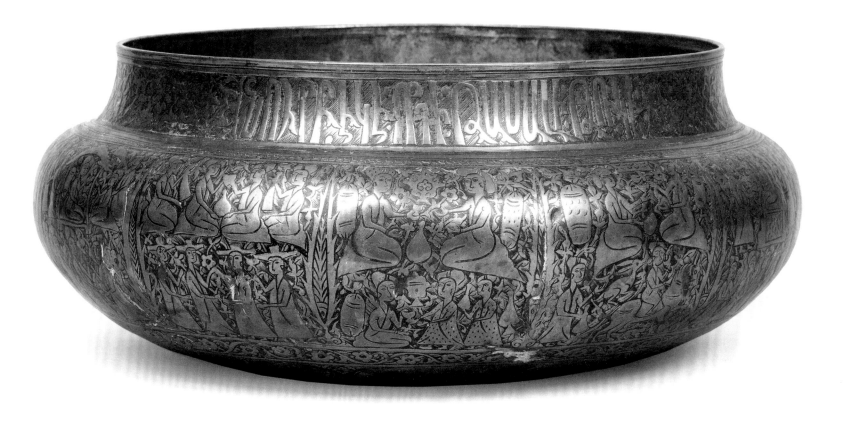

Altar curtain from the Church of Surb Karapet

270 x 365 cm, silk, embroidered with silver thread
Kesaria 1788
Sam Fogg 16703

The use of an altar curtain to separate the raised altar (խորան) from the congregation at certain points during the Divine Liturgy goes back to the fourth century CE, inspired by a letter of Macarius of Jerusalem to the Armenian Katholikos Vertanes. Intended to separate congregation and priests during prayer, the curtain resembles to some extent the veil of the Temple, which protected the Holy of Holies. In the Armenian rite, the curtain is drawn during the preparation for holy communion, the private prayers of the celebrant thereafter, and moreover during the forty days of the Great Lent, symbolizing man's expulsion from the Garden of Eden and a time of repentance and forbearance.

This magnificent exemplar, made from red silk and with an embroidered inscription in silver thread, was

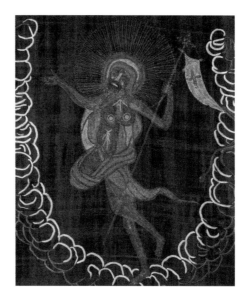

given to the Monastery of St John the Baptist (Սուրբ Կարապետ) in 1788. According to the memorial inscription, the benefactor, Mahtesi Astuacatur, presented the monastery with this curtain in memory and for the salvation of his deceased parents

on 25 March. The inscription is placed at the centre of the curtain, below the depiction of the Risen Christ, while its corners are each decorated with a scene from the life of Christ: the Crucifixion, the Descent from the Cross, the Burial, and the Resurrection.

The Monastery of St John the Baptist, famed for its ability to heal those suffering from mental illness, according to legend, was established already under St Gregory the Illuminator in the fourth century CE; destroyed during the genocide in World War I, parts of its ruins have been used by the local Kurdish communities to build their houses.

Ervine, R. R., *Worship Traditions in Armenia and the Neighboring Christian East: An International Symposium in Honor of the 40th Anniversary of St. Nersess Armenian Seminary*, St Vladimir's Seminary Press, Crestwood, NY, 2006.

Lynch, H. F. B., *Armenia, Travels and Studies, vol. II: The Turkish Provinces*, Longmans, London, 1901.

RM

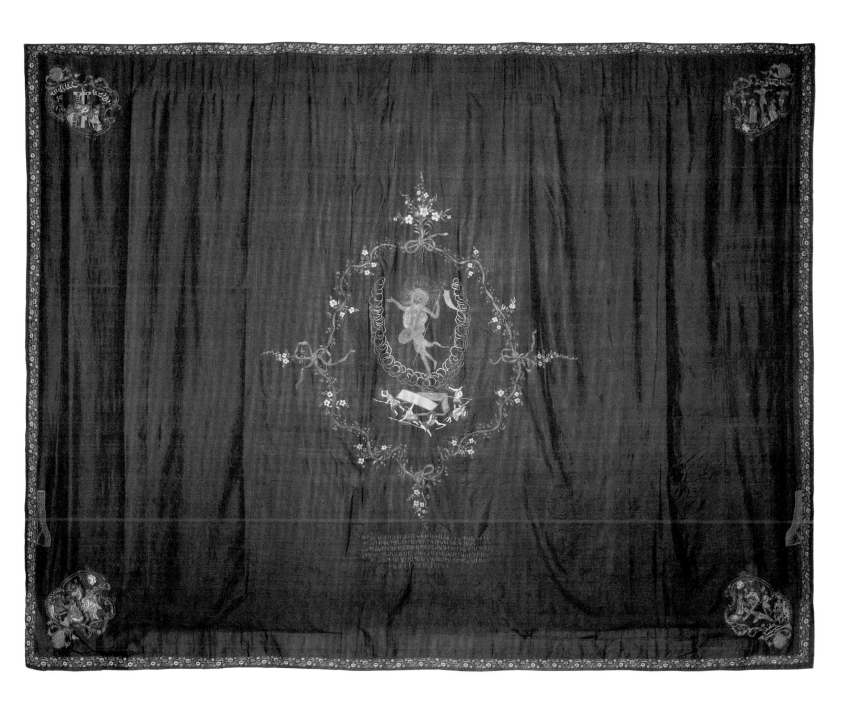

77

An Armenian map of the world

Map of the World (Համատարած Աշխարհացոյց)

124 x 158 cm, paper
T'ovmas Vanandec'i
Amsterdam 1695
British Library, *920.(89.)

This double-hemisphere map, designed and engraved on eight copper plates by the brothers Adrian and Peter Schoonebeek, was commissioned and printed by Archbishop T'ovmas Vanandec'i. Since an Armenian community was already long established in Amsterdam, T'ovmas settled there in 1695 and established a new printing press, following the closure of a previous press in which the famous Oskan Bible had been published. The success of the various Armenian printing presses was to no small extent due to the religious tolerance of the Protestant Netherlands; many other printers in Venice, Rome or Lviv were less productive owing to restrictions imposed by the Catholic Church.

Closely resembling a great number of similar rather costly maps of the era, both the map and its surrounding depictions of astronomical constellations and the Copernican solar system are labelled in Armenian exclusively. Together with a key to this map and other geographical and mercantile treatises penned by his nephew, Łukas Vanandec'i, T'ovmas created invaluable tools for the ever growing and expanding community of Armenian merchants. The inclusion of figures from Greco-Roman mythology surrounding the map, such as Helios in his chariot and Poseidon in the sea, are common features of this type of map; they also bear Armenian labels and may be meant to acquaint the Armenian beholder, to whom they would be less familiar, with archetypes of Western art and symbolism.

The *Map of the World* (Համատարած Աշխարհացոյց) was one of the first maps to feature a coordinate system with the main longitudinal and latitudinal lines noted on the map. Within the Armenian language community, it has further been adopted as the standard for transcription of geographical designations.

Barber, P., and T. Harper, *Magnificent Maps: Power, Propaganda and Art*, British Library, London, 2010.

Koeman, C., 'A World-Map in Armenian Printed at Amsterdam in 1695', *Imago Mundi*, vol. 21, 1967, pp. 113–14.

RM

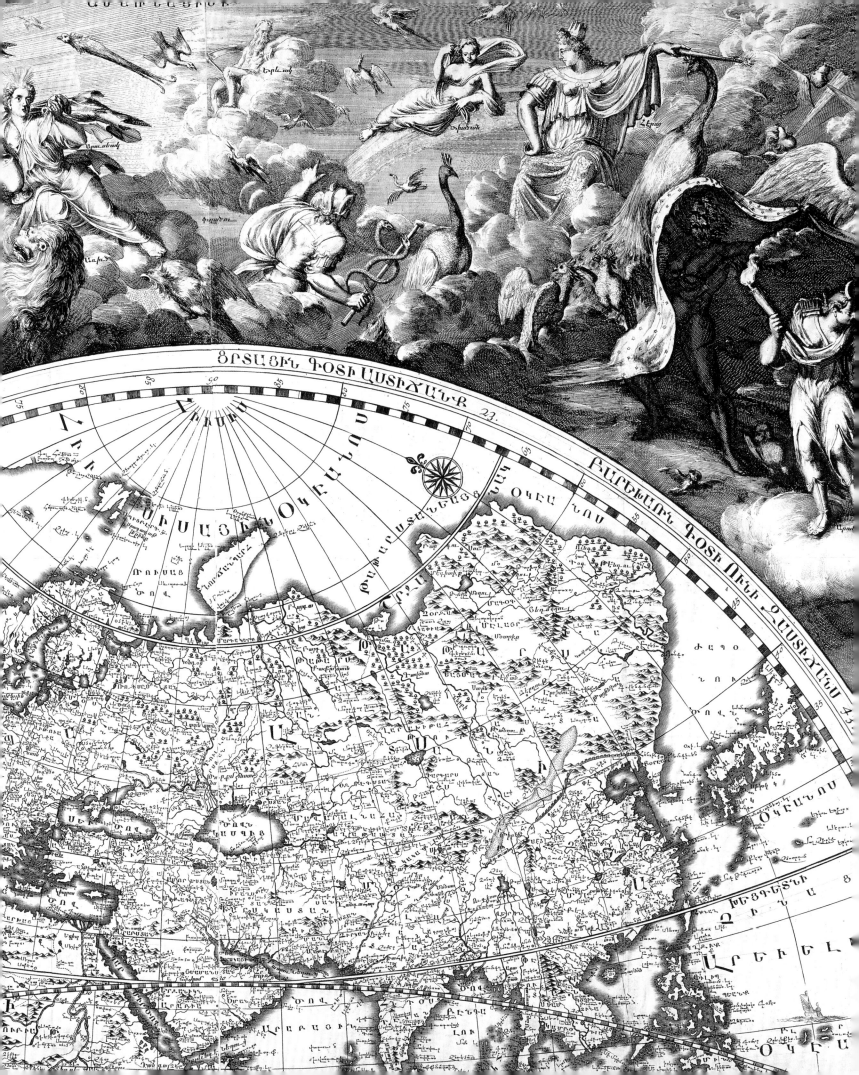

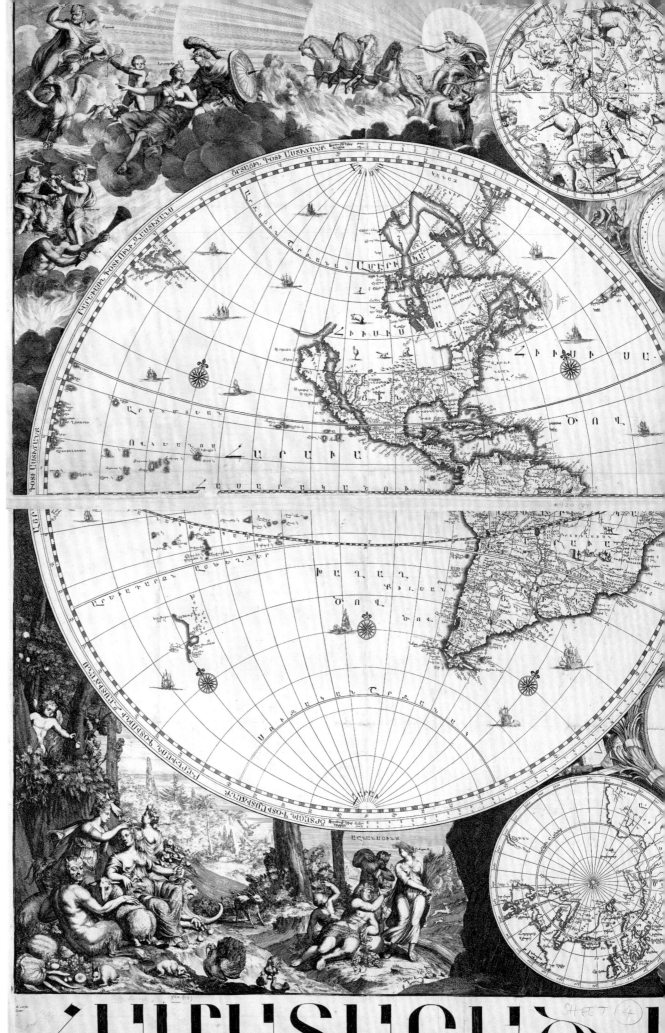

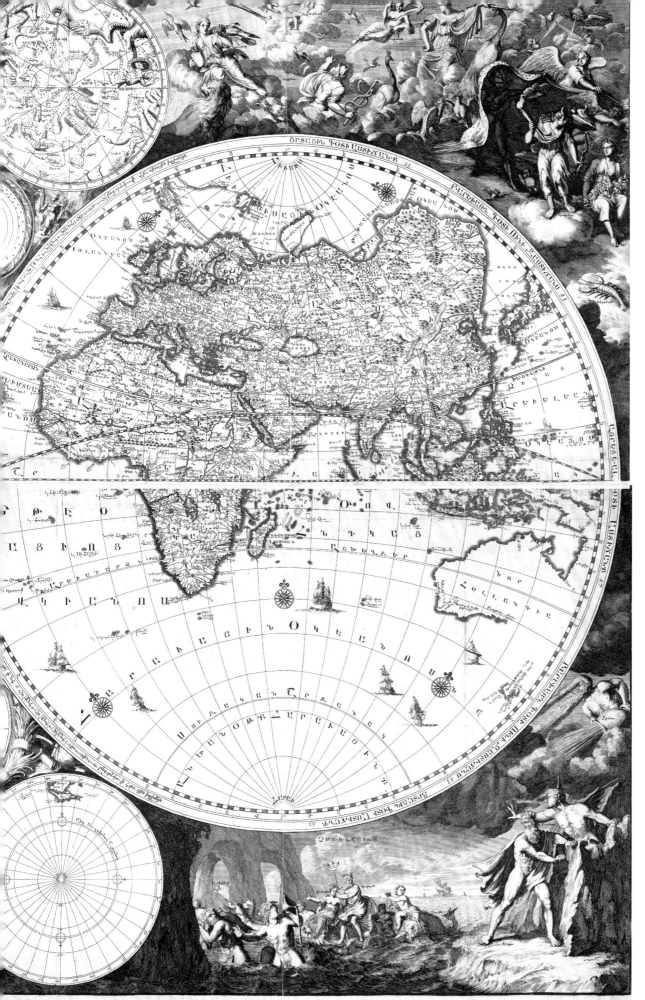

78
A pastoral staff

68.3 x 14.9 cm, silver and silver-gilt
18th century
Victoria and Albert Museum, M.343:1, 2-1903

As in the Western Church, clergymen of a certain rank are presented with a staff as a sign of their office at the time of their consecration. The exemplar presented here is the stave of a *vardapet* (վարդապետ), a celibate priest in the Armenian Apostolic Church, who has attained the degree of Doctor of Theology, comparable in rank to an archimandrite.

In opposition to the crosiers, or pastoral staves, in the Western Church, which are fashioned after the model of a shepherd's crook, staves in the Eastern Churches resemble a crutch and usually have a tau-shaped (⊤) head, often in the form of a snake. In this context, the symbol of the snake may express two concepts: wisdom (according to Genesis 3.1), since the snake is 'the most wise of the wise beasts'; and Moses' healing of the people by holding up a brass snake on a pole (Numbers 21.8-9). The staff itself stands for the support the *vardapet* is meant to give to the faithful, as well as being an instrument of castigation of the recalcitrant.

This double-headed model is parcel-gilt, its shaft decorated with strips of silver chased with a vine pattern. A single-headed model, with the snake's head similarly curling down, exists as well. These staves are usually fully collapsible, as the oval knob indicates; when assembled, they stand approximately five feet tall.

Krikorian, M. K., *Die Armenische Kirche*, Peter Land, Frankfurt/Main, 2002.

Watts, W. W., *Catalogue of Pastoral Staves*, Victoria and Albert Museum, Board of Education, London, 1924.

RM

79

An Armenian needlework headdress
Octagonal crochet needlework

Ø 24 cm, wool
Naira Proyan
Gyumri, late 20th century, before 2002
Private collection (KM)

This woollen headdress was made by a young woman from Gyumri (in Soviet times called Leninakan, in the Tsarist period Alexandrapol) dedicated to the tradition of needlework and embroidery.

The design is an octagon radiating from a circular centre. The circular form consists of eight stalks carrying bunches of grapes which fit into an outer band of quadrangular shapes that lend the piece its octagonal outer shape. The crocheted grapes are closely worked and in relief, reaching up to over 0.5 cm in height. The theme of the grapes, together with the circular centre and the perpetuity of the octagon, lend the piece a symbolic meaning of eternity and abundance,

together with a reference to Christ as the true Vine (Jn 15.1–8), as well as his life-giving sacrifice on the cross. As is common in many aspects of Armenian arts and crafts, Christian motives occur together with pre-Christian ones, yielding a rich and subtle set of meanings.

The item was presented to the current owner as a gift when he made a film on Armenian needle handwork for the Third International Biennial of Contemporary Art held in Gyumri, Armenia, in 2002. It was among the pieces blessed by Father Nerseh *vardapet* Xalatyan, priest at Ējmiacin, the Mother See of the Armenian Apostolic Church, in the monastery of Geghard in 2002.

Odian Kasparian, A., *Armenian Needlelace and Embroidery*, EPM Publications, McLean, VA, 1983.

Third International Biennial of Contemporary Art, Gyumri, Armenia, 2002.

TMvL

80

An Armenian needlework window band
Crochet needlework

111.5 x 15 cm, wool
Haygouhi Touma Momdjian
Lebanon 1950s
Private collection (KM)

The mother of the owner, the poet and painter Krikor Momdjian, made the band in Lebanon in the 1950s when he was a small boy, specifically to decorate the upper side of his bedroom window. Momdjian then used it in the Netherlands to decorate one of the windows of his own children's bedrooms.

The band consists of a long rectangle from which triangles are hanging. The general shape is often used for cushion and tablecloth endings. The finely worked upper hem and the delicate bulb-shaped decoration hanging from the triangles enclose a band in which branches of flowers are depicted, one above each triangle. Each branch has three leaves and a flower, with a smaller flower placed below it, perhaps indicating flower buds. It repeats the lush decoration found in illuminated manuscripts, on cross-stones, in Armenian xač'k'ars (խաչքար, the impressive and beautiful cross-stones one finds everywhere in Armenia), and running around the outside of the famous church at Ałt'amar in Lake Van in Vaspurakan, now in the south-east of Turkey, thereby emphasizing the joy of nature and its force for life.

The band was blessed in 2002 in the monastery of Geghard in Armenia by Father Nerseh *vardapet* Xalatyan, in

a ceremony filmed by the owner, and shown at this exhibition in the film *The Blessing* (Օրհնություն).

The owner recollects that his mother and older sister used to make needlework like this continuously. This is also the picture that emerges from Alice Odian Kasparian's description of the traditional occupation of girls and women in Armenia before the genocide, and its continuation among the survivors in the diaspora thereafter. For another example, see the collar made in the late nineteenth or early twentieth century (cat. 85). The other item belonging to Momdjian shows that the tradition is also continued in Armenia among the younger generation; one of its functions is to express one's Armenian identity, while it also provides a confirmation of one's rootedness in this tradition (cat. 79).

Abrahamian, L. and N. Sweezey (eds), *Armenian Folk Arts, Culture and Identity*, Indiana University Press, Bloomington, IN, 2001.

Odian Kasparian, A., *Armenian Needlelace and Embroidery*, EPM Publications, McLean, VA, 1983.

Third International Biennial of Contemporary Art, Gyumri, Armenia, 2002.

TMvL

81
Lithograph of a cross-stone (խաչքար)
Lithograph

39 x 34 cm, paper
Krikor Momdjian
Netherlands 1982
Private collection (KM)

This is an artistic rendition of a cross-stone (խաչքար); tens of thousands have been created by Armenians at least since the ninth century, often in highly intricate compositions, including a variety of Christian and pre-Christian symbolism. Their functions vary: they can demarcate boundaries, commemorate particular events, invoke the memory of and request intercession for certain persons, and mark graves. Stone is often associated with Armenia's mountainous character, all too abundant in the material, while the cross is both the symbol of Christianity, often simply referred to as the Holy Sign (Սուրբ Նշան), and of the suffering that forms part of its history, including the genocide of 1915. At the same time the empty cross is the sign of the Resurrection, and of hope restored – not a tool for torment, but an instrument of delivery.

Krikor Momdjian's work is remarkable in its texture, closely imitating the coarseness and unevenness of rough stone, which, along with its shape, associates this work of art with the earliest of the preserved cross-stones, as can be seen in the large graveyard at Noratus on the shores of Lake Sevan, among many later ones.

The evocation of an early, almost primeval cross-stone from Armenia on paper in a polder in the Netherlands by an Armenian diaspora artist is an act of creation, a statement of identification with his culture, its long history and religious confession, and its value in constituting a meaningful present. Born in Lebanon in 1945 to parents who had survived the genocide, Krikor studied art in Florence and Paris, worked as an architect and established himself as an artist in the Netherlands in the early 1970s. His paintings, etchings and installations are often accompanied by inscriptions and poems, and he publishes poetry in Armenian, English, French, Arabic and Dutch. His work is rich in themes reflecting questions about (up)rootedness and productive cosmopolitanism, combined with an absorption of Armenian traditional art in highly personal and often very colourful interpretations. It expresses a continued faith in humanity without gratuitously erasing the memory of atrocity and injustice from his work, in an attempt to build on trust as the basis for human relationships.

Kleisen, J., *De grenzen voorbij. Beyond Borders. Krikor Momdjian's ikonen van passie | icons of passion*, Momdjian Foundation, Woubrugge, 1996.

Krikor, *Orange Moon gedichten en schilderijen*, Momdjian Stichting, Alphen aan den Rijn, 2009.

TMvL

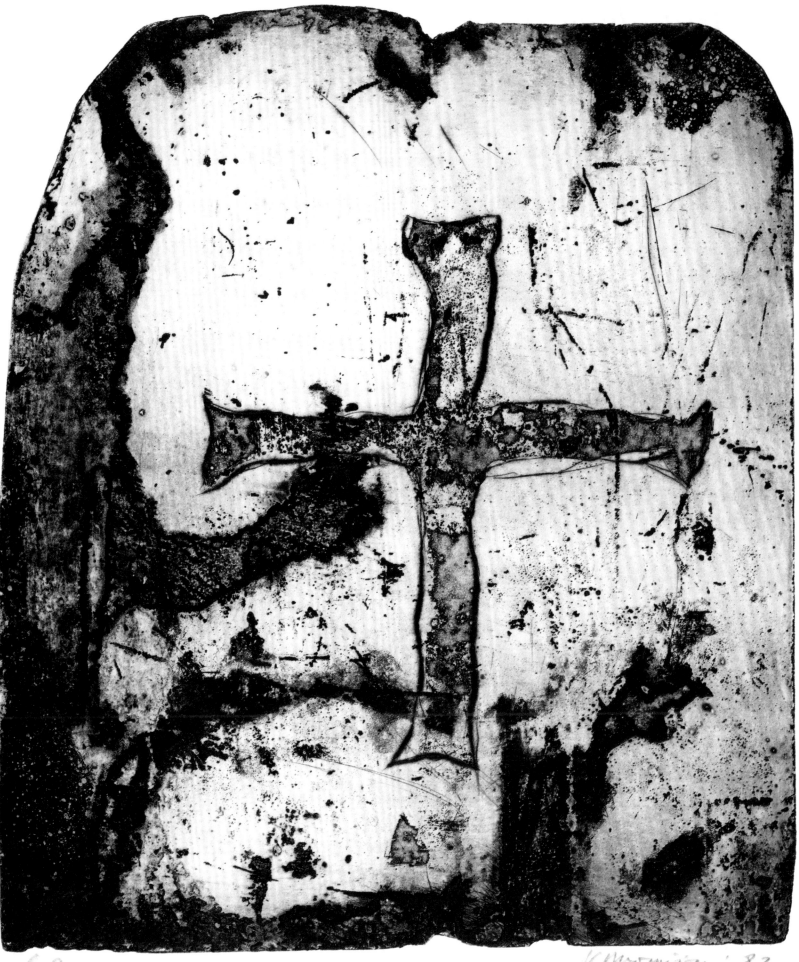

K.Mrożyński '82

The Chalvardjians' family samovar
Samovar

34.2 x 53 x 20 cm, nickel-plated brass
Factory of the Brothers Salyščev
Tula, Russia 1901–18
Private collection

The date of manufacture of this samovar – a container in which water was boiled and on top of which a small pot of very strong tea was placed – falls between 1901, that of the latest dated stamp, and 1918, the year in which the Russian orthography used on the samovar was reformed. It was in use by the Chalvardjian family in Cilicia before 1920 and travelled with Eugénie Chalvardjian (née Bohdjalian) to Milan and then Cairo. It passed on to her daughter and thence to the United Kingdom when she emigrated in 1961.

The samovar brings its own recommendations in the form of thirteen medallions recording the prizes the design had won at exhibitions of crafts and agriculture, some of them international (French and Russian) between 1899 and sometime before World War I. Six small ones are placed on the upper part, seven larger ones decorate the belly. They contain symbols of agricultural abundance, but also busts of tsars Aleksandr III (r. 1881–94) and Nicholas II (r. 1894-1917); see medallions 9 and 11. Medallion no. 8 features two women probably wearing late-nineteenth-century dress and possibly symbolizing France and Russia.

The inscription indicating the samovar's provenance is placed between the medallions on the upper part and reads 'Samovar Factory of the Brothers Salyščev in Tula':

САМОВАРНОЕ
ЗАВЕДЕНІЕ
БР.
САЛЫЩЕВЫХЪ
ВЪ ТУЛЕ

Tula was renowned for its production of weaponry, and of samovars. A staple item of classical Russian novels and daily reality, Armenians used them throughout the Russian, Ottoman and Persian empires.

The Tula Museum of Samovars – the Beginning of XX century of samovars, www.shopsamovar.com.ru/museum07 (accessed 11 August 2014).

TMvL

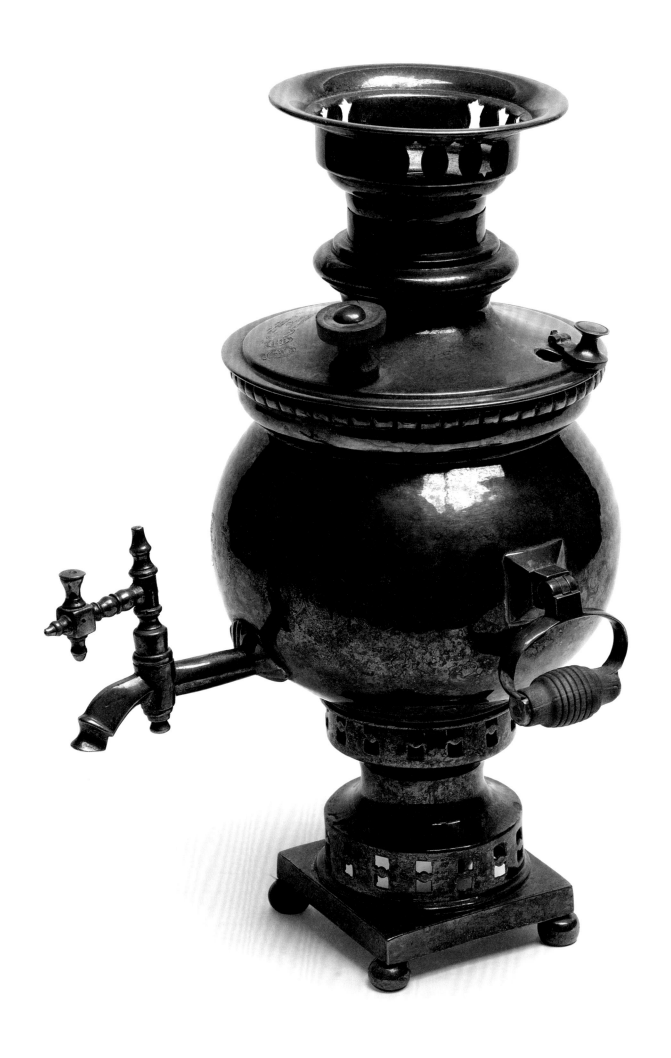

Cups and saucers used to serve Armenian coffee
Demitasse cups and saucers

Cups: 5.3 cm (circ.) x 5.2 cm (h); Saucers: 11.4 cm (circ.)
Glazed white industrial earthenware, printed decoration
Manufacture W.H. Grindley & Co.
Tunstall, Staffordshire, United Kingdom, before 1925
Private collection

The donor's great-grandmother Eugénie Chalvardjian (née Bohdjalian) served coffee in these cups. They were manufactured in Staffordshire before 1925, but it is unclear whether they were acquired in Cilicia (before 1920), Italy (between 1920 and 1924) or Egypt (1924 or later). Egypt seems the most likely; as a former British protectorate, and still very much within the British sphere of influence in the 1920s, it would have had the closest trade links with the UK. The six towns that now make up the city of Stoke-on-Trent, Staffordshire, were the centre of the ceramic industry in eighteenth- to twentieth-century Britain and its empire. W. H. Grindley & Co., the maker of these cups, manufactured primarily for export.

Traditional Armenian coffee (սուրճ), is made in a similar way to Arabic, Turkish and Greek coffee. Very finely ground coffee beans are heated in a special pot (սրճաման, or ջեզվէ) with water and sugar if desired. As the coffee comes close to boiling, a foam forms; the pot is removed from the heat and allowed to settle, then heated again and perhaps a third time. The coffee is poured into demitasse cups with care so as not to disperse the foam. It is drunk without disturbing the grounds, which settle at the bottom of the cup. It was customary for a woman with special knowledge to invert the finished cup onto its saucer to allow the sediment to run down the side, forming shapes and patterns which were interpreted to tell the fortune of the coffee drinker, similar to the reading of tea leaves. The donor's mother and grandmother recollect Eugénie reading coffee cups for family and friends. While the reading of coffee cups is still practised by some Armenians today, the traditions of interpretation have not been passed on in the family.

Hunt, T., *Ten Cities that Made an Empire*, Allen Lane, London, 2014.

Uvezian, S., *The Cuisine of Armenia*, Hippocrene Books, New York, 1998.

NNQ

84(a) Photo 1

Eugénie Bohdjalian and nephews, around 1905
Eugénie Bohdjalian and nephews

9.2 x 13.8 cm, photo (belonging to Eugénie Bohdjalian)
Probably Tarsus, Cilicia, Ottoman Empire c.1905
Private collection

This picture depicts the donor's great-grandmother, Eugénie Bohdjalian, and two of her nephews. Eugénie was born in 1897 in Tarsus, the youngest of eight children of Bedros and Ilemon Bohdjalian. Tarsus, the birthplace of St Paul, had been one of the principal cities of the medieval Armenian kingdom of Cilicia. At the turn of the twentieth century it was part of the Ottoman *vilayet* (province) of Adana, in which Armenians formed a significant minority within a diverse population of Turks and other Muslims, Greeks, Syrians and Jews. The donor's family believes that the nephews are Roupen and Isahag Kantzabedian, the sons of Eugénie's elder sister Assanet. Their father, Sarkis Kantzabedian, was deported and perished in 1915, but other members of the family survived, in part due to the protection of Eugénie's future husband Mardiros Chalvardjian. The children, members of a prosperous and educated family, are dressed according to European fashions of the time and hold contemporary toys. Eugénie and the younger of the boys appear to be wearing lace collars akin to the needlelace collar (cat. 85).

Hewsen, R. H., 'Armenia Maritima: The Historical Geography of Cilicia', in R. G. Hovannisian and S. Payaslian (eds), *Armenian Cilicia*, Mazda Publishers, Costa Mesa, CA, 2008, pp. 27–65.

NNQ

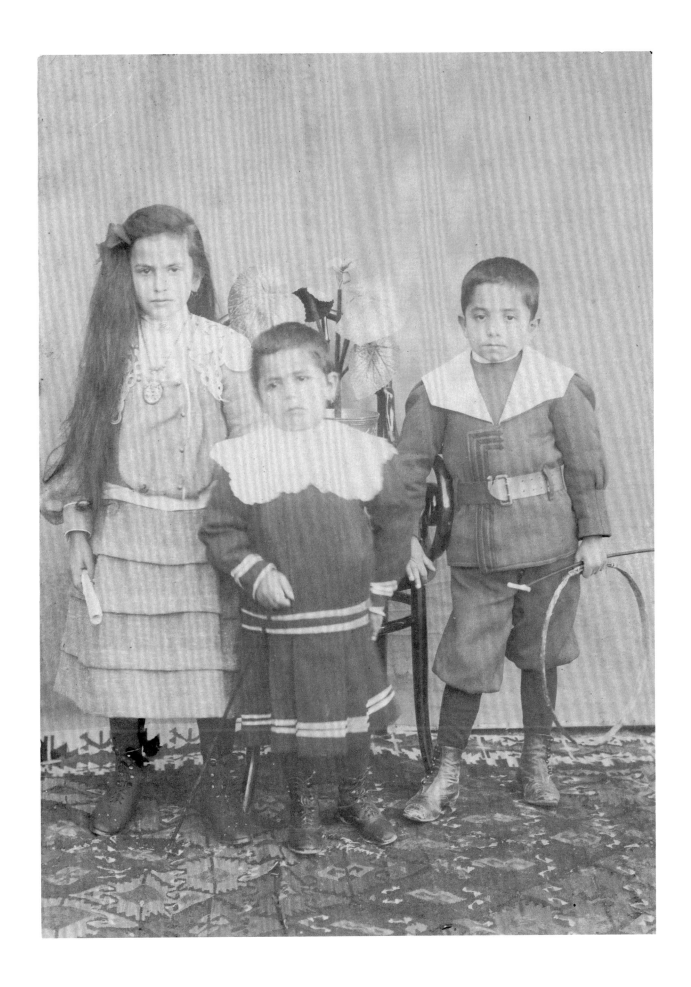

Juniors at St Paul's Institute Tarsus, 1906

16.2 x 11.8 cm, photo (belonging to Eugénie Bohdjalian)
Tarsus, Cilicia, Ottoman Empire 1906
Private collection

St Paul's Institute in Tarsus was founded by the American civil war veteran, attorney and newspaper editor, Colonel Elliott F. Shepard, in 1887 and admitted its first students in 1888. It was transferred in 1903 to the American Board of Commissioners for Foreign Missions, a Protestant mission organization which by 1907 ran seven colleges and four theological seminaries in Ottoman Asia Minor and Armenia. The institute comprised an academy and a college, the former offering education equivalent to a US high school and the latter to a US college; its graduates went on to teach, to study medicine or for the ministry and into business, among other occupations. The students, drawn from across Cilicia, were overwhelmingly Armenian, the remainder being Greek or Syrian.

This photograph depicts the Junior (penultimate college year) class of 1905–06. The donor's great-great-uncle, Aram Bohdjalian (born in Tarsus in 1885), is second from the right in the back row. On graduation in 1907 Aram stayed in Tarsus, his hometown, as a merchant. There he witnessed the first round of the Cilician massacres in April 1909 and was traumatized by this experience. The family, including Aram, Kevork, their sister (the donor's great-grandmother Eugénie) and their mother Ilemon, was able to escape to Mersina (Mersin) and thence to Cyprus, thus surviving the second round of massacres. They returned to Tarsus when the situation stabilized.

Aram never recovered from what he had experienced in 1909; today he might have been diagnosed with post-traumatic stress disorder. He never married and in later life he resided with Eugénie and her husband Mardiros Chalvardjian in Cairo. Aram had a facility with mathematics and encouraged Eugénie in her studies; she went on to study at the American University in Cairo and to teach mathematics in Cairo and then the UK. Aram died in Cairo in 1952.

'Catalogue of St. Paul's Institute', (1904) in Digital Library for International Research Archive, Item #11217, www.dlir.org/archive/items/show/11217.

'Catalogue of St. Paul's Collegiate Institute', (1906–07) in Digital Library for International Research Archive, Item #11223, www.dlir.org/archive/items/show/11223.

'The higher educational work of the American Board', in Digital Library for International Research Archive, Item #11227, www.dlir.org/archive/items/show/11227.

T. Davidson Christie, 'Report of St. Paul's Collegiate Institute', (1906) in Digital Library for International Research Archive, Item #11237, www.dlir.org/archive/items/show/11237.

All sites accessed 11 August 2014.

NNQ

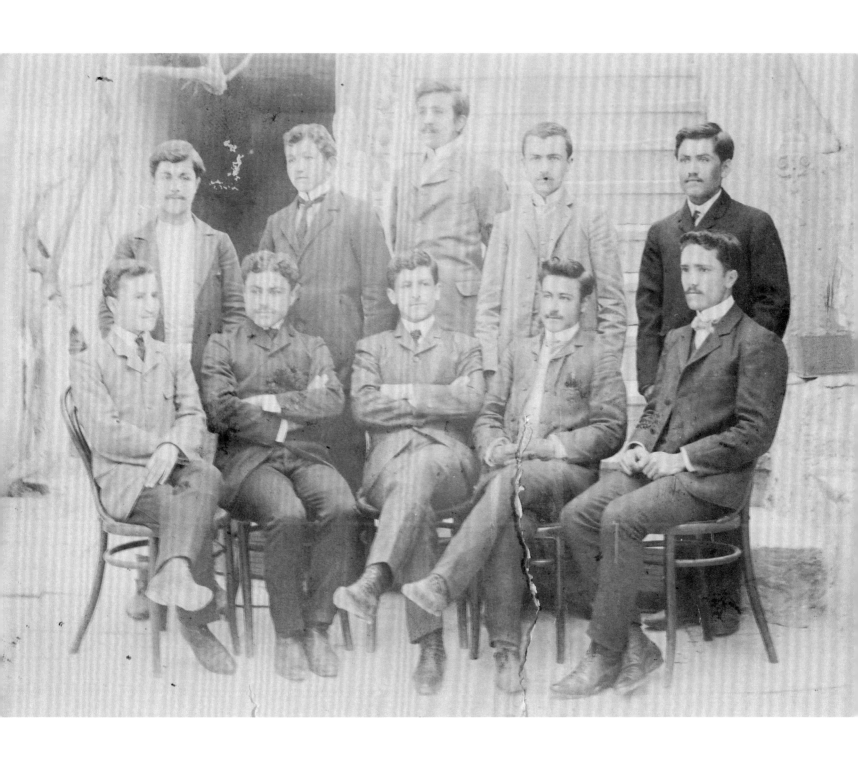

84(c) Photo 3
The flour mill at Tarsus

15 x 9.9 cm, print from photo (belonging to Eugénie Bohdjalian)
Tarsus, Cilicia, Ottoman Empire *c.*1915
Private collection

Mardiros Chalvardjian (born in Adana in 1880) and his elder brother Khatcher owned a substantial flour mill in Tarsus. The Chalvardjians were wealthy, owning land as well as the mill, and were protected in 1915 due to their standing with the local authorities and because they provided the troops stationed in the region with flour. They were among very few Armenians of Tarsus to avoid deportation in 1915. They were also able to protect their employees and Mardiros's elder son Kegham recalled that they 'hid people sent to the desert', that is, deportees. Raymond Kévorkian writes that 'the Shalvarjians … participated in a vast assistance network that most certainly helped prolong or save the lives of many Armenians in transit in the region'.

The noted Armenian writer Yervant Odian and his companions found refuge at the mill for three weeks during their deportation in September 1915. Odian reported that between twenty and thirty other deportees were employed and sheltered at the mill at that time. He mentioned Mardiros and his nephews (Khatcher's sons Aram and Ardashes) by name. Odian described the mill as 'located on the bank of the River Guntos, half an hour's distance from the town [Tarsus]. That large mill, which was founded by the Shalvardjian brothers, was a real European establishment, which produced 50,000 to 60,000 kilogrammes of flour a day. Each building was lit by electric light, thanks to the current of the river Guntos'. Odian again sought assistance from the Chalvardjians on his return journey.

The Chalvardjians were also able to protect Mardiros's intended bride, Eugénie Bohdjalian, and her immediate family in 1915.

Kévorkian, R., *The Armenian Genocide: A Complete History*, I.B.Tauris, London, 2011; Part IV, Chapter 21 and from p. 597.

Odian, Y., *Accursed Years: My Exile and Return from Der Zor, 1914–1919*, Gomidas Institute, London, 2009; pp. 84, 94, 259–60.

NNQ

84(d) Photo 4
Engagement photo of Eugénie Bohdjalian and Mardiros Chalvardjian

17.8 x 22.8 cm, photo (belonging to Eugénie Bohdjalian)
Adana or Tarsus, French Mandate Cilicia c.1919
Private collection

Mardiros Chalvardjian and Eugénie Bohdjalian married in Adana in 1919. Their first son, Kegham, was born in June 1920.

After the surrender of the Ottoman Empire to the Allies at the end of October 1918, Cilicia was occupied by British and then French forces. The occupiers encouraged survivors of the deportations to return to Cilicia and many did so. Meanwhile, Mustafa Kemal's Turkish Nationalist forces were gathering in strength; by 1920 the area north of the cities of Mersina, Tarsus and Adana was occupied by Kemalist forces. Through 1920 the situation became increasingly precarious for Armenians in Cilicia. Mardiros understood that it was no longer safe to remain when in 1920 he encountered a good friend, who was a Turk, in the same train compartment. The friend refused to acknowledge him in this public context, something Mardiros had not experienced, even in 1915. Mardiros, Eugénie and their baby son departed to join relatives in

Milan, abandoning their wealth, which was tied up in the mill and in land. The French forces completed their withdrawal from Cilicia in late 1921, at which time the remaining Armenian population of the region was evacuated, many to Cyprus and to the remaining French Mandate region, which became Lebanon and Syria.

Mardiros and Eugénie's second child, a daughter, was born in Milan in August 1922. In Italy, Mardiros engaged in business but with little success, and the family emigrated again in 1924. Intending to engage in business in India, as their ship boarded in Beirut he encountered Mr Bulbulian, who had been his right-hand man in Tarsus and who had settled in Alexandria. Bulbulian reported that there were good business prospects in Egypt, so the family disembarked in Alexandria and settled in Cairo. There Mardiros built another industrial flour mill, this time on the bank of the Nile. A second daughter was born in 1927 and their youngest child, a son, in 1933.

Moumdjian, G. K., 'Cilicia under French Administration', in Richard G. Hovannisian and Simon Payaslian (eds), *Armenian Cilicia*, Mazda Publishers, Costa Mesa, CA, 2008, pp.457–94.

NNQ

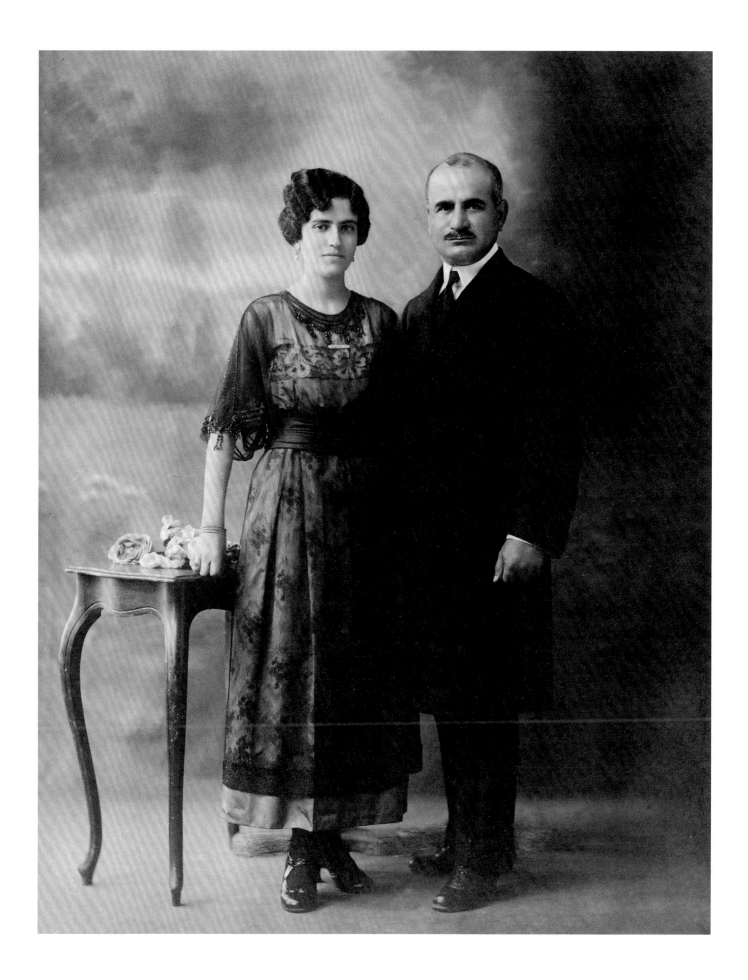

85

A woman's needlelace collar

16.5 cm (greatest depth); 51 cm (width), ecru (raw) silk
Possibly Kharpert (Elâziğ), Ottoman Empire c.1890
Private collection

Traditional Armenian lace is made with just a needle and thread, typically fine cotton or silk. The technique is similar to net-making, but on a much finer scale. Different patterns are achieved by varying the size of the loops between knots and the connections between rows.

This lace collar belongs to the donor's grandmother, one of several textile items that were brought from Cilicia and have passed down through the family, including fine crochet and also Cilician (or Aintab) drawn work. The collar combines many of the traditional patterns used in Armenian needlelace. It is made of forty medallions, each comprising a cross worked in dense triangular loops, bordered with a decorative pattern. These medallions are pieced together, the spaces being filled by six unbordered crosses and approximately sixty tiny simple medallions. The inner edge is bordered with an open pattern and then a row of tiny triangles with a fancy edging.

The cultivation, preparation and dyeing of silk were traditional Armenian occupations in Ottoman Turkey. Armenian women of all classes made needlelace and used it to trim headscarves, garments and lingerie. Alice Odian Kasparian documents how American missionaries organized a cottage industry to support Armenian orphans and widows of the 1895–6 Hamidian massacres. Lace-trimmed handkerchiefs, lace collars and cuffs were also exported to the US and to Europe.

The shape and material of this collar reflect European fashions of the late nineteenth century; it would have been made to accompany women's fashionable daywear from around 1890. Wide lace collars of this type were also fashionable for children in this period, comprising part of the 'Little Lord Fauntleroy' suit for boys, popularized by Frances Hodgson Burnett's novel of 1885 and reflected in the dress of the children in cat. 84(a).

Kasparian, A. O., *Armenian Needlelace and Embroidery*, EPM Publications Inc., McLean, VA, 1983.

NNQ

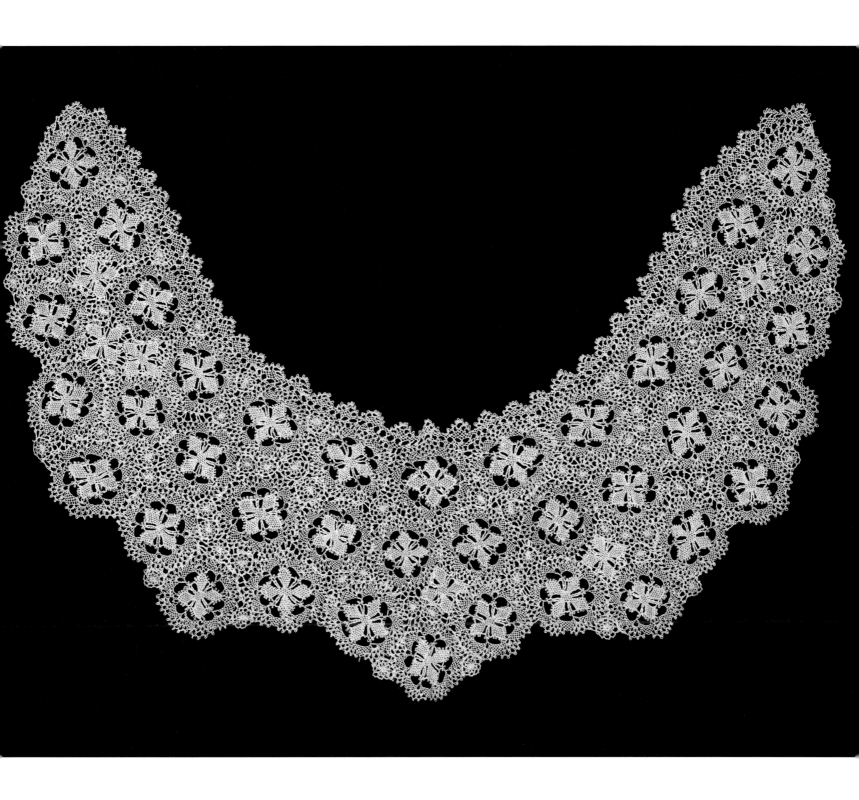

Portrait of St Grigor Narekacʻi and the beginning of the *Book of Lamentation*
Grigor Narekacʻi, *Book of Prayers* (Գիրք աղօթից)

21.5 x 17 cm, paper
Yovhannēs and Pōłos
Constantinople 1782
Private collection (DT) pp. 2–3

The title page of this volume of Grigor Narekacʻi's works is missing, but it can be identified by its colophon as the seventh printing, dated 1782. Further pages are missing (e.g. 3–24), others are detached from the spine and inserted as single leaves between pages attached to the spine. The leather binding, which seems to be original, is detached and much reduced in size. Apart from the *Narek* (the *Book of Lamentation*), the volume contains Grigor Narekacʻi's other works, his *Vita*, and a eulogistic prayer of the revered monk.

The book has sustained damage from transportation or usage. It is kept stored away, wrapped in four layers of variously coloured cloth and linen. A small triangular white pouch is attached to a white cord, wrapped around the *Narek* as well, never to be separated from it. A variety of devotional items – a cross, prayer images – are kept in the book, along with two pouches containing earth from the owners' Armenian home in the Ottoman Empire before they were driven out during the genocide of 1915. The family owning this *Narek* reveres it as a *tan surb* (տան սուրբ), a 'saint of the house', an object through which divine protection is channelled, underlining the special place the *Narek* continues to have in Armenian culture. Its author offered it as a 'bloodless sacrifice in words to the King of Heaven'. Clerical users said of it: 'Greater are the gifts of grace of this book than those of other holy books in the church.' But its appeal stretched to people from all walks of life. It was an elixir for the body, while it continues to function as a treasury of spiritual education for each new generation.

The left page shows St Grigor reading; on a lectern a Bible (Աստուածաշունչ) is seen. Three scenes from St Grigor's life are depicted: his raising of the roasted pigeons when his orthodoxy was in doubt, the teaching of his pupils, and the healing of a man possessed by a demon.

Drost Abgarjan, A., 'Veneration and Reception of Surb Grigor Narekacʻi in Armenian Culture and Spirituality', in J.-P. Mahé and B. L. Zekiyan (eds), *Saint Grégoire de Narek théologien et mystique*, Pontificio istituto Orientale, Rome, 2006, pp. 57–81.

Oskanyan, N., Kʻnarik Korkotyan and Antʻaram Savalyan, *Hay girkʻə 1512–1800 tʻvakannerin. Hay hnatip grkʻeri matenagitutʻyun* [The Armenian Book in the years 1512–1800. Bibliography of Armenian Old Printed Books], Aleksandr Myasnikyan National Library, Erevan, 1988, no. 722, pp. 536–7.

Xačʻatryan, P. M., and A. A. Łazinyan, *Grigor Narekacʻi. Matean ołbergutʻean* [Grigor Narekacʻi. The Book of Lamentation], HSSH GA hratarakčʻutʻyun, Erevan, 1985, nos 6, 8, pp. 201–06.

TMvL

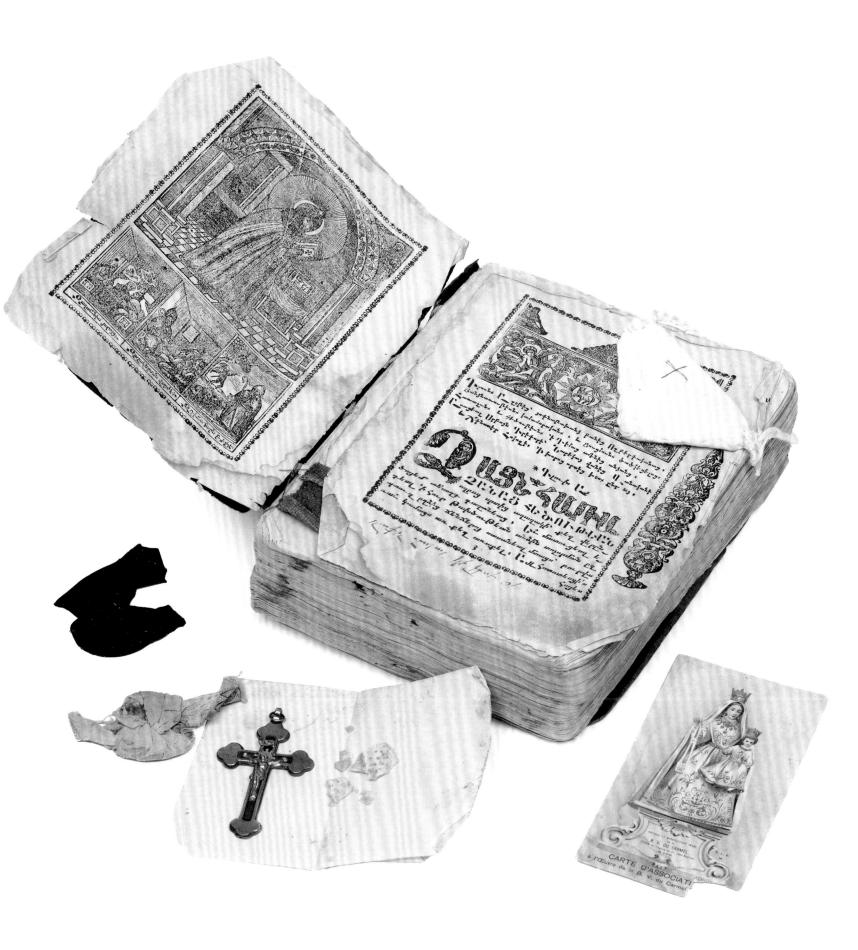

87

The opening of discourse twenty-four in the *Narek*
Grigor Narekac'i's Book of Lamentation (Մատեան ողբերգութեան)

17.2 x 12.7 cm, paper
Petros, aided by Sargis, Grigor
Monastery of T'ełenik' 13th century
MS. Arm. f. 5 fols 58v–59r

This manuscript of the *Narek*, bound in tooled brown leather, with a cross in the centre at both front and back, was copied in clear bolorgir by Petros, aided by Sargis, Grigor and others, after Petros had hurt his hand; this is commemorated in a marginal commentary on fol. 58v. It is incomplete, containing only discourses two to eighty-seven out of ninety-five. The main colophon is also absent; at the end of some of the discourses a short colophon is placed, numbering forty-two in total. One of these mentions that the manuscript was copied from a good exemplar in the possession of a certain Pōłos.

Petros copied this manuscript in the Monastery of T'ełenik' (Թեղ[է] նեաց Վանք) in Bjni, in the Republic of Armenia. Built before the tenth century, activity is attested between the thirteenth and the eighteenth centuries.

Grigor Narekac'i's *Book of Lamentation* is one of the most venerated works of Armenian culture. Written on the request of his fellow monks by a holy man who spent most of his life in the monastery of Narek just south of Lake Van, it is a book of penitential prayer written in an astonishingly rich and beautiful Armenian, matching its emotional and spiritual depths. It has been an inspiration, comfort and talisman for over a millennium. The oldest copy preserved was ordered in 1173 by Nersēs Lambronac'i, the ecumenical theologian and archbishop of Tarsus (M1568). It has been copied ever since, and very widely printed (cat. 86).

Baronian, S., and F. C. Conybeare, *Catalogue of the Armenian Manuscripts in the Bodleian Library*, Clarendon Press, Oxford, 1918, col. 173, no. 77.

Cuneo, P., *Architettura Armena*, De Luca Editore, Rome, 1988, pp. 172–4, no. 56.

Samuelian, T. J., *St Grigor Narekats'i. Speaking with God from the Depths of the Heart. The Armenian Prayer Book of St Gregory of Narek*, Bilingual Classical Armenian – English Edition, Vem Press, Yerevan, 2001.

Thierry, J.-M., *Répertoire des monastères arméniens*, Brepols, Turnhout, 1993, p. 110, no. 612.

TMvL

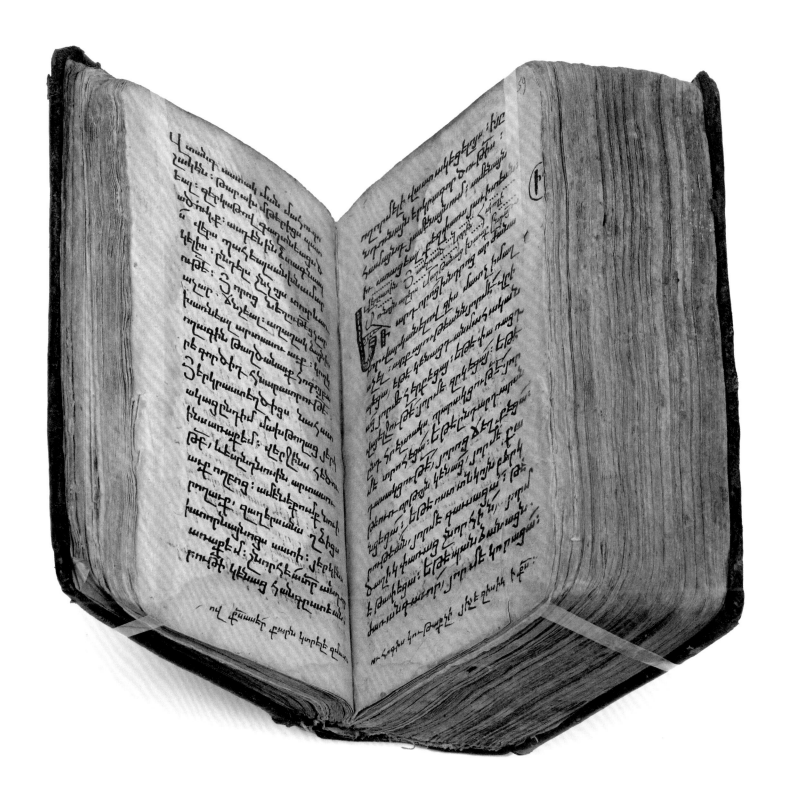

The Song of Freedom
Xač'atur Abovean, The Wounds of Armenia (Վէրք Հայաստանի)

24 x 16 cm, paper
Nersisean School (publication made possible by Agha Gevorg Arcruni)
Tiflis 1858
Private collection (TMvL) pp. 72–3

Xač'atur Abovean's *The Wounds of Armenia* was written in the early 1840s, but published only in 1858, several years after its author had disappeared. Long heralded as the beginning of modern literature in Eastern Armenian, that view is now rightly challenged.

The language is not the standard modern Eastern Armenian, but the nineteenth-century dialect of K'anaker, containing many words and expressions from Persian, Turkish and Kurdish – precious little of which Abovean translates into what was to become the standard Eastern Armenian half a century after he wrote the novel. Initially writing in Classical Armenian, Abovean soon realized that this could not be the medium for the elevation of the Armenian people.

The novel's form reminds strongly of the epic tales told by *ašuls* (աշուղ), poet-storytellers who interspersed their stories with lyrical poems, as seen in Abovean's novel. At the same time, entertainment could be usefully yoked to educational purposes: Abovean recognized that a nation is carried by its faith, Armenian Christianity, and its language, Armenian, a scattering of vivid dialects lacking a standard for written and oral communication.

Enlightenment ideas about education were mingled with romantic insights into the value of the vernacular. This was in fact a practical insight gained by Abovean during his early years in the progressive, German-speaking University of Dorpat, now Tartu, in Estonia, which then formed part of the Russian Empire.

The Wounds of Armenia remains the landmark novel of protest against the political oppression and lack of education of the Armenians. Wisely presented as a historical novel describing the dying days of Persian rule, it can be understood as well as an indictment of Russian rule, heralded as liberating in 1828, when Russian troops entered Erevan, but soon recognized by Abovean as a continued form of colonial oppression. It does remain a highly engaging expression of liberation, both of individual conscience and from political oppression.

Baladouni, V. (ed.), *Khachatur Abovian. The Preface to Wounds of Armenia: Lamentation of a Patriot: A Historical Novel*, Grakanut'yan ev arvesti t'angaran, Erevan, 2005.

TMvL

Critical views on the diaspora
Šahan Šahnur, *Retreat without Song* (Նահանջը առանց երգի)

17.4 cm, paper
Paris 1929
Private Collection (TMvL) pp. 168–9

Born in Constantinople (Istanbul) in 1903, Šahan Šahnur emigrated to Paris in 1923, following the continuing mistreatment of the Armenian population in Turkey. Trained as a photographer, Šahnur worked in this profession for many years, but was also a prolific author, composing prose and poetry in Armenian and French.

His first novel, *Retreat without Song* (Նահանջը առանց երգի), published in 1929 and previously serialized in the Armenian newspaper *Yaŕaǰ* (Յառաջ, 'Forward'), was seminal in alerting the Armenian diaspora community to the threats of assimilation and the loss of cultural and national identity. The story follows the photographer Bedros, a young immigrant from Constantinople, and details his amorous affairs, especially with Jeanne, whose moods and feelings towards Bedros are fluctuating. Leaving debauched Paris with Jeanne and her son to finally settle into a calmer, rural life, Bedros' inner calm is rocked by the fate of some of his compatriots, the loss of a child with Jeanne, and her ensuing suicide.

Šahnur illuminates, based on his own experience, the difficulties of an 'Oriental'-facing Western culture, letting Bedros decry all French women as 'prostitutes' in view of his lover's unfaithfulness and promiscuity. More than a critique of Western morality, *Retreat without Song* is a warning beacon against overly zealous acculturation in all its guises: loss of faith or respect of one's parents, indecency, and, foremost, loss of their mother tongue. In a rousing speech, one of Šahnur's characters exclaims: 'We pay, as a final ransome, that which is to come: as final ransome, children who could have grown up, generations who could have come after us. Because those that will come in the future will be non-Armenians, in word and in deed, willingly and unwillingly, knowingly and unknowingly: forgive them, Ararat, forgive them!'

Brenner, J., *Mon histoire de la littérature française contemporaine*, B. Grasset, Paris, 1988.

Shahnour, S., *Retreat without Song*, transl. and ed. by Mischa Kudian, Mashtots Press, London, 1982.

RM

Ս․յապէս է որ ուրիշներ կը խափշրին, խա-
ւարութեան մը դէպաց։

«Հայերը գիրք մը ունին։ Սէոնց աննե-
գէծ, գզուելի, անՆասնական, վատառոշ, և ասել
նեռ ասելի անբարոյական Գիրքն է ան — Նա-
բեկը։ Կ՚ասբառանեմ պայն իրրև, անենամեծ
Թշնամին հայութեան,կ՚ասբառանեմ այն Թէ։
ուտակւանը որ ամառ սողէրը Թեան և ասել Թէ
որբա՞ն փառացեռ աներովենքեր մը ունեցաւ այդ
Թունաստրէ հատորը։ Հայերը պան ընդունեցին
իրրացայգին,ընդդրկիգիՆ։Ասէկ սեբռունելգին
չար պայն ջնջել, դրոսեսանե անոր լեզուական
և բանաստեգծական իից իից յատկուԹիւններն
փառուելով ծամկւած բողն Հնշմակէց։ Թող-
Նակոռ ասն վափաւ կանող օբէն օբգն, ասբինե
աբրին, ու ան ևսա սիրելսէ մեծ Թունաստրունե
ցար պայն ջնջել, դրոսեսանե անոր լեզուական
ինրց պաստունոսներ եսռ։ Պաբառումենե ինք
դրոսեսանե այն վափաւական տաշմանրին հո-
գիին պէս արշարմաբռելգինք և անգիառանք հո-
չուԹինը մեջ լսնե, մեջ ուԹէն, կամ րբին, ասԿ-
տակւանուԹենան։ — Հկունպաննե, ջլսադբիսե, չնե-
անոր սբառ ու Թեռ մեկմաբին վափպասռուն Թեան
լեռանե ամՆսոռբն Կբառաբական, ճամսակեբպան
ապեբուաբիսե, անգիառանքիտ։ Սնն մեջ անՆե
ցայսացանք գեպի, ճաունցանք Նպատակ․ խոբղդ
մեծ թակալ մը մեծ բակրբ իբ ճաւբերուն մեջ
չՀոդրեսէ։ Կ՚ասբառանեմ այն Թշուառարանը
որ...»

ՊուոնկագրուԹեան վռսյ խոսսւած ատեն,որ մը
Սուբջն ապասն Կաբպայաւունգ ՓիեռՆէ։

Nigoghos Sarafian's introspection

Nigoghos Sarafian, The Bois de Vincennes (Վենսէնի անտառը)

24 cm, paper
Imp. de la Manutention
Paris 1988
Private Collection (TMvL) pp. 38–9

As a result of the repressions against the Armenian population of the Ottoman Empire, many families sought refuge abroad, thus establishing the large Armenian diaspora communities in Europe, the USA and Russia.

Born and educated first in Romania and Bulgaria, and later in Constantinople (Istanbul), Nigoghos Sarafian, then aged eighteen, would emigrate to Paris and become an influential literary critic, poet and community activist. While working as a typesetter for a French newspaper, Sarafian and other writers of Armenian heritage founded the literary review *Menk'* (Մենք, 'We') as a means of communicating their collective and individual reactions to life in exile, writing in their Western Armenian mother tongue.

First published in 1947, *The Bois de Vincennes* (Վենսէնի անտառը) captures in twenty-five reflective and thoroughly crafted meditations of poetic prose Sarafian's struggle with his own identity, the history of the

Armenian people and the Other: life in a foreign culture and language. The setting of his deliberation, the Bois de Vincennes, a park at the outskirts of Paris, serves him both as an allegory for his discussions, and lends his abstract thought a physical, graspable form.

The question which seems to have troubled Sarafian most urgently was that of identity: 'Our language, on the verge of dying out. Our values, denied by strangers, by the diaspora, and even by our own homeland … Part of our people – the diaspora – stands on the verge of being assimilated, while another part is condemned to assimilation in its own country. … [Abroad] you assimilate, ashamed, all the while being aware of the foolishness of a reality that only hides your inner emptiness.'

Apart from dealing with history, his essays and poems also deal with other topics more typical for the genre: love, frustration, war and the cleansing effect of nature.

Sarafian, N., *The Bois de Vincennes*, transl. by Christopher Atamian, with an introduction by Marc Nichanian, Armenian Research Center, University of Michigan-Dearborn, Dearborn, MI, 2011.

RM

ՆԻԿՈՂՈՍ ՍԱՐԱՖԵԱՆ

ՎԵՆՍԵՆԻ ԱՆՏԱՌԸ

ՓԱՐԻԶ 1988

91
Krikor Beledian, *Wandering* (Ընջում)

21 x 14 cm, paper
Sargis Xač'enc', P'rint'info (made possible through financial support from the Calouste Gulbenkian Foundation, Lisbon)
Erevan 2012
Private collection (TMvL) front cover

The poet, scholar and critic Krikor Beledian was born in Lebanon in 1945. He has lived in Paris since the 1970s. *Wandering* (Ընջում), the relation of nocturnal wanderings through the labyrinth of Paris streets, is a stream-of-consciousness composition pronounced by an Armenian in the Parisian diaspora, probably in the 1960–70s. Time and place shift easily, with the memories and musings of the main character, who conducts a monologue throughout the novel, albeit quoting whole conversations with or monologues of others, such as his mother. It is a masterpiece of holding together past and present through memory and its interpretation, while paying meticulous attention to the main character's immediate surroundings through sense-perception, the celebration of language in many a manifestation of long lists of objects, impressions, adjectives, in evocations of different people's speech, including Armenian dialects with their peculiarities and their loan words from Arabic, for example. The coherence of the person is his fragmented state that the reader witnesses and becomes part of.

The text has a musicality, a rhythm, a power of association and various leitmotifs, such as the fifth-century author Koriwn's report of the first verse from the Bible translated into Armenian, 'Knowing wisdom and …' (Proverbs 1.2), which seems to guide the character. However, the quotation is never complete, just crosses the protagonist's mind on various occasions, and is sometimes paralleled or juxtaposed, opposed, perhaps by the famous refrain from Vahan Terian's poem: 'Turn, merry-go-round, turn' – and here also the second part of the line, 'I've heard your voice for ages', is absent.

The archaeology of feelings, and of naming in Armenian undoubtedly plays a role. The opening words of the Armenian Bible translation open up the story of Armenia's Christianity, the beginning also of Armenian as a written language, and of its written literature. The book opens with a quotation from St Augustine's *Soliloquies*, evoking uncertainty about identity and about place: 'Was it I, or was it someone else, was it inside, or outside? I don't know. That is the reason why I try to bring this to light … I will do what you say'.

Six of the seven parts of *Gišeradarj* (Գիշերադարձ), a neologism that might mean 'Turn of the Night', have been published, and all will eventually be published, together with Beledian's other work, by the Erevan-based publishing house Sargis Xač'enc'. The co-operation represents a striking example of the reception and production of a writer of the diaspora in the independent Republic of Armenia.

TMvL

ԳՐԻԳՈՐ ՊԸԼՏԵԱՆ

ՇՐՋՈՒՄ

ՍԱՐԳԻՍ ԽԱՉԵՆՑ • ՓՐԻՆԹԻՆՖՈ

Ełiše Č'arenc''s 'Requiem Aeternam'
Ełiše Č'arenc''s Collected Works

20.5 x 13.5 cm, paper
Sovetakan groł
Erevan 1987
Private collection (TMvL) pp. 268–9

In 'Requiem Aeternam. To the Memory of Komitas', Ełiše Č'arenc' brings together personal tragedy, the Armenian genocide as a national disaster, and the continued plight of his people under the socialist experiment gone mad during Stalin's purges. It was written on the occasion of the reburial in 1936 in Soviet Armenia of the composer, choir director, musicologist and gatherer of folk songs Komitas, who had died the previous year in Paris, after a mental illness had clouded his genius for twenty years due to his experience of the Armenian genocide in the Ottoman Empire in 1915, making him both a survivor and a victim of the atrocities visited upon his people.

Č'arenc' had voluntarily enlisted in the Armenian military forces in Tsarist Russia in World War I and had likewise witnessed the devastation and desolation caused by the murderous implementation of the order to eliminate the Armenians, as reflected in his *Dantesque Legend* (Դանթեական առասպել), published in 1918. A fervent proponent of the socialist revolution of 1917, he fought with the Red Army in the Civil War, helped build a socialist Armenia and became one of the foremost authors and organizers of the new culture.

Enjoying the protection of Ałasi Xanǰyan, Armenia's highest party official, he drew criticism, became personally isolated and culturally and politically ostracized when Xanǰyan was eliminated by Beria, Stalin's chief executioner, in 1936. He was arrested in 1937 and died in prison.

Despite rejecting the nationalist path of his nation for its political future, Č'arenc' revoked his rejection of the poets and thinkers of the past, and increasingly turned to their work, the style and tone of which he had in various periods of his life emulated in a brilliant poetic œuvre, and the religious side of which he now also embraced in his poetic work, encompassing both Buddha and Jesus.

The last years of Č'arenc''s life give a piercing insight into the role of poetry in his view of life – a brutally honest scrutiny of reality within and outside himself, a quest for truth and meaning, their presence and expression in a relentlessly manipulated and manufactured society – acknowledging a reality not subject to human agency and which the poet was unable, and unwilling to betray. To this last period belongs 'Requiem Aeternam', an emblem of revivifying mourning through art.

Nichanian, M. (ed.), *Yeghishe Charents Poet of the Revolution*, Mazda Publishers, Costa Mesa, 2000.

TMvL

Նայեց նա մի պահ հրաշքի նման
Իր աչքերի դեմ բսնկված այդ վեհ,
Այդ շնդալով անցնող պատկերին—
Եվ ընկճվելով նրա ամեհի
Մեծության ներքո, այդ անգրկելի,
Անհուն վեհության—սուզվեց նա կրկին
Իր սովորական մամտանքի մեջ...

Եվ նովելը մեր վերջացավ այստես—
1929

REQUIEM AETERNAM
ԿՈՄԻՏԱՍԻ ՀԻՇԱՏԱԿԻՆ

Ա

Հայրենի երգն ես դու մեր՝
Վերածարձած հայրենիք։—
Դեմքիդ տանջանքն է դրել
Անագորույն մի կնիք։—
Եվ հանճարի հեռակա
Հուրն է հանգչում ճակատիդ,
Ինչպես մարող ճառագայթ
Արարատի գագաթին։—

Բ

Հայրենի ե՛րգն ես դու մեր
Հալածական, ինչպես ամպ,
Որ քամիներն են քշել
Եվ տարբներն ապստամբ։—
Ժողովրդի հանճարեղ
Սրտով երկնած ձայն ու շունչ,
Որ բարբառել ես դարեր
Օտարության մշուշում։

Գ

Առանձին ձայնն է ինչպես
Դառնում հնչյուն հայրենի—
Դաշնության մեջ լոկ հնչեղ
Հայրենական ձայների,—
Այդպես մեր հին դաշնության
Ով մարգարե տաղագիր,
Դու գտանում ես ահա
Ե՛վ ժողովուրդ, և՛ երկիր։

93

The first Armenian translation of James Joyce's *Ulysses*
James Joyce, Ulysses, translated by Samvel Mkrtč'yan

25 x 18.5 cm, paper
Samvel Mkrtč'yan
Erevan 2012
Private collection (TMvL) pp. 218–19

This first ever Armenian translation of James Joyce's *Ulysses* (original publication 1922) is an all-round tour de force. Samvel Mkrtč'yan (1959–2014), a seasoned literary translator from English, made a splendid effort to achieve a text sounding as rich and varied in Armenian as it does in English. The back jacket text states: 'translated, regurgitated, transmogrificated, epitomized, reworded, reiterated, relanguaged, transsemificated, etceterized into armenian by samvel mkrtchyan'. The translator also designed the book. The layout of the page, with its marginal explanatory notes and annotated images, offers the Armenian reader an immediate entry into the multifarious associations and erudition of the book's author, thus integrating almost a century of interpretation into the Armenian version. The physical appearance of the book is impressive: produced as a print on demand work by the translator himself, its cover could be commissioned from Armenian artists and thus gave each copy the individual character associated with a medieval manuscript.

The work reminds of the care and determination lavished on translations into Armenian from the earliest renderings onward. The enrichment of Armenian language and culture through this translation, understanding and incorporation of works from a variety of cultures has been a continuous undertaking throughout the centuries. Mkrtč'yan remarks that the translation of *Ulysses* 'offers a wonderful occasion to fully use the Armenian language, which despite its detractors offers the possibility even from the most enigmatic source to render in a praiseworthy manner seemingly unimaginable linguistic artifices'. The inner back flap of the dust jacket contains a (tongue-in-cheek?) challenge to Armenian culture, in a playful elaboration on Louis XIV's self-assured pronouncement: 'The state is me. In Armenian history this period will be remembered solely by the publication of Ulysses'.

The schedule Joyce gave to his friend Stuart Gilbert, containing titles for the book's eighteen episodes and three divisions, is added to the text. The opened pages form part of the chapter styled 'Scylla and Charibdis', with the rock Scylla standing for Aristotle, Dogma, Stratford; the whirlpool Charibdis for Plato, Mysticism, London; Ulysses: Socrates, Jesus, Shakespeare.

TMvL

218

219

«Գլոուբ» թատրոնը

¹⁸ Ի՞նչ եք ուզում (ֆր.):

^ե որդի, հայր (ֆր.):

94
A champion of reconciliation: Hrant Dink
Hrant Dink, Être Arménien en Turquie (Being Armenian in Turkey)

21 cm, paper
Fradet
Reims 2007
DR434 DIN 2007 front cover

In the recent past, the Turkish-Armenian journalist and editor Hrant Dink became one of the most widely known proponents of both a peaceful reconciliation of Armenians and Turks, and the recognition of the Armenian genocide.

Born to Armenian parents in 1954, Dink and his brother were sent to an orphanage when their parents separated. After taking a degree in zoology at Istanbul University and completing his military service, Dink was co-founder and editor-in-chief of the only bilingual Turkish-Armenian weekly newspaper, *Agos*, for which he was active from 1996 onward.

Dink's writing, a collection of which is presented in this volume, *Être Arménien en Turquie*, spans a variety of topics, but is chiefly concerned with civil and minority rights in Turkey, and the Armenian question; his position on the latter is noteworthy as, throughout his career, he remained critical of both parties: of the Turkish for 'not making

the least concession on the subject' (p. 20), and of the Armenians for defining themselves by their conflict with the Turks. In spite of his criticism of Turkish policy, Dink considered Turkey his fatherland, and advocated a peaceful multi-culturalism.

A line from his 2004 article 'Getting to know Armenia' resulted in a trial and a six-month suspended jail sentence for denigrating Turkishness under the infamous §301 of the Turkish penal code; his statement that Turkish Armenians need to replace their own (!) 'poisoned blood associated with the Turk, with fresh blood associated with Armenia' was, said Dink in later articles, willfully misunderstood and used against him. Other prominent writers who have been prosecuted under this article, but later acquitted, include Orhan Pamuk and Elif Şafak.

Hrant Dink was assassinated on 19 January 2007 outside the offices of *Agos* by a seventeen-year-old Turkish nationalist.

Dink, H., *Être Arménien en Turquie*, transl. from Turkish, with a preface by Etyen Mahcupyan, Fradet, Reims, 2007.

RM

HRANT DINK
Être Arménien en Turquie

L'Orient/Actualité

Fradet

95
A family secret
Fethiye Çetin, *Anneannem (My Grandmother – An Armenian-Turkish Memoir)*

20 cm, paper
Metis Yayınları
Istanbul 2004
CT1908.G33 CET 2012 [Arm.] front cover

The extent, reality and long-lasting nature of crimes committed against the Armenian people during the genocide is clearest in the representations made by survivors and their families. Fethiye Çetin, a Turkish lawyer and human rights activist, in her book *Anneannem*, relates the life story of her Armenian-born grandmother, Heranuş, who during one of the death marches of 1915 was forcefully separated from her mother and subsequently adopted by a Turkish family. The story of her conversion to Islam, the repression of her heritage and difficult childhood as a convert is counterbalanced by her later happy family life, punctuated by unfruitful attempts at reuniting with her surviving relatives who had emigrated to the USA.

While her grandmother's familial background was known to the community at large, Çetin describes the first time she spoke about the events that led to her separation as follows:

'What this woman had lived through defied belief and after burying these memories for so many years, it taxed her brain to put them into words.' That such adoptions were not uncommon is evident both from Çetin's story as well as from documents of the time, recorded amongst others in an account to Sir Mark Sykes by a Turkish lieutenant in charge of one of the death marches: 'I did leave on the way [to Erzincan] about 200 children with Muslim families, who were willing to take care of them and educate them.' The same statement expressly underlines that innumerable men, women and children were murdered on the way.

Çetin, who represented the family of Hrant Dink after his assassination, meant for her book 'to reconcile us with our history and reconcile us with ourselves', reaffirming her grandmother's wish that 'these days may vanish, never to return'.

Akçam, T., *The Young Turks' Crime Against Humanity. The Armenian Genocide and Ethnic Cleansing in the Ottoman Empire*, Princeton University Press, Princeton/Oxford, 2012.

Çetin, F., *My Grandmother, an Armenian-Turkish Memoir*, ed., transl. and with a preface by Maureen Freely, Verso, London/New York, 2009.

Walker, Ch. J., 'World War I and the Armenian Genocide', in Richard G. Hovannisian (ed.), *The Armenian People from Ancient to Modern Times*, Volume II, Macmillan, London, 1997.

RM

FETHİYE ÇETİN
ANNEANNEM

anlatı

metis

Postcards of Armenians and Turks celebrating the new constitution

Osman Köker, Armenians in Turkey 100 Years Ago: With the Postcards from the Collection of Orlando Carlo Calumeno

25 x 35 cm, paper
Birzamanlar Yayıncılık
Istanbul 2005
DR435.A7 K58 KOE 2013 [Arm.] pp. 72-3

The Armenians occupied an important role in the running of the Ottoman Empire, frequently holding high positions as state officials in the diplomatic service, and serving as experts on trade and technology. The two postcards on the right page are striking witnesses of the concept the Young Turks originally declared central to their policies: both exemplars show celebrations of the newly proclaimed constitution. The upper card, at whose centre stands the proponent of the constitution, Sultan Abdülhamid, shows writing in (from left to right) Armenian, Greek, Ottoman Turkish, French and Ladino, all reading: 'Long live the constitution, freedom, fraternity, equality'. Similar slogans are found in Turkish and Armenian in the lower image, in which Turks and Armenians can be seen rallying together.

Many more postcards from the collection of Orlando Carlo Calumeno are assembled in this volume of Osman Köker, who therein tells the story of the various districts and cities of the Ottoman Empire in which Armenian influence was significant. These popular postcards show various attractions from all over the Empire in the late nineteenth and early twentieth century. Of particular relevance are those images which document the state of various Armenian quarters before and after pogroms: the Armenian quarter of Adana, for example, was a centre of commerce in which Armenians made up more than a quarter of the population; it was burnt to the ground in April 1909, resulting in more than 20,000 casualties.

Davidian, V.-Kh., *Treasured Objects: Armenian Life in the Ottoman Empire 100 Years ago*, Armenian Institute, London, 2012.

Kévorkian, R. H., 'The Cilician Massacres, April 1909', in Richard G. Hovannisian and Simon Payaslian (eds), *Armenian Cilicia, UCLA Armenian History and Culture Series: Historic Armenian Cities and Provinces*, vol. 7, Mazda Publishers, Costa Mesa, CA, 2008.

Köker, O., and O. C. Calumeno, *Armenians in Turkey 100 years ago: with the postcards from the collection of Orlando Carlo Calumeno*, Birzamanlar Yayıncılık, Istanbul, 2005.

RM

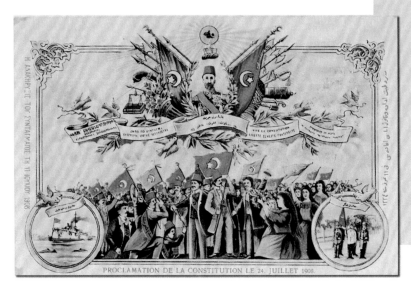

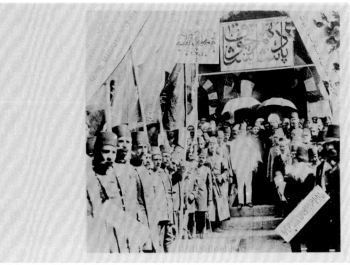

Map detailing centres of the Armenian genocide, routes of death marches and escape routes
R. H. Hewsen, Armenia: a Historical Atlas

29 x 44 cm, paper
University of Chicago Press
Chicago 2001
691.1 Hew Ref. pp. 232–3

The pogroms and massacres against the Armenians of the Ottoman Empire in the late nineteenth and early twentieth centuries were only the prelude to what Henry Morgenthau Jr, then ambassador of the United States to the Ottoman Empire, described as 'a campaign of race extermination', which commenced in full in 1915. During World War I, under the pretext of disloyalty to the Empire, more than one million Armenians were shot outright or deported, perishing from starvation, disease or exhaustion in the course of death marches into the Syrian and Mesopotamian desert. While recognized by more than twenty countries and the European Parliament, the United Kingdom has not officially acknowledged the events of 1915 as genocide, nor has the Republic of Turkey.

The map shown here details the course of events, routes of deportation and the local incidence of massacres; it further indicates those localities in which the Armenian population resisted the Ottoman forces, consisting of regular army, local gendarmerie and paramilitary troops of mercenaries and willing locals. The inhabitants of the Van region were most successful at holding position, and were later reinforced by the Russian Caucasian Army and Armenian volunteer battalions. The Armenians of the region later abandoned it and sought refuge in Russian territory. Acts of Armenian resistance have also entered history through literature: the novel *The Forty Days of Musa Dagh*, written by the Austrian-Bohemian novelist Franz Werfel, details the resistance of a number of villages in the Hatay Province of southern Turkey, and their final, if short-lived rescue at the hand of the French cruiser *Guichen*.

Some Armenians, returning from Russian exile in 1918, sought violent retribution against the Turkish populace for the atrocities committed, thus engendering further repressions in the years to come. The genocide found its end only in 1921, when approximately one-third of the Armenian population had perished, together with similarly prosecuted Assyrians and Greeks.

Akçam, T., *The Young Turks' Crime Against Humanity. The Armenian Genocide and Ethnic Cleansing in the Ottoman Empire*, Princeton University Press, Princeton/Oxford, 2012.

Horton, G., *The Blight of Asia: an account of the systematic extermination of Christian populations by Mohammedans and the culpability of certain great powers; with the true story of the burning of Smyrna*, Taderon, Reading, 2003.

Hovanissian, R. G., *The Armenian Genocide: History, Politics, Ethics*, Macmillan, London, 1991.

Werfel, F. V., *The Forty Days of Musa Dagh*, ed. and transl. Geoffrey Dunlop and James Reidel, with a preface by Vartan Gregorian, David R. Godine, Boston, 2012.

RM

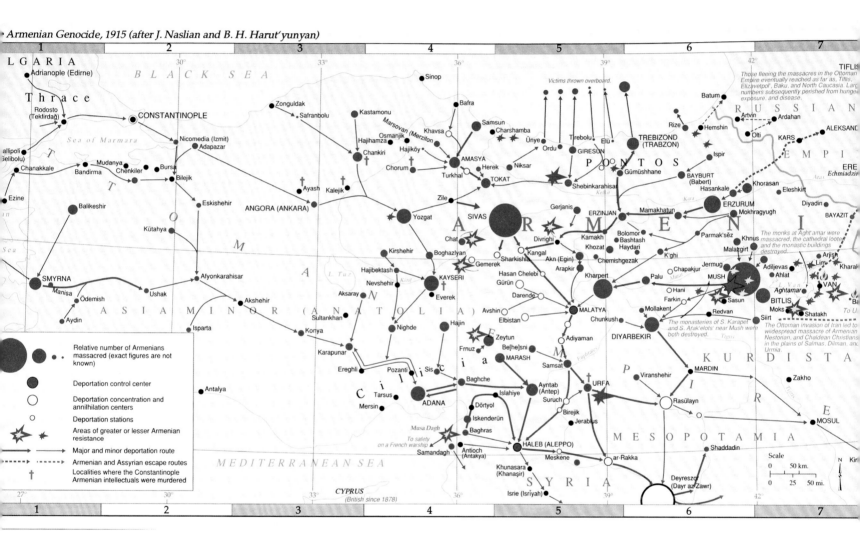

Armenian Genocide, 1915 (after J. Naslian and B. H. Harut'yunyan)

LGARIA
Adrianople (Edirne)

Thrace

Rodosto (Tekfirdağ)
CONSTANTINOPLE

BLACK SEA

Sinop
Zonguldak
Safranbolu
Kastamonu
Bafra
Samsun
Charshamba
Khavsa
Marsovan (Merzifon)
Osmanjik
Hajihamza
Chankiri
Hajiköy
AMASYA
Herek
Niksar
Chorum
Turkhal
TOKAT

Those fleeing the massacres in the Ottoman Empire eventually reached as far as, Tiflis, Elizavetpol', Baku, and North Caucasia. Large numbers subsequently perished from hunger, exposure, and disease.

Victims thrown overboard.

TIFLIS
Batum
RUSSIAN
Rize
Artvin
Ardahan
Hemshin
Olti
ALEKSAND
KARS
EMPI
ERE
Echmiadzir

Sea of Marmara

Nicomedia (Izmit)
Adapazar

allipoli
Gelibolu)
Chanakkale
Mudanya
Chenkiler
Bursa
Bandirma
Bilejik
Ezine

Balikeshir

Eskishehir

Ünye
Tirebolu
Elü
TREBIZOND (TRABZON)
Ordu
GIRESUN
PONTOS
Gümüshhane
BAYBURT (Babert)
Hasankale
Ispir
Khorasan
Eleshkirt
ERZURUM
Mokhragyugh
Diyadin
BAYAZIT

Kütahya

Zile
Yozgat
SIVAS
Gerjanis
ERZINJAN
Mamakhatun
A R M E N I
Parmak'sëz
Khnus
Malazgirt
The monks at Aght'amar were massacred, the cathedral looted, and the monastic buildings destroyed.

Sea

SMYRNA
Manisa
Ödemish
Ushak
Aydin

Afyonkarahisar

Kirshehir
Chat
Divrighi
Kamakh
Khozat
Bolomor
Bashtash
Haydari
K'ghi
Chapakjur
Jermug
Adiljevas
Ahlat

ASIA MINOR (ANATOLIA)

Boghazlyan
Hajibektash
Nevshehir
Aksaray
KAYSERI
Everek

L. Tuz

Sharkishla
Kangal
Sharkishla
Gemerek
Akn (Egin)
Arapkir
Hasan Chelebi
Gürün
Darende
Avshin
Elbistan

Chemishgezak
Kharpert
Palu
K'ghi
Hani
MUSH
Aghtamar
BITLIS
Moks
Shatakh
Lim
Arjish
Khara
VAN
Sasun
Redvan
Siirt

Akshehir
Sultankhan
Nighde
Hajin
MALATYA
Chunkush
Mollakent
The monasteries of S. Karapet and S. Arak'elots' near Mush were both destroyed.

Konya
Karapunar
Ereghli
Pozanti
Sis
Zeytun
Be[he]sni
Adiyaman
DIYARBEKIR
Viranshehir
MARDIN
Zakho
KURDISTA
The Ottoman invasion of Iran led to widespread massacre of Armenian Nestorian, and Chaldean Christians in the plains of Salmas. Dilman. and Urmia.

Isparta
Antalya
Frnuz
MARASH
Samsat
To safety
C i l i c i a
Tarsus
Baghche
Islahiye
Ayntab (Antep)
Suruch
URFA
Rasülayn
MOSUL
Mersin
ADANA
Dörtyol
Iskenderün
Birejik
Jerablus
I R
E
Musa Dagh
Baghras
Antioch (Antakya)
HALEB (ALEPPO)
Meskene
ar-Rakka
MESOPOTAMIA
Shaddadin
On a French warship
Samandagh
Khunasara (Khanaşir)
SYRIA
Isrie (Isrîyah)
Deyreszo (Dayr az Zawr)
Scale
0 50 km.
N
Kir

MEDITERRANEAN SEA

CYPRUS
(British since 1878)

0 25 50 mi.

Relative number of Armenians massacred (exact figures are not known)

Deportation control center

Deportation concentration and annihilation centers

Deportation stations

Areas of greater or lesser Armenian resistance

Major and minor deportation route

Armenian and Assyrian escape routes

† Localities where the Constantinople Armenian intellectuals were murdered

Timeline

c. 3000 BCE	Indo-European migration from north of Black, Caspian Seas.
c. 1200 BCE	Possible time of Proto-Armenians to have entered Anatolia.
9th–6th cs BCE	Kingdom of Urartu on Armenian plateau.
c. 590–550 BCE	Rule of Medes over Armenia.
c. 547 BCE	Armenia a satrapy of the Achamaenid Empire.
c. 520 BCE	Bisotun inscription: earliest mention of Armenia.
3rd c. BCE	Orontid/Ervandid Armenian dynasty.
c. 250–224 BCE	Parthian Arsacid dynasty rules over Iran.
c. 190 BCE–early CE	Artašēsid/Artaxiad Armenian dynasty.
99–59 BCE	Empire of Tigran the Great.
12–428	Parthian Aršakuni/Arsacid dynasty rule as kings of Armenia.
66	Trdat crowned king of Armenia by Nero in Rome.
late 1st c.	Alleged evangelization by apostles Thaddeus and Bartholomew.
224	Sasanians overthrow Parthian rule in Iran.
(towards) 314	Adoption by King Trdat of Christianity as state religion upon the evangelization by Grigor the Illuminator.
387	Partition of Armenia: larger eastern part to Iran, smaller western part to Byzantium.
390	Abolition of the Western Armenian kingdom.
405	Mesrop Maštoc' invents the Armenian alphabet.
428	Sasanian King of Kings grants Armenian *naxarars* abolition of the Aršakuni/Arsacid monarchy.
428–654	Marzpanate: Governors are often Armenians.
591	Partition of Armenia: larger part to Byzantine Empire, smaller part to Sasanian Empire.
654–884	Arab domination.
8th–9th cs	Paulician heresy flourishes.
718–29	Katholikosate of Yovhannēs Ojnec'i (John of Odzun).
775	Revolt against Arab rule crushed in the Battle at Bagrevand.
9th–11th cs	T'ondrakian heresy flourishes.
884–1064	Bagratid and Arcruni Armenian kingdoms.
884	Caliph and Emperor recognize Ašot Bagratuni as king.
908	Caliph recognizes Gagik Arcruni as king.
c. 950–1003	Grigor Narekac'i.
961	Ani capital of the Armenian Bagratid kingdom.
c. 985–1059	Grigor Pahlawuni Magistros.
1019–59	Katholikosate of Petros Getadarj.
1018	First Seljuk invasions.
1020	Senek'erim Arcruni cedes kingdom to Byzantium.
1045	Gagik II Bagratuni cedes kingdom to Byzantium.
1065	Seljuks take Ani. Migrations to Crimea and eastern Europe.
1065–1203	Katholikosate of members of the Pahlawuni family.
1073–1375	Armenian presence, from 1198 kingdom, in Cilicia.
1102–73	Nersēs Šnorhali, Katholikos 1166–73.
1292	Katholikosate at Hṙomkla conquered, moved to Sis.
1307/1316	Widely opposed unions with Church of Rome.
1375	Fall of Armenian kingdom of Cilicia to the Mameluks.
1387–1403	Three invasions by Timur Lane.
1410–1502	Kara Koyunlu rule (until 1468), then Ak Koyunlu.
1441	Katholikosate moves from Sis to Ējmiacin at Vałaršapat near Erevan. At Sis a Katholikosate remains.
1461	Armenian Patriarchate established in Constantinople.

1502/1517	Persian (until 1828) and Ottoman (until 1922) domination.
1511–13	First Armenian books printed by a Yakob at DIZA in Venice
1547/1562/1585	Katholikoi convene councils to plead for European help.
1604	Safavid Shah Abbas I deports Armenians from the Ararat valley and Julfa. The latter build New Julfa at Isfahan.
17th–18th cs	Armenian merchants from New Julfa prosper in multi-nodal network reaching Indian, Atlantic and Pacific Oceans.
1666–8	Oskan Erevancʻi prints first Armenian Bible in Amsterdam.
1677/1679–1711	Katholikos convenes council; Israyel Ōri pleads with Pope, European leaders, Russia for liberation of Armenia.
1676–1749	Mxitʻar Sebastacʻi, spiritual and educational leader.
1700	Mxitʻar founds Catholic Mekhitarist Brotherhood, established from 1717 at San Lazzaro, Venice.
1828	Treaty of Turkmenchai: Russia conquers eastern Armenia.
1831	Catholic Armenian millet founded in Ottoman Empire.
1836	*Položenie* regulates relations between Armenian Church and Tsarist Russia.
early 1840s	Xačʻatur Abovean, *Wounds of Armenia* published in 1858.
1850	Protestant Armenian millet founded in Ottoman Empire.
1860/1863	Constitution for Armenian millet in Ottoman Empire.
1876–1909	Rule of Sultan Abdülhamid II thwarts reforms.
1878	Treaty of San Stefano followed by Treaty of Berlin.
1894–6	*c.* 200,000 Armenians killed in Ottoman Empire.
1908	Young Turk revolution in Ottoman Empire.
1909	*c.* 30,000 Armenians killed in massacre in Adana.
1915–17	Armenian genocide: over one million fall victim.
1915	Katholikosate of Sis moves to Aleppo, then Antelias.
24 May 1918	Battle of Sardarapat: victory vouchsafes survival.
28 May 1918	Proclamation of the Armenian Republic.
1918–20	First Armenian Republic.
	Global diaspora of refugees and survivors of the genocide.
31 May 1920	USA senate refuses mandate over Armenia.
10 August 1920	Treaty of Sèvres.
1920	First Armenian Republic divided between Turkey and Bolshevik Russia.
1920/1922–91	Second Armenian Republic: one of the republics of the USSR. Moscow hands Naxijevan and Karabagh to Azerbaijan.
1923	Treaty of Lausanne.
1936–8	Stalinist terror and purges.
1946–9	Policy of 'return' to Soviet Armenia.
1949–52	Stalinist campaign against nationalist deviation.
1965	Demonstrations at fiftieth anniversary of the genocide.
1975	Civil war in Lebanon adds to global Armenian diaspora.
1979	Islamic revolution in Iran adds to global Armenian diaspora.
February 1988	Demonstrations in Stepanakert and Yerevan for independence of Nagorny Karabagh from Azerbaijan.
7 December 1988	Earthquake in northern Armenia claims *c.*35,000 lives.
1990–94	Karabagh War. Situation remains unresolved.
23 September 1991	Proclamation of Independence: the Third Republic born.
16 October 1991	Lewon Ter Petrosyan President of the Republic of Armenia.
22 September 1996	Ter Petrosyan re-elected.
1996	Katholikos and Pope agree text on Christology.
1998	Ter Petrosyan abdicates over 'leniency' in Karabagh policy.
1998	Robert Kʻočʻaryan elected president.
1999	EU-Armenia Partnership and Cooperation Agreement.
2001	1700th anniversary of the adoption of Christianity.
2001	Armenia admitted to Council of Europe.
2003	Kʻočʻaryan re-elected.
2004	Armenia enters into European Policy of Neighbouring States, including the Eastern Partnership.
2005	1600th anniversary of the invention of the alphabet.
2005	Constitutional reform.
2008	Serž Sargsyan elected president.
2012	500th anniversary of the first printed Armenian book.
2013	Sargsyan re-elected.
2015	Armenia accedes to Custom Union consisting of Russia, Belarus and Kazakhstan.

MAP 1
Armenia in the 2nd
and 1st century BCE

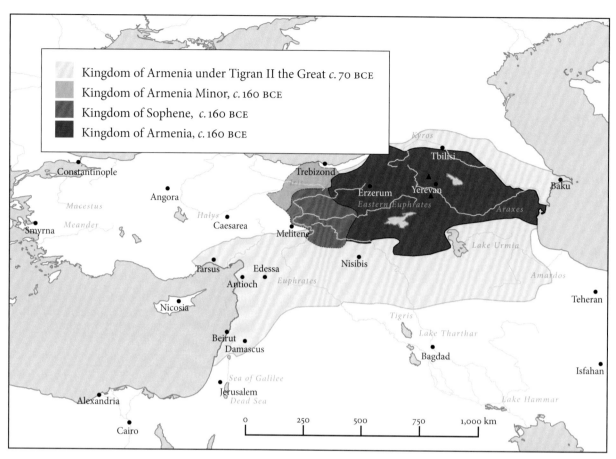

MAP 3
Armenia and
surrounding
countries in the 21st
century

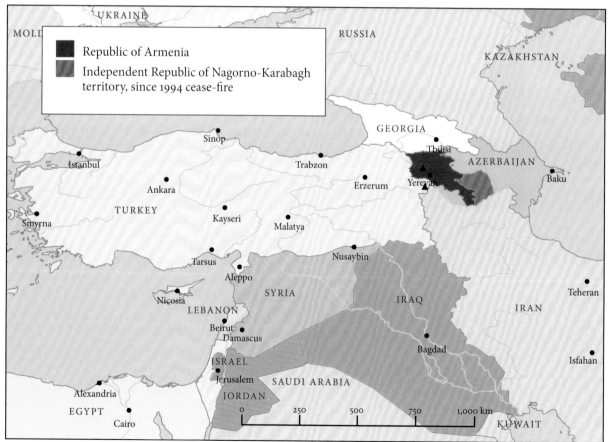

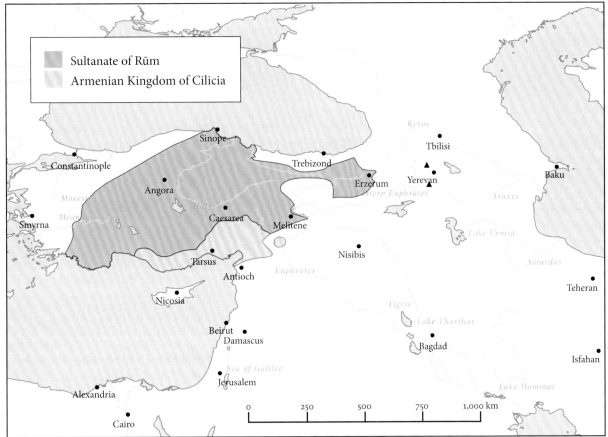

MAP 2

Cilician Armenia in

c. 1220 CE

Sultanate of Rūm

Armenian Kingdom of Cilicia

Constantinople

Sinope

Trebizond

Kyros

Tbilisi

Angora

Erzerum

Yerevan

Baku

Macester

Halys

Eastern Euphrates

Araxes

Smyrna

Meander

Caesarea

Melitene

Lake Urmia

Tarsus

Euphrates

Nisibis

Amardos

Antioch

Teheran

Nicosia

Tigris

Beirut

Lake Tharthar

Damascus

Bagdad

Isfahan

Sea of Galilee

Jerusalem

Alexandria

Lake Hammar

Cairo

0 250 500 750 1,000 km

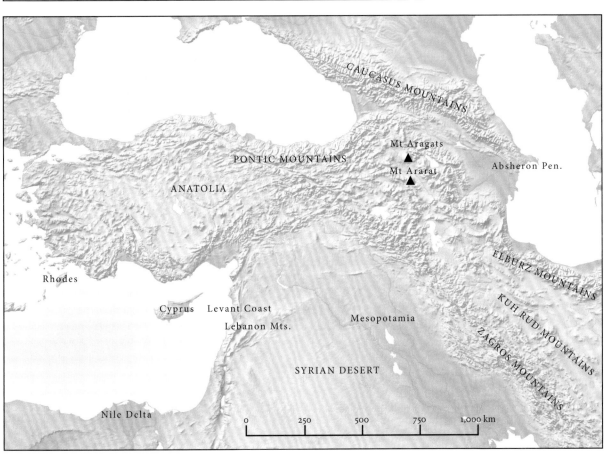

MAP 4

A topographical map
of Asia Minor and
the Caucasus

CAUCASUS MOUNTAINS

PONTIC MOUNTAINS

Mt Aragats

Mt Ararat

Absheron Pen.

ANATOLIA

ELBURZ MOUNTAINS

Rhodes

KUH RUD MOUNTAINS

Cyprus Levant Coast

Lebanon Mts.

Mesopotamia

ZAGROS MOUNTAINS

SYRIAN DESERT

Nile Delta

0 250 500 750 1,000 km

Bibliography

Abrahamian, L. and N. Sweezey (eds), *Armenian Folk Arts, Culture and Identity*, Indiana University Press, Bloomington, IN, 2001.

Adontś, N., *Denys de Thrace et les commentateurs arméniens*, transl. from Russian, Imprimerie Orientaliste, Louvain, 1970.

Akçam, T., *The Young Turks' Crime Against Humanity. The Armenian Genocide and Ethnic Cleansing in the Ottoman Empire*, Princeton University Press, Princeton/Oxford, 2012.

Akçam, T., *A Shameful Act: The Armenian Genocide and the Question of Turkish Responsibility*, Constable, London, 2007.

Arakelyan, M., *Mesrop of Xizan: An Armenian Master of the Seventeenth Century*, Sam Fogg, London, 2012.

Aslanian, S. D., *From the Indian Ocean to the Mediterranean: The Global Trade Networks of Armenian Merchants from New Julfa*, University of California Press, Berkeley, 2011.

Auroux, S., *La révolution technologique de la grammatisation. Introduction à l'histoire des sciences du langage*, Mardaga, Liège, 1994.

Avedichian, P. G., *Sulle Correzioni Fatte ai Libri Ecclesiastici Armeni nell'anno 1677*, Tipografia armena di San Lazzaro, Venice, 1868.

Avedichian, P. G. Dott., *Pataragamatoyc' Hayoc'. Liturgia Armena. Liturgia della messa armena trasportata in Italiano*, Tipografia armena di San Lazzaro, Venice, 1854.

Axworthy, M., *The Sword of Persia. Nader Shah. From Tribal Warrior to Conquering Tyrant*, I.B.Tauris, London and New York, 2006.

Ayvazyan, H., *Hay Sp'yuṙk' Hanragitaran* [Armenian Diaspora. Encyclopædia], Armenian Encyclopædia Publishing House, Erevan 2003.

Azadian, E. Y., S. L. Merian and L. Ardash, *A Legacy of Armenian Treasures: Testimony to a People*, The Alex and Marie Manoogian Foundation, Taylor, MI, 2013.

Baghdiantz McCabe, I., *The Shah's Silk for Europe's Silver: The Eurasian Silk Trade of the Julfan Armenians in Safavid Iran and India (1590–1750)*, Scholar's Press, Atlanta, GA, 1999.

Baker, J., S. Harlacher, S. K. Batalden, and Zs. Gulácsi, *Sacred Word and Image: Five World Religions*, Art Museum, Phoenix, AZ, 2012.

Baladouni, V. (ed.), *Khachatur Abovian. The Preface to Wounds of Armenia: Lamentation of a Patriot: A Historical Novel*, Grakanut'yan ev arvesti t'angaran, Erevan, 2005.

Barber, P., and T. Harper, *Magnificent Maps: Power, Propaganda and Art*, British Library, London, 2010.

Bardakjian, K.k, *A Reference Guide to Modern Armenian Literature, 1500–1920. With an Introductory History*, Wayne State University Press, Detroit, 2000.

Baronian, S., and F. C. Conybeare, *Catalogue of the Armenian Manuscripts in the Bodleian Library*, Clarendon Press, Oxford, 1918.

Bedoukian, P. Z., *Coinage of Cilician Armenia*, rev. ed., Paul Z. Bedoukian, Danbury, CT, 1979.

Bedoukian, P. Z., *Coinage of the Artaxiads of Armenia*, Royal Numismatic Society, Special Publication No. 10, London, 1978.

Bedoukian, P. Z., 'A Classification of the Coins of the Artaxiad Dynasty of Armenia', *Armenian Numismatic Society Museum Notes*, vol. 14, 1968, pp. 41–68.

Bedoukian, P. Z., 'Coins of the Baronial Period of Cilician Armenia (1080–1198)', *Armenian Numismatic Society Museum Notes*, vol. 12, 1966, pp. 139–45.

Bedoukian, P. Z., 'The Bilingual Coins of Hetoum I, (1226–1270), King of Cilician Armenia', *Armenian Numismatic Society Museum Notes*, vol. 7, 1957, pp. 219–30.

Beledian, K., *Les Arméniens*, Brepols, Turnhout, 1994.

Bloom, J. M., *Paper Before Print: The History and Impact of Paper in the Islamic World*, Yale University Press, New Haven and London, 2001.

Bodleian Library Record, volume XI, 1984.

Bournoutian, G. A., *Aṙak'el of Tabriz. Book of History* (Aṙak'el Dawrizhets'i, Girk' patmut'eants'), Mazda Publishers, Costa Mesa, 2010.

Bournoutian, G. A., *The Chronicle of Abraham of Crete* (Patmut'iwn of Kat'oghikos Abraham Kretac'i), Mazda Publishers, Costa Mesa, 1999.

Bournoutian, G. A., *Abraham of Erevan. History of the Wars (1721–1738)* (Abraham Erewants'i, Patmutiwn paterazmats'n), Mazda Publishers, Costa Mesa, 1999.

Brenner, J., *Mon histoire de la littérature française contemporaine*, B. Grasset, Paris, 1988.

Broutian, G., 'Persian and Arabic Calendars as Presented by Anania Shirakatsi', in *Tarikh-e Elm*, vol. 8, 2009, pp. 1–17.

Buschhausen, H., H. Buschhausen and E. Korchmasjan, *Armenische Buchmalerei und Baukunst der Krim*, Tafeln, Editions Nairi, Erevan, 2009.

Buschhausen, H. and H. Buschhausen, 'Die Herkunft der Armenier im ehemaligen Gebiet der Habsburgermonarchie', *Steine Sprechen*, vol. XLII/2–3, no. 127, August 2003, pp. 2–22.

Cardon, D., *Natural Dyes: Sources, Tradition, Technology, and Science*, Archetype, London, 2007.

Catalogue No. 534. *Caucasica*. Published on the occasion of the First Conference of the Association Internationale des Études Arméniennes (AIEA), Leiden, The Netherlands, August 29–31, 1983, E. J.Brill Ltd Leiden, Antiquarian Booksellers, Leiden, 1983.

'Catalogue of St. Paul's Institute', (1904) in Digital Library for International Research Archive, Item #11217, www.dlir.org/archive/items/show/11217.

'Catalogue of St. Paul's Collegiate Institute', (1906–07) in Digital Library for International Research Archive, Item #11223, www.dlir.org/archive/items/show/11223.

Čemčemean, S., 'Surb Łazari tparani cnundə 1789–1989' [The origins of St Lazarus's printing office 1789–1989], in *Bazmavêp*, vol. 147, 1989, pp. 7–36; vol. 148, 1990, pp. 259–73.

Çetin, F., *My Grandmother, an Armenian-Turkish Memoir*, ed., transl. and with a preface by Maureen Freely, Verso, London/New York, 2009.

Christie, T. D., 'Report of St. Paul's Collegiate Institute', (1906) in Digital Library for International Research Archive, Item #11237, www.dlir.org/archive/items/show/11237.

Clackson, J. P., 'The "Technē" in Armenian', in Vivien Law and Ineke Sluiter (eds), *Dionysius Thrax and the Technē grammatikē*, Nodus, Münster, 1995.

Clercq, J. de, P. Swiggers and L. van Tongerloo, 'The Linguistic Contribution of the Congregation De Propaganda Fide', in M. Tavoni et al. (eds), *Italia ed Europa nella linguistica del Rinascimento: confronti e relazioni*. Atti del Convegno internazionale Ferrara, Palazzo Paradiso 20–24 marzo 1991. Vol. II: *L'Italia e l'Europa non romanza. Le lingue orientali*, Panini, Modena, 1996, pp. 439–58.

Coulie, B., 'Collections and Catalogues of Armenian Manuscripts', in V. Calzolari (ed.) with the collaboration of M. E. Stone, *Armenian Philology in the Modern Era. From Manuscript to Digital Text*, Brill, Leiden–Boston, 2014, pp. 23–64.

Coulie, B., 'Répertoire des bibliothèques et des catalogues de manuscrits arméniens Supplément III', Le Muséon, vol. 117, 2004, pp. 473–96.

Coulie, B., 'Répertoire des bibliothèques et des catalogues de manuscrits arméniens Supplément II', Le Muséon, vol. 113, 2000, pp. 149–76.

Coulie, B., 'Répertoire des bibliothèques et des catalogues de manuscrits arméniens Supplément I', Le Muséon, vol. 108, 1995, pp. 115–30.

Coulie, B., 'Répertoire des bibliothèques et des catalogues de manuscrits arméniens', Brepols, Turnhout, 1992.

Covakan, N. (Norayr Połarean), *Hay nkarołner (ŽA–ŽĒ dar)* [Armenian Painters (11th–17th centuries)], Tparan Srboc' Yakobeanc', Jerusalem, 1989.

Cowe, S. P., 'Redefining Armenian Literary Identity in Istanbul', in R. G. Hovannisian and S. Payaslian (eds), *Armenian Constantinople*, Mazda Publishers, Costa Mesa, 2010, pp. 431–44.

Cowe, S. P., 'The politics of poetics: Islamic Influence on Armenian Verse', in J. van Ginkel, H. Murre-van den Berg and Th. M. van Lint, *Redefining Christian Identity: Cultural Interaction in the Middle East since the Rise of Islam*, Peeters, Leuven, 2005, pp. 379–403.

Cowe, S. P., 'Medieval Armenian Literary and Cultural Trends (Twelfth–Seventeenth Centuries)', in Hovannisian, *The Armenian People*, I, pp. 293–325.

Cowe, S. P., 'Models for the Interpretation of Medieval Armenian Poetry', in J. J. S. Weitenberg, *New Approaches to Medieval Armenian Language and Literature*, Rodopi, Amsterdam, 1995, pp. 29–45.

Cox, C. E., *The Armenian Bible*, Krikor and Clara Zohrab Information Centre, New York, 1996.

Cross, F. L., and E. A. Livingstone (eds), *The Oxford Dictionary of the Christian Church*, 3rd edition revised, Oxford University Press, Oxford, 2005.

Cuneo, P, *Architettura Armena*, De Luca Editore, Roma, 1988.

Dadoyan, S. B., *The Armenians in the Medieval Islamic World. Paradigms of Interaction. Seventh to Fourteenth Centuries*, 3 Volumes, Transaction Publishers, New Brunswick and London, 2011–14.

Dadoyan, S. B., *The Fatimid Armenians. Cultural and Political Interaction in the Near East*, Brill, Leiden – New York – Köln, 1997.

Dankoff, R., '"The Story of Faris and Vena": Eremya Çelebi's Turkish Version of an Old French Romance', *Journal of Turkish Studies*, vol. 26, no. 1, 2002, pp. 107–61.

Davidian, V.-Kh., S. P. Pattie, G. Stepan-Sarkissian (eds). *Treasured Objects: Armenian Life in the Ottoman Empire 100 Years Ago*, Armenian Institute, London, 2012.

Dédéyan, G. (ed.), *Histoire du peuple arménien*, Privat, Toulouse, 2007.

Dédéyan, G. and I. Augé, 'Le rayonnement de l'État arménien de Cilicie', 'Le dilemma de l'Église: ouverture ou défense de la tradition nationale', in Dédéyan (ed.), *Histoire du peuple arménien*, pp. 336–56.

de Lamberterie, C., 'Grec, phrygien, arménien: des anciens aux modernes', *Journal des Savants*, 2013, pp. 3–69.

de Lamberterie, C., 'L'arménien', in Françoise Bader (ed.), *Langues indo-européennes*, CNRS éditions, Paris, 1994, pp. 137–63.

Der Nersessian, S., *Miniature Painting in the Armenian Kingdom of Cilicia from the Twelfth to the Fourteenth Century*, 2 vols, Dumbarton Oaks Research Library and Collection, Washington, DC, 1993.

Der Nersessian, S., and A. Mekhitarian, *Armenian miniatures from Isfahan*, Les Editeurs d'Art Associés, Armenian Catholicosate of Cilicia, Brussels, 1986.

Der Nersessian, S., *Armenian Art*, Arts et Métiers Graphiques, Paris, 1977 and 1978.

Dink, H., *Être Arménien en Turquie*, transl. from Turkish, with a preface by Etyen Mahcupyan, Fradet, Reims, 2007.

Dournovo, L., *Armenian Miniatures*, Harry N. Abrams, New York, 1961.

Drampian, I., Akop Dzugaetsl, Publishing Office of the Mother See of Holy Ējmiacin, Ējmiacin, 2009.

Drost Abgarjan, A., 'Veneration and Reception of Surb

Grigor Narekac'i in Armenian Culture and Spirituality', in Jean-Pierre Mahé and Boghos Levon Zekiyan (eds), *Saint Grégoire de Narek théologien et mystique*, Pontificio Istituto Orientale, Roma, 2006, pp. 57–81.

Dulaurier, É., *Recherches sur la chronologie arménienne: technique et historique*, Imprimerie Impériale, Paris, 1859.

Durand, J., I. Rapti, D. Giovannoni (eds), *Armenia Sacra*, Somogy, Paris, 2007.

Eftekharian-Laporte, S., 'Le rayonnement international des gravures flamandes aux XVIe et XVIIe siècles: les peintures murales des églises Sainte-Bethléem et Saint-Sauveur à la Nouvelle-Djoulfa (Ispahan)', PhD thesis, Université libre de Bruxelles, 2006.

Eganyan, Ō., A. Zeyt'unyan, P'. Ant'abyan, *Mayr c'uc'ak hayerēn jeṙagrac' Maštoc'i anuan Matenadarani* [Catalogue of Armenian Manuscripts in the Maštoc' Institute (Matenadaran)], HSSH GA hratarakč'ut'yun, Erevan, 1984.

Eggenstein-Harutunian, M., *Einführung in die Armenische Schrift*, Buske, Hamburg, 2000.

Ervine, R. R., *Worship traditions in Armenia and the neighboring Christian East: an international symposium in honor of the 40th anniversary of St. Nersess Armenian Seminary*, St. Vladimir's Seminary Press, Crestwood, NY, 2006.

Feingold, M., 'Oriental Studies', in T. H. Aston and N. Tyacke (eds), *The History of the University of Oxford*, vol. 4: *Seventeenth-century*, Clarendon Press, Oxford, 1977.

Feydit, F., *Amulettes de l'Arménie chrétienne*, Mekhitarist Congregation, Venise-St. Lazare, 1986.

Galadza, P., 'Books, Liturgical; 2. Eastern Churches; 2.1 *Armenian', in Paul F. Bradshaw, *The New SCM Dictionary of Liturgy and Worship*, SCM Press, London, 2002, pp. 67–8.

Garsoïan, N. G., *Interregnum. Introduction to a Study on the Formation of Armenian Identity (ca 600–750)*, Peeters, Louvain, 2012.

Garsoïan, N. G., 'L'Histoire attribuée à Movsēs Xorenac'i: que reste-t-il à en dire?', *Revue des Études Arméniennes*, vol. 29, 2004, pp. 29–48.

Garsoïan, N. G., 'The Emergence of Armenia' and 'The Aršakuni Dynasty', in Hovannisian, *The Armenian People*, I, pp. 37–94.

Garsoïan, N. G., 'The Marzpanate (428–652)', in Hovannisian, *The Armenian People*, I, pp. 95–115.

Garsoïan, N. G., 'The Arab Invasions and the Rise of the Bagratuni', in Hovannisian, *The Armenian People*, I, pp. 117–142.

Garsoïan, N. G., 'The Independent Kingdoms of Medieval Armenia', in Hovannisian, *The Armenian People*, I, pp. 143–85.

Garsoïan, N. G., "The Byzantine Annexation of the Armenian Kingdoms in the Eleventh Century', in Hovannisian, *The Armenian People*, I, pp. 187–98.

Garsoïan, N. G., *L'Eglise arménienne et le grand schisme d'Orient*, Peeters, Louvain, 1999.

Garsoïan, N. G., 'The Problem of Byzantine Integration into the Byzantine Empire', in Hélène Ahrweiler and Angeliki E. Laiou, *Studies on the Internal Diaspora of the Byzantine Empire*, Dumbarton Oaks Research Library and Collection, Washington, DC, 1998, pp. 53–124.

Garsoïan, N. G., The *Epic Histories Attributed to P'awstos Buzand* (Buzandaran Patmut'iwnk'), Harvard

University Press (dist.), Cambridge, MA, 1989.

Gēorgean, A., *Hay manrankarič'ner. matenagitut'iwn IX–XIX dd.* [Bibliography of Armenian Miniature Painters from the ninth to the nineteenth century], Cairo, 1998.

Greenwood, T., 'A Reassessment of the Life and Mathematical Problems of Anania Širakac'i', *Revue des Études Arméniennes*, vol. 33, 2011, pp. 131–86.

Greenwood, T. W., 'Armenian Neighbours (600–1045)', in J. Shepard (ed.), *The Cambridge History of the Byzantine Empire, c. 500–1492*, Cambridge University Press, Cambridge, 2008, pp. 333–64.

Greenwood, T. and E. Vardanyan, *Hakob's Gospels: The Life and Work of an Armenian Artist of the Sixteenth Century*, Sam Fogg, London, 2006.

Hacikyan, A. J., G. Basmajian, E. S. Franchuk and N. Ouzounian, *The Heritage of Armenian Literature*, Wayne State University Press, Detroit, 2000.

Hacopian, H., *Arc'axi manrankarč'akan arvestə* [The Art of Artsakh Miniatures], Nairi, Erevan, 2014.

Hakobyan, H., *The Medieval Art of Artsakh*, Parberakan, Erevan, 1991.

Hakobyan, G. A., *Šarakanneri žanrē hay mijnadaryan grakanut'yan mej (X–XV dd.)* [The genre of *šarakans* in Middle Armenian literature (10th–15th centuries)] , Haykakan SSH GA Hratarakč'ut'yun, Yerevan, 1980.

Hakobyan, H., *Miniatures of Artsak-Utik XIII–XIV cc.*, Xorhrdayin Grogh, Erevan, 1989.

Hakobyan, V. and A. Hovhannisyan, *Hayeren jeṙagreri ŽĒ dari Hišatakaranner (1601–1620 T'T')* [Colophons of seventeenth-century Armenian Manuscripts (1601–1620)], Erevan, 1974.

Hewsen, R. H., 'Armenia Maritima: The Historical Geography of Cilicia', in R. G. Hovannisian and Simon Payaslian (eds), *Armenian Cilicia*, Mazda Publishers, Costa Mesa, CA, 2008, pp. 27–65.

Hewsen, R. H., 'Matteos Mamourian: A Smyrnean Contributor to the Western Armenian Renaissance', in Hovannisian, *Armenian Smyrna*, Mazda Publishers, Costa Mesa, CA, 2012, pp. 167–75.

Hewsen, R. H., *Armenia. A Historical Atlas*, The University of Chicago Press, Chicago and London, 2001.

Hewsen, R. H., 'The Geography of Armenia', in Hovannisian, *The Armenian People*, I, pp. 1–17.

Hewsen, R. H., *Ašxarhac'oyc': The Seventh Century Geography*, Caravan Books, Delmar, NY, 1994.

Hewsen, R. H., *The Geography of Ananias of Širak (Ašxarhac'oyc'). The Long and Short Recensions*, Dr Ludwig Reichert Verlag, Wiesbaden, 1992.

Hewsen, R. H., 'Science in Seventh-Century Armenia: Ananias of Sirak', *Isis*, vol. 59, no. 1, 1968, pp. 32–45.

'The higher educational work of the American Board', in Digital Library for International Research Archive, Item #11227, www.dlir.org/archive/items/show/11227.

Hille, J. and S. L. Merian, 'The Armenian Endband: History and Technique', *The New Bookbinder*, vol. 31, 2011, pp. 45–60.

Holst, J.. H., *Armenische Studien*, Harrassowitz, Wiesbaden, 2009.

Horton, G., *The Blight of Asia: An Account of the Systematic Extermination of Christian Populations by Mohammedans and the Culpability of Certain Great Powers; with the True Story of the Burning of Smyrna*, Taderon, Reading, 2003.

Hornus, Pasteur J.-M. and Mgr N. Zakarian, P. S.

Sukiasyan, 'L'église dans l'Arménie contemporaine (1921–2007)', in Gérard Dédéyan (ed.), *Histoire du peuple arménien*, Privat, Toulouse, 2007, pp. 741–86.

Hovannisian, R. G. (ed.), *The Armenian People from Ancient to Modern Times*. Volume I: *The Dynastic Periods: From Antiquity to the Fourteenth Century*. Volume II: *Foreign Dominion to Statehood: The Fifteenth Century to the Twentieth Century*, Macmillan, London 1997.

Hovannisian, R. G., 'Armenia on the Road to Independence', in Hovannisian, *The Armenian People*, II, pp. 275–301.

Hovannisian, R. G., 'The Republic of Armenia', in Hovannisian, *The Armenian People*, II, pp. 303–346.

Hovannisian, R. G., *The Armenian Genocide: History, Politics, Ethics*, Macmillan, London, 1991.

Hunt, T., *Ten Cities that Made an Empire*, Allen Lane, London, 2014.

Išxanyan, R̄., *Hay grk'i patmut'yun. Hator 1. Hay tpagir girk'ə 16–17-rd darerum* [History of the Armenian book. Volume 1. Armenian printed books in the sixteenth and seventeenth centuries], reprint, Antares, Erevan, 2012.

J̌ahukyan, G., 'Hay baṙaranagrut'yun', in Franz Josef Hausmann (ed.), *Wörterbücher: ein internationales Handbuch zur Lexikographie*, vol. 3, Walter de Gruyter, Berlin, 1991.

Kampouri-Vamvoukou, M., 'Le Roman d'Alexandre et ses representations dans les manuscrits byzantins', in *Ap'ieroma sti mnimi toy Sotiri Kissa* (in Greek with French resume), University Studio Press, Athens, 2000.

Kasparian, A. O., *Armenian Needlelace and Embroidery*, EPM Publications., McLean, VA, 1983.

Kerovpyan, A., 'La notation neumatique arménienne', in Mutafian, *Arménie: la magie de l'écrit*, pp. 127–9.

Kévonian, K., 'Marchands arméniens au XVIIe siècle. A propos d'un livre arménien publié à Amsterdam en 1699', *Cahiers du Monde russe et soviétique*, vol. 16, no. 2, 1975, pp. 199–244.

Kévorkian, R., *The Armenian Genocide: A Complete History*, I.B.Tauris, London–New York, 2011.

Kévorkian, R. H., 'The Cilician Massacres, April 1909', in R. G. Hovannisian and S. Payaslian (eds), *Armenian Cilicia*, UCLA Armenian History and Culture Series: *Historic Armenian Cities and Provinces*, vol. 7, Mazda Publishers, Costa Mesa, CA, 2008.

Kévorkian, R. H., *Arménie entre Orient et Occident: trois mille ans de civilisation*, Bibliothèque nationale de France, Paris, 1996.

Kévorkian, R. H., *Catalogue des «Incunables» arméniens (1511–1695) ou chronique de l'imprimerie arménienne*, Patrick Cramer, Genève, 1986.

Khan, Y. R., and T. Ohanyan, 'Deceptive Covers: Armenian Bindings of 18th-Century Imprints from Constantinople', *The Book and Paper Group Annual*, The American Institute for Conservation of Historic and Artistic Works, Book and Paper Group, Washington, DC, vol. 32, 2013, pp. 109–117.

Kleisen, J., *De grenzen voorbij. Beyond Borders. Krikor Momdjian's ikonen van passie | icons of passion*, Momdjian Foundation, Woubrugge, 1996.

Koeman, C., 'A World-Map in Armenian Printed at Amsterdam in 1695', *Imago Mundi*, vol. 21, 1967, pp. 113–14.

Köker, O., and O. C. Calumeno, *Armenians in Turkey 100 Years Ago: with the Postcards from the Collection of Orlando Carlo Calumeno*, Birzamanlar Yayıncılık, Istanbul, 2005.

Korkhmazian, E. M., 'Deux manuscrits arméniens écrits et illustrés à Bologne', in Boghos Levon Zekiyan (ed.), *Atti del Quinto Simposio Internazionale di Arte Armena*, San Lazzaro, Venice, 1991, pp. 517–26.

Korkhmazian, E., I. Drampian and G. Hakopian [H. Hakobian], *Armenian Miniatures of the 13th and 14th Centuries*, Aurora Art Publishers, Leningrad, 1984.

Kouymjian, D., 'Some Iconographical Questions about the Christ Cycle in Armenian Manuscripts and Early Printed Books', *Analecta Ambrosiana*, Milan, 2015.

Kouymjian, D, 'Catalogue of the Liturgical Metalwork', in S. Dadoyan (ed.), *Treasures of the Catholicosate of Cilicia*, Cilician Catholicosate, Antelias, 2015, pp. 158–297.

Kouymjian, D., 'The Archaeology of the Armenian Manuscript: Codicology, Paleography, and Beyond', in Valentina Calzolari (ed.), *Armenian Philology in the Modern Era. From Manuscript to Digital Text*, Brill, Leiden–Boston, 2014, pp. 5–22.

Kouymjian, D., 'Illustrations of the Armenian Alexander Romance and Motifs from Christian Iconography', in U. Bläsing, J. Dum-Tragut, T. M. van Lint (eds), with assistance from Robin Meyer, *Armenian, Hittite, and Indo-European Studies. A Commemoration Volume for Jos J.S. Weitenberg*, Peeters, Leuven, 2015, pp. 149–82.

Kouymjian, D., 'Did Byzantine Iconography Influence the Large Cycle of the Life of Alexander the Great in Armenian Manuscripts?', in M. Janocha (ed.), *Bizancjum a renesansy: Dialog kultur, dziedzictwo antyku: tradycja i współczesność* (Byzantium and Renaissances: dialogue of cultures, heritage of antiquity: tradition and modernity), Instytut Badań Interdyscyplinarnych 'Artes Liberales' UW, Warsaw, 2012.

Kouymjian, D., 'The Art of Miniature Painting', in D. Kouymjian and C. Mutafian (eds), *Artsakh Karabagh. Jardin des arts et des traditions arméniens / Garden of Armenian Arts and Traditions*, Somogy, Paris, 2011.

Kouymjian, D., 'The Decoration of Medieval Armenian Manuscript Bindings', in G. Lanoë and G. Grand (eds), *La reliure médiévale: pour une description normalisée: actes du colloque international (Paris, 22–24 mai 2003) organisé par l'Institut de recherche et d'histoire des textes (CNRS)*, Brepols, Turnhout, 2008, pp. 209–218.

Kouymjian, D., 'Illustrations du Roman d'Alexandre', in Mutafian, *Arménie: la magie de l'écrit*, pp. 164–72.

Kouymjian, D., 'Armenia from the Fall of the Cilician Kingdom to the Forced Emigration under Shah Abbas (1604)', in Hovannisian, *The Armenian People*, II, pp. 1–50.

Kouymjian, D., 'L'Iconographie de l'Histoire d'Alexandre le Grand dans les manuscrits arméniens', in L. Harf-Lancner, C. Kappler and F.Suard (eds), *Alexandre le Grand dans les littératures occidentales et proche-orientales, Actes du Colloque de Paris, 27–29 novembre 1997*, Université Paris X, Nanterre, 1999.

Kouymjian, D., 'The New Julfa Style of Armenian Manuscript Bindings', *Journal of the Society of Armenian Studies*, vol. 8, 1995 (published 1997), pp. 13–36.

Kouymjian, D., 'Inscribed Armenian Manuscript Bindings: A Preliminary General Survey', in H. Lehmann and J. J. S. Weitenberg (eds), *Armenian Texts, Tasks, and Tools*, Aarhus University Press, Aarhus, 1993, pp. 101–109.

Krikorian, M. K., *Die Armenische Kriche*, Peter Land, Frankfurt/Main, 2002.

Kurdian, H., 'C'uc'ak hayerēn jeṙagrac' Manšēsdri Čan Ṙaylenc' matenadaranin' [Catalogue of Armenian Manuscripts in the John Rylands Library, Manchester], *Sion*, vol. 49, 1975.

Lalayan, E., *C'uc'ak hayerēn jeṙagrac' Vaspurakani* [Catalogue of Armenian Manuscripts in Vaspurakan], Tiflis, 1915.

Landau, A. and T. M. van Lint, 'Armenian Merchant Patronage of New Julfa's Sacred Spaces', in M. Gharipour (ed.), *Sacred Precincts. The Religious Architecture of Non-Muslims Across the Islamic World*, Brill, Leiden–Boston, 2014, pp. 308–33.

Landau, A. S., 'European Religious Iconography in Safavid Iran: Decoration and Patronage of Meydani Bet'ghehem (Bethlehem of the Maydan)', in W. Floor and E. Herzig (eds) *Iran and the World in the Safavid Age*, I.B.Tauris, London–New York, 2012, pp. 425–46.

Landau, A. S., 'Farangī-Sāzī at Isfahan: the Court Painter Muḥammad Zamān, the Armenians of New Julfa and Shāh Sulaymān (1666–1694)', DPhil thesis, University of Oxford, 2006.

Lane, J. A., *The Diaspora of Armenian Printing, 1512–2012*, Special Collections of the University of Amsterdam, Amsterdam, 2012.

Leroy, J., *Manuscrits syriaques à peintures conservés dans les bibliothèques d'Europe et d'Orient; contribution à l'étude de l'iconographie des Eglises de langue syriaque*, Geuthner, Paris, 1964.

Leyloyan-Yekmalyan, A., *L'art du livre au Vaspurakan XIVe–XVe siècles: étude des manuscrits de Yovannēs Xizanc'i*, Peeters, Paris, 2009.

Louth, A., 'Cyril of Alexandria', in F. Young, L. Ayres and A. Louth (eds), *The Cambridge History of Early Christian Literature*, Cambridge University Press, Cambridge, pp. 353–7.

Lymberopoulou, A., 'A Winged Saint John the Baptist Icon in the British Museum', *Apollo*, 158.501, November 2003, pp. 19–24.

Lynch, H. F. B., *Armenia, Travels and Studies*, vol. II: *The Turkish Provinces*, Longmans, London, 1901.

Łazaryan, V., *Xoranneri Meknut'yunner, Sargis Xač'enc'* [Commentaries of canon-tables], Erevan, 1995.

Łorłanyan, N. K., *Abraham Kretac'i. Patmut'yun* [Abraham Kretac'i. History], HSSH hratarakčut'yun, Erevan, 1973.

Macray, W. D., *Annals of the Bodleian Library*, second ed., Clarendon Press, Oxford, 1890.

Mahé, J.-P., 'Connaître la Sagesse: le programme des anciens traducteurs arméniens', in R. H. Kévorkian (ed.), *Arménie entre Orient et Occident. Trois mille ans de civilisation*, Bibliothèque nationale de France, Paris, 1996, pp. 40–61.

Mahé, J.-P., 'Quadrivium et cursus d'études au 7e siècle en Arménie et dans l'Empire Byzantin d'après le "K'nnikon" d'Anania Shirakac'i', *Travaux et Mémoires*, vol. 10, 1987, pp. 159–206.

Marutyan, H., 'Home as the World', in L. Abrahamian and N. Sweezy (eds), *Armenian Folk Arts, Culture and Identity*, Indiana University Press, Bloomington, IN, 2001.

Mathews, T. F. and R. S. Wieck (eds), *Treasures in Heaven: Armenian Illuminated Manuscripts*, The Pierpont Morgan Library, New York, 1994.

Mathews, T. F. and A. K. Sanjian, *Armenian Gospel Iconography. The Tradition of the Glajor Gospel*, Dumbarton Oaks Research Library, Washington, DC, 1991.

Mathews, T. F., 'The Classic Phase of Bagratid and

Artsruni Illumination: The Tenth and Eleventh Centuries', in Mathews and Wieck, *Treasures in Heaven*, pp. 57–8.

Mathews, T. F., 'The Iconography of the Canon Tables', in Mathews and Sanjian, *Armenian Gospel Iconography*.

Maurer, P., 'Kardinal Giovanni Bona. Cistercienser, geistlicher Schriftsteller und Pionier der Liturgiewissenschaft', *Analecta Cisterciensia*, vol. 59, 2009, pp. 3–166.

Mazaeva, T. and H. Tamrazyan (eds), *La Miniature Arménienne: Collection du Maténadaran*, Editions Naïri, Erevan, 2006.

Medieval Manuscripts, Catalogue 14, London, Sam Fogg, 1991, lot 45.

Merian, S. L., 'Illuminating the Apocalypse in Seventeenth-Century Armenian Manuscripts: The Transition from Printed Book to Manuscript', in K. B. Bardakjian and S. La Porta (eds), *The Armenian Apocalyptic Tradition: A Comparative Perspective*, Brill, Leiden, 2014, pp. 603–39.

Merian, S. L., 'Protection against the Evil Eye? Votive Offerings on Armenian Manuscript Bindings', in J. Miller (ed.), *Suave Mechanicals. Essays on the History of Bookbinding*. Volume 1, The Legacy Press, Ann Arbor, Michigan, 2013, pp. 43–93.

Merian, S. L., 'The Armenian Silversmiths of Kesaria/Kayseri in the Seventeenth and Eighteenth Centuries', in R. G. Hovannisian (ed.), *Armenian Kesaria/Kayseri and Cappadocia*, Mazda Publishers, Costa Mesa, CA, 2013, pp. 117–185.

Merian, S. L., 'The Characteristics of Armenian Medieval Bindings', in G. Fellows-Jensen and P. Springborg (eds), *Care and Conservation of Manuscripts*, vol. 10, Museum Tusculanum Press, University of Copenhagen, Copenhagen, 2008.

Merian, S. L., T. F. Mathews and M. V. Orna, 'The Making of an Armenian Manuscript', in Mathews and Wieck, *Treasures in Heaven*, pp. 124–34.

Merian, S. L., 'The Structure of Armenian Bookbinding and its Relation to Near Eastern Bookmaking Traditions', Ph.D. thesis, Columbia University, 1993.

Merian, S. L., 'Cilicia as the Locus of European Influence on Medieval Armenian Book Production', *Armenian Review*, vol. 45, no. 4/180, Winter 1992, pp. 61–72.

Mignon, L., 'Lost in Transliteration: A Few Remarks on the Armeno-Turkish Novel and Turkish Literary Historiography', in E. Balta and M. Sönmez (eds), *Between Religion and Language*, Eren, Istanbul, 2011, pp. 111–23.

Mirak, R., 'The Armenians in America', in R. G. Hovannisian (ed.), *The Armenian People*, II, Macmillan, Basingstoke, 1997.

Momdjian, K., *Orange Moon gedichten en schilderijen*, Momdjian Stichting, Alphen aan den Rijn, 2009.

Mosshammer, A. A., *The Easter Computus and the Origins of the Christian Era*, Oxford University Press, Oxford, 2008.

Moumdjian, G. K., 'Cilicia under French Administration', in R. G. Hovannisian and S. Payaslian (eds), *Armenian Cilicia*, Mazda Publishers, Costa Mesa, California, 2008, pp. 457–94.

Mutafian, C. (ed.), *Arménie: la magie de l'écrit*, Somogy, Paris, 2007.

Nercessian, Y. T., *Armenian Coins and their Value*, Armenian Numismatic Society, Los Angeles, 1995.

Nersessian, V. N., *A Catalogue of the Armenian Manuscripts in the British Library acquired since the year 1913 and of collections in other libraries in the United Kingdom*, The British Library, London, 2012.

Nersessian, V., *Treasures from the Ark, The British Museum*, London 2001.

Nersessian, V., *The Bible in the Armenian Tradition*, British Library, London, 2001.

Nersessian, V., *Catalogue of Early Armenian Books, 1512–1850*, British Library, London, 1980.

Nersoyan, T., *Pataragamatoyc' hay aṙak'elakan uḷap'aṙ ekeḷec'woy* [Divine Liturgy of the Armenian Apostolic Orthodox Church, with Variables, Complete Rubrics and Commentary], Saint Sarkis Church, London, 1984.

Nichanian, M., *Writers of Disaster. Armenian Literature in the Twentieth Century*. Volume 1, *The National Revolution*, Gomidas Institute, Princeton & London, 2002.

Nichanian, M. (ed.), *Yeghishe Charents Poet of the Revolution*, Mazda Publishers, Costa Mesa, 2000.

Nichanian, M., *Ages et usages de la langue Arménienne*, Editions Entente, Paris, 1996.

Odian, Y., *Accursed Years: My Exile and Return from Der Zor, 1914–1919*, Gomidas Institute, London, 2009.

Odian Kasparian, A., *Armenian Needlelace and Embroidery*, McLean, VA, 1983.

Orengo, A., 'L'Owrbat'agirk' («Il Libro del Venerdì») e gli inizi della stampa armena', *Egitto e Vicino Oriente*, vol. 34, 2011, pp. 225–36.

Orengo, A., 'Gli scambi culturali armeno-italiani (XV–XVIII sec.)', in C.Mutafian (ed.), *Roma–Armenia*, Edizioni De Luca, Rome, 1996.

Ôrmanean, M. A., *Cisagitut'iwn Hayastaneayc' Surb Ekeḷec'uoy* [Liturgiology of the Holy Armenian Church], Tparan Srboc' Yakobeanc', Jerusalem, 1977.

Oshagan, V., 'Modern Armenian literature and intellectual history from 1700 to 1915', in Hovannisian (ed.), *The Armenian People*, II, pp. 139–74.

Oskanyan, N., K. Korkotyan and A. Savalyan, *Hay girk'ə 1512–1800 t'vakannerin. Hay hnatip grk'eri matenagitut'yun* [The Armenian Book in the years 1512–1800. Bibliography of Armenian Old Printed Books], Aleksandr Myasnikyan National Library, Erevan, 1988.

Oskean, H. H., *Barjr Hayk'i vank'erə* [The Monasteries of Barjr Hayk'], Mekhitaristenverlag, Vienna, 1951.

Outtier, B., 'Les recueils arméniens manuscrits', in Mutafian, *Arménie: la magie de l'écrit*, pp. 94–103.

Panossian, R., *The Armenians. From Kings and Priests to Merchants and Commisars*, Hurst, London, 2006.

Papazian, K. S., and P. M. Manuelian, *Merchants from Ararat: A Brief Survey of Armenian Trade through the Ages*, Ararat Press, New York, 1979.

Pehlivanian, M., 'Mesrop's heirs: the early Armenian book printers', in E. Hanebutt-Benz, D. Glass, G. Roper et al. (eds) *Middle Eastern Languages and the Print Revolution*, WVA-Verlag Skulima, Westhofen, 2002, pp. 53–92.

Petrosyan, E. and A. Ter-Step'anyan, *S. Grk'i hayeren meknut'yunneri matenagitut'yun* [Bibliography of the Armenian Commentaries on Sacred Scripture], Armenian Biblical Society, Erevan, 2002.

Poḷarean, N. A., *Cisagitut'iwn* [Liturgiology], T'aguhi Tamšěn himnadir, New York, 1990.

Porter, C., 'Armenian Cochineal: A Study of the Methods of Collection and Uses – Tradition and the Future', paper presented at the Dyes in History and Archaeology conference, Montpellier, November 2004, unpublished.

Pseudo-Callisthenes, *The Romance of Alexander the Great*, ed. Albert M. Wolohojian, Columbia University Press, New York, 1969.

Redgate, A. E., *The Armenians*, Blackwell Publishing, Oxford, 1998.

Renoux, C., 'Traduction liturgiques et rite arménien', in M. Albert, R. Beylot, R.-G. Coquin, B. Outtier, C. Renoux and A. Guillaumont (eds), *Christianismes Orientaux. Introduction à l'étude des langues et littératures*, Les Éditions du Cerf, Paris, 1993, pp. 130–36.

Renoux, A. (Charles), Le *codex arméniene Jérusalem 121*, 2 vols, Brepols, Turnhout, 1969, 1971.

Robertson, G., QC, *An Inconvenient Genocide. Who Now Remembers the Armenians?*, Biteback Publishing, London, 2014.

Ross, D. J. A., 'A funny name for a horse, Bucephalus in Antiquity and the Middle Ages', *Bien dire et bien apprendre*, vol. 7, 1989, pp. 55–6.

Ross, D. J. A., Alexander *Historiatus, a Guide to Medieval Illustrated Alexander Literature*, Warburg Institute, London, 1963; 2nd ed., Athenäum, Frankfurt am Main, 1988.

Russell, J. R. (translation), 'Two Interpretations of the Ten Canon Tables', Appendix D, in Mathews and Sanjian (eds), *Armenian Gospel Iconography*, 1991, pp. 206–11.

Russell, J. R., 'The Formation of the Armenian Nation', in Hovannisian, *The Armenian People*, I, 19–35.

Russell, J. R., 'Carmina Vahagni', *Acta Antiqua Academiae Scientiarum Hungaricae*, vol. 32, 1989, pp. 317–30.

Russell, J. R., *Yovhannēs T'lkuranc'i and the Mediaeval Armenian Lyric Tradition*, Scholars Press, Atlanta, 1987.

Samuelian, T. J., *St Grigor Narekats'i. Speaking with God from the Depths of the Heart. The Armenian Prayer Book of St Gregory of Narek*, Bilingual Classical Armenian–English Edition, Vem Press, Yerevan, 2001.

Sanjian, A. K., 'The Armenian Alphabet', in P. T. Daniels and W. Bright (eds), *The World's Writing Systems*, Oxford University Press, New York, 1996, pp. 356–7.

Sanjian, A. K. and A. Tietze (eds), *Eremya Chelebi Kömürjian's Armeno-Turkish Poem 'The Jewish Bride'*, Otto Harrassowitz Verlag, Wiesbaden, 1981.

Sanjian, A. K., *Colophons of Armenian Manuscripts, 1301–1480: A Source for Middle Eastern History*, Harvard University Press, Cambridge, MA, 1969.

Sarafian, N., *The Bois de Vincennes*, transl. by Christopher Atamian, with an introduction by Marc Nichanian, Armenian Research Center, University of Michigan-Dearborn, Dearborn, MI, 2011.

Seferian, S., 'Translator-Enlighteners of Smyrna', in R. G. Hovannisian (ed.), *Armenian Smyrna/Izmir. The Aegean Communities*, Mazda Publishers, Costa Mesa, 2012, pp. 153–66.

Seth, M. J., *History of the Armenians in India. From the Earliest Times to the Present Day*, Luzac & Co., London, 1897.

Shahnour, S., *Retreat without Song*, transl. and ed. by Mischa Kudian, Mashtots Press, London, 1982.

Simonyan, H., *Patmut'iwn Aḷek'sandri Makedonac'woy* [History of Alexander of Macedon], Armenian Academy of Sciences, Erevan, 1989.

Sirinian, A., 'On the Historical and Literary Value of the Colophons in Armenian Manuscripts', in V. Calzolari (ed.), *Armenian Philology in the Modern Era. From Manuscript to Digital Text*, Brill, Leiden–Boston, 2014, pp. 65–100.

Step'anyan, H. A., *Hayatar t'urk'erēn grk'eri ew hayatar t'urk'erēn parberakan mamuli matenagitut'iwn (1727–1968)* [Bibliography of Armeno-Turkish books and periodical press], Turkuaz Yayınları, İstanbul, 2005.

Step'anyan, H. A., *Hayatar t'urk'eren grakanut'yunə (Ałbyuragitakan hetazotut'yun)* [Armeno-Turkish Literature (A Source Study)], Erevan University Press, Erevan, 2001.

Stone, M. E., D. Kouymjian and H. Lehmann, *Album of Armenian Paleography*, Aarhus University Press, Aarhus, 2002.

Strohmeyer, V. B., *The Importance of Teseo Ambrogio degli Albonesi's Selected Armenian Materials for the Development of the Renaissance's Perennial Philosophy and an Armenological Philosophical Tradition*, Publishing House of the National Academy of Sciences "Gitutyun", Yerevan, 1998.

Suny, R. G., *They Can Live in the Desert but Nowhere Else: a History of the Armenian Genocide*, Princeton University Press, Princeton and Oxford, 2015.

Suny, R. G., F. M. Göçek and N. M. Naimark (eds), *A Question of Genocide. Armenians and Turks at the End of the Ottoman Empire*, Oxford University Press, New York – Oxford, 2011.

Suny, R. G., 'Soviet Armenia', in Hovannisian, *The Armenian People*, II, pp. 347–87.

Terian, A., *The Armenian Gospel of the Infancy: with Three Early Versions of the Protevangelium of James*, Oxford University Press, Oxford, 2008.

Terian, A., *Macarius of Jerusalem. Letter to the Armenians, AD 335*, St Vladimir's Seminary Press, St Nersess Amenian Seminary, Crestwood, New York, 2008.

Tēr Vardanean, G., Description of M2587: Letter to the Director of the Matenadaran, H. T'amrazyan, 7 August 2014.

Thierry, J.-M., *Répertoire des monastères arméniens*, Brepols, Turnhout, 1993.

Thomson, R. W., 'Armenian Biblical Commentaries: The State of Research', *JSAS*, vol. 18, no. 1, 2009, pp. 9–40.

Thomson, R. W., 'Armenian Literary Culture through the Eleventh Century', in Hovannisian, *The Armenian People*, I, 200–05.

Thomson, R. W., 'Supplement to a Bibliography of Classical Armenian Literature to 1500 AD: Publications 1993–2005', *Le Muséon* 120 (1–2), 2007, 163–213.

Thomson, R. W., *A Bibliography of Classical Armenian Literature to 1500 AD*, Brepols, Turnhout, 1995.

Thomson, R. W., *Moses Khorenats'i. History of the Armenians*, Caravan Books, Ann Arbor, 2006 (2nd, rev. ed.; 1st ed. 1978).

Thomson, R. W., *Elishē. History of Vardan and the Armenian War*, Harvard University Press, Cambridge, MA, 1982.

Thomson, R. W., *Agathangelos. History of the Armenians*, State University of New York Press, Albany, 1976.

Traina, G., C. Franco, D. Kouymjian and C. Veronese Arslan, *La Storia di Alessandro il Macedone, Codice miniato armeno del secolo XIV (Venezia, ms. San Lazzaro 424)*, 2 vols., Helios, Padua, 2003.

The Tula Museum of Samovars – the Beginning of XX century of samovars, www.shopsamovar.com.ru/museum07 (accessed 11 August 2014).

Üngor, U. Ü., *The Making of Modern Turkey, Nation and State in Eastern Anatolia, 1913–1950*, Oxford University Press, Oxford, 2011.

Uvezian, S., *The Cuisine of Armenia*, Hippocrene Books, New York, 1998.

Vardanyan, E., 'Les amulettes', in Mutafian, *Arménie: la magie de l'écrit*, pp. 123–5.

Vardanyan, Ṙ. H., *Hayoc' Tonac'uyc'ě: 4–18-rd darer* [The Armenian Church Calendar: 4th–18th Centuries], HH GAA "Gitut'yun" Hratarakč'ut'yun, Erevan, 1999.

Walker, C. J., 'World War I and the Armenian Genocide', in Hovannisian (ed.), *The Armenian People*, II, pp. 239–73.

Watkins, C., *How to Kill A Dragon: Aspects of Indo-European Poetics*, Oxford University Press, Oxford, 1995.

Watts, W. W., *Catalogue of Pastoral Staves*, Victoria and Albert Museum, Board of Education, London, 1924.

Werfel, F. V., *The Forty Days of Musa Dagh*, ed. and transl. G. Dunlop and J. Reidel, with a preface by V. Gregorian, David R. Godine, Boston, 2012.

West, M. L., *Indo-European Poetry and Myth*, Oxford University Press, Oxford, 2007.

Wilkinson, R. J., *Orientalism, Aramaic, and Kabbalah in the Catholic Reformation: The First Printing of the Syriac New Testament*, Brill, Leiden, 2007.

Winkler, G., 'Armenian Worship', in P. F. Bradshaw (ed.), *The New SCM Dictionary of Liturgy and Worship*, SCM Press, London, 2002, pp. 25–8.

Winkler, G., *Koriwns Biographie des Mesrop Maštoc': Übersetzung und Kommentar*, Pontifico Istituto Orientale, Rome, 1994.

Xač'atryan, P. M., and Aršaloys A. Ł., *Grigor Narekac'i. Matean ołbergut'ean* [Grigor Narekac'i. The Book of Lamentation], HSSH GA hratarakč'ut'yun, Erevan, 1985.

Xorenac'i, M., *History of the Armenians*, ed. R. W. Thomson, second revised edition, Caravan Books, Ann Arbor, 2006.

Yovsēp'ian, G., *Xałbakeank' kam Pṙošeank' hayoc' patmut'ean mēj* [The Xałbakians or Pṙošians in Armenian History], Catholicosate of Cilicia, Antelias, 1969, re-edition of Vagharshapat, 1928.

Zakarian, L., *Iz istorii Vaspurakanskoi miniatiury* [From the history of miniatures from Vaspurakan], Akademia Nauk, Erevan, 1980.

Žamagirk' Hayastaneayc' S. Ekełec'woy [Book of Hours (Breviary) of the Holy Church of the Armenians], St Vartan Press, New York, 1986

Index